Italian Renaissance Maiolica from the William A. Clark Collection

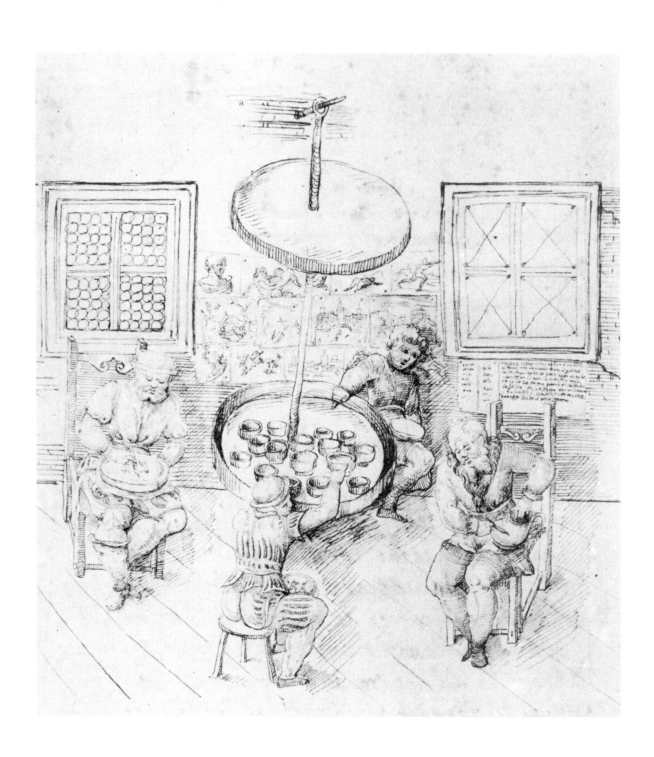

Wendy M. Watson

Italian Renaissance Maiolica

from the William A. Clark Collection

The Corcoran Gallery of Art and
The Mount Holyoke College Art Museum

Scala Books

First published in 1986 by Scala Books Ltd
Russell Chambers, Covent Garden, London WC2E 8AA

Designed by Alan Bartram
Produced by Scala Books
Filmset by August Filmsetting, England
Printed and bound in Italy by Graphicom, Vicenza

ISBN 0–88675–020–2 (paperback)
ISBN 0–935748–68–7 (US hardback)
ISBN 0–85667–226–2 (UK hardback)

Library of Congress Cataloging-in-Publication Data

Watson, Wendy M., 1948–
 Italian Renaissance Maiolica
 from the William A. Clark Collection.

 Catalog of a travelling exhibition organized by
 The Corcoran Gallery of Art and
 the Mount Holyoke College Art Museum.
 Bibliography: p. 188
 Includes index.
 1. Majolica, Italian—Exhibitions. 2. Majolica,
Renaissance—Italy—Exhibitions. 3. Clark, William A.
(William Andrews), 1839–1925—Art collections—
Exhibitons. 4. Majolica—Private collections—Washington
(DC)—Exhibitions. 5. Corcoran Gallery of Art—
Exhibitions. I. Corcoran Gallery of Art. II. Mount Holyoke
College Art Museum. III. Title.
NK4315.W35 1986 738.3′7 86–2262
ISBN 0–88675–020–2

Black and white and color photographs
of the Corcoran maiolica are
by Ed Castle.

Front cover: Plate with Alexander and Diogenes
(Master of the Coppa Bergantini), cat. 10

Back cover: Allegorical subject (Nicolò da Urbino), cat. 45

The exhibition was co-organized by
The Corcoran Gallery of Art
and the Mount Holyoke College Art Museum
and supported by a grant from
the National Endowment for the Arts.

Exhibition schedule

Mount Holyoke College Art Museum
South Hadley, Massachusetts
24 March–25 May 1986

The Mary and Leigh Block Gallery
Northwestern University
Evanston, Illinois
12 June–10 August 1986

The Elvehjem Museum of Art
University of Wisconsin, Madison
6 September–9 November 1986

Bowdoin College Museum of Art
Brunswick, Maine
19 December 1986–15 February 1987

Los Angeles County Museum of Art
Los Angeles, California
5 March–17 May 1987

The Saint Louis Art Museum
Saint Louis, Missouri
9 June–9 August 1987

Gardiner Museum of Ceramic Art
Toronto, Ontario, Canada
12 September–15 November 1987

Museum of Fine Arts
Boston, Massachusetts
7 December 1987–6 February 1988

Dayton Art Institute
Dayton, Ohio
5 March–7 May 1988

University Art Museum
University of Minnesota, Minneapolis
4 June–31 July 1988

The Corcoran Gallery of Art
Washington DC
September 1988–April 1989

Contents

Frontispiece:
Drawing of maiolica painters at work in a studio, from Cipriano Piccolpasso's
"I tre libri dell'arte del vasaio" (1557) (By courtesy of the Board of Trustees of
the Victoria and Albert Museum)

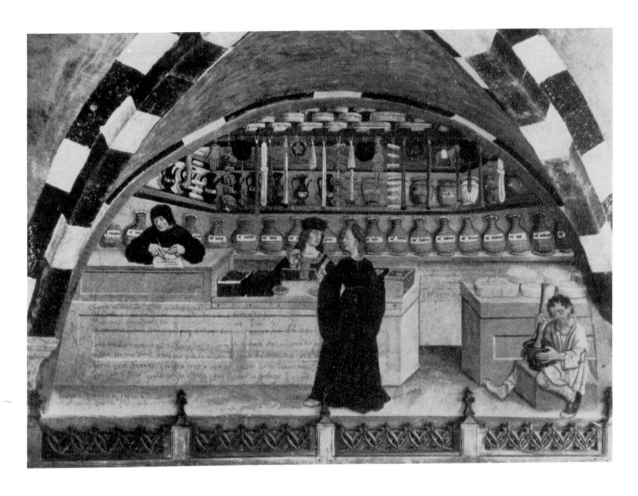

Lunette fresco of a pharmacy in
the Maniero di Issogne, Valle
d'Aosta, 1494–1507

Preface

The making of Italian Renaissance maiolica was inherently a process of collaboration. Anonymous potters formed the objects which were painted by skilled, but often equally anonymous artists. These artisans, in turn, frequently relied upon their patrons for themes and designs, in many cases drawing upon the work of major masters of painting and sculpture. We can see echoes in maiolica – as well as more direct adaptation – of the work of artists like Pinturicchio, Raphael, and Giulio Romano.

It seems particularly fitting, therefore, that the present exhibition and catalogue should come forth from the fruitful collaboration between two museums, the Mount Holyoke College Art Museum and the Corcoran Gallery of Art. Although curators frequently organize exhibitions that are shared with other institutions, few have catalogued a collection belonging to another museum, and organized a travelling exhibition drawn entirely from that collection. In this case, the Corcoran was the possessor of an outstanding collection of Italian Renaissance maiolica but had no curator to catalogue it. The Mount Holyoke College Art Museum, on the other hand, had in the person of Wendy Watson someone extremely interested in the project.

The problems arising from such an undertaking between two institutions, one urban and one academic, with different audiences separated geographically by hundreds of miles, were surprisingly few and minor. Certainly, the richness of the collection made the task pleasurable for all parties. Moreover, the cooperation among staff members of both museums at various levels contributed appreciably to the ease with which the project proceeded. The result – this extremely beautiful and scholarly catalogue, and the exhibition it accompanies – has proven to be well worth the effort.

From the outset, both Mount Holyoke and the Corcoran were convinced that the exhibition would be memorable and should be shared with others. Not only does the William A. Clark Collection constitute one of the major holdings of maiolica in America, but the exhibition is among the first in this country devoted exclusively to these extraordinary examples of Italian Renaissance art. Our colleagues in other institutions were equally enthusiastic and we wish to thank them for their confidence. A list of participating museums appears at the front of this catalogue.

Partial funding for the exhibition and catalogue was provided by the National Endowment for the Arts. The Corcoran Gallery would also like to thank the J. Paul Getty Trust for its assistance in conserving the works included in the show. A final word should be said of Senator William A. Clark, whose vision as a turn-of-the-century art collector encompassed not only painting and sculpture, but also the decorative arts, thus leading to the formation of this outstanding collection.

MICHAEL BOTWINICK, Director
The Corcoran Gallery of Art

TERI J. EDELSTEIN, Director
Mount Holyoke College Art Museum

Acknowledgments

From a casual conversation several years ago with the Corcoran's curator Edward Nygren came the revelation that there was at the Corcoran Gallery of Art an extensive collection of Italian Renaissance maiolica acquired by William A. Clark at the turn of the century and presented to the museum in 1926. Although a few pieces from the group had been exhibited during the last half century, and some initial research undertaken by Joan Prentice von Erdberg in the 1950s, a complete catalogue had yet to be written. The plans that I had then been formulating for a loan exhibition of Italian maiolica from various American collections were soon altered to concentrate specifically on the very fine – and for the most part unpublished – holdings of the Clark Collection.

The very existence of these hidden riches was not the only revelation that I experienced in the research for this exhibition and its accompanying catalogue. My investigations into the complex world of maiolica soon brought an awareness of the breadth of knowledge necessary to comprehend the significance of this "minor art" and its close associations with the major arts, the literature, and the intellectual currents of the Italian Renaissance. My initiation into these mysteries was facilitated by many helpful individuals in a broad range of fields and to all of them I owe a great debt.

Timothy Wilson, of the British Museum, and John V. G. Mallet, of the Victoria and Albert Museum, proved to be the most generous and stimulating guides in this venture, offering both information and encouragement at every step along the way, suffering endless inquiries by mail and in person, and adding Washington to their travel itineraries in order to look at the Clark maiolica at first hand. Many other keepers of maiolica collections both in the United States and abroad graciously opened their storerooms and files to me and spent hours in discussions of various questions and problems. Among them were Carmen Ravanelli Guidotti and Gian Carlo Bojani, of the Museo Internazionale delle Ceramiche, Faenza; Grazia Biscontini, of the Castello Sforzesco, Milan; Caterina Marcantoni, of the Museo Correr, Venice; Otto Mazzucato, of the Museo di Roma; Catherine Hess and Peter Fusco, of the J. Paul Getty Museum; Susan Caroselli, of the Los Angeles County Museum of Art; Ann Poulet, of the Museum of Fine Arts, Boston; C. Douglas Lewis, of the National Gallery of Art, Washington; and Lois Katz, of the Sackler Collection.

Indispensable guidance and information were provided on specific questions of iconography, bibliography, and provenance by numerous individuals, particularly Rudolf E.A. Drey, Sara Maddox, Donald Maddox, Frederick J. McGuiness, Andrew W. Moore, E. James Mundy, Sheryl Reiss, Claudia Rousseau, Carole E.

Straw, Julia Triolo, and John Waldman. Struggles with particularly difficult inscriptions and translations were considerably eased by Augusto Campana, David Grose, Philippa Goold, Angelo Mazzocco, and Valentino Pace. Other friends and scholars who contributed support in myriad ways were Micaela Azzano, Bettina Bergmann, Brigitte Cirla, Craig Felton, and Jennifer Josselson. The resources of the Bibliotheca Hertziana in Rome were fundamental to the completion of the research for this catalogue in Italy. In America, where such pursuits can prove difficult and time-consuming, the librarians of the Williston Memorial Library of Mount Holyoke College, particularly Janet Ewing and Irene Cronin, made my task infinitely more pleasurable.

The staffs of both the Mount Holyoke College Art Museum and the Corcoran Gallery of Art proved to be unstintingly supportive from the inception of the project. Upon her arrival as director at Mount Holyoke, Teri Edelstein joined in the planning, energetically helping to arrange for the publication of the catalogue and the tour of the exhibition. Sean Tarpey and Margery Roy assisted with countless details throughout the various stages of the exhibition, and Mia Schläppi and Erin Hogan cheerfully and patiently typed the manuscript of the catalogue. Michael Botwinick, William Bodine, Edward Nygren, Rebecca Gregson, Elizabeth Beam, Barbara Moore, Anne Prager, and many others at the Corcoran Gallery of Art offered invaluable material assistance and constant encouragement in all phases of the project. The conservation of the works in the exhibition was carried out by Meg Loew Craft with painstaking care and exactitude. Kathy Elgin of Scala Books gave many useful editorial suggestions, and provided valuable advice on many other aspects of the catalogue.

I owe a special debt of gratitude to Elizabeth T. Kennan, President of Mount Holyoke College, whose confidence in the value of this study was backed by the offer of a sabbatical during which the research was begun; neither the catalogue nor the exhibition would have been possible without her substantive support. I am grateful also to Odyssia Skouras Quadrani, former Chairman of the Art Advisory Committee of the Mount Holyoke College Art Museum, whose love of both Mount Holyoke and Italy were evident in her unflagging enthusiasm for the project from its earliest beginnings. My final thanks must go to my husband, John L. Varriano, who continually exhibited remarkable patience and unfailing good humor, offering inspiration when my own threatened to wane; his contributions as art historian, travelling companion, and editor have played a central role in the realization of this catalogue.

WENDY M. WATSON, Curator
Mount Holyoke College Art Museum

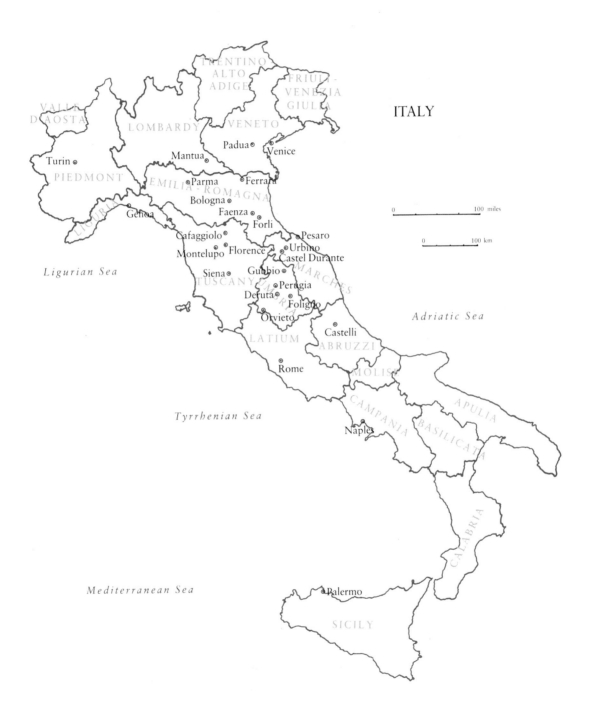

ITALY

VALLE
D'AOSTA

TRENTINO
ALTO
ADIGE

FRIULI-
VENEZIA
GIULIA

LOMBARDY

VENETO

PIEDMONT

Turin ⊙

Mantua ⊙

Padua ⊙

Venice ⊙

EMILIA - ROMAGNA

Parma ⊙

Ferrara ⊙

Bologna ⊙

LIGURIA

Genoa ⊙

Faenza ⊙

Forli ⊙

Pesaro ⊙

Cafaggiolo ⊙

Urbino ⊙

Montelupo ⊙

Florence ⊙

Castel Durante

MARCHES

Siena ⊙

Gubbio ⊙

UMBRIA

TUSCANY

Perugia ⊙

Deruta ⊙

Foligno ⊙

Orvieto ⊙

Castelli ⊙

LATIUM

ABRUZZI

Rome ⊙

MOLISE

Ligurian Sea

Adriatic Sea

CAMPANIA

APULIA

Naples ⊙

BASILICATA

Tyrrhenian Sea

CALABRIA

Mediterranean Sea

Palermo ⊙

SICILY

0 _____ 100 miles

0 _____ 100 km

Introduction

"At its best, Italian maiolica seems as it were to concentrate the quintessence of all the qualities which go to make up the greatness and abiding charm of Italian art. Herein lies, I think, its unique fascination."[1] Thus Tancred Borenius, historian and antiquarian, described the sustained appeal of the varied products of the Italian medieval and Renaissance potter's craft from their own time up to the present day. Although the term "maiolica" normally conjures up an image of High Renaissance wares of the golden age of Italian ceramics, tin-glazed earthenware was produced throughout the peninsula as early as the 11th–12th centuries in more archaic forms. More familiar, perhaps, are the sophisticated polychromatic *istoriato* ("historiated," or narrative) wares of the *cinquecento* which avid 18th- and 19th-century collectors called "Raphael-ware" in homage to the great Renaissance master whose works often found new expression through ceramic artisans as "paintings on clay."

In the grander scheme of things, Italian maiolica represents only one point in the extended continuum of ceramic history. One of man's earliest technologies and, in the words of Robert Charleston, "the longest lived handicraft of which we have continuous knowledge,"[2] pottery making grew out of the simple need in prehistoric times for a container more efficient than a man's two hands and more durable than a hollow gourd. Any archaeologist will testify to the inestimable value of ceramics as the most basic of cultural documents, and to their enduring nature, even under the most destructive burial conditions lasting thousands of years. Although they may seem fragile because they are easily broken, baked clay vessels will survive longer than most other materials, even if only as fragments or potsherds.

Italian maiolica is itself quite friable and subject to chipping, and few pieces have come down to our own time completely free from damage. Many of the works in the Clark Collection have undergone restoration and conservation at various points in their history, as can be seen, for example, in the early repairs made with metal staple-like reinforcements in the ancient Greek tradition (cat. 26). The very evidence of these time-consuming mends attests to the value which has tradition-ally been accorded maiolica wares, and the great esteem in which they are still held. Perhaps their enormous appeal can be explained by Borenius' further com-ment that "whatever our individual likes and dislikes, the relation of the works of the potter's art to the general tendencies of style, prevailing at any given moment, always remain profoundly interesting."[3]

In Renaissance Italy such things as maiolica, tapestries, furniture, medals, glass-ware, jewelry, and metalwork were not so easily separable from the major arts of painting, sculpture, and architecture as they may seem to us today. Indeed, the dec-orative arts were thought of as integral factors contributing to a general ambiance of beauty and refinement in the everyday life of the upper classes in cultural centers like Urbino, Ferrara, and Florence. In this role, they partook of many of the same aesthetic and intellectual considerations that underly the painting and sculpture of their time, and today remain capable of revealing a great deal to us about the broad diffusion of interest in classical antiquity, for example, or the complex work-ings of aristocratic and ecclesiastical patronage.

The Italian maiolica of the Clark Collection ranges chronologically from the latter part of the 15th century to the end of the 16th century, a period of little more than one hundred years in which the potters and painters produced what are generally considered to be Italy's very finest painted ceramics. These extraordinary wares were made possible by a unique combination of technical, artistic, cultural, and

1 Tancred Borenius, "Italian Maiolica in the Collection of the Rt. Hon. F. Leverton Harris, II," *Apollo* 1 (1925), 323.
2 Charleston, 9.
3 Borenius, loc. cit.

4 Caiger-Smith/*TGP*, 21–24.

5 Ibid., 23.

6 Charleston, 212–216. The Medici experimented briefly with soft-paste porcelain in the late 16th century, but it was left to French craftsmen at Rouen and Saint-Cloud to manufacture it in any quantity. The formula for hard-paste, or true porcelain was rediscovered in Germany by the alchemist-turned-potter Friedrich Böttger, who in 1710 founded the Meissen factory that still remains in operation today.

7 See David Whitehouse, "The Origins of Italian Maiolica," *Archaeology* 31 (March 1978), 42–49, and bibliography cited there for archaeological evidence regarding early maiolica in Italy.

economic circumstances which came together in that period of fertile imagination we call the Renaissance.

Ceramics, of course, had been actively produced throughout the peninsula since man first came to understand the capabilities of clay, with particularly notable phases occurring during the period of Greek colonization (5th–3rd centuries BC), when immigrant craftsmen established a flourishing industry throughout the southern provinces and Sicily; the Etruscans, farther to the north, and later the Romans maintained their own active pottery-manufacturing concerns, turning out – like their Greek predecessors – both undecorated utilitarian vessels and more elaborate luxury wares intended for the households of the upper classes. Between the end of the Roman empire and the late 15th century, however, technological innovations were introduced into Italy that radically changed the course of European ceramic history.

Primary among these was the use of an impermeable transparent lead-based glaze, and following it, the white tin-glaze, which were applied to the surfaces of porous earthenware vessels. Ceramics with vitreous colored glazes were, in fact, known in Roman times, apparently developed by the famous glass workshops of Egypt and Syria. Ultimately, however, it was this very technology which contributed to the invention of a white-glazed pottery in the Islamic world of the 9th century. By that time, trade connections were already well-established between the Middle East and China, where T'ang potters had already developed the first porcelain.[4]

The arrival of this miraculously fine white translucent ware must have been greeted with great admiration in the courts of the caliphs, where many pieces were known to have been sent as gifts.[5] And that appreciative response was followed quickly by a rush to recreate them as closely as possible using the available technologies. The white tin-based glaze subsequently invented by Islamic craftsmen, in imitation of the more delicate Chinese porcelain, formed the basis for the later and much sought-after Hispano-Moresque wares of the 11th century and beyond, as well as Italian maiolica, French faience, Delftware, and the related earthenwares of central Europe and Britain. Its greatest importance lay in the fact that the smooth, opaque white glaze layer proved to be a very receptive ground for the painting of detailed ornamental designs and, eventually, complex narrative scenes. More stable than the earlier clear lead glaze, it did not shift or run in the kiln, so that the painters' compositions were preserved perfectly, and permanently, in the glaze layer after firing. The technique came to dominate European ceramics until the importation of porcelain from China began in the 17th century, and the discovery soon afterwards of soft-paste and then hard-paste, or true porcelain, by French and German artisans.[6]

The question of how Italian potters learned of the formula for tin-glazed earthenware is a complicated one. Archaeological excavations in the last few decades in Italy have unearthed evidence that two different forms of maiolica were already being produced there by the middle of the 13th century: (1) pottery painted in brown and green which is known as archaic maiolica, or "Orvieto ware" because of its profusion in that area, and (2) the so-called "proto-maiolica," with its broader polychrome palette, that was exported to the Eastern Mediterranean and has been found at Corinth and on various sites on the island of Cyprus.[7] The overwhelming Islamic presence along the north African coast, in Spain and in nearby Sicily was probably an important factor in the transmission of the technique to the Italian peninsula, although the exact mechanics of this exchange have yet to be documented.

Hugo van der Goes, detail from
the *Portinari Altarpiece* (c.1476;
Uffizi Gallery, Florence)

8 Piccolpasso I, folios 46v and 47r. Recently, Caiger-Smith (in *Lustre Pottery*, 127) has suggested that the term "maiolica" is derived from the Spanish name for lustre, "obra de málequa."

9 By the late 16th century, in fact, Faenza had become synonymous with maiolica manufacturing, and *"una Faenza"* was the term used in Naples for a ceramic workshop; see Mallet/*English*, 23.

10 Caiger-Smith/*TGP*, 71.

11 This passage was originally thought to have been written in 1383, but now appears to be an interpretation of the late 15th century, according to Caiger-Smith (see *TGP*, 71, and 8 above).

12 E.g. Rackham, cat. 51.

The name "maiolica," in fact, was only invented later, as a term applied to Spanish wares imported into Italy. Spanish tin-glazed lustre wares were shipped to Italian ports by traders from the island of Majorca, and it is thought that the term was a corruption of the name of that geographical mid-way point. Interestingly, the word "maiolica" signified something completely different to 16th-century Italians, as we know from Cipriano Piccolpasso's famous treatise of 1557 on the art of pottery-making. The section which he specifically entitled "Maiolica," or "Golden maiolica,"[8] referred exclusively to the metallic lustre that was commonly applied to Arabic and Spanish ceramics, and eventually to Italian wares in the specialized lustre kilns at Gubbio, Deruta, and elsewhere (cats. 33, 36 and 37). Later, the word "faience" – the French translation of the name of one of Italy's foremost pottery-producing centers, Faenza – was adopted as a general designation for all tin-glazed earthenware.[9]

The extraordinarily fine Hispano-Moresque ceramics of the Valencian centers, particularly those of Paterna and Manises, were actively imported into Italy during the 15th century, many as a result of direct commissions from ecclesiastical patrons and noble families like the Medici and the Borgias, whose coats of arms appear on them.[10] A famous passage by Francisco Eximenez of Gerona described these wares late in the 15th century:

"The communal industry of Paterna and Caceres is the making of fine jars, jugs, bottles, chargers, plates, bowls and tiles, and like desirable objects. But the beauty of the golden ware of Manises excels them all, painted in a masterly manner, which with good reason has made all the world its admirer, so that the Pope himself and the Cardinals and Princes of the world all covet it, and are amazed that anything so excellent and noble could be made from common clay."[11]

We know from their appearance in paintings such as Hugo van der Goes' Portinari altarpiece – commissioned around 1476 by an Italian patron – that Spanish lustred wares were popular not only in Italy, but throughout Europe. These sumptuous decorated ceramics brought with them the awareness that clay vessels could be more than simple household containers, and they became symbols of status in the European countries to which they were exported. Their ornamental repertory was based on stylized leaves and flowers, animals and birds, Arabic calligraphy, scrolls, interlace, and other Islamic-derived patterns, although some artists painted representational scenes including human figures in a more Western mode.

Italian artisans of the *cinquecento* were clearly influenced by the products of their Hispano-Moresque colleagues, and even made albarelli (drug jars) with pseudo-Kufic writing in imitation of Spanish drug jars.[12] They had already begun to develop their own styles, however, going beyond the green and brown archaic wares that had characterized their native production, as technological advances expanded the range of ornamental possibilities. Craftsmen in Tuscany, for instance, started to use a thick blue pigment to decorate jars with birds and animals set against a background of foliage resembling oak leaves.

Soon after the middle of the 15th century, additional pigments based on metal oxides were developed that could withstand high kiln temperatures, and a broader palette became available: green (made from copper), blue (cobalt), purple (manganese), yellow (antimony), and ochre, orange, and red (iron). Perhaps this was the most critical moment in the fortunes of Italian maiolica. The basic techniques of tin-glazed earthenware were now established, and a full range of colors was finally at hand. The combination of a technology ripe for exploitation, and the rich atmosphere of artistic activity – particularly in the area around Florence where

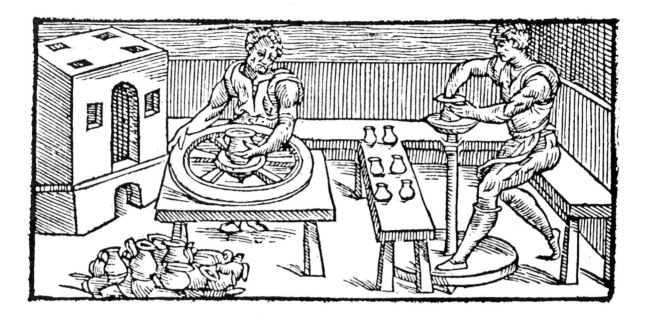

Tuscan potters could not have failed to be influenced by the achievements of contemporary painters, sculptors, and practitioners of the other decorative arts – was bound to be a fruitful one.

What we know today about the techniques of tin-glazed earthenware in Renaissance Italy comes in great part from the remarkable treatise of Cipriano Piccolpasso, *I tre libri dell'arte del vasaio* (*The Three Books of the Potter's Art*) of 1557.[13] A native of the flourishing pottery-manufacturing town of Castel Durante (later renamed Urbania under Pope Urban VIII), Piccolpasso (c. 1523/4–1579) undertook this manuscript at the request of Cardinal François de Tournon, a prominent Renaissance churchman and humanist who had great interests in literature and the arts, as well as science and mathematics.[14] De Tournon may have intended to put the treatise to use as a guide for improving the quality of French maiolica, which by the mid-16th century was being manufactured in Lyon (de Tournon's own see since 1551) and other cities owing to the migration of Italian potters.[15] Unfortunately, the cardinal died in 1562, shortly after the completion of Piccolpasso's work and the manuscript – now in the library of the Victoria and Albert Museum – was never published.

As he himself freely acknowledged, Piccolpasso based his treatise on Vannoccio Biringuccio's *Pirotechnia*, published in Venice in 1540, which mainly treats the field of metallurgy, but includes information also on chemistry, military arts, gunpowder, fireworks, and the making and firing of pottery.[16] Cipriano Piccolpasso came from a family of patrician rank and was given a thorough humanistic education in preparation for a career at court or in one of the higher professions such as law or the military.[17] In the tradition of Castiglione, who required that the perfect courtier have a knowledge of painting and drawing, he apparently acquired such skills, and turned as well towards the investigation of the art of pottery. Whether he ever actually worked as a potter has not been confirmed but it is thought that he was probably introduced to the craft by his brother Fabio, who was reported to have been the master of a maiolica workshop.[18] Twice in the manuscript, however, Piccolpasso refers to aspects of ceramic manufacture that he learned through practical

Woodcut illustration of potters at work from Vannoccio Biringuccio's *De la pirotechnia* (Venice, 1540)

13 A very fine facsimile edition of Piccolpasso's treatise, with a thorough introduction and translation, is that of Ronald Lightbown and Alan Caiger-Smith (Scolar Press, London, 1980, 2 vols.); for the correct dating of the manuscript, see vol. I, xxiv. An earlier treatise was written in 1301 by Abu'l Qasim of Kashan, in Central Persia; see J.W. Allan (transl.), "The Treatise of Abu'l Qasim of Kashan," in *Iran* (Journal of the British Institute of Persian Studies) IX (1973), 111–120.
14 Piccolpasso II, xxiii–xxiv.
15 Ibid., xii.
16 Vannoccio Biringuccio, *De la pirotechnia* (Venice, 1540; ed. Adriano Carugo, 1977).
17 Piccolpasso I, xii.
18 Ibid.

19 Ibid., xxi.

20 In addition to the excellent technical descriptions provided in the 1981 edition of Piccolpasso's work (see [13] above), Alan Caiger-Smith offers much useful information about methods and materials in his *Tin-Glazed Pottery* (1973).

21 The term "wine lees" refers to a crust that forms on the inside of wine casks; it is removed from the barrels, shaped into loaves, dried, and then burned, after which it is ready for use in pottery-making. Piccolpasso is careful to note that wine lees should be burned at least a mile outside of town, the smell being so acrid that it is "apt to make pregnant women miscarry." (Piccolpasso II, 51).

22 Caiger-Smith/*TGP*, 199.

23 Piccolpasso II, 101–102.

24 Ibid., 101.

25 Ibid., xvii. Piccolpasso describes this in 1557, though it is not clear exactly when the practice of using a clear finishing glaze began; Caiger-Smith says only that it was "adopted gradually in the course of the 15th century."

Opposite:
Drawing of a kiln being fired, from Cipriano Piccolpasso's "I tre libri dell'arte del vasaio" (1557) (By courtesy of the Board of Trustees of the Victoria and Albert Museum)

experience, so it is clear that he did try his hand at pottery-making, if only as an interested dilettante.[19]

The three-part treatise covers most essential elements of the craft, ranging from the collection and preparation of clay, formation of vases, and construction of pottery wheels, tools, and kilns, to the composition of glazes, pigments, and lustres, the various firing techniques, and examples of popular painted designs of the time. Although Piccolpasso could not have realized it, very little was to change in the ceramic technology he described until the major innovations in the 18th century of porcelain and other durable wares.

As Piccolpasso described in Book I of his opus, the earthenware vessels were either thrown on a potter's wheel or formed by pressing clay into molds.[20] They then were fired in the kiln, reaching a hard, porous state called "biscuit ware." Next, the bare buff-colored biscuit pieces were dipped into the liquid tin-glaze, or *bianco*, as Piccolpasso called it, receiving a smooth coat of the fine white mixture. To form the glaze, oxides of tin and lead were combined with a substance called *marzacotto*, a flux or silicate of potash, consisting of sand and wine lees.[21] It is the particles of tin oxide that are actually responsible for the opacity and whiteness of the *bianco*, because they are suspended in the glaze layer and reflect light.[22]

The plate or vessel was now ready to be painted. The painting of maiolica required an extremely sure and steady hand, because once the wet pigment from the artist's brush touched the chalky surface of the *bianco*, it was instantly absorbed. There was no opportunity for repairing an error or implementing a change of mind in this demanding medium.

Although Piccolpasso wrote exhaustively on the technical aspects of making and firing maiolica, he said remarkably little about the actual painting of designs or narrative scenes on the wares themselves, devoting fewer than three pages to the topic. Fortunately, a charming drawing that illustrates this section has proved revealing: on the rear wall in this scene are numerous prints or drawings tacked up as models for the painters (see frontispiece). The craftsmen are shown just as Piccolpasso so ingenuously described them, at work on their vases: "Painting on pottery is different from painting on walls, since painters on walls for the most part stand on their feet, and painters on pottery sit all the time; nor could the painting be done otherwise, as will be seen in the drawing of it; and the ware that is being painted is held on the knees with one hand beneath it . . . the hollow ware is held with the hand inside it."[23]

He did not, in any part of his treatise, discuss the means by which images derived from prints were transferred by artists to their wares, a common practice particularly among painters of *istoriato* wares like Xanto (cats. 52 and 53). At the same time, however, he was careful to mention such minute details as the most preferred materials for paintbrushes – the whiskers of mice.[24]

When the decoration of a piece was complete, it was finished with a layer of clear glaze called *coperta*, which had to be applied very carefully – probably by sprinkling it from a brush – to avoid ruining the delicate painted surface of the *bianco*. The overglaze provided a clear, smooth finish and made the colors appear even more saturated and brilliant.[25] The second firing, probably at around 950–1000°C, melted the glaze, fusing the pigments permanently. Wares had to be set within the kiln so as to avoid their touching and sticking together while the glaze was in its softened state. If gold or red lustre was to be applied to a work, it had to be done in a special third firing in a low-temperature reducing kiln. The

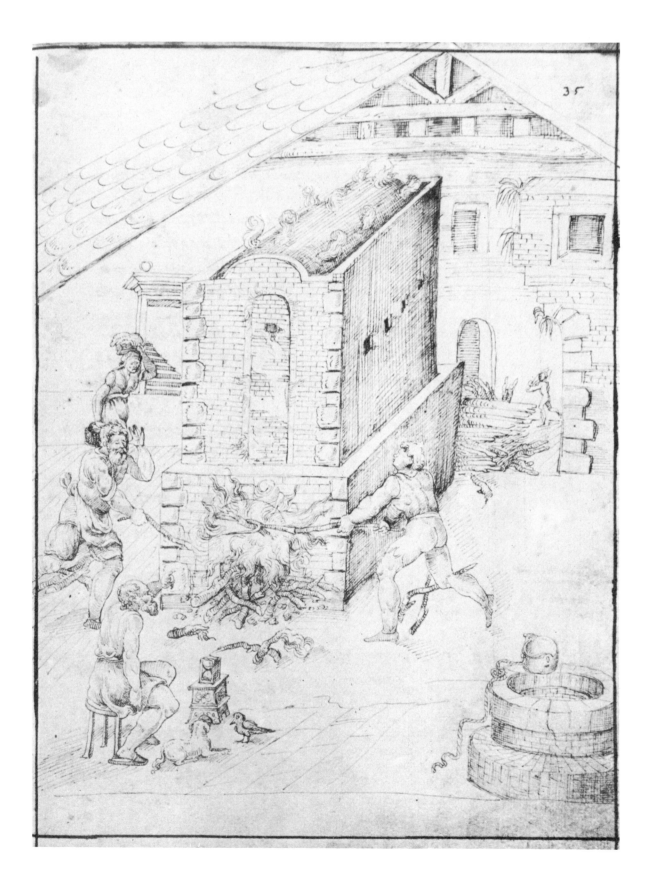

26 For an excellent overview of drug jars in Europe, see Rudolph E.A. Drey, *Apothecary Jars* (London, 1978) and an expanded version of that work, *Les Pots de Pharmacie du Monde Entier* (Paris, 1984).

27 Some Italian pharmacies retain remnants of this image today, particularly in Venice.

28 Mallet/*Gonzaga*, 42.

29 See Giulio Romano's painting *The Wedding of Cupid and Psyche* in the Palazzo dee Tè (ill. in F. Hartt, *Giulio Romano*, New Haven, 1958, II, fig. 254), which includes a prominent *credenza* of luxurious metal wares.

metallic components of the lustre pigments would remain on the surface of the glaze, adding a luminous reflective quality to the piece (cats. 36 and 38).

Ceramic workshops produced two basic categories of wares: the simple everyday domestic pottery that was used for cooking, food storage and preservation, and serving at table, and the more elaborate painted ceramics which, while functional, were more important for their decorative qualities. Domestic pottery, which may also have been painted, was usually used until it wore out or broke, and consequently fewer well-preserved examples of it remain. Wares of the second group, obviously more valuable and better cared-for, have survived in reasonable quantities through the centuries, and thus present to modern viewers a somewhat misleading view of Renaissance ceramics. To what extent the more ornamental works were used – if at all – remains unclear today. However, some of the finely painted wares certainly functioned as pharmaceutical containers whose shapes reflect their particular applications. Albarelli, spouted syrup jars, round-bodied vessels, and tall-necked jars (cats. 25, 30, 69 and 16), whether bearing drug labels or not, generally show signs of wear. In fact, pharmacies required hundreds of vessels to contain their normal stocks of herbs, drugs, syrups, ointments, powders, pills and sweet confections, and provided a special economic base for the ceramic industry. Some workshops seem to have been almost exclusively occupied in turning out apothecary jars to meet their needs.[26] And while pharmacists today take pride in a more antiseptic, laboratory-like image, those of Renaissance Italy placed greater emphasis on an aesthetic ambiance that included not only the beautifully painted jars and pitchers, but ornamental furniture, and even paintings and sculpture.[27]

Some of the other painted wares were also clearly functional, like salt cellars, inkstands, and ewers, for example. Curiously, we have little evidence as to whether the finest *istoriato* plates were employed in the serving of food. As John Mallet has noted, the great services like that made for Isabella d'Este show few signs of wear, although it must also be remembered that this was an age when metal eating utensils were rare and most food was taken with the hand.[28] It seems that such luxury wares were, for the most part, intended for decoration and display, arranged on *credenze*, or sideboards, in much the same way that gold and silver vessels were often put out to be admired.[29]

As the art of maiolica developed, these luxurious polychromatic wares came to be seen as appropriate gifts for special occasions like betrothals, marriages, or births. Services were commissioned by patrician families with their coats of arms, or perhaps those of another distinguished individual to whom they were to be presented. It is thought that the large Deruta *piatti da pompa* (display plates) with images of St. Francis may have been sold to the more well-heeled pilgrims to nearby Assisi. Ceramic plaques with religious imagery – like the Clark example (cat. 27) which was made in a spirit of supplication – were also produced in various workshops.

With the upsurge of the *istoriato* style at the end of the first quarter of the 16th century, the importance of the ceramic object itself was far surpassed by that of the painted decoration. Unlike ancient Greek potters, maiolica artisans were not unduly preoccupied with the shapes of their vessels, at least until later in the 16th century when complicated molded wares came into fashion. The surface of a vase, or particularly a plate, came to be seen as little more than a support for the elaborate narrative scenes favored by renowned painters like Nicolò da Urbino, Francesco Xanto Avelli, and others.

Much of what we know about the composition and operation of a Renaissance ceramic atelier comes from Piccolpasso's manuscript and his revealing drawings.

Archival records have also been gleaned for additional information about the identities of potters and painters, the size and production levels of shops, and other economic factors which contributed to the industry. As in other trades, it was not uncommon for several members of a family to be involved in a single pottery workshop, as was the case with Guido Durantino and his sons and descendants who worked under the Fontana name. This practice probably proved to be an economical one, as well, because there were many varied tasks requiring different levels of skill, ranging from gathering and preparing the clay, glaze, and pigments, to making and painting the pots, firing them, and eventually marketing the wares.[30]

Basing their estimate on the information provided by Piccolpasso, Caiger-Smith and Lightbown have suggested that a typical small balanced workshop might include eight or nine individuals: a foreman-owner/manager (who may or may not have been a master craftsman himself), two potters, two or three painters, a kiln man, and two general workers.[31] Since it was more time-consuming to paint vessels than it was to form them on the wheel, painters usually outnumbered the throwers. The largest ateliers, like that of Xanto (see p. 25), must have employed many painters, working in a style and to specifications set by the master whose name appeared on the signed pieces. It is also possible that more than one artist worked on a single vessel, as was sometimes the case in antiquity; a similar form of specialization may have existed among Renaissance craftsmen, with artisans talented in a particular genre executing grotesques, borders, and landscapes, or simply filling in the plain areas of the backgrounds.[32]

By the third quarter of the 15th century, pottery-makers had made significant progress in freeing themselves from their traditional and somewhat pedestrian role as manufacturers of utilitarian clay vessels. Influenced by the magnificent Hispano-Moresque wares, and armed with a new expanded technology, they began to explore new design possibilities. On the foundations of the Islamic-derived motifs of the imported ceramics and their own native traditions, the artisans of Tuscany (especially Florence) and soon afterwards Faenza, developed a new decorative vocabulary that included the elegant scrolled leaf pattern (cat. 19) that became a hallmark of the "Gothic-floral" style, the stylized Persian palmette (resembling an abstract pinecone), a colorful peacock-feather design (cat. 1), and the so-called San Bernardino rays (cat. 25), as well as numerous other floral and geometric patterns (cat. 5).

The renowned tile floor in S. Petronio, Bologna, made in 1487 under the direction of the Faentine artisan Petrus Andrea, is a veritable catalogue of the rich ornamental repertory of the time. It also shows a new reliance on motifs derived from classical antiquity – many of them taken from architecture, like the bead-and-reel and egg-and-dart patterns – just as similar antiquarian interests had characterized the work of Renaissance painters like Andrea Mantegna and Melozzo da Forlì a few years earlier (cat. 2). A cornucopia of other motifs appear in the center of each hexagonal tile – trophies, birds, animals, coat of arms, fantastic creatures, portraits, and everyday objects like eye-glasses and tools – all of which were to play a part in the subsequent styles that eventually led to the most complex compositions of all, the *istoriato* wares of the *cinquecento*.

Among the other developments at this critical stage in the latter part of the 15th century was the airy blue and white floral pattern that came to be known as the *alla porcellana* style (cat. 21), based, as its name suggests, on Chinese Ming porcelain that was entering the peninsula through the eastward-looking city of Venice.

30 The work of maiolica artisans could indeed be laborious, and was not without its hazards. Lead-poisoning was a significant problem because of the constant contact with glazes containing the metal, causing nerve damage and other maladies. As early as the 17th century, this occupational disease was discussed in a treatise on work-related illnesses (see Carlo Grigoni, "Le malattie professionali dei vasai," *Faenza* XX, 1942, 51–57). The lead in glazes posed a danger as well to owners of finished wares, as medicines or acidic foods stored in them were capable of absorbing the poisonous metal.

31 Piccolpasso II, xxii.

32 Even Piccolpasso's drawing of four painters working in a single studio suggests the possibility of collaboration. (See Mallet/*PLIII*, 172–173, and "Pottery and Porcelain at Erddig," *Apollo* CVIII, 1978, 42).

33 Giorgio Vasari, *Le vite de' più eccellenti pittori scultori e architettori*, (1550; ed. R. Bettarini and Paolo Barocchi, Florence, 1966), from the *Introduction on Painting*, Chapter XXVII, 143–144. For information on grotesques in the Renaissance, see Nicole Dacos, *La Découverte de la Domus Aurea et la Formation des Grotesques à la Renaissance* (Studies of the Warburg Institute, XXXI, Leiden, 1969).

34 Rackham, 47 and cat. 167.

35 A writing set with Apollo and the Muses (after Raphael) is in the Metropolitan Museum of Art; see cat. 63 for further information.

Around the turn of the century, the rediscovery of the buried monuments of ancient Rome had an immense effect on all the visual arts. These underground chambers or grottoes, as they were known, revealed wall paintings and stucco decorations that astounded their viewers, and became known as "grotesques." Studies were made of the hitherto unknown images by Pinturicchio, Signorelli, Filippino Lippi, Perugino, and many others, and the style soon spread throughout Italy, not only in painting but in the decorative arts as well. Their impact was still evident half a century later in the amusing and rather disapproving comments of Vasari:

"Grotesques are a type of quite licentious and ridiculous painting, used by the ancients to fill up empty spaces, and in some places look as if they are floating in the air. There are all sorts of monsters, their size depending on the available space, and their forms depending on the imagination of the painter. There are no particular rules for making them, and thus hanging from the thinnest thread is a weight it could not possibly bear, or a horse with legs of leaves, or a man with crane's legs, along with many small ribbons and birds. And he who possesses the strangest imagination is considered the best painter."[33]

Maiolica painters adopted these whimsical and fantastic forms with enthusiasm, including them in the decorative schemes of Sienese albarelli (cat. 25), on the borders of Faentine plates (cats. 10 and 26), and as the main subjects of Castel Durante dishes (cat. 42). Grotesques were very much in vogue in maiolica in the first decades of the 16th century and became even more prevalent in the white-ground wares of the Fontana and Patanazzi workshops in the second half of the *cinquecento*.

Three-dimensional wares like the two Faenza inkstands in the Clark Collection (cats. 3 and 4) testify to the potters' awareness of the sculptural possibilities of clay. Such charming and often naive works sometimes functioned as ornamental table-pieces as well as utilitarian objects. Their subject matter ranged from large decorative reliefs of religious scenes like the Deposition or Nativity, to a fountain with the Judgement of Paris, or an unusual ewer with the head of a bull surmounted by a nude female figure who may represent Europa.[34] The best-known of three-dimensional ceramic pieces were the architectural embellishments made by the Della Robbia atelier of Florence, although these were to remain an isolated phenomenon in the history of Italian tin-glazed earthenware.

The interest in sculptural ceramics was rekindled by the Fontana workshop in Urbino after the mid-16th century. Their development of a new style based on delicate grotesques set against a white ground was well-suited to the more complex mold-made shapes. Until the end of the century, Urbino studios produced elaborate salt cellars, writing sets, inkwells, and other forms (see cat. 63), many of which included three-dimensional chimeras, putti, dolphins, or groups of human figures representing complex subjects like Apollo and the Muses.[35]

One of the most important technical innovations of the *quattrocento* for the design and production of ceramics was the invention of the printing press and the attendant developments in printmaking. Woodcut images had, of course, been made in northern Europe as early as the end of the 14th century, but it was Gutenberg's movable-type press that was the catalyst for their proliferation. Subsequently, printed books with woodcut illustrations, like Francesco Colonna's *Hypnerotomachia Poliphili* (1499) and the 1497 edition of Ovid's *Metamorphoses*, were widely mined by maiolica artists as sources for their imagery (cat. 45). Copperplate engraving, which appeared in Italy a few decades after its invention in the North, had

an even greater impact on these artisans. Engravings and woodcuts by northern artists like Martin Schongauer and Albrecht Dürer circulated actively among Italian craftsmen, and frequently inspired the compositions on maiolica plates.[36] Other multiple images by native Italians, such as the so-called *Tarocchi* prints (cat. 1), obviously enjoyed a similar popularity.

Prints of this sort made possible the transmission of artistic compositions to a much broader geographical area and to individuals of a different socio-economic class than was previously the case. Unlike paintings, which usually existed as unique examples that were the preserve of the wealthy and the privileged, prints could be owned, studied, and adapted by artisans at their leisure. We have as yet little evidence about how maiolica painters obtained prints, although we know from the large numbers of extant works based on them that they did so enthusiastically. John Mallet has suggested that because engravings were costly, artisans may have borrowed rather than bought them.[37] In the end, the widespread diffusion of prints was in good part responsible for the evolution of *istoriato* wares that began in the workshops of Faenza early in the 16th century.

Although the principal pottery centers of Renaissance Italy were located for the most part in the north-central provinces of Tuscany, Umbria, and Emilia Romagna, where the necessary raw materials abounded, ceramic production extended from Sicily and Naples to Venice. The evolution and interaction of these centers and their maiolica workshops are the subject of an extensive scholarly literature,[38] and are briefly discussed in the relevant catalogue entries that follow. A brief summary of the major centers and their contributions may, however, be helpful.

Appropriately, it was in the area around Florence that innovative ideas about maiolica began to emerge in the mid-15th century. Florence, one of the largest cities in Europe, was also the wellspring of Italian Renaissance artistic activity, the site of major works by such masters as Masaccio, Fra Angelico, Brunelleschi, Alberti, and Donatello. Lively trade connections between Florence and Spain had led to the importation of lustred Hispano-Moresque wares to satisfy the taste of prominent families like the Medici, and created a market for luxury ceramics that was soon filled by local products. In response to the needs of newly-founded hospitals and pharmacies in the region, native artisans and their studios began to produce vessels like the beautiful oak-leaf jars with their slightly raised designs in rich blue pigment. With the new polychrome palette came the decorative repertory of the "Gothic-floral" style in the 1470s and 1480s (cats. 19 and 20), its Islamic reminiscences now tempered by the influence of Gothic and classical ornament. Under the patronage of the Medici, Tuscan potteries flourished, including those of the nearby towns of Cafaggiolo and Montelupo (cats. 21 and 22).

The workshops of Faenza burst into activity at the same time, following the example of the Tuscan-Florentine industry and sharing many of the same newly-generated patterns. Faenza soon became the dominant maiolica-producing center, refining the technical processes and creating new styles that would strongly affect the future of all tin-glazed earthenware in Italy and throughout Europe. Not the least of the Faentine innovations was the decoration of ceramics with increasingly elaborate narrative compositions, sometimes based on prints or other works of art (cats. 1 and 2).

By the early 16th century, talented painters such as the anonymous Master of the Resurrection Panel[39] were already laying the ground for the *istoriato* style that was

36 E.g. Faenza plate of c.1510 derived from Schongauer's *Death of the Virgin* (British Museum; ill. in Caiger-Smith/*TGP*, color pl. I) and the V & A plaque with the *Resurrection* of the same time based on a Dürer woodcut (ill. Charleston, color pl. 29).
37 Mallet/*English*, 21.
38 See Bibliography.
39 See [36], above.

40 For information on the Petrucci Palace tiles, see Giacomotti, 105–109; Rasmussen, 116–127; and Rackham, 132–133.

taken up by Faentine shops like the famous Casa Pirota establishment and that of the Bergantini family (cat. 10), and eventually became one of the major prevailing trends in Urbino, Pesaro, and other centers. Later, Faenza was also known for its rich ornamental molded wares in the *a quartieri* style (cats. 11–13 and 73) and the famous *bianchi di Faenza* – brilliant white wares with sketchily-drawn putti and other subjects in orange, yellow, and blue.

A group of striking albarelli from the last decades of the 15th century were also traditionally assigned to Faenza, but now appear to document an active ceramic industry in Naples at that time (cats. 23 and 24). The highly individualized portraits on these handsome drug jars are enclosed within contour panels – a convention popular in *quattrocento* Tuscany and Faenza (cat. 1) – and their reverses are covered with swirling Gothic-floral leaves that also found great favor in northern Italy.

In Siena, native artisans – together with craftsmen like Maestro Benedetto who migrated there from Faenza in the early 16th century – were engaged in the production of colorful plates and albarelli featuring grotesque decoration (cats. 25 and 26) and elegant tiles like those made for the Petrucci Palace in Siena around 1509.[40] The ceramic industry of Siena was one of the earliest in Italy, having been established in the 13th century, and it provided serious competition for the later Florentine ateliers. Curiously, relatively few Sienese wares have survived until today, and the activity there underwent a significant decline before the middle of the *cinquecento*.

A large group of finely painted pharmaceutical wares (cats. 30 and 31), also from the first decade of the century, were long thought to be products of Siena, but recent opinion favors the Umbrian town of Deruta as their source. These vivid polychrome albarelli and pitchers bear a range of subjects including putti, monsters, genre scenes, saints, animals, and portraits, all enclosed within sumptuous wreaths of fruit or foliage with trailing ribbons. Deruta is probably best known, however, for the large *piatti da pompa*, or display plates, with idealized Peruginesque images of young women and men, depictions of St. Francis and St. Jerome, and other religious, heraldic, and allegorical subjects, often accompanied by inscribed names or mottoes (cats. 32–33 and 101–102). These wares were manufactured throughout the first half of the 16th century in two distinct color schemes: one using yellow, orange, green and blue pigments on a white ground, and the other limited only to blue, with gold and sometimes red lustre.

In fact, it was probably in Deruta around 1500 that the secrets of the lustre technique were first thoroughly understood and put into use by Italian artisans. *Istoriato* wares were also produced to some extent at Deruta, most notably by Giacomo Mancini, known as "El Frate" (cat. 35) from the 1540s to the 1560s. The isolation of this town may have had something to do with the generally formulaic nature of its ceramics, and it declined as a pottery-making center after the middle of the century.

Gubbio played a unique role in the history of Italian Renaissance maiolica, specializing in the application of lustres to the wares of other towns as well as to its own. The arrival of Giorgio Andreoli, "Maestro Giorgio," in this Umbrian center in 1498 and his subsequent exploitation of the lustre technique, was critical to its success. Both wheel-thrown and mold-made pieces were produced in Gubbio, usually lavishly treated with the reflective red and gold metallic lustres (cats. 36–39). The marks of Maestro Giorgio's workshop also appear with great frequency on the wares of other centers like Castel Durante and Urbino which were shipped to Gubbio's specialists for a final application of the famous iridescent tones (cat. 43).

Not far from Urbino, the capital of the duchy, was the small town of Castel Durante, advantageously located on the Metauro River, whose banks yielded a plentiful supply of pottery clay. Although ceramics had been made there since medieval times, it was only in the 16th century, due in part to the influence of Faenza, that the industry began to flourish. In the first decade of the century, a talented Faentine artisan known as Giovanni Maria arrived in Castel Durante and established a shop, turning out remarkable plates in a style that came to be known as the *a candelieri* pattern – symmetrical compositions of decorative figures and objects arranged like a candelabrum (cat. 42). Other painters of Castel Durante achieved widespread recognition for their popularization of designs based on ancient trophies, (cats. 43 and 44), for their idealized portraits of beautiful women (*bella donna* plates) and men, and for their *bianco sopra bianco* (white on white) and *alla porcellana* (blue on white) ornamental patterns.

It is not surprising, given the town's proximity to Urbino and its associations with Faenza, that *istoriato* wares were also produced there. Among them were the distinctive plates by an anonymous artist who inscribed them simply "in Castel Durante" in the mid-1520s (cat. 41). The works of this painter are stylistically re-

Drawing of the town of Castel Durante, from Cipriano Piccolpasso's "I tre libri dell'arte del vasaio" (1557) (By courtesy of the Board of Trustees of the Victoria and Albert Museum)

41 Conti/*Bargello*, cat. 16. Paride Berardi's recent archival investigations (Berardi, 17, n. 9) have provided proof of notions postulated by Burr Wallen in 1968 (see Wallen, "A Majolica Panel in the Widener Collection," *Report and Studies in the History of Art, National Gallery of Art*, Washington DC, 1968, 94–105; note 4 of that article provides additional bibliographical references to documents concerning the manufacture of maiolica in Urbino).

42 Rackham/*Ital. Mai.*, 12.

lated to but perhaps less accomplished than those of another artist – once known as Nicola Pellipario – who was active at the same time in the Duchy of Urbino, hence his old appellation "Pseudopellipario," bestowed by Bernard Rackham. John Mallet rechristened this artist the "in Castel Durante" Painter after his particular manner of signing works, partly in recognition of the artist's own talents, and partly because of recent archival revelations proving that Nicola Pellipario was not, in fact, the eminent maiolica craftsman we know today as Nicolò da Urbino.

Since it was quite common for ceramic workshops to be run by members of a single family, it was long believed that the artist who signed himself "Nicolò" or "Nicola" was Nicola Pellipario, the father of Guido Durantino, who in turn was *maestro* of a major Urbino studio. Although Guido's father was indeed named Nicola, he had already died by 1527, the year before the maiolica painter of the same name signed and dated the superb large plate in the Bargello with his monogram and the inscription: "fata in botega de Guido da castello durante / In Vrbino" (made in the shop of Guido from Castel Durante, in Urbino).[41] The history of Durantine narrative wares has been altered radically by the discovery that the artist of the Bargello plate may never have worked at Castel Durante at all, but instead probably practiced his trade in Urbino.

With the flowering of the *istoriato* wares – the first true narrative style in Western ceramics since Greek vase-painting died out in the 3rd century BC – came the emergence of artists as definable personalities. The practice of inscribing, signing, and dating works became more common, lessening some of the difficulty in attributing and studying them. In the case of the immensely gifted Nicolò da Urbino, for instance, a combination of stylistic and documentary evidence has facilitated the reconstruction of a distinguished career extending from the late teens to around 1540. His lyrical Correr Service is distinguished by originality in palette (dominated by pale blue, lavender, and yellow), composition, and choice of subject matter; it was probably made late in the second decade of the century and is named after the Venetian museum that houses seventeen of the plates. From the artist's mature period are the superb service of c.1525 made for Isabella d'Este, the so-called Ladder Service of ten finely-painted pieces including the Clark dish of c.1525–28 (cat. 45), and another group painted for Isabella's son, Duke Federico and his wife Margherita Paleologo after their marriage in 1531.

It is not clear to what extent Nicolò and other painters were influenced by their patrons in the design and choice of subject matter of these services, although it is tempting to suggest an interaction similar to that experienced by Renaissance painters and sculptors. The estimation of ceramics and their makers had, by this time, risen greatly, and as Rackham asserted, "pottery was . . . adopted not merely as part of the useful furniture of life but also, in partnership with paintings, sculpture, silversmith's work, and embroidery, as a means of providing an atmosphere of beauty."[42] In addition to being less costly than the luxurious gold and silver services that were often exhibited on *credenze*, it had the advantage of permanent, brilliant color. The display of painted *istoriato* wares in one's palazzo would, in the very choice of subject matter, testify to the high level of the host's erudition.

While earlier maiolica painters had discovered the advantages of using prints as sources for their own figures and compositions, it was the *istoriato* artists who institutionalized the practice. Nicolò, for instance, adapted the woodcuts from the 1497 edition of Ovid's *Metamorphoses* in his Correr Service, and later turned for inspiration to the rich store of prints by Marcantonio Raimondi and others. He was unusual among his colleagues in his consuming fascination with architecture,

creating structures based both on reality – such as the ducal palace at Urbino[43] – and on his own vivid Bramantesque fantasies.[44]

Nicolò da Urbino was probably never the master of his own shop, but his influence on other Urbino narrative painters was considerable. From the large body of work traditionally attributed to his hand, at least one other major painter has recently emerged. Regrettably, this man appears never to have signed or dated his works, although he inscribed a number of them with descriptions of their themes. John Mallet has thus called him the "Painter of the Milan Marsyas" after one of the marked plates in the Castello Sforzesco[45] (cats. 46 and 47). It is obvious from his style and choice of subject matter that he must have worked closely with Nicolò, and may have been a member of the same atelier. Certain figures in the Milan painter's plates, for example, appear to be derived either from known compositions by Nicolò, or from a common graphic source.

The identification of this "new" artist and the revised view of Nicolò da Urbino's biography exemplify the recent progress in reconstructing the history of these innovative Urbino wares of the 1520s. One of the more troublesome aspects of maiolica connoisseurship has always been the difficulty of distinguishing not only between the hands of different painters, but also the evolving stages of a single artist's career. It was precisely this problem that engendered the long debate over the authorship of the many works signed with the initials "F.R." and "F.L.R." and those with a quick flourish resembling a "y" or "φ" (cats. 49 and 50). Today these are generally considered to be products of that most prolific of *istoriato* painters. Francesco Xanto Avelli da Rovigo, before he became master of his own studio around 1530 (cats. 51–54).[46]

Xanto was born in the town of Rovigo, northeast of Ferrara, around 1486/7.[47] The first of his signed and dated works is a plate in the Castello Sforzesco of 1530, the same year he began to write the phrase "in Urbino" on his pieces.[48] Although it is not certain exactly when Xanto arrived in Urbino, he was obviously there by 1530, and is known to have married around that time.[49] It is unlikely that he would have moved to the city prior to 1521, because it was not until that year that his great hero, Duke Francesco Maria della Rovere, was finally able to recover his duchy after the death of Pope Leo X.[50]

Xanto appears to have been quite a remarkable and perhaps even flamboyant personality in comparison to other maiolica artists of the time. We know surprisingly little about him although the series of sonnets that he wrote in honor of Duke Francesco Maria survive, providing us with at least some historical reference points in his life.[51] Notations in verse – some of them derived from the ducal poems – appear on the backs of a number of plates as descriptions or comments about the subject matter (cat. 53), revealing the artist to be a reasonably well-educated man of some intellectual pretensions. A familiarity with a wide range of literary and artistic sources is also demonstrated by his choice of subject matter. He repeatedly used prints by Marcantonio Raimondi, Gian Giacomo Caraglio, Marco Dente, and others after designs by major artists like Raphael, Rosso Fiorentino, Baccio Bandinelli, and Giulio Romano. Far from being a slavish copyist, however, Xanto adapted figures and compositions in ingenious and, at times, bizarre ways. He was known to have turned standing figures sideways and even upside-down if it suited his artistic needs. Liverani certainly must have been thinking of him when he wrote that the painting of maiolica artists "remains an independent art . . . even when it makes use of some earlier model, whose shapes it will none the less never follow blindly."[52]

Xanto's workshop must have been a very large one, to judge from the large

43 See Rackham, cat. 574; comparative photographs of the plate and ducal palace are shown in G. Papagni's *La maiolica del Rinascimento in Casteldurante, Urbino, e Pesaro* (Fano, n.d., c.1980).

44 See B. Rackham, "Nicola Pellipario and Bramante," *BM* LXXXVI (1945), 144–148.

45 Castello Sforzesco, inv. 133.

46 For details of this complex problem, see Mallet/PLIII, and Mallet, "A maiolica plate signed 'F.R.'," *Art Bulletin of Victoria* (1976), 4–19.

47 See Mallet, "La biografia di Francesco Xanto Avelli alla luce dei suoi sonetti," *Faenza* LXX (1984), 398–402. This revised chronology makes Xanto at least thirteen years older than was previously thought and would permit the attribution of the maiolica signed "F.R." and "F.L.R." of the early 1520s, and the pieces signed with the "Y/φ" flourish of c.1527–30 to a fully mature artist, rather than a youthful prodigy.

48 Castello Sforzesco, inv. M232 (ill. in Petruzzellis-Scherer, fig. 1); his latest dated piece is 1542.

49 Carmen Ravanelli Guidotti, "Iconografia raffaellesca nella maiolica della prima metà del XVI secolo," in M.G.C. Dupré dal Poggetto and P. dal Poggetto, *Urbino e le Marche prima e dopo Raffaello* (Florence, 1983), 457.

50 Mallet, "La biografia . . .," 400.

51 Biblioteca Vaticana, Fondo Urbinate, *Cod. Lat.* 794. See also, Guido Vitaletti, "Le rime di Francesco Xanto Avelli," *Faenza* VI (1918), 11–15; Francesco Cioci, "La proposta per una ristampa, Due sonetti inediti di Francesco Xanto Avelli," *Faenza* LV (1979), 297–301; and Mallet's 1984 article (see [47] above).

52 Giuseppe Liverani, quoted in Mallet/*English*, 19–20.

53 See B. Rackham, "The Maiolica-Painter Guido Durantino," *BM* LXXVII (1940), 182–188. Despite the title of the article, Rackham himself remarks (p. 182) that "we have no clear evidence that Guido was not only a master but also himself a maiolica-painter." He refers (p.182, note 1) to documents in which Guido is mentioned, including his last will in 1576.

54 See J.A. Gere, "Taddeo Zuccaro as a Designer for Maiolica," *BM* CV (1963), 306–315; T. Clifford and J.V.G. Mallet, "Battista Franco as a Designer for Maiolica," *BM* CXVIII (1976), 387–410.

55 Clifford and Mallet, op. cit., 391.

number of works that are preserved today. Throughout his œuvre, there is a remarkable degree of stylistic consistency that undoubtedly resulted from both his strict overseeing of his assistants, and his reliance on a standard repertory of prints. While we cannot document the methods by which figures or whole compositions were transferred from paper to the surface of the ceramics, they were probably either traced with a stylus, or "pounced" – a process which involved forcing charcoal dust through holes pricked in the outline of an image. Unfortunately, the increasing demand for *istoriato* wares in the 1530s sometimes resulted in a decline of quality.

One of Xanto's contemporaries – perhaps an active rival – was Guido Durantino, once thought to be the father of Nicolò da Urbino. Guido, a native of nearby Castel Durante as his name indicates, was a well-documented figure in the *cinquecento* ceramic industry, although it remains unclear whether he was actually a painter of maiolica or strictly a master potter who headed a large workshop.[53] Inscriptions on several works indicate that they were made in his atelier, but never state that they are by his own hand. His Urbino practice was probably established in the early 1520s, and the inscription on the famous St. Cecilia plate in the Bargello proves that Nicolò was working there in 1528 among the other painters.

Guido's three sons, Camillo, Orazio and Nicolo, as well as his grandson Flaminio, were known to have participated actively in the workshop, and Orazio eventually established his own studio in the 1560s. All three brothers and their descendants adopted the name Fontana, which appears in the inscriptions on some of their works. Evidence points to Orazio as the author – while in Guido's shop in the mid-1530s – of the fine plate in the Clark Collection after Raphael's great tapestry design of *St. Paul Preaching to the Areopagites at Athens* (cat. 48).

The Fontana continued to manufacture *istoriato* wares in the tradition established by Xanto and Guido Durantino, although some of their multi-figured compositions are overcrowded and somewhat frenzied. They were actively patronized by the Dukes of Urbino, producing an extensive set of beautiful apothecary jars for Guidobaldo II's ducal pharmacy in the early 1560s and soon afterward a large and luxurious service of highly ornamental wares in elaborate shapes for the same patron. Under the influence of the Fontana, a new style became current in Urbino based on grotesques distributed liberally over a white ground, with reserved medallions for narrative scenes (cats. 59 and 60). The delicate and often whimsical forms, derived from Raphael's loggia decorations (and hence also called the *a raffaellesca* style), were particularly adaptable to the complex molded ceramic shapes that were becoming popular at the time.

Duke Guidobaldo also called upon major artists like the Zuccari and Battista Franco to provide designs specifically for the decoration of maiolica.[54] Maiolica painters had long based their compositions on the works of High Renaissance artists through the medium of prints, but at last painters became more directly involved in the making of ceramics. Guidobaldo's particular interest in high-quality decorative arts also led him to obtain designs for a silver inkwell from Michelangelo and for a harpsichord cover from Bronzino.[55]

A number of other talented *istoriato* painters worked in Urbino in the mid-16th century as well, such as Francesco Durantino (cats. 57 and 109), Guido da Merlino, and others (cats. 56 and 58). Dominating the ceramic industry there in the last quarter of the century was the Patanazzi workshop (cats. 63 and 64), which took over the *a raffaellesca* style from the Fontana, turning out great quantities of plates and complex molded wares, as well as inkwells and small sculptures. While some

of these maintained a high level of quality, many show the inevitable decline of mass-produced wares.

Although Urbino was clearly the principal center of *istoriato* painting from the time of Xanto on, the nearby coastal town of Pesaro also had a share of the market. Recent research has even suggested that the role of Pesaro in the history of maiolica was considerably greater than was previously realized.[56] Among its most active painters of narrative wares was Sforza di Marcantonio (cats. 66 and 67) whose distinctive work is just now beginning to be recognized and actively studied by scholars.[57] Another Pesaro artist, known as the Zenobia Painter (cat. 68) after the subject of two of his finest plates, had a special fondness for subjects from ancient history, a trend also found in the Fontana and Patanazzi wares of Urbino.

Venice was an important maiolica-producing center in the 16th century as well, and its ceramics were much admired by Piccolpasso. He referred often to the city in his treatise, and his comments on technical methods, designs, and innovations emanating from the workshops of Venice suggest that there remains much to be discovered about its ceramic industry.[58] As the primary port of the northern Adriatic coast of Italy, Venice was particularly susceptible to influence from China and the Middle East, and many of its own wares reflect this, based as they often are on flowers and foliage and the blue and white color scheme borrowed from Ming porcelain. Potters and painters from other centers like Faenza, Pesaro, Castel Durante, and Urbino are known to have visited and worked there, bringing with them the styles and trends of their cities.[59] Venetian artisans experimented also with techniques such as the blue-tinted glaze that was popular at Faenza, and the delicate *bianco sopra bianco* (white-on-white) decoration found on Durantine wares.

The most renowned of all the Venetian workshops flourished during the third quarter of the 16th century under the guidance of an artisan known as Maestro Domenico. The large number of extant pieces from his atelier indicate that it must have been a substantial one, with wares made in a variety of styles, the most common being loosely-drawn figural or *istoriato* pieces (cat. 70) and colorful drug jars covered with luxuriant fruit and foliage encircling medallions containing portraits or images of saints (cats. 69 and 120).

In addition to these major ceramic-producing centers whose works are represented in the Clark Collection, many other Italian towns like Padua, Rimini, Verona, Palermo, and Rome were active in the industry during the Renaissance. Later, in the 17th and 18th centuries, the Ligurian potteries of Albisola and Savona, and those in Castelli d'Abruzzo and Naples grew up to meet the demands of an ever-expanding market, and styles evolved correspondingly. The brilliant white molded and pierced wares of Faenza – the famous *bianchi di Faenza* – were influential in this regard, and the later maiolica of these centers relied more often on casually sketched, quickly painted figures and scenes in a reduced palette, dominated by blue and white, on complex shapes with molded handles and lids.[60] The time-consuming conventions of earlier *istoriato* and lustred wares were abandoned in favor of styles and shapes that could be more quickly and easily produced, probably for a less wealthy clientele.

By this time, of course, the popularity of Italy's rich polychrome ceramics had extended far beyond the boundaries of the peninsula. The taste for Italian maiolica in the North was well-established, as we know from the fact that Germans, in particular, commissioned special pieces or even services from the artisans of Venice and Urbino (cat. 58). Shipping delicate tin-glazed earthenware was not a simple matter, however, and long-distance patronage left much to be desired in the choosing of designs, subject matter, and colors.

56 See Berardi's 1984 study, noted in Bibliography.
57 See cat. 66, [7].
58 Piccolpasso II, xxiii.
59 Giacomotti, 409.
60 Caiger-Smith/*TGP*, 99. For later Italian maiolica, see Oreste Ferrari, *Maiolica italiana del seicento e settecento* (Milan, 1965).

61 Caiger-Smith/*TGP*, 105; even earlier (in 1512) an Italian craftsman known as Guido da Savino established a shop in Antwerp.

62 An excellent brief account of this transmission, and additional bibliography, is given by Alan Caiger-Smith (*TGP*, Chapter 7); see also Chapters 8–12, for the history of tin-glazed earthenware in other European countries.

63 Mallet/*Fortnum*, 398–399.

64 Mallet/*English*, 22.

65 Ibid.

66 See G.C. Bojani, G.W. Carriveau et al., "Some Comparisons among Majolica Samples from Faenza and Pesaro," *Faenza* LXX (1984), 494–506, and another forthcoming article in *Interceram* by Carriveau.

It was not long before Italian craftsmen began to migrate to other areas of Europe, most notably to France, where they were apparently working as early as the 1520s.[61] The towns of Lyon and Nevers became particularly important centers of maiolica manufacture as a result. Changing their methods to suit the available raw materials and the vagaries of local tastes, Italians founded workshops in Spain, Flanders, Portugal, Holland, and England, turning out tiles, pharmaceutical vessels, and decorative wares as they had at home. Eventually, the technique spread throughout the continent – to Switzerland, Germany, Eastern Europe and even Russia[62] – dominating the market for ceramics until it was finally displaced by porcelain, first imported from China and later manufactured in the great factories of Germany, France, Austria, England and elsewhere.

Since the 19th century, when the study of Italian maiolica began in earnest, the question of attribution has traditionally played a major role. The struggle to determine whether a piece was painted in Deruta or Faenza, Cafaggiolo or Montelupo, Urbino or Pesaro, has occupied scholars and connoisseurs, often to the exclusion of enquiries into the iconography, function, patronage, and other interesting aspects of Italian tin-glazed earthenware. The emphasis on the assignment of these wares to one center or another also had a great impact on the history of collecting, as those who sought to form distinguished collections usually desired a balanced group of objects illustrating the styles of the most important workshops. C. D. E. Fortnum, for example, in his catalogue of the Ashmolean's holdings, explained the principles upon which he built that collection, stating that his "main object was to obtain fairly representative examples of the various Italian fabriques, and of the master potters who worked at them."[63]

Unfortunately, the question of attribution has also been one of the most difficult facing students of maiolica. Signed and dated works that provide concrete documentation are far less common than might be expected. Contributing to the complexity of the issue is the fact that potters and painters frequently moved from one center to another – sometimes enticed by patrons desiring to set up workshops – taking with them their technical knowledge and stylistic innovations. Technological developments and glaze recipes were jealously guarded by these artisans and their families; formulas for lustre glazes, for instance, were extremely closely-held secrets.

Decorative patterns and designs on the other hand were more easily obtainable, and painters from one center were quite likely to adopt an especially beautiful or intriguing pattern from another town, especially if it was popular with clients. The availability of designs through the medium of prints also facilitated the migration of an image from one region to another. For instance, the figure of Orpheus on a Castel Durante plate in the Clark Collection (cat. 41) was derived from the same Raimondi print that inspired the painter of a later Venetian plate. So, to quote the great maiolica scholar Ballardini, "It is not as easy as it seems to judge of old maiolica."[64] And, as John Mallet has added to that warning: "Not having read our books and articles, the potters sometimes made pieces untypical of their usual production."[65]

In recent years the task has been made easier by archaeological excavations that attempt to document works at their site of production. Other current scientific studies involve the comparison of trace elements in raw clays and in fragments of finished works in an effort to learn more about methods of production and technique, and even to identify works by means of compositional analysis.[66]

It has perhaps been less evident that Renaissance painted ceramics have much to reveal about the culture and society that produced them. As a recent writer suggested, one must take into account the "political significance of ceramics . . . it is an area where the 'fine' arts cross constantly with industrial design, foreign affairs, propaganda, and taste."[67] The estimation of tin-glazed earthenware rose rapidly in the minds of aristocratic patrons like Lorenzo de' Medici, who in 1490 compared it as equal in merit to the works of silversmiths and jewelers.[68] The ceramic medium also became the subject of Renaissance investigations into the secrets of nature. Alfonso d'Este, Duke of Ferrara, saw pottery as a craft worthy of study by artisans and princes alike.[69] And it was out of this historical milieu that Cipriano Piccolpasso's remarkable treatise came. Piccolpasso cited the great value and even the necessity of pursuing knowledge in the mechanical arts (in which he included pottery-making) as well as the higher arts of literature and music. Admiringly, he wrote of Cosimo I de' Medici, Grand-Duke of Tuscany, who "is willing to work with his own hand . . . to work like a master, here wielding the hammer, there painting, sometimes sculpting, now acting as a carpenter in work on artillery, often as a founder at the furnaces, experimenting with metals to see if bronze comes out in a hard or soft alloy."[70] Along with changes in the attitude toward the craft of ceramics itself came new ideas about the possibilities inherent in the medium.

Maiolica was, above all, a painter's medium, and it was in this area that the greatest strides were made, particularly in the first half of the 16th century. The development and evolution of the *istoriato* style was perhaps the most remarkable event in the history of western ceramics since antiquity. Narrative subjects on maiolica sometimes touched on the activities of everyday life, as in the scenes of childbirth found on the special ceramic sets made for new mothers, or the unusual plate in the Victoria and Albert that shows a maiolica artist painting a work in the presence of two clients.[71] Contemporary historical events, or those from the recent past appear occasionally, as in the dish of around 1516 representing the reigning Pope Leo X being carried in procession,[72] the earlier Clark plate depicting the meeting of Petrarch and Charles IV (cat. 1), or Xanto's allegorical versions of the Sack of Rome in 1527.[73] By far the most popular subjects, however, were mythological or religious themes, or legends taken from ancient history.

While the concept of applying scenes of this sort to the surface of Renaissance ceramics was itself a novel and innovative one, maiolica artists were not as concerned with synthesizing new styles of painting as much as they were with responding to or adapting modes set out for them by established practitioners of the major arts. In this regard, it is important to remember that by the 1520s and 30s, when maiolica painters were making use of High Renaissance compositions by Raphael and others, mannerist trends were already well-established in the work of painters like Giulio Romano, Rosso Fiorentino, and Pontormo. Clearly, the artisans were influenced by prevailing tastes, attitudes and ideas, and not unmindful of the economic importance of decorating their wares with subjects that had already gained acceptance among their aristocratic and ecclesiastical clientele. Like painters and sculptors of the *quattrocento* and early *cinquecento* they were able to choose from a broader range of subjects than their medieval predecessors, who were restricted in great part to themes drawn from Christian doctrine. The rebirth of interest in antiquity that characterized the Renaissance, and which was made acceptable by its fusion into the concept of Neoplatonism, provided new sources of subject matter drawn from mythology and the history of ancient Greece and Rome.

Other major sources of inspiration for artisans were the classical texts of Ovid, Virgil, Plutarch, and others which were also frequently consulted by Renaissance

67 "Editorial: Of Meissen Men: Ceramics and Academics," *BM* CXXVII (1985), 275.
68 Caiger-Smith/*TGP*, 81.
69 Piccolpasso I, xix.
70 Ibid., xx.
71 Rackham, cat. 307.
72 Ibid., cat. 318.
73 Kube, cat. 76.

74 Charles Hope, "Artists, Patrons, and Advisers in the Italian Renaissance," in *Patronage in the Renaissance*, eds. G.F. Lytle and Stephen Orgel (Princeton, 1981) 315.

75 Quoted in Hope, op.cit., 329.

76 Some of Nicolò's early Correr plates show that he also used contemporary romances as sources for his images.

77 Clifford/Mallet, "Battista Franco . . .," 391 (see [54] above).

78 Gere, "Taddeo Zuccaro . . .," 306 (see [54] above).

79 Clifford/Mallet, 388.

80 Ibid., 395.

81 Mallet, "Mantua and Urbino: Gonzaga Patronage of Maiolica," *Apollo* CXIV (1981), 165.

82 Norman, 19 (an excellent survey of maiolica-collecting is given here, pp. 19–30; see also his useful bibliography of collection and sale catalogues, pp. 407–425); for the Swedish collection, see H.D. Lutteman, *Majolika från Urbino* (Stockholm, 1981).

83 For further information on forgeries and reproductions, see G. Conti, *Mostra della maiolica toscana. Le riproduzioni ottocentesche* (Monte San Savino, 1974), and the *Deruta* catalogue.

painters and their humanist patrons in an attempt to add a degree of authenticity to their antiquarian themes.[74] Alberti, in his *De Pictura* (1435–36), advocated this practice: "The eminent painter Phidias used to say that he had learned from Homer how best to represent the majesty of Jupiter. I believe that we too may be better endowed and more accomplished painters from reading our poets."[75] While few maiolica craftsmen – perhaps only Xanto – were as learned as contemporary Renaissance painters, they seem to have supplemented the original literary texts with more recently published moralized versions that occasionally were printed in the vernacular language.[76] The visual evidence of Xanto's plates, for example, also reveals that he probably consulted the texts of ancient mythographers like Hyginus to obtain fuller descriptions of subjects treated only briefly in Ovid.

It does seem strange that so few major artists – apart from Battista Franco, the Zuccari, and perhaps Barocci[77] – are known to have executed designs for maiolica in an age when important painters and sculptors frequently turned their hands toward the decorative arts in the form of tapestries, precious metalwork, and so on. Taddeo Zuccaro, as we know from Vasari's accounts, was commissioned by the Duke of Urbino, Guidobaldo II, to produce drawings for a major service to be presented to King Philip of Spain.[78] Vasari goes on to say that the Duke later obtained designs also from Battista Franco for two services, one for his brother-in-law Cardinal Alessandro Farnese and one for Emperor Charles V.[79] It has been suggested that an unknown adviser working for Guidobaldo may have been responsible for drawing up a programme for at least one of these sets,[80] although this remains completely undocumented. Even the superb service made for Isabella d'Este by Nicolò da Urbino appears to have been designed by the painter with little or no interference from this discriminating Renaissance patron.[81] To this day, no contracts have been found to reveal the mechanics of maiolica patronage. It seems likely, however, that patrons gave artists control of the actual designs, after first stipulating the desired iconography either specifically or in a more general manner.

Eventually maiolica ceased to dominate the ceramic market as porcelain surpassed it in popularity, but these brilliant Italian Renaissance wares retained their fascination among collectors. By the 17th century, such luminaries as Cardinal Mazarin and Queen Christina of Sweden are recorded as having Italian maiolica among their varied collections.[82] German, French, and especially English connoisseurs of the 18th and 19th centuries accumulated extensive hoards of the tin-glazed earthenware, some of which form the basis of the great museum collections in those countries today. Duke Anton Ulrich, for example, is said to have had almost a thousand pieces of the Italian wares in his possession in the early 18th century, and these were later incorporated in the art museum in Brunswick that bears his name. The degree to which forgeries and reproductions were turned out, particularly in the 19th century, is testimony to the continued appeal of Renaissance maiolica and the enthusiasm with which it was acquired.[83]

The Clark Collection is itself composed of works that have passed through the hands of some of the most distinguished European collections, such as those of Alessandro Castellani, Andrew Fountaine, Oscar Hainauer, Emile Gavet, and others. The collection was bequeathed to the Corcoran Gallery of Art by William A. Clark (1839–1925), an industrialist and United States Senator whose passion for art caused him to assemble a vast number of paintings, sculptures, drawings, carpets, tapestries, and ceramics, including the superb group of Italian Renaissance maiolica that is among the museum's treasured holdings today.

Catalogue

Notes on the catalogue

The numbers of the objects in the checklist (which gives works in the Clark Collection that are not included in the exhibition) follow consecutively those of the pieces in the entries. A question mark following provenance indicates that I have found no reference in extant literature to substantiate notations in the records of the Corcoran Gallery of Art.

The notes on the shapes of plates refer to drawings on page 187 derived either from Rackham's Victoria and Albert catalogue (R) or Lessmann's Braunschweig catalogue (L). These approximate as closely as possible the shapes and profiles of the Clark pieces, although there is a certain amount of variation between the actual works and the Rackham/Lessmann shapes.

The heraldic descriptions are by Timothy Wilson of the British Museum, with advice from Anne Payne of the British Library. Given the limited range of colours available to maiolica painters, a certain amount of interpretation is inevitable in heraldic descriptions: for example, on lustre pottery, lustre sometimes represents *gules* (red) and sometimes *or* (gold). All stars have, in contrast to English heraldic usage, been blasoned simply as "stars" (translating the Italian *stelle*) on the supposition that the heraldic distinction between stars with five, six, or any other number of points was too fine for the average maiolica painter.

Key to abbreviations:
H = height
D = diameter
Inv. = inventory number
Cat. = catalogue number

1. Dish with Petrarch and the Emperor Charles IV

Probably Faenza, c.1470–80

H 7.0 cm; D 38.6 cm; shape R2
Inv. 26.316
Provenance: Hainauer; Clark
Bibliography: Hainauer, 32 (ill.), 109,
cat. 294 (M14); Corcoran/Erdberg, 72,
fig. 9; Corcoran/*Bulletin*, cat. 2

1 This notion was first suggested by
 James Breckenridge in a letter of 5
 March 1954 to Joan Prentice von
 Erdberg (see Corcoran files).
2 Although rather whimsically represen-
 ted here, the eagle is the ancient symbol
 of Empire and of power.
3 I owe the knowledge of this source to
 Professor E. James Mundy, Mount
 Holyoke College. The *Re*, or *King* en-
 graving by the Master of the E-Series is
 illustrated *Ital. Engrs.*, 97, cat. 20.

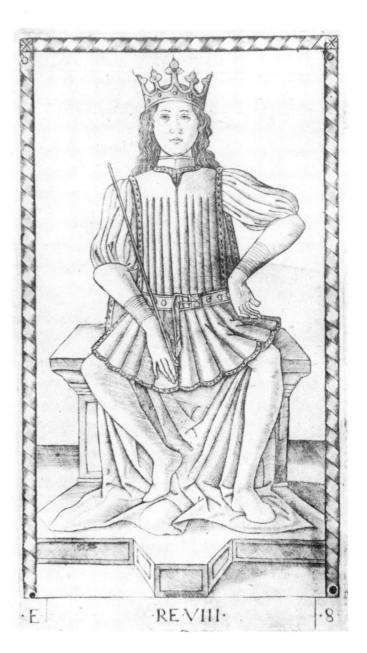

·E· ·RE·VIII· ·8·

The scene on this plate appears to represent the meeting of the Emperor Charles IV
with the medieval poet and scholar Petrarch, a subject otherwise unknown in
Italian Renaissance maiolica.[1] Petrarch holds an open book, indicating his scholar-
ly role, and is accompanied by a diminutive attendant carrying a second volume;
the Emperor, whose rank is underscored by his size and dominant central position,
is attended by a court musician playing a drum and flute, and by a small eagle.[2]

The general composition and decorative details are clearly the invention of the
maiolica painter, although the figure of the monarch seems to have been derived
from one of the so-called *Tarocchi*, or tarot-card prints, which were produced
around 1465–67 by the Ferrarese engraver known as the Master of the E-Series.[3]
The Emperor and his costume are very similar to those depicted in the engraving

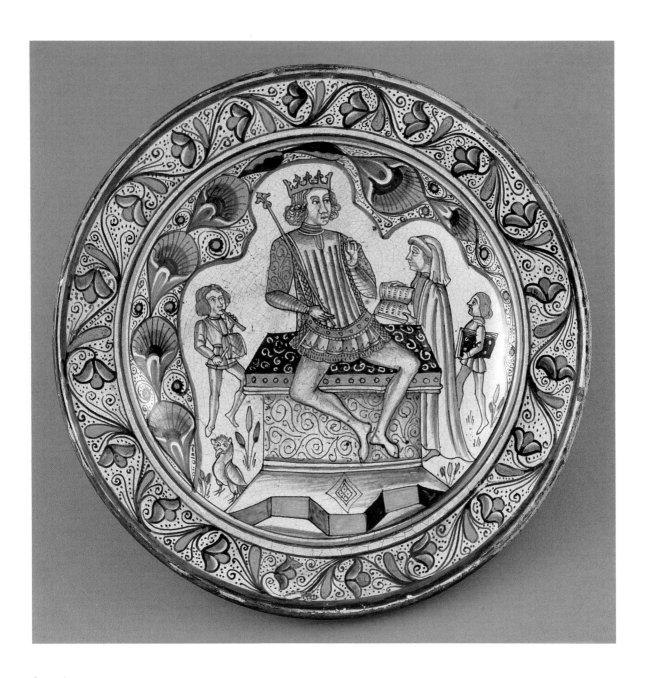

Opposite:
Master of the E-Series, *Re* (*King*)

4 *Ital. Engrs.*, 87.

5 Deborah Shinn, *Sixteenth-Century Maiolica: Selections from the Arthur M. Sackler Collection and the National Gallery of Art's Widener Collection* (Washington, DC, 1982), cat. 40, p. 27.

6 From Petrarch's *Lettere familiare*, Book XIX, 3, in Morris Bishop's *Letters from Petrarch* (Bloomington, Indiana, 1966), 156–160.

7 Bishop, op. cit., 157–158.

8 Andrea Castagno's fresco of Petrarch in his series of famous men and women from the Villa Carducci in Legnaia (1448) is one example.

9 Rackham, 245.

10 The costume of Petrarch, in fact, bears a very close resemblance to that of the *Merchant* from the E-series of the *Tarocchi* (see *Ital. Engrs.*, 93, cat. 16).

11 Rackham, cat. 112.

12 Ibid., 31.

and the architectonic plinth on which he sits bears a striking resemblance to the one in the print. The style of the graphic conception was indeed well-suited to the current trends in maiolica-painting in mid-15th-century Italy. The *Tarocchi* must have been among the earliest multiple images available for use in maiolica workshops, as no evidence exists for printmaking in Italy prior to the 1460s.[4] Their popularity seems to have been long-lived, and they remained influential well into the 16th century; the design of a dish made in Gubbio around 1530–40 showing a woman on a swan is copied from an image belonging to the same set of prints.[5]

Although maiolica painters often depicted stories from classical history, they were less fascinated with events from the more recent past. The Clark plate is therefore unusual in its portrayal of a comparatively recent event. An account of his meeting with the Emperor (in December 1354) is contained in a letter from Petrarch to Laelius written on 25 February 1355.[6] The Emperor, of course, knew of Petrarch by reputation, and had received several strong letters from him exhorting him to unite Italy and make Rome its capital. After his coronation in Milan, the Emperor retired to his winter quarters in Mantua and summoned Petrarch to meet with him there.

According to Petrarch, their conversation continued over several days, during which they discussed Petrarch's life, philosophies, and writings, especially his *De vita solitaria* and the still-unfinished *De viris illustribus*.[7] That the painter of this plate should refer to the encounter between Charles IV and Petrarch more than 125 years after it occurred is testimony to the widespread popular knowledge of the event through the poet's *Lettere familiare*, which he collected and edited in imitation of Cicero's 1st-century BC *Letters to Atticus*.

As one of the initiators of the rebirth of humanistic studies that was to culminate in the Renaissance, and one of the medieval period's greatest poets and scholars, Petrarch appears with some frequency in Italian Renaissance painting.[8] In maiolica, however, his portrait is rare. Bernard Rackham lists a scant three fragments that he suggests may carry the poet's likeness,[9] but no other known piece of maiolica portrays him in a narrative composition. It is possible, given the painter's reliance on the *Tarocchi* for his image of Charles IV, that he drew upon another print for the figure of Petrarch, although a source has yet to be identified.[10]

The uniqueness of the Clark plate adds to the difficulty of assigning it with assurance to a particular center of manufacture. Its decorative elements – such as the contour panel, peacock-feather band, engraved spirals on the plinth, and general figural style – as well as its shape and coloration, suggest that it could have been made either in central Italy, around Deruta, or farther to the north, in Faenza. Affinities with an unusual plate in the Victoria and Albert Museum, London,[11] may indicate that both were produced in the same place – Faenza – at about the same time (c.1470–80). The London plate shows an equally unique subject – a young woman in contemporary dress aiming an arrow at a semi-nude youth bound to a mast; both stand precariously atop a four-wheeled cart and between them is a chalice with a heart pierced by arrows. A further relationship between the two pieces may lie in the fact that the figure of youth is itself adapted from another early Italian engraving, the *Trionfo della Fama*, from a set illustrating the *Triumphs of Petrarch* of c.1460–80.[12]

2. Dish with Christ as Man of Sorrows
Faenza or Pesaro, c.1480–1500

Unusual in both its shape and thinness, this dish bears an image very common in the major arts of the Renaissance, but rare in maiolica.[1] The subject of Christ as 'Man of Sorrows' was an extremely popular one in 15th-century painting; Giovanni Bellini, for example, executed many versions of it,[2] as did another *cinquecento* artist, Pedro Berruguete, a Spaniard who is kown to have worked in Italy and particularly at Urbino in the 1470s. His *Christ in a Sarcophagus Supported by Two Angels*,[3] now in the Brera Gallery, Milan, may have been one source of inspiration for the painter of the Clark dish. The attitude of Christ's head, arms, and body, as well as details of the beard and musculature bear a strong resemblance to the Brera painting; the youthful angels who minister tenderly to the dead Christ in both cases have expressive individualized faces and contemporary costumes with active drapery. Another source of influence may have come from Berruguete's colleague Melozzo da Forlì, who was also active at the court of Urbino. His works reflect a strong interest in classical architectural details similar to the molding on the edge of Christ's antique-style sarcophagus.[4] The treatment of the front surface of the sarcophagus, with its curving stripes and speckles, suggests that the painter was attempting to approximate the effect of colored marble.

Stylistically, the dish resembles two maiolica plaques at the Victoria and Albert Museum, both of which were thought by Rackham to have been influenced by Melozzo da Forlì or even based on designs by him. One shows an enthroned Virgin and Child with small clouds in the background and the date 1489 at lower left; the second represents the Annunciation, with the Virgin and angel placed within a walled courtyard. Decorative details such as the trefoil crested border and the double-striped pattern of the fabric[5] appear on both the Clark plate and the Annunciation panel; the small scudding clouds behind the Virgin and Child closely resemble those etched through the blue pigment on the present plate. Similarities of face and figure type, drapery style, and general palette – based on blue, purple, orange, green – suggest that these three works were probably made in the same workshop, if not by the same master. Although the two London pieces have been traditionally ascribed to Faenza, Paride Berardi recently suggested that they may belong more properly to an area farther south near the Metauro River and probably to the town of Pesaro itself.[6] He also associates both plaques with the circle of Melozzo and Luca Signorelli.[7]

The Clark dish has an uncommon shape, with steeply sloping sides and a flat bottom lacking any footring. Its walls are exceptionally thin, and the quality of the glaze is very fine.

H 3.6 cm; D 22.7 cm; approx. shape L3
Inv. 26.307
Provenance: Hainauer; Clark
Bibliography: Hainauer, 33 (ill.), 107, cat. 285 (M5); Corcoran/*Bulletin*, fig. 4, cat. 4

1 Other pieces with related themes are a Faenza plate at Sèvres dated 1485 (Giacomotti, cat. 151) and one in the Petit Palais collection given to Cafaggiolo, dated 1535 (Cora/Fanfani, pl. 89); the latter shows Christ with the Virgin and Mary Magdalen, and includes a Roman-style sarcophagus.
2 See Giles Robertson, *Giovanni Bellini* (Oxford, 1968), pls. xiva–b, xviii, xliia–b.
3 See C.C. Onesti, *Mostra di Melozzo e del quattrocento romagnolo* (exh. cat., Forlì, 1938), cat. 184. Berruguete is known to have had a hand in the decoration of Federico da Montefeltro's palace, along with other artists such as Justus van Ghent.
4 Note the moldings in his fresco for the Vatican Library, *Sixtus IV Appointing Platina* (c.1474–77), and in the dome of the Sacristy of St. Mark in the Basilica of the Santa Casa di Loreto (1480s).
5 A vertical striped pattern appears on Christ's loincloth in the Clark plate, whereas the double stripes run horizontally along the lower edge of the Virgin's robe in the Annunciation panel; the folds of her robe also appear to be arranged in vertical pairs.
6 Berardi, 287 and 292.
7 Ibid., 287.

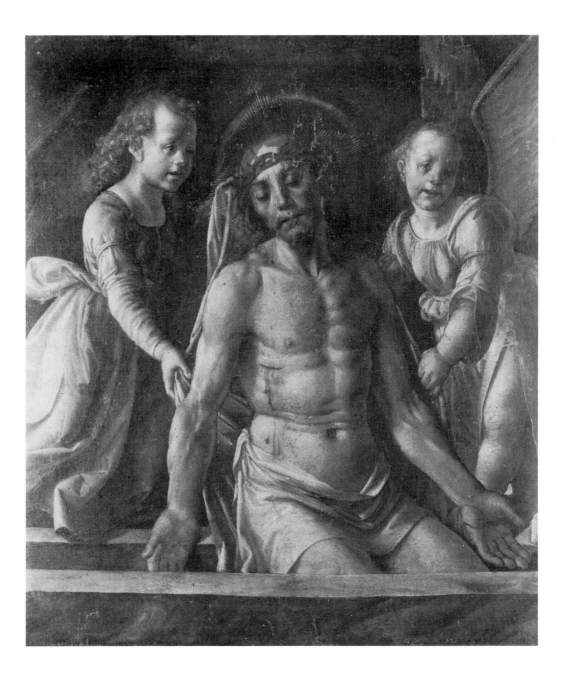

Pedro Berruguete, *Christ in a
Sarcophagus Supported by Two
Angels* (Brera Gallery, Milan)

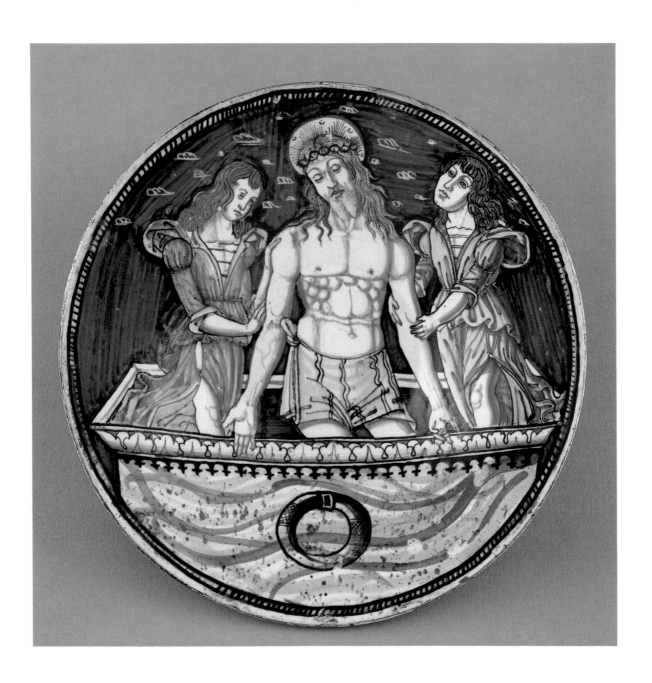

3. Inkstand with St. George and the Dragon
Faenza, late 15th–early 16th century

H 26.2 cm; base 21.0 × 12.5 cm
Inv. 26.420
Provenance: Gavet (?); Clark
Bibliography: Corcoran/Erdberg, 72,
fig. 7; Corcoran/*Bulletin*, fig. 3, cat. 5;
Corcoran/Clark, 75, fig. 57

1 The workshop was founded by Luca
della Robbia (1399–1482), and carried
on by family members Andrea
(1435–1525), Giovanni (1469–1529),
and others well into the 16th century.
2 Eva Cserey, "Di un calamaio in
maiolica del Rinascimento al Museo
delle Arti Applicate di Budapest,"
Faenza LXI (1975), 88.
3 For the Budapest piece, see the Cserey
article (2 above) pls. XXXII–XXXIV; for
the Sèvres piece, see Giacomotti, cat.
290; for additional examples and bib-
liography, see Giacomotti, 73–74.
4 A list of sixteen pieces of various sub-
jects is given in Ugolino della Gherar-
desca, "Una rara plastica maiolicata,"
Faenza XXXVI (1950), 79–80.
5 Now in the Musée de la Renaissance,
Ecouen (Giacomotti, cat. 291). For de-
tailed discussions of the piece, see G.
Liverani, "Di un calamaio quattrocen-
tesco al Museo di Cluny," *Faenza* LXI
(1975), 7–12, and J.V.G. Mallet, "Un
calamaio in maiolica a Boston," *Faenza*
LXII (1976), 79–85.
6 The piece with the Saracen, probably
Ferrarese, is in the Cora Collection,
now at the Museo Internazionale delle
Ceramiche in Faenza (Cora/Faenza,
cat. 162); a St. George in the V&A
(Rackham, cat. 1376) is of uncertain
origin. Another St. George with the
Dragon is in the Detroit Institute of
Arts (ill. in Bruce Cole, *Italian
Maiolica from Midwestern Collections*,
Bloomington, Indiana, cat. 27, p. 63),
probably Faenza, c.1500.
7 Hall, 136–137.
8 Cf. similar armor shown in a sculpture
in Naples by Francesco Laurana and
others in Lionello Boccia, *Le armature
di S. Maria delle Grazie in Curtatone di
Mantova e l'armature Lombardia dell
'400* (Busto Arsizio, 1982), pl. 82–83. I
owe the knowledge of this reference to
Dr. John Waldman.

In addition to vases, plates, plaques, and tiles, Italian Renaissance ceramic work-
shops also turned out three-dimensional pieces, the best-known being the often
large-scale glazed terracotta sculptures of the Della Robbia family in Florence.[1] At
the same time, however, there was an active workshop (or workshops) – probably
in Faenza – manufacturing plastic groups, both small and relatively large, in the
form of inkwells, fountains, and non-utilitarian decorative sculptures.

In the second half of the 15th century, artisans began to ornament inkwells –
first with color and then with modelled figures[2] – so much so that by the time the
Clark inkstand was produced around the turn of the century, its function was
almost secondary to its decorative effect as a luxury item. The receptacles for ink
and other writing paraphernalia have now become subordinate to the overall im-
pression of the piece as a table-top sculpture. In this period, when literacy rates in
Italy were low, an inkstand would also have been seen as a symbol of education
and status.

The name of at least one painter who produced these charming three-
dimensional pieces remains to us today; inkstands in the form of Nativity scenes in
Budapest and Sèvres carry inscriptions of a certain "Giovanni Acole," who appears
to have specialized in such works.[3] The fashion for plastic maiolica pieces seems to
have died out shortly thereafter, and the more sculptural qualities of clay were not
exploited to any great extent until workshops began producing elaborate salt-
cellars and grand trilobed basins after the mid-century.

A variety of themes was drawn upon for the earlier inkwells and fountains,
although the Nativity, or *presepio*, was one of the most common. Others included
the Deposition, the Judgement of Paris, Romulus and Remus with the she-wolf,
warriors in battle, and equestrian figures such as St. George.[4] Other equestrian ink-
stands are a Faentine knight in the Cluny collection,[5] which is probably closest in
style and period to the Clark piece, and three other mounted figures battling
dragons – one dressed as a Saracen and two representing St. George.[6]

The legend of this saint was a very popular one in Italy, especially after the 13th
century[7], and his defeat of the evil dragon alludes to the victory of the Christian
faith over the forces of darkness. However, the Clark inkwell has, in the end, a
whimsical effect which downplays the bloody dragon-slaying that is about to
occur, and which is so commonly depicted in painted versions of the subject. In
addition, it was probably designed with structural as well as iconographic and
decorative concerns in mind.

This carefully modelled and finely painted inkwell uses a limited palette of blue,
purple, green, and orange, as well as such traditional Tuscan motifs as the trefoil-
shaped flowers on the ink container and three-dot patterns on the flat base. Its
maker fashioned the figures with skill and dexterity, paying special attention to the
details of the saint's armor. The helmet and armor are so carefully described, in
fact, that they can easily be identified as types in common usage in Italy around
1470, especially the visored *celata* (a type of helmet) and the edge of mail hanging
below the breastplate.[8]

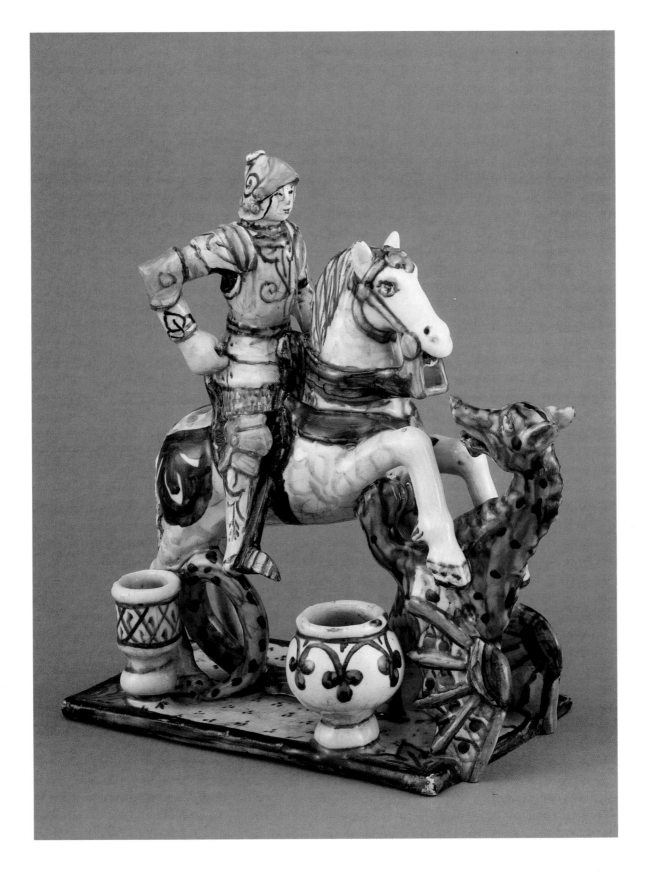

4. Inkstand with a sleeping knight
Faenza, late 15th–early 16th century

Coat of arms: Argent, a chevron gules
between three mullets pierced azure
H 12.2 cm; W 21.7 cm; D 16.4 cm
Inv. 26.415
Provenance: Gavet (?); Clark
Bibliography: Corcoran/Erdberg, 72;
Corcoran/*Bulletin*, cat. 6

A second inkstand in the Clark Collection betrays its function more readily than does cat. 3. This inkstand is composed of a platform supported by lions' feet and surmounted by a slumbering knight who leans against an ink container.[1] On the front of the base are painted two recumbent rabbits flanking a three-dimensional coat of arms which also serves as the handle of a small drawer meant to contain writing materials. Rabbits, the traditional symbol of fertility, were often used to ornament objects intended as wedding gifts, which this inkwell may have been. The arms have yet to be identified although they are of a type common to a number of Tuscan families in the area of Florence.

The knight's armor is very similar to that of the St. George inkstand (cat. 3), and is recognizable as a late 15th-century type. Here, however, the helmet – a sallet, or *celata* – is unvisored and has instead a foliate pattern on top. The single figure serves no particular narrative function here – perhaps due in part to the loss of other attributes or even another figure which may once have belonged to it – but Eva Cserey has noted the popularity among maiolica craftsmen of scenes from the lives of *cavalieri* (knights).[2] In addition, these artisans used the motif of a sleeping knight in at least two other compositions: a fountain in the Victoria and Albert Museum shows Mercury approaching a sleeping armored figure of Paris whose horse stands at the rear[3], and an inkwell in Faenza with Mercury, Paris, and the three goddesses, Juno, Venus, and Minerva.[4]

Various decorative elements find parallels on other ceramic inkstands and vessels of the late 15th–early 16th centuries. The sinuous floral motif which winds around the base of the Clark piece can be found on the 1487 Faentine tiles of S. Petronio, Bologna; a vase in the Louvre and one in the Victoria and Albert display the same pattern as well.[5] The rabbits, arrayed against dotted backgrounds, also resemble one on a tile in S. Petronio.[6] All of these elements have in the past been considered characteristic of Faenza workshops, although Berardi's recent research may argue for a shift of some attributions towards the Pesaro area.[7]

1 As might be expected with pieces of this sort, the present inkwell has sustained some damage over the years. A recent examination by Meg Loew Craft shows that several sections have been replaced, including the lions' feet, the proper left leg of the knight, the shield, and spear. Other elements were once attached at the back left of the inkstand, behind the head of the knight (perhaps a similar shield and spear), and some other fairly large object – maybe even another figure – appears to have occupied the space on the right side.

2 Eva Cserey, "Di un calamaio in maiolica del Rinascimento al Museo delle Arti Applicate di Budapest," *Faenza* LXI (1975), 86.

3 This represents a 15th/16th-century version of the Judgement of Paris legend in which the goddesses appear to the young shepherd-prince in a dream (see Rackham, cat. 158).

4 In the Museo Internazionale delle Ceramiche, (ill. in Conti, fig. 133; attributed to Faenza, early 16th c.).

5 For an illustration of the S. Petronio tiles, see Conti (fig. 121; note the tile with a barrel in the center and the spiral floral pattern surrounding it); the Louvre vase (Faenza, late 15th c.) is illustrated in Conti (fig. 119), and the V&A piece (Faenza, c.1510) is in Rackham (cat. 215).

6 Cf. a tile in Conti (fig. 121) which shows a related dotted background.

7 See Paride Berardi's 1984 study on the maiolica of Pesaro cited in the Bibliography.

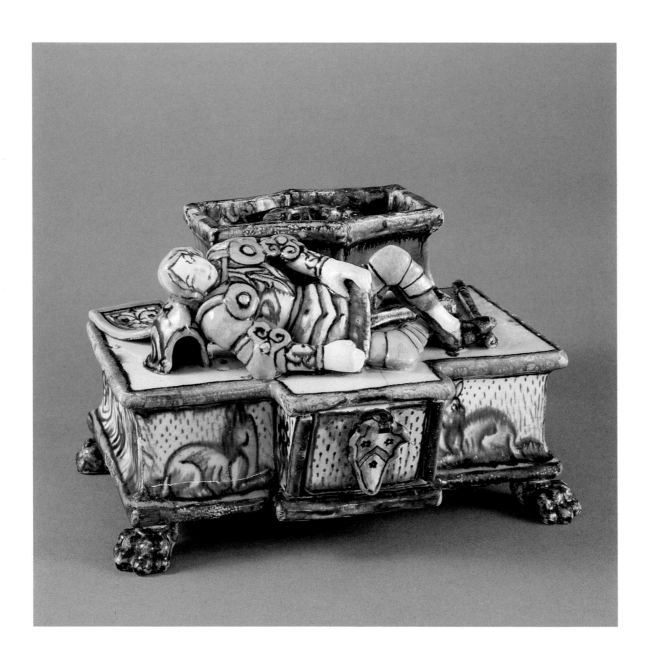

5. Basin with geometric patterns and dragon
Faenza (?), c.1480–1500

H 4.7 cm; D 38.2 cm; approx. shape R4
Inv. 26.315
Provenance: Hainauer; Clark.
Bibliography: Hainauer, 33, cat. 293
(M13); Corcoran/Erdberg, 72;
Corcoran/*Bulletin*, cat. 46

1 Giacomotti, 130.
2 See Metropolitan Museum of Art, inv.
 46.85.17 and 41.100.270; Giacomotti,
 cats. 451–452; and Rackham, cat. 128.
3 Bernard Rackham, "Italian Maiolica:
 Some Debated Attributions . . .," *BM*
 XCIII (April 1951), 109.
4 E.g. Giacomotti, cat. 164 (attr. to
 Faenza, c.1500) and cats. 451–452 (attr.
 to Deruta, c.1480–1500); see pp. 49 and
 130–131 for further information about
 these arguments.
5 They were known as "oak-leaf jars,"
 taking their name from the distinctive
 decorative scheme in high-relief blue
 pigment.
6 Piccolpasso I, folio 67r.

Reverse

This basin is one of a group of large pieces with rosettes or central tondos containing animals, surrounded by colorful concentric zones of small geometric elements. Controversy has long surrounded them, with some scholars taking the position that they belong to Faenza, others arguing for Deruta, and still others questioning their authenticity altogether. Giacomotti's recent investigation of relevant pieces in French museums has shed some light on the question and offered new thoughts on the relationship between Faenza and Deruta in the late 15th century.[1]

The Clark plate is linked to works in the Metropolitan Museum of Art, the Cluny Collection, the Louvre, and especially to one in the Victoria and Albert Museum.[2] The latter contains many corresponding geometric patterns, and its central field, showing a boar ambling through a landscape with cypress trees, is very close indeed to the dragon of the present piece. Rackham first attributed the London basin to Faenza, later changing his opinion – probably quite rightly – in favor of Deruta.[3] While similarities between the two pieces might suggest that both are products of Deruta, certain aspects of the Clark dish imply a Faentine origin instead.

Giacomotti herself has attributed pieces of this group to both Faenza and Deruta, supporting the assignments with ample arguments regarding both stylistic and technical aspects.[4] It now apears that a "Faentine transitional style," as she calls it, did exist in Deruta, and that pieces with the concentric geometric decoration were produced there in the late 15th–early 16th centuries, influenced by a style then current in Faenza. They are sometimes distinguished by their more Derutese shape – rather thickly made with a beveled edge and pierced footring – and by a yellow lead-glazed reverse. The Clark piece, in contrast, is thinner, with a sharp inner junction between the rim and bowl but a smooth, unarticulated exterior profile and no footring. Most notably, the reverse bears a unique and striking design of green, blue, and orange oak leaves and acorns on a white ground. Based on these physical attributes, it seems likely that the Clark plate belongs more correctly to Faenza than Deruta.

No specific iconographical significance can yet be given to the unusual oak leaf pattern on the reverse, although it naturally brings to mind the Della Rovere family who were great patrons of the arts and produced two popes (Sixtus IV, 1471–84, and Julius II, 1503–13). Oak trees were, of course, quite common to central Italy, and patterns based on their foliage appear on earlier maiolica jars of the first half of the 15th century[5] and later in the 1530s on Castel Durante wares; Piccolpasso reproduces a design relating to the Durantine plates in his treatise.[6] In the last quarter of the 15th century, however, the pattern was a rare one on maiolica, and the Clark basin appears to be the only surviving example of its kind.

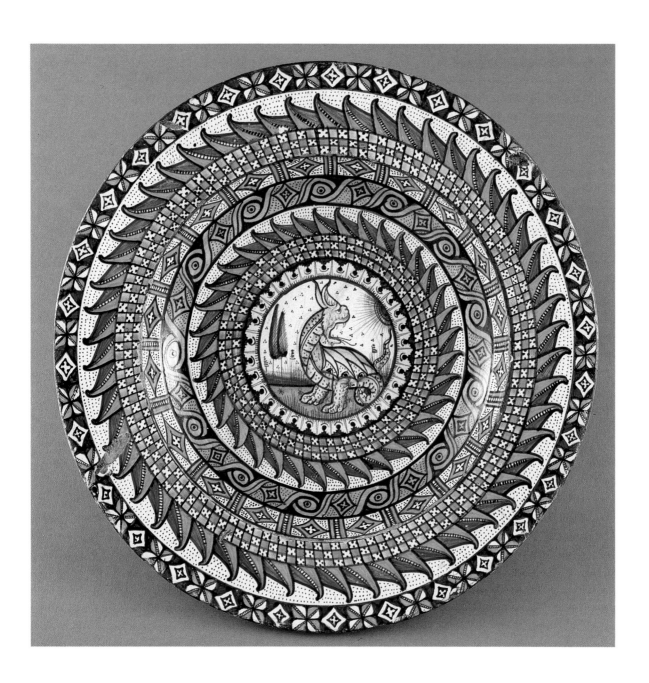

6. Plate with clasped hands
Faenza, late 15th–early 16th century

7. Plate with seraph
Faenza, early 16th century

6.
Inscribed on recto, on banderole:
"MA / FIΔ"
H 3.0 cm; D 23.6 cm; shape L2
Inv. 26.406
Provenance: Gavet, Clark
Bibliography: Gavet, cat. 441, ill. pl.
LII[ter]; Corcoran/*Bulletin*, cat. 15

7.
H 3.2 cm; D 23.5 cm; shape LII
Inv. 26.413
Provenance: Gavet; Clark
Bibliography: Gavet, cat. 442;
Corcoran/*Bulletin*, cat. 17

1 *Corpus I*, 13; see also Giacomotti, 48, and Conti, cat. 122.
2 Other examples with classical motifs are in the Louvre (Giacomotti, cats. 171, 172, and 200).
3 Join-Dieterle, 110.
4 Similar excavated fragments from the Argnani collection are now in the Louvre (Giacomotti, cats. 186–200).
5 Other Faenza plates with clasped hands are in the V&A (Rackham, cat. 221), Sèvres (Giacomotti, cat. 175), and Italian private collections (see F. Liverani, *Maioliche faentine dall'arcaico al rinascimento*, Bologna, n.d., 60–61), and formerly in the Adda Collection (Adda, cat. 287, pl. 118A). A plate with the same motif from Gubbio (c.1530) is in the Bargello (Conti/*Bargello*, cat. 192), and one from Deruta (c.1510) is in the V&A (Rackham, cat. 440).
6 A piece inscribed "FIDES" is in the Berlin Kunstgewerbemuseum (Hausmann, cat. 125).
7 E.g. fragments in the Louvre (Giacomotti, cats. 185–197) and intact plates in Faenza (Conti, fig. 131), Arezzo (Conti, fig. 132), and an Italian private collection (see 5 above).
8 Two Montelupo plates are in the Cora Collection (Cora/Faenza, cats. 520–521); a piece with a similar ribbon band is attributed to Cafaggiolo (Cora/Fanfani, cat. 125).
9 E.g. the border of Clark cat. 10 and a jar at the V&A (Rackham, cat. 246).

At the end of the 15th century some Faenza workshops turned to the production of smaller plates and shallow cups whose decoration relied less on the orientalizing aesthetic that had prevailed in most earlier *quattrocento* wares. The shift towards a style that was more synthetic and independently motivated reflected the new artistic sensibilities of the Renaissance. A conspicuous example of the transition is the famous pavement of the St. Sebastian chapel in S. Petronio made in 1487 by a Faentine master. While it reveals both Gothic and oriental influences, it also contains classical elements and looks forward to the new *stile bello* ("beautiful style") of Ballardini.[1]

The decorative vocabulary of these small wares from Faenza is typified by the present plates, as well as by two others in the Clark Collection (cats. 71 and 72). It is based on concentric geometric and floral bands which were, in some cases, original creations, and in others (such as the egg-and-dart and guilloche patterns) borrowed from antique sources.[2] The central designs often included portraits, or ornamental motifs such as those of the four Clark dishes: seraph heads, emblematic clasped hands, candelabra, or flowers. With their restricted but brilliant coloration of saturated blue, yellow, and orange, these pieces appear almost jewel-like, and are testimony to the assessment of many scholars that Faentine artists enjoyed an undeniable superiority over those of other centers in the domain of ornament.[3] Numerous fragments found in excavations in Faenza itself secure the attribution of the plates to that center, although variations on the style are also seen in Deruta and other maiolica-manufacturing towns.[4]

The clasped-hands motif of cat. 6 appears with some frequency on maiolica, especially on wares of Faenza, Gubbio, and Deruta,[5] and symbolizes union, or a pledge of faith, as in the joining of hands in the marriage ceremony. Occasionally, as in this instance, the image is accompanied by an inscription referring to fidelity.[6] Encircling the central tondo is a striking folded-ribbon pattern that was a favorite Faentine motif and can be found on numerous dishes and excavated potsherds.[7] The ribbon band, sometimes in an even bolder and more schematic form, was also adopted by the artists of Montelupo and Cafaggiolo.[8]

Seraphim – angels depicted with heads only and one or more pairs of wings – were popular with Renaissance painters, who used them in scenes like the Assumption or the Coronation of the Virgin to represent the heavenly spheres. Maiolica craftsman found them well-suited to hexagonal tiles (such as those in S. Petronio) and the central tondos of plates like the present one and cat. 38, although they were also commonly incorporated in border schemes or on jars.[9]

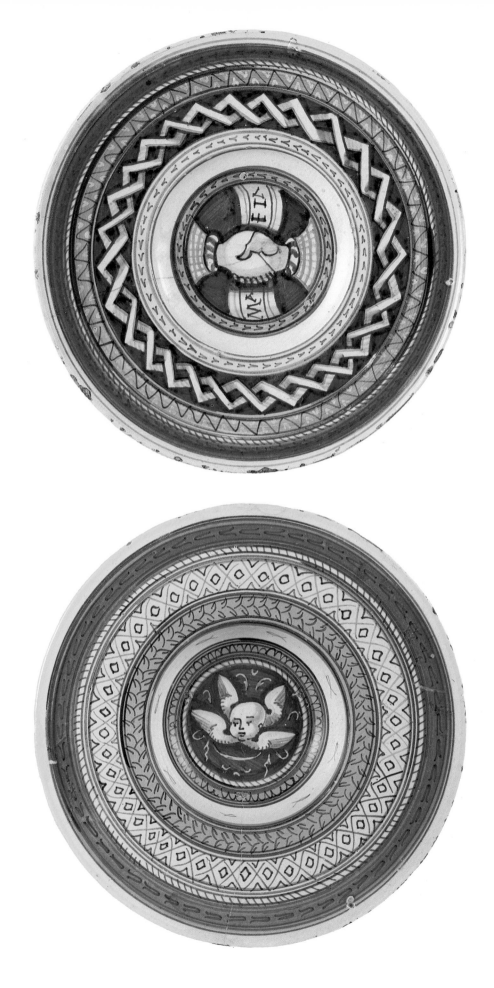

8/9. Pair of albarelli with putti

Faenza, c.1500–10

Inscribed on back: "Bo"
H 20.3 cm and 20.7 cm; D 12.9 and
12.2 cm
Inv. 26.400 and 26.404
Provenance: Gavet; Clark
Bibliography: Gavet cats. 454 and 453;
Corcoran/Erdberg, 72;
Corcoran/*Bulletin*, cats. 12 and 13.

1 B. Rackham, "A New Chapter in the
History of Italian Maiolica II," *BM*
XXVII (1915), 50.
2 Rackham, cat. 373 (c.1510).
3 Rackham, "A New Chapter . . .," 50.
4 Ibid.
5 Among the patterns found on these al-
barelli are chevrons, schematic guil-
loche patterns, metope-type bands with
interspersed circles, triangles, or
crossed squares, x-bands, and con-
tinuous rinceaux, to name a few. The
palette, similar to that of the
concentric-patterned Faenza plates, is
restricted to blue, orange, yellow, and
green, with an occasional touch of red-
dish lustre.
6 Inv. 84.DE.112, formerly in the
Morgan, Widener, Bak, and Sonnen-
berg collections; see Sotheby's (New
York), sale catalogue, 5 June 1979, lot
356.
7 Cf. examples in the V&A (Rackham,
cats. 142, 142A, and 142B), and Bologna
(Guidotti/*Bologna*, cat. 29).
8 A list of albarelli in the group is given
by Rasmussen, 84–86; the two which
he mentions as having been in the
Sonnenberg collection (one with a beg-
gar, the other with a woman feeding
geese) are now in the Getty Museum.
9 Erwin Panofsky, *Studies in Iconology:
Humanistic Themes in the Art of the
Renaissance* (New York, 1962), 95.
10 Ibid., 121.
11 Ibid., 126–7, figs. 95 and 100.

These two richly-colored drug jars – known as *albarelli* and used to store dry or viscous compounds – belong to a group of at least nineteen related vases. Otto von Falke[1] argued that because of the large inscription "Bo" on their reverses, they must belong to the Sienese workshop of Maestro Benedetto, whose best-known work is a blue and white plate in the Victoria and Albert Museum with St. Jerome, inscribed "fata i siena da m[aestr]o benedetto."[2] He allowed that they were, in fact, very different in character, and usually inferior in execution to other pieces by the painter, but explained these anomalies by assigning the albarelli to the hands of workshop assistants.[3] Rackham pointed out the inconsistency of this argument, suggesting that "the mark 'Bo' indicates ownership rather than authorship," and at the same time offered the comment that "all the pieces on which it occurs have the appearance of belonging to the same set, perhaps made for some private pharmacy."[4] He did not, however, challenge von Falke's assignment of the group to Siena.

Although the meaning of the prominently inscribed letters has yet to be explained, it now seems more probable that these rather squat albarelli were manufactured in a Faentine workshop. The distinctive metope-like format – the main face of each showing a single figure on a rectangular panel framed by vertical bands – is unlike any earlier works from Faenza; however, the decorative horizontal bands on the shoulder and foot bear a strong resemblance to those on the late 15th–early 16th century Faentine plates like cats. 6, 7, 71 and 72[5].

Another clue that may point to Faenza as the source for these wares is found on one of two albarelli in the Getty Museum.[6] The figure on the Getty vase is a bearded man wearing a cape, tunic, and ragged leggings, who walks with the aid of a crutch (perhaps a beggar?). In his left hand he carries a ceramic pitcher, or *boccale*, whose decoration was carefully delineated by the painter. A closer examination of this detail reveals it to be a typical Faentine *boccale* of the last decade of the 15th century, with a central medallion enclosed by a ladder pattern from which tufted rays spring.[7] The presence of a vase of this style would also be consistent with a date for the albarelli in the early part of the 16th century.

The subjects found on the drug jars can be divided into two basic groups: one consisting of putti, and the other showing allegorical or genre figures.[8] Variations in the quality of draughtsmanship should allow the assignment of the nineteen or more pieces to individual hands, some clearly more accomplished than others. The Getty pair and the Louvre piece with the Angel of the Annunciation, for example, are certainly the products of a more talented master, while the Clark putti, although charming, show deficiencies in the artist's understanding of anatomy and perspective.

The putti, or cupids, of these albarelli show by their contexts and attributes that they are not intended as angels, but as symbols of profane love in a purely secular sense. Familiar figures in Hellenistic and Roman art, such youthful winged boys represented the often-mischievous god Eros, the son and frequent companion of Venus. Some Renaissance depictions of the god, however, depart from the traditional portrayals of antiquity, and one of the Clark jars shows Cupid blindfolded and bound, with his arrow-filler quiver and his bow, broken in two, on the ground nearby. As Panofsky has pointed out, "this figure was very rarely blind in classical literature, and it was never blind in classical art."[9]

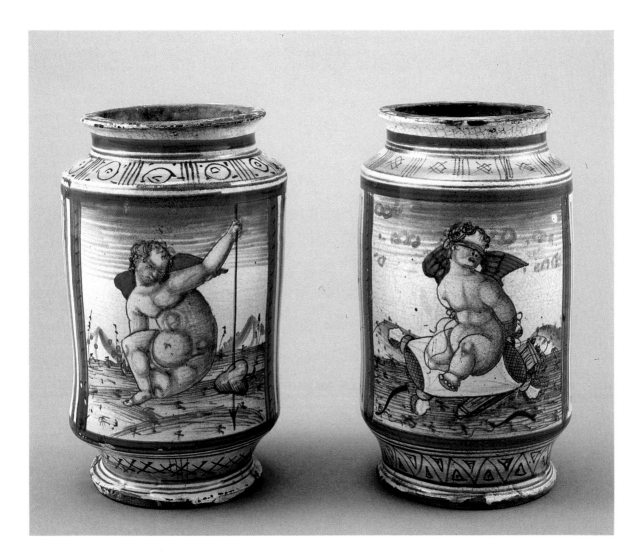

The iconographical development of the "blind cupid" type in the Middle Ages is complex, but by the 14th century, it had acquired a precise meaning as the personification of illicit sensuality, as opposed to pure Divine Love.[10] In the Renaissance, this allegorical interpretation was less strictly applied, except in cases where "profane love" was being specifically contrasted with sacred or spiritual love. And in Renaissance depictions of the punishment of Cupid for his frequent pranks and misdeeds – also a favorite theme in Hellenistic literature and art – he is almost always both bound and blindfolded.[11]

Detail of reverse (Inv. 26.400)

10. Plate with Alexander and Diogenes
Faenza, 1524, Master of the Coppa Bergantini

Inscribed on recto in small cartouches on rim: "1524"; at lower left of composition: "DIOGENES / ALESAN/DER"; on verso in center: "1524"
Coat of arms: Or, a fess between three stars gules, impaling or a horse's head couped proper (?) (unidentified)
H 4.4 cm; D 45.8 cm; shape L22
Inv. 26.309
Provenance: Castellani; Hainauer; Clark
Bibliography: Castellani, cat. 224; Hainauer, 32, 34, 35 (ill.), 108, cat. 287 (M7); Corcoran/Erdberg, 72; Corcoran/*Bulletin*, cat. 19; Corcoran/Clark, 75.

1 Cora/Faenza, cat. 65.
2 Norman, 127 (see Adda, cat. 317); for the V&A dish with David and Goliath, see Rackham, cat. 806.
3 Rackham, 99–100.
4 *Corpus I*, pl. XVIII. This piece is marked with the round symbol previously ascribed to the Casa Pirota workshop; for a discussion of this problematic mark and the Casa Pirota, see Norman, 105–108.
5 The other version was once in the Berlin Schlossmuseum (now destroyed; ill. in G. Liverani, "Fata in Faenza in La Botega de Maestro Piere Bergantino," *Faenza* XVII (1939), pl. Vb.).
6 Bernard Rackham, "Italian Maiolica: Some Debated Attributions; a Follower of Signorelli," *BM* XCIII (April 1951), 110. Rackham notes the painter's "aptitude for introducing dogs, cats, and other animals – often irrelevantly – in the foregrounds of his pictures."
7 Ibid.
8 Ibid.; Rackham has compared specific animals in the maiolica painter's dishes to those in Dürer's *Melencolia* and his *Visitation* woodcut in the *Marienleben* series.
9 Ian Scott-Kilvert (transl.), *The Age of Alexander, Nine Greek Lives by Plutarch* (Harmondsworth, England, 1973), 266.
10 OCD, 849.
11 Jacob Burkhardt, *The Civilization of the Renaissance in Italy* (New York, 1958), vol. II, 324–325.

This large and extraordinary plate – certainly one of the finest pieces in the Clark Collection – can be attributed to an artist we know only as the "Maestro della Coppa Bergantini" or the "Green Man." The latter sobriquet was applied to him because of his use of a blue ground in the *a berettino* technique so popular in Faenza. When yellow pigment was applied over the ground – as it is in the areas meant to represent flesh – it takes on a greenish tone. More recently, the artist has been renamed the Master of the Bergantini Cup after a fine bowl in the Cora Collection that is inscribed: "FATA IN FAENZA I LABOTEGA / D Mº PIERE BERGATIO. M.CCCCC / 1529 adi 17 d zugno" (made at Faenza in the workshop of Master Pietro Bergantino, 1529, the 17th day of June)[1].

This inscription, one of several extant notations on maiolica by the painter, tells us a great deal about the piece, but neglects to reveal the name of the painter himself, obviously an accomplished artist. It was not unusual for a workshop owner to put identification of his bottega above that of the particular artist, and this practice is seen in other centers such as Gubbio and Urbino, where the names of Maestro Giorgio or Xanto adorn pieces from their workshops.

We know from other inscribed pieces that the "Green Man" worked in several shops in Faenza and probably in other towns. Norman has noted one signed work by him, a bowl of c.1540 with St. Jerome, which bears a mark attributed to the workshop of Virgiliotto Calamelli of Faenza, while another dish by the artist in the Victoria and Albert is inscribed: "FATA IN FORLI" (made in Forlì, another maiolica-manufacturing center near Faenza).[2]

Rackham gives a list of dated pieces by this master ranging from 1524 to 1550;[3] the earliest known work, a plate in Arezzo illustrating a group of philosophers is prominently marked, like the Clark dish, with the year 1524.[4] While quite different in subject, the two plates are clearly by the same hand and have many elements in common: the arrangement of a central scene within a border of *a berettino* grotesques, the general palette, and the poses and anatomical delineation of the figures.

The theme of Alexander and Diogenes – rare in Renaissance painting but quite popular later in the 17th century – was taken up twice by the Master of the Bergantini Cup. The other plate was made eleven years later in 1535 and shows a different approach to the subject.[5] In this second version, the composition is reversed and much simplified, although certain characteristic aspects of the painter's work remain, such as the stylized trees and sweeping landscape, the circular clouds, the inclusion of a patron's still-unidentified *stemma*, or coat of arms, the use of contemporary costume, and the mannered depiction of the round-headed figures and whimsical horses and dogs.[6]

Rackham and others have pointed out the "Green Man's" connections to the art of Luca Signorelli (after 1441–1523), saying "he must have been well acquainted with [Signorelli's] compositions and those of his pupils; the Faenza master must surely have visited Orvieto and other Umbrian cities where they could be seen."[7] Stylistic affinities between the two show the indebtedness of the ceramic painter to Signorelli and his followers, especially in the treatment of the graceful and expressive nudes with their carefully rendered musculature, and the monumental handling of the clothed figures, many of whom sport the colorful striped leggings that are also seen in the frescoes of the S. Brixio Chapel in Orvieto. In addition, the influence of the North can be felt in the maiolica master's occasional use of German and Netherlandish costumes, and the mountainous wooded landscapes and animals which can be linked to those in well-known prints by Dürer.[8]

The story of the meeting of Alexander the Great and the 4th-century BC philo-

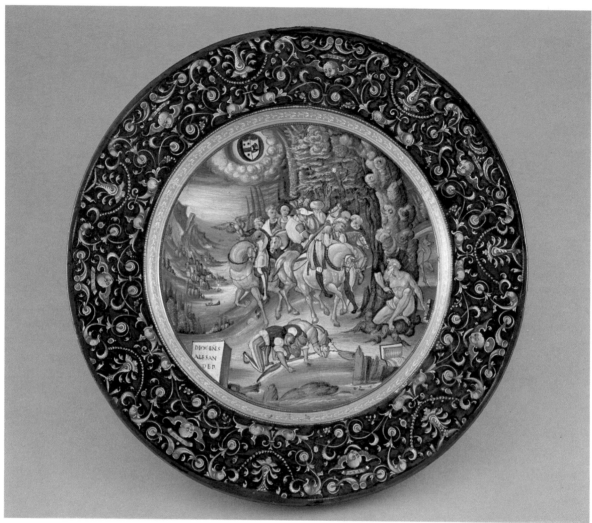

sopher Diogenes was recorded in the *Parallel Lives* of Plutarch (AD 50–120). Diogenes, who rejected all conventions, believed that happiness could best be attained by adhering to the simplest and most natural life. While in Corinth, Alexander sought out the philosopher and came upon him lying in the sun. When the king asked Diogenes if there was anything he could do for him, the latter replied, "Yes, you can stand a little to one side out of my sun." So great was Alexander's admiration for the philosopher's independence of mind that he remarked to his mocking followers, "You may say what you like but if I were not Alexander, I would be Diogenes."[9]

Plutarch's *Lives* were designed to point up the individual virtues – and occasionally the vices – in the great men of the age, and to serve a specifically educational and moralizing purpose. He often included anecdotes such as the one described above to exemplify particular aspects of the character of his heroes. Plutarch's writings were popular in the Middle Ages, although his influence in the Renaissance was even greater, especially in France, England, and Italy.[10] A great resurgence of interest in the biographies of virtuous men and women began as early as the 14th century, and ancient writers such as Suetonius and Plutarch provided apt models for this revitalized literary genre.[11]

Reverse

11. Molded dish with female figure
Faenza, c.1540–50
12. Molded dish with book-motifs
Faenza, c.1540–50

11.
H 4.8 cm; D 27.0 cm
Inv. 26.387
Provenance: Hainauer; Clark
Bibliography: Hainauer, 34, 119, cat.
361 (M85); Corcoran/*Bulletin*, cat. 35.

12.
H 7.6 cm; D 29.1 cm
Inv. 26.386
Provenance: Hainauer; Clark
Bibliography: Hainauer, 34, 39 (ill.),
188, cat. 360 (M84); Corcoran/*Bulletin*,
cat. 34.

In the second quarter of the 16th century, a style became current in Faenza based upon what Piccolpasso called the *a quarteri* (quartered) pattern of leafy rinceaux and other motifs arranged in radiating compartments.[1] These two *crespine*, or molded dishes, from the Clark Collection represent variations on that theme, one having a triangular central panel with a figure that may represent goddess Diana or the personification of Philosophy, and radial ornamental elements disposed around the plate in triads;[2] the other, divided into sixteen less strict "compartments," has a whimsical border of winged spheres and open books.[3] Both display the palette typical of the style, based on a rich dark blue ground with the usual white underlayer, and contrasting yellow, green, and orange pigments defining the decoration; Faentine *a quartieri* dishes also appear quite frequently, however, with blue-stained glaze like that of cat. 10[4]

In general, the painted patterns are conditioned by the undulating forms of these mold-made *crespine* which were inspired by metal wares. The shallow dish with the standing figure has a rare triangular foot which is reflected in the three-sided central panel on its main surface. The other bowl, which has unfortunately lost its original foot, is unusual in that its overall decoration emanates from a central point; much more common is the format with a reserved field, like that of cats. 11 and 73, occupied by warriors, saints, putti, or mythological characters.[5] The reverses were usually painted with leafy sprigs in blue and yellow, also following the shapes defined by the mold. Occasionally pieces of this type were dated or marked "Faenza" on the back as well.[6]

A *crespina* very similar to cat. 11, with a tripartite border scheme and a standing female figure holding a staff, is in the collection of the Kunstgewerbemuseum in Cologne.[7] The small book-motifs of cat. 12 show up on a number of molded Faentine dishes, including examples in Pesaro, the Louvre and the Metropolitan Museum of Art.[8] These ornamental wares remained in demand throughout the century, and Faentine potters continue to turn them out, although as might be expected with such a formulaic style, the quality of execution degenerated with time.[9]

1 See Piccolpasso I, folio 70r, for his example of the style. Fragments of wares of this type were dug up at Faenza (some examples are ill. in F. Argnani's *Il Rinascimento delle ceramiche maiolicate in Faenza*, Faenza, 1898, pl. xxvi, figs. iii and v).

2 A similar figure on a piece in the Adda Collection was described by Rackham as a personification of Philosophy, based on similarities to a figure on one of the so-called *Tarocchi* engravings (Adda, cat. 318, pl. 124A).

3 The abstract winged spheres of both these plates may be derived from the winged putto heads that grace the borders of earlier *a berettino* Faentine plates such as those of cat. 10.

4 E.g. dishes in the V&A (Rackham, cats. 300–302) and in Pesaro (Della Chiara, cat. 97).

5 These figures are depicted variously in bust-length, ¾-length, or full-length formats (see Lessmann, cats. 20–25). For another example of this rare overall design, see Gavet, cat. 407).

6 A piece dated 1547 is in the Museo Civico, Pesaro (Della Chiara, cat. 108) and another dated 1548 was illustrated in J. Chompret, *Répertoire de la Majolique italienne*, Paris, 1949, vol. II, fig. 584. Kube (cat. 17) illustrates an *a berettino crespina* inscribed "Faenza."

7 Klesse, cat. 279.

8 Pesaro (Della Chiara, cat. 96); Louvre (Giacomotti, cat. 934); and Metropolitan Museum of Art (inv. 32.100.380).

9 Giacomotti, 305.

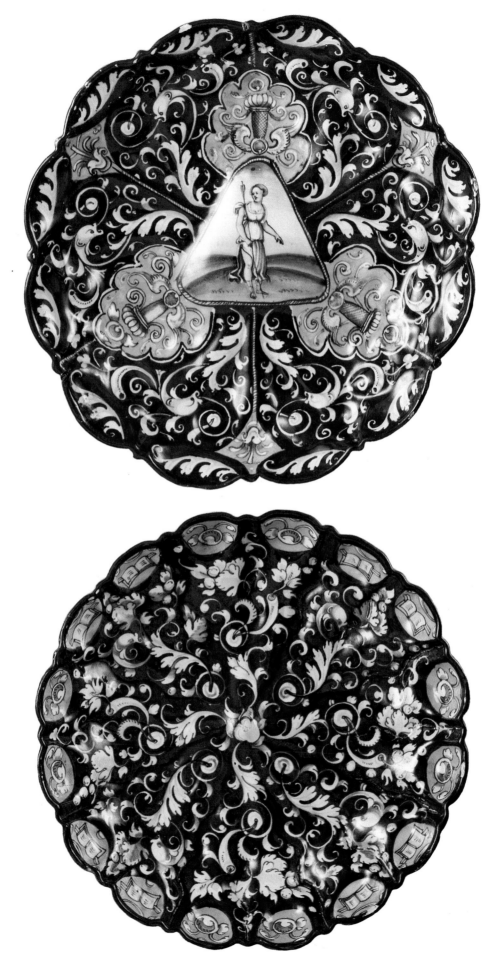

13. Drug jar with head of a warrior
Faenza, c.1540–50

Inscribed on band, on front: "dia irris"
(made from iris)
H 26.7 cm; D 19.8 cm
Inv. 26.371
Provenance: Castellani; Hainauer;
Clark
Bibliography: Castellani, cat. 197;
Hainauer, 117, cat. 349 (M69);
Corcoran/*Bulletin*, cat. 37.

1 E.g. Giacomotti, cats. 961 and 964–966;
cat. 964 bears the inscription
"1569 IN FA/ENCIA."
2 E.g. Liverani, cat. 67; and a later plate
(mid-16th c.) in the Cora Collection
(Cora/Faenza, cat. 108, color pl. IV)
with five medallion portraits, one of
which is extremely like that of the
Clark jar.
3 For earlier examples of Faentine jars of
this shape, see Conti, figs. 118–120.
4 Various labels use the terms "Syrᵒ"
(syrup) or "Loch" (a honey-like
compound).
5 LeStrange, 151.
6 Giacomotti, 305.

This globular jar from Faenza can also be said to belong to the *a quartieri* style, although the compartmentalized decoration is somewhat different from that of the three related *crespine* in the Clark Collection (cf. cats. 11, 12 and 73). Here the compartments are arranged on the convex surface in a strict geometric fashion. The leaves, tendrils, and winged spheres, however, retain their liveliness within the constricting linear bands that define the boundaries of each tile-like unit. Although the dark blue is less dominant than on the footed dishes mentioned above, the palette remains generally the same.

The decorative format of these Faentine pharmacy jars typically includes a medallion on one face with an image of a saint or warrior, and sometimes a multi-figured composition.[1] On the present piece, the roundel encloses a bust of a helmeted Roman warrior with a cloak draped over his shoulders. The painterliness of this image is quite divergent from the precise execution of the geometric ornament around it, and may suggest that more than one artist worked on the piece. Profile warrior heads were often seen on Faenza wares of the period,[2] and the motif was picked up later by Venetian maiolica artists who produced large ovoid jars like Clark cat. 120 in the last quarter of the century. Similarities among them suggest that craftsmen may have been using common sources, such as prints or coins, for these heads.

Pharmacy containers of the same shape were made in Faenza from the late 15th century on, although the earlier ones seldom display drug labels.[3] The inscriptions on the *a quartieri*-style jars of the mid-century most often represent drugs of a syrup or honey-like consistency, as the wide mouth would indicate.[4] The Clark piece is marked "dia irris," or "made from iris"; the roots or rhizomes of the flower – especially the so-called "Florentine Iris" – were an essential ingredient of medicines since antiquity, and decoctions of iris were said to be useful for "purging corrupt phlegm and choler," and for calming cramps, convulsions, or coughs.[5] The Florentine Iris, or Orris, as it was also known, was the species most widely cultivated in Italy for a broad range of medicinal and cosmetic uses.

Albarelli of the same style were also made in substantial numbers at this time by Faentine potters who evidently were supported in large part by the pharmaceutical trade's need for containers. This particular decorative convention was also transmitted to Sicily, where many similar pieces, usually of lower quality, were turned out by local artisans in the later 16th and early 17th centuries.[6]

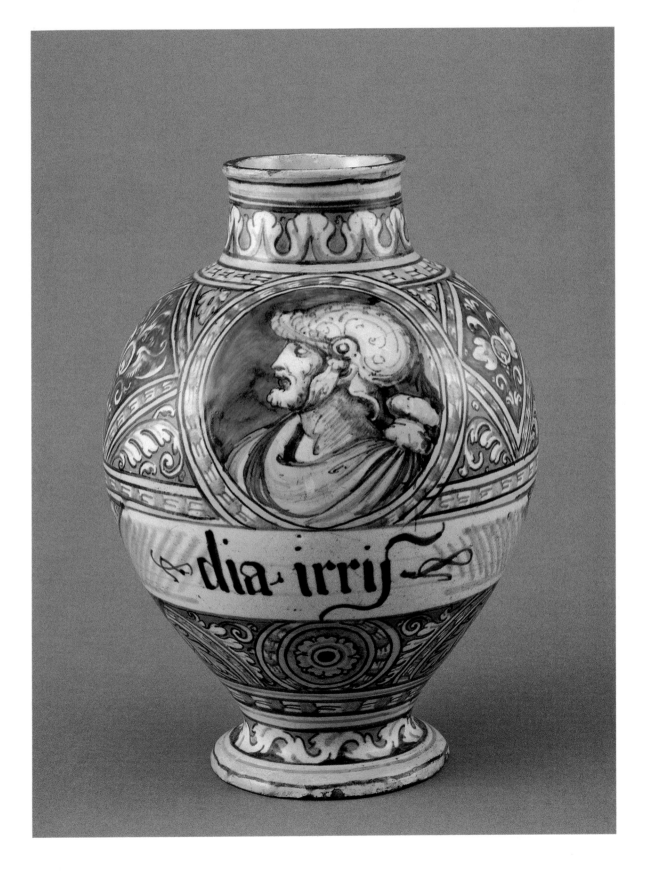

14–17. Orsini-Colonna pharmacy jars

c. 1520–40

14. Tall two-handled drug jar with bust of a young man
Inscribed on band around lower body:
"a bertonice" (solution of *Stachys betonica*, wood betony)
H 36.9 cm; D 20.8 cm; D with handles 23.1 cm
Inv. 26.321
Provenance: Hainauer; Clark
Bibliography: Hainauer, 37, 110, cat. 299 (M19); Corcoran/Erdberg, 72; Corcoran/*Bulletin*, cat. 22.

15. Tall drug jar with bearded man wearing helmet
Inscribed on band around lower body:
"a appii" (solution of *Apium*, wild celery)
H 41.4 cm; D 22.6 cm
Inv. 26.324
Provenance: Hainauer; Clark
Bibliography: Hainauer, 37, 110, cat. 302 (M22); Corcoran/Erdberg, 72; Corcoran/*Bulletin*, cat. 26.

16. Tall drug jar with the Death of Cleopatra
Inscribed on band around lower body:
"a melissa" (solution of *Melissa officinalis*, lemon balm)
H 43.0 cm; D 23.1 cm
Inv. 26.325
Provenance: Hainauer; Clark
Bibliography: Hainauer, 37, 110, cat. 303 (M23); Corcoran/Erdberg, 72; Corcoran/*Bulletin*, cat. 26

17. Dragon-spouted drug jar with busts of women
Inscribed on band around lower body:
"olem de castoreo" (an oily compound made from *Castoreo*, a substance obtained from beavers)
H 21.0 cm; D 15.5 cm
Inv. 26.389
Provenance: Hainauer; Clark
Bibliography: Hainauer, 119, cat. 363 (M87); Corcoran/Erdberg, 72; Corcoran/*Bulletin*, cat. 30.

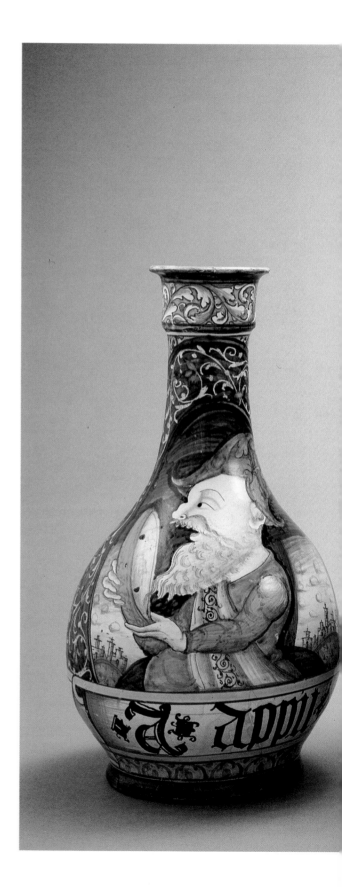

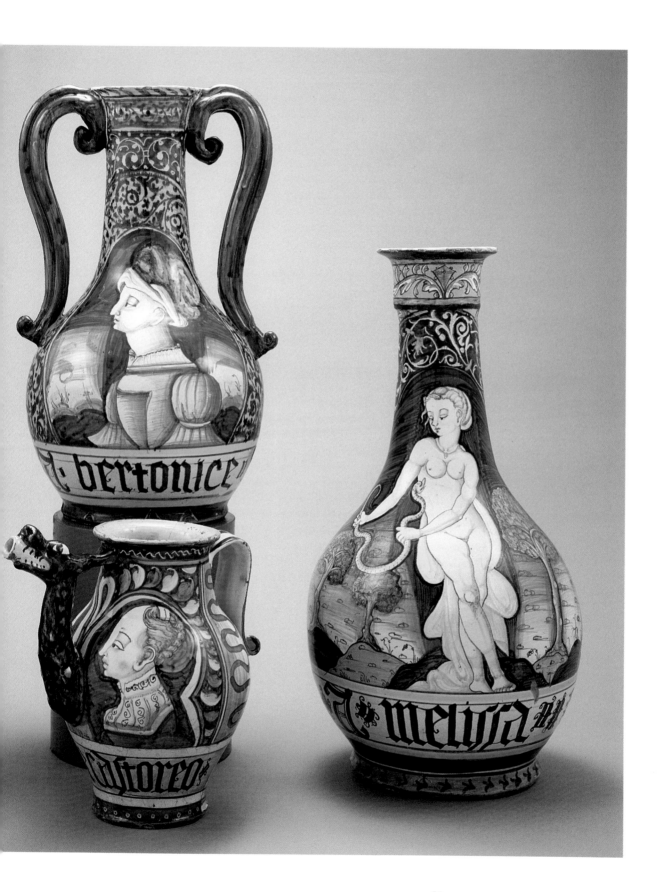

1 British Museum, inv. 52.11–29.2 (ill. in Liverani, cat. 24).

2 Giacomotti (p. 63) gives the date of the reconciliation as 1517, following Rackham (p. 78), although the correct date is 1511 (see *DBI*, vol. 27, 292 and 347; and Timothy Wilson, "The Origins of the Maiolica Collections of the British Museum and the Victoria & Albert Museum 1851–55," *Faenza*, LXXI, 1985, 71).

3 Rackham divided them into two series, an earlier group, thought by him to have been made "early in the 16th century," and a later one, which he dated on stylistic grounds to c.1530–40; see Rackham, 78.

4 Wood betony (cat. 14) was recommended from antiquity as a treatment for myriad problems ranging from paralysis and rabies to simple headaches (LeStrange, 55–56); solutions containing *Melissa officinalis*, or lemon balm (cat. 16) were mentioned by Dioscurides as a treatment for scorpion and dog bites as well as the pains of gout (Freeman, 19–20).

5 See a globular jar in the Hermitage (Kube, cat. 14); jars with high pedestals can also be found in the Hermitage (Kube, cat. 15) and in the Lehman Collection at the Metropolitan Museum of Art (inv. 1975.1.1115).

6 See examples in Rackham (cats. 253–256) and Giacomotti (cats. 261–267).

7 Interestingly, Kube (pp. 13–15) has noted that the death of Cleopatra was one of the most popular subjects in plays that were enacted on festive occasions or during carnivals and was therefore very familiar to the general public during the 15th and 16th centuries.

So numerous are the jars from the so-called Orsini-Colonna pharmacy series that they are found in nearly every major maiolica collection in the world; the Corcoran Gallery counts thirteen pieces among its holdings. The name was given by Rackham to the group based upon a tall two-handled drug vase in the British Museum which shows a bear embracing a column (emblems of the Orsini and Colonna families), with the words "ET SARRIMO BONI AMICI" ("and we will be good friends").[1] The scene has traditionally been interpreted by maiolica scholars as an allegory of the reconciliation between the two families,[2] although no documentation has been found to support any relationship between such an event and the commissioning of a large pharmacy set.

Both the style and quality vary widely, and there appear to have been several hands at work on these vases over a period of approximately two decades, beginning in the late teens.[3] Except for two plates – one in the Clark Collection (cat. 18) and one in the Hermitage – all of the Orsini-Colonna wares were intended for pharmaceutical use, as their labels clearly indicate[4]. Inscriptions on bands around the lower parts of the vessels were normally written in blue in Gothic lettering, although Roman letters were used occasionally as well (see cat. 77 and 84). The decorative repertory includes curling acanthus-like leaves much like those of Deruta wares, as well as carefully incised rinceaux, and the palette is a rich, saturated one. Among the diverse shapes are dragon-spouted pitchers, tall jars with narrow necks and bulbous bodies (with and without handles), and albarelli, all of which are represented in the Clark Collection. Other forms include globular jars and two-handled vases of various configurations on high pedestals;[5] a number of rounded lids survive that fit most of the shapes and must have been a welcome solution to the awkward practice of tediously attaching parchment covers with string.[6]

The subject matter ranges from the ordinary to the whimsical (cat. 79) and even startling (cat. 18). Many of the pieces bear standard frontal or profile images of men and women in contemporary costume (cats. 14 and 17); others show gnomelike bearded men in helmets or soft caps (cats. 15 and 77), bizarre cross-eyed women (cat. 83), or gaily cavorting putti (cat. 79). Another group, more iconographically traditional, show subjects like St. George slaying the dragon (cat. 82), the Magdalen in the wilderness (cat. 80), and the death of Cleopatra, (cat. 16).[7] And pervading nearly all these images is a strong sense of caricature, satire, and the grotesque. The distinctive handling of both the decorative and thematic aspects of the Orsini-Colonna group is its most outstanding characteristic, and the one that, in the end, makes it so difficult to assign it to any particular ceramic center.

Bernard Rackham suggested that these vessels were made for a single pharmacy, although it is curious that not a trace of it remains in either documentary or archaeological form.[8] The circumstances surrounding the commissioning of the jars thus remains a mystery, as does the location of the workshop that produced them. No wasters (remains of imperfectly-manufactured pieces) have been discovered at any of the various centers to which the group has been attributed in the past – Deruta, Castel Durante, Cafaggiolo, and Faenza – and the standard association of the group with Faenza appears to be based almost entirely on conjecture.

Recent investigations into the ceramics of Castelli, a small town in the Abruzzi, have resulted in some surprising conclusions which may shed light on the origins of the Orsini-Colonna set.[9] This remote town in the mountainous region northeast of Aquila was amply supplied with the natural resources needed for a ceramic industry, and even in antiquity Pliny and others wrote of pottery being exported from the area.[10] Castelli gained its greatest renown for the beautiful painted wares of the Grue family in the 17th and 18th centuries, and during that time the town became one of the leading ceramic centers of Italy, despite its out-of-the-way location.

Fortnum noted evidence for ceramic workshops at Castelli as early as 1368, although documentation is scanty until the second half of the 16th century when inscriptions referred to an artisan named Orazio Pompeii who had established a workshop there.[11] A remarkable tile ceiling and pavement in the church of S. Donato near Castelli was apparently executed under his direction in the early 17th century, and many of the tiles show figures that are surprisingly close to those of the Orsini-Colonna pharmacy wares.[12] Although the Castelli tiles postdate the jars in question, they may represent the holdover of a style that was once current in that town. It is also possible, of course, that the reappearance of Orsini-Colonna stylistic traits could be interpreted as nothing more than an adaptation by Castelli artists of another center's decorative vocabulary.

The uniqueness of the Orsini-Colonna style argues for an assignment of these wares to an isolated workshop that was removed from the mainstream of the ceramic industry,[13] or one dominated by an artisan of extremely independent and unorthodox turn of mind. On the other hand, certain elements of these works betray a knowledge of the ceramics of other centers, such as the leaves (like those on the neck of cat. 16) that once caused scholars to attribute the set to Deruta. Much remains to be done before the true origin of the group is determined, but it now appears that the evidence from Castelli may prove to be a key element in the solution of the problem.

8 Adda, 70; Rackham 78.

9 Recent publications on Castelli ceramics include L. Moccia, *Le antiche maioliche di Castello d'Abruzzo* (exh. cat., Palazzo Venezia, Rome, 1968); G.A. Crucitti, *La ceramica in terra d'Abruzzo* (L'Aquila, 1970); and M.G.C. Dupré dal Poggetto et al., *Antiche maioliche popolari di Castelli, 2ª Biennale delle ceramiche antiche popolari* (exh. cat., Castelli and Sesto Fiorentino, Florence, 1980).

10 Fortnum, 336.

11 Ibid., 338.

12 The bearded man on a tile reproduced as the frontispiece in Crucitti's catalogue (see note 9, above) is very similar to a figure on cat. 77.

13 This idea was also mentioned by John Mallet in a conversation, 7 July 1985.

18. Dish with an allegorical subject
Orsini-Colonna Group, c.1520–40

Inscribed on recto, on band: "PIGLI/A
E / NO PENETIRE PEGIO / NO PO:
STARE CHE / ARESTITV / IRE"
H 4.3 cm; D 23.7 cm; shape R14
Inv. 26.308
Provenance: Hainauer; Clark
Bibliography: Hainauer, 108, cat. 286
(M6); Corcoran/Erdberg, 72;
Corcoran/*Bulletin,* fig. 6, cat. 33.

1 See cats. 14–18 for general information
on the Orsini-Colonna group.
2 Kube, cat. 52.
3 E.g. Cora/Faenza, cat. 775; Giacomotti,
cat. 253; and Clark cat. 15.
4 See Clark cat. 78; Cora/Faenza, cat.
775; and Kube, cat. 52.
5 I am grateful to Augusto Campana,
Angelo Mazzocco, and Valentino Pace
for their assistance with the translation
of this inscription.
6 See Jacob Burckhardt, *The Civilization
of the Renaissance in Italy,* (2 vols,
New York, 1958); Erwin Panofsky,
*Studies in Iconology, Humanistic
Themes in the Art of the Renaissance*
(New York, 1962); other references can
be found in Paul Barolsky, *Infinite Jest:
Wit and Humor in Renaissance Art*
(Columbia, Missouri, 1978).
7 Barolsky, 3–4.
8 See Giacomotti, cat. 253, and Jiřina
Vydrová, *Italienische Majolika in
Tschechoslowakischen Sammlungen*
(Prague, 1960), pl. 8. The theme of
"Roman Charity" was very uncommon
on Italian maiolica.
9 For contemporary Castel Durante
pieces of similar size and shape with
subjects of young women and inscribed
banderoles on a dark blue background,
see Giacomotti, cats. 805–806; cf. also
Clark cat. 39.

One of the most unusual of the so-called Orsini-Colonna group[1] both in form and
iconography is this shallow cup on a low foot. With the exception of one other
plate in the Hermitage,[2] the rest of the set is comprised entirely of apothecary jars
in various forms with inscriptions identifying their contents. While the Clark and
Hermitage dishes are anomalies in a group that is otherwise pharmaceutical in
nature, their imagery and style of execution are completely consistent with the
other Orsini-Colonna wares. The singularly unconventional figures that appear on
both plates are found throughout the group – on tall drug jars in the Cora Collec-
tion and the Louvre, and elsewhere in the Clark Collection.[3] Indeed, there is a cer-
tain cast of characters that appears over and over again on these pieces – some of
them outright caricatures and others more straightforward in their representation –
such as a bearded older man with long mustaches in a soft cap, a curly-haired
youth with a lumpy, irregular profile, and an extremely cross-eyed young woman.

The figure on the present plate is a young woman in contemporary dress who re-
appears on other Orsini-Colonna pieces, gesturing towards a bowl of fruit (?),
holding the end of an inscribed banderole, or pointing to a vessel adorned with the
Chigi coat of arms (itself another perplexing element in the mystery of these
wares).[4] On the Clark dish, her role is both puzzling and provocative: with her left
hand she clutches a yellow bird, while with her right she displays her naked breast.
A motto on a twisted ribbon behind the woman does not immediately clarify the
meaning of this obscure allegory. The inscription, which contains various abbrevi-
ations and is written in a form of dialect, can be translated as "Take and don't re-
gret it – the worst that could happen is that you would have to give it back."[5] By
itself, such a statement could be ambiguous, but combined with the proferred
breast and the bird – then, as now, the symbol of the male member in Italian slang
– it takes on a clearly sexual and ironic meaning.

As Burckhardt, Panofsky, and others have pointed out,[6] humor and wit were in-
tegral elements of Renaissance art and literature, although the humorous aspects of
the visual arts have often been overlooked by scholars. The playfulness inherent in
Renaissance culture is apparent not only in the witty writings of Italian courtiers
like Castiglione, and in the comedies of Ariosto, but also in Giulio Romano's ar-
chitectural designs and frescoes for the Palazzo del Tè, for example, and in the
paintings of Mantegna, Botticelli, and Raphael, as well as the gardens, grottoes,
and decorative arts of the time.[7] Love and sex were favorite topics that were joked
about by Renaissance artists and authors, not the least of whom was Pietro
Aretino, whose erotic sonnets inspired a series of images designed by Giulio
Romano and engraved by Marcantonio Raimondi (see cat. 52).

The *"impresario"* behind the Orsini-Colonna ceramics – whether the patron or
the head of the workshop responsible for their execution – was obviously an indivi-
dual who also appreciated satire, irony, caricature and playfulness to great extent.
The Clark dish, however, appears to be unique among the surviving members of
the series for the directness of its sexual innuendo. Could it be that the painter was
roguishly transforming the related but entirely chaste subject – *Caritas Romana* –
that he used on at least two other vessels in the series?[8] Or, by using this particular
shape and decorating it with a female image accompanied by an inscribed band-
erole, might he have been taking the opportunity to poke fun at the *coppe amatorie*
(love cups) of Castel Durante that were being manufactured at the same time?[9]

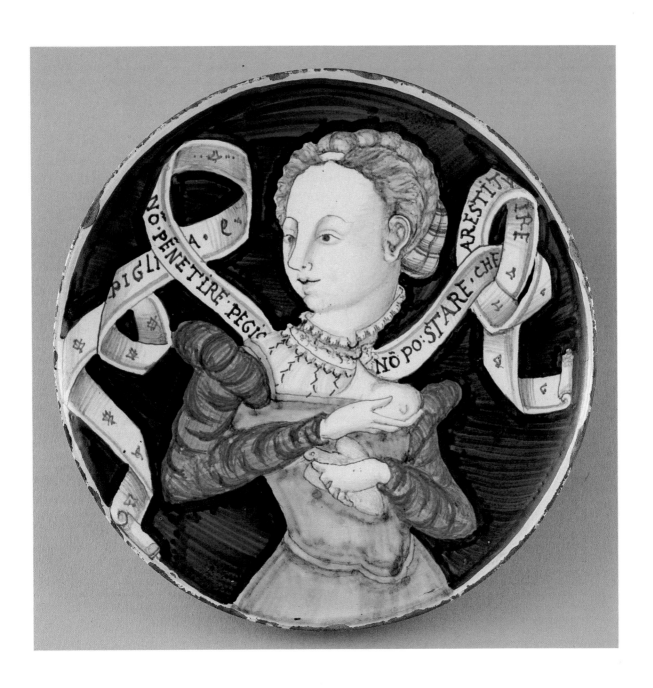

19. Dish with Gothic-floral pattern
Central Italy/Tuscany, c.1470–90

H 7.7 cm; D 36.9 cm; shape R2
Inv. 26.421
Provenance: Gavet (?); Clark
Bibliography: Corcoran/*Bulletin*, cat. 44.

1 Giacomotti, 23.
2 Ibid.
3 See Donatone and Berardi. Note also the Gothic-floral decoration on the reverses of Clark cats. 23 and 24 which are attributed to Naples.
4 Rackham, *Ital. Mai.*, 14. The two roundels are in the V&A (Rackham, cat. 128A) and the Cluny collection (Giacomotti, cat. 79; dated 1475).
5 For the Bargello plate, see Conti, fig. 89; a pair of related two-handled jars are in the Wallace Collection, (Norman, cats. c80 and c81), and another is at the V&A (Rackham, cat. 106); see also a signed and dated piece (1489) with similar *a sgraffio* decoration (Giacomotti, cat. 151), and a closely related plate with the Orsini arms in the Pringsheim collection (Pringsheim, cat. 16).
6 Berardi, figs. 26, 37, and 46.
7 Norman, 7.

The "Gothic-floral" pattern which forms the central decoration of this large, thickly-potted dish was one of the most popular motifs of the so-called "severe style" of Italian Renaissance maiolica. It was Gaetano Ballardini who, borrowing from the terminology of ancient Greek ceramics, first applied it to 15th-century wares of central Italy.[1] Their ornamentation was characterized principally by motifs drawn from nature, such as plants, animals, and sometimes human figures, often influenced by an oriental aesthetic filtered through earlier Hispano-Moresque ceramics.

Although most of these pieces were once ascribed either to Faenza or Florence, it is now thought that their decorative patterns may have been in much wider use throughout the peninsula. The 1487 pavement of the St. Sebastian chapel in Bologna's S. Petronio comprises most of the motifs common to the style, but while it is thought to have been made by an artisan from Faenza, Petrus Andrea, it is not certain that it was actually made there.[2] In recent years Donatone, Berardi, and others have turned a new eye to these early Renaissance pieces and offered alternative attributions to workshops in Pesaro, Naples, and elsewhere.[3]

The vocabulary of the Clark dish, executed in the standard palette of the day (blue, purple, green, and yellow), includes the swirling graceful petals of the Gothic floral pattern, with smaller flourishes filling the white background spaces. Surrounding the central field is a band of *a sgraffio* spirals, scratched through the manganese purple to form the white linear shapes, and on the outermost border, a band of blue "San Bernardino" rays. The latter were named after the emblem adopted by St. Bernardino of Siena: the sacred initials "IHS" surrounded by wavy radiating lines. Rackham notes two maiolica roundels featuring this design; one of them, dated 1475, was once inserted in the wall of a house in Faenza.[4]

There is no lack of comparisons for the Clark plate, and pieces with similar floral designs, scratched motifs, and rays exist in the Bargello, the Wallace Collection, the Victoria and Albert, and the museum at Sèvres, to name only a few.[5] In addition, a number of interesting related fragments have been cited by Berardi in his recent arguments for redirecting many traditional attributions to the city of Pesaro.[6]

The reverse of the Clark plate, while undecorated, offers interesting information about its manufacture as well. The shape of the piece itself – a rather deep dish with a thick-edged rim and small footring – is not unlike the large display plates (e.g. cat. 32) for which Deruta later became famous. As in those pieces, the footring of the present is pierced for hanging and the reverse is covered by a lead-glaze. A.V.B. Norman commented on the latter practice, saying that "although Piccolpasso does not mention it, many large dishes were only coated in *bianco* [the white tin-glaze mixture] on their upper surface, presumably as a measure of thrift. The under surface was then covered only in transparent lead glaze. This is particularly common on Deruta ware."[7]

This plate was previously assigned by von Erdberg to a Florentine workshop, although little specific proof exists to support that attribution. The new view of this style's wide currency in 15th-century Italy and the possible connection to the glazing practices of Deruta in Umbria may favor a broader assignment of the Clark plate, at least temporarily, to Central Italy/Tuscany.

20. Two-handled jar with Gothic rinceaux
Tuscany, possibly Florence, c.1480–1500

H 22.6 cm; D 15.2 cm; D with handles
22.6 cm
Inv. 26.409
Provenance: Gavet (?); Clark.
Bibliography: Corcoran/Erdberg, 72;
Corcoran/*Bulletin*, cat. 45;
Corcoran/Clark, 74.

1 Cf. Conti, figs. 87–90, 92; also
 Cora/*Firenze*, pls. 206, 207, and 209.
2 Compare, for example, the floral
 panels of the Ara Pacis Augustae (ill. in
 G.M.A. Hanfmann, *Roman Art*, New
 York, 1964), figs. 102–103), and
 orientalizing Hispano-Moresque wares
 such as the plate in the Wallace Collec-
 tion (Norman, cat. C1; Manises,
 c.1404–30).

During the last few decades of the 15th century, two-handled drug jars, shaped like albarelli and decorated in the so-called "severe style," began to be produced in Tuscany. Their basic form echoes that of the traditional pharmacy container, the albarello, but with the addition of side handles of various types, including a plain strap handle, a flat cut-out variety, or the twisted version of the present piece. Attribution of these pharmaceutical vessels has proven to be problematic, although Florence and Faenza, the two preeminent maiolica centers of the century, are most often named. Even so, the cross-currents of influence between the two cities make it difficult to assign works to one or the other with complete confidence.

The Clark jar is consistent with many extant vessels in shape and general arrangement of decoration – a continuous geometric pattern encircles the rim, and the two main faces have related vertical bands framing a central panel.[1] Quite unusual, however, are the beautiful painted Gothic rinceaux that appear in the main panels. Most two-handled vases have as their primary decoration Gothic-style letters, coats of arms, animals, or geometric versions of flowers. Here, the graceful serpentine floral pattern at once recalls both classical and oriental precursors,[2] as well as the intricate foliate designs of medieval illuminated manuscripts. The disjuncture between these delicate spiral patterns and the more severe framing bands is made less jarring by the chromatic unity of the palette, which is limited to blue, orange and green on a cream-white background.

21. Footed dish with the arms of the Medici
Tuscany, probably Cafaggiolo, c.1513–21

Coat of arms: Or, five torteaux two, two and one, in chief a hurt charged with three fleurs-de-lis or; the shield is surmounted by the papal tiara or and keys or and argent crossed in saltire
H 7.1 cm; D 22.3 cm
Inv. 26.303
Provenance: Castellani; Hainauer; Clark
Bibliography: Castellani, cat. 244; Hainauer, 31, 34, 107, cat. 281 (M1); Corcoran/Erdberg, 72, fig. 10; Corcoran/*Bulletin*, cat. 43; *Detroit*, 55 (ill.), cat. 93; Corcoran/Clark, 74.

1 See Bibliography above.
2 Norman, 10. Join-Dieterle, in the catalogue of the Petit Palais collection (p. 65), gives the death dates of the brothers as follows: Piero (1507) and Stefano (1532).
3 Cora/Fanfani, 9.
4 For general information about Cafaggiolo wares, see: Gaetano Guasti, *Di Cafaggiolo e d'altre fabbriche di ceramiche in Toscana* (Florence, 1902) and Cora/Fanfani. Serious ceramic production in Cafaggiolo is now thought to have lasted from c.1490 to 1590 (see Cora/Fanfani, 6).
5 Join-Dieterle, 65.
6 E.g. Cora/Fanfani, 62–63, cats. 42–43.
7 Piccolpasso II, folio 69v.
8 Examples of the *mezzaluna dentata* with the SP inscription are illustrated in Cora/Fanfani: 1) a pitcher made for the Ospedale di S. Maria di Nuova in 1507, Collezione Dott. Chavaillon, (ill. p. 23, cat. 2), and 2) a pitcher in the British Museum (ill. p. 53, cat. 34). The British Museum example also displays the *a sgraffio* technique.
9 Cora/Fanfani, 94, cat. 79. This piece is marked with the motto of Giuliano de' Medici, the brother of Pope Leo X.
10 E.g. Cora/Fanfani, cats. 9, 37, 39, and 79. The interest of the Medici in ceramics continued throughout the century and their arms appear on Deruta wares as well as those of other ceramic centers in addition to Cafaggiolo (see Timothy Wilson, "Some Medici Devices on Pottery," *Faenza* LXX, 1984, 433–440). Around 1575 Duke Francesco I de' Medici set up a workshop

The style, lively color scheme, and coat of arms of this footed dish identify it as a Tuscan product from the region near Florence. Bode and von Erdberg both suggested Cafaggiolo – probably correctly – as its source,[1] although there is much dispute about attributions to this center. The output of the workshops there is now believed to have been much smaller than was previously thought, its production level only a fraction of that of Montelupo, with which it was closely allied.

Potters were known to have migrated from one center to another, encouraged in part by patrons establishing new factories. Such was the case with two brothers from Montelupo, Piero and Stefano di Filippo, who came north to Cafaggiolo to run the new pottery founded there by Pierfrancesco de' Medici in 1498.[2] Although based in Florence, the powerful Medici family was known to have had a villa in this small town since at least 1427.[3] Piero and Stefano, whose combined monogram is found on many pieces from their workshop, brought with them the technical expertise required for the high-quality luxury wares that were made in Cafaggiolo for the Medici and other clients over the next hundred years.[4] Among these were the formula for the elusive red pigment and a vocabulary of patterns such as the blue and white *alla porcellana* decoration (derived from Chinese imported porcelain), both of which are found on the Clark dish. The bright red color – used here on the Medici coat of arms and to highlight the border pattern – appeared for the first time on Italian maiolica in Montelupo wares of the last decade of the 15th century.[5] Prior to that time, no ceramic pigment of this hue had been developed that could withstand the high firing temperatures of the maiolica kilns.

The close ties between Montelupo and Cafaggiolo, of course, make it extremely difficult today to differentiate the products of each center except for those marked with potters' initials or with the inscription "In Chafaggiuolo."[6] The presence of a Medici coat of arms, in combination with several characteristically Cafaggiolesque motifs, however, argues persuasively for the attribution of the Clark dish to that center. The *alla porcellana* design of its reverse was common in Montelupo as well, and popular enough to be recorded in one of Piccolpasso's drawings.[7] The so-called *mezzaluna dentata* (or "toothed half-moon"), though, seems to have been a characteristic Cafaggiolo development, and the scratched, or engraved, technique of the main border design is found in other Cafaggiolo pieces as well.[8] A particularly close parallel to the Clark footed dish is a plate in a private collection with a similar *a sgraffio* pattern.[9]

The Medici coat of arms is enhanced by the addition of the papal tiara and crossed keys of St. Peter. Two of the family's four popes were elected to office in the first half of the 16th century: Giovanni de' Medici became Pope Leo X (1513–21) and Giulio took the name Clement VII (1523–34). Although the Clark piece was thought by Bode and von Erdberg to have been executed during the reign of Clement, it now seems more consistent stylistically with ceramics made around 1515, and the papal *stemma* must therefore refer to Leo.

Leo X's artistic interests, like those of other Medici family members, clearly extended to maiolica, as numerous pieces with Medici crests and mottoes attest.[10] A unique plate in the Victoria and Albert Museum actually shows him being carried in solemn procession, accompanied by soldiers, musicians, and ecclesiastics,[11] and a remarkable *boccale* in the Cora Collection features a life-like portrait inscribed with Leo's name and the potter's mark "SP."[12]

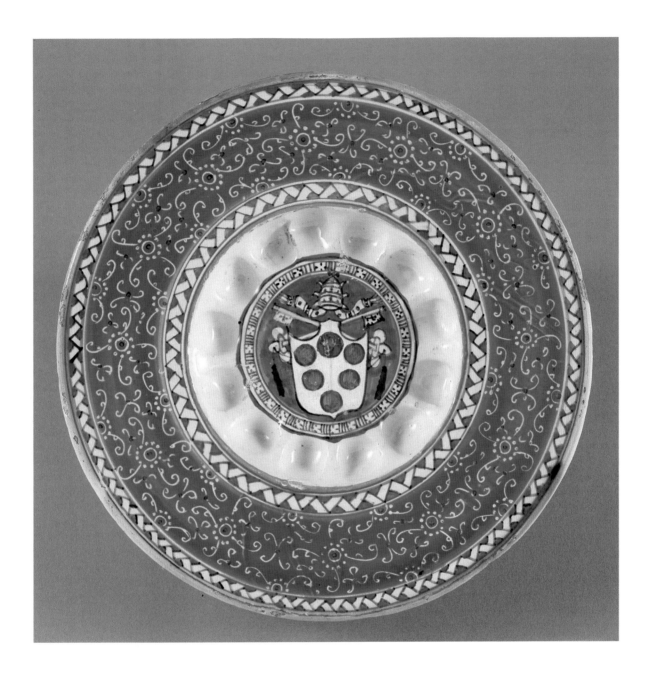

in the Boboli Gardens to conduct
Europe's first successful experiments in
the attempt to duplicate Chinese por-
celains. Fewer than sixty pieces of this
rare soft-paste "Medici porcelain" re-
main today (see Charleston, 212).

11 Rackham, cat. 318.
12 Cora/Fanfani, cat. 14.

22. Plate with St. Catherine of Alexandria
Tuscany, possibly Cafaggiolo, c.1510–20

H 1.7 cm; D 23.7 cm; shape L2
Inscribed on verso: "Bo" (crossed with a paraph)
Inv. 26.304
Provenance: Hainauer; Clark
Bibliography: Hainauer, 35 (ill.), 40, cat. 282 (M2); Corcoran/*Bulletin*, cat. 68; Corcoran/Clark, 74

1 Hall, 58.
2 Ibid.
3 Cf. Cora/Fanfani, cats. 18, 24, 29, 20, and 118.
4 A summary of both opinions can be found in: B. Rackham, "A New Chapter in the History of Italian Maiolica, I," *BM* XXVII (1915), 28–35, and "A New Chapter . . ., II," *BM* XXVII (1915), 49–55; see also Otto von Falke, "Siena oder Deruta?," *Pantheon* IV (1929), 363 ff.; Rackham, V&A catalogue, 134, and his "Italian Maiolica: Some Debated Attributions . . .," *BM* XCIII (April 1951), 106–111.
5 Rackham, 134.
6 See comments regarding these initials in the two articles of 1915 by Rackham (see 4 above).
7 Documents show that Maestro Benedetto was working in Siena in 1509 and was mentioned as being there as late as 1521–22 (Rackham, 127). Ravanelli Guidotti recently suggested an attribution of the present Clark piece to this workshop (verbal communication, 6/4/85).
8 Rackham, 134.
9 See Giacomotti index (p. 494), under "petales."
10 Cf. a *boccale* in the Berlin Kunstgewerbemuseum (inv. 36.57; ill. in Liverani, cat. 40), and especially a dish illustrated in Cora/Fanfani (cat. 118; art market, 1965).
11 A list of Cafaggiolo potters mentioned in archival sources is given by Cora and Fanfani (p. 169), none of which can be identified with the inscription "Bo" of the present dish.

A figure of St. Catherine of Alexandria occupies the central field of this small but colorful and densely decorated plate. Venerated as an Early Christian martyr, St. Catherine is normally represented, as she is here, with the palm of martyrdom and the spiked wheel on which she was tortured. Early accounts of her life say that she was of royal birth and from an early age showed great erudition.[1] The 4th-century saint thus became known as a patron of education and is often depicted with symbols of learning, such as the book that she holds in her left hand, or with mathematical instruments or a celestial globe.[2] In the Renaissance, St. Catherine of Alexandria was also thought of as the namesake and inspiration of Catherine of Benincasa (c.1347–80), the patron saint of the city of Siena, with whom she sometimes appears in paintings.

The vivid red of the saint's cloak and border elements was a color developed in Tuscany, probably in Montelupo, that is especially characteristic of wares of the region. Its presence, along with such stylistic details as the basket-topped putto-heads, may suggest Cafaggiolo as the place of manufacture of this dish.[3] None of the related Cafaggiolo pieces, however, have the transversely-striped petal pattern that appears on the reverse of the Clark piece.

For nearly a century, maiolica scholars have attempted to sort out the so-called "petalback group" and determine a common source for pieces decorated in this manner. Otto von Falke claimed a Sienese origin for these late 15th–early 16th-century works, while Rackham arrived at the conclusion that they belonged to Deruta.[4] As Rackham noted, petalback dishes are frequently inscribed with various initials (B, F, G, M, P, R, V, and CB, FR, and IB), sometimes crossed by a paraph, as on the present plate;[5] these letters may represent either the name of the painter, the workshop head, or the owner of the piece.[6] Although some scholars continue to hold the opinion that all pieces marked "Bo" – like the present one – belong to the Sienese workshop of Maestro Benedetto, there is insufficient evidence to support that theory.[7]

The range of attributions for plates bearing petalback reverses has been, and continues to be quite broad – they had been assigned at various times to Faenza, Forlì, Cafaggiolo, and Pesaro, in addition to Deruta and Siena.[8] Giacomotti, in her catalogue of Italian maiolica in the national museums of France, illustrates many such pieces – some of them actually inscribed with their place of manufacture – in chapters on Faenza, Siena, Deruta, Montelupo, and Padua.[9]

It now seems evident that while many of these works can be assigned with certainty to Deruta, it is not possible to construct a cohesive group of all maiolica with petalback reverses. These patterns are themselves diverse (compare the present plate with cat. 93), and the motif was almost certainly one of many that were transferred from one center to another. Attributions based on the style and coloration of the obverses of petalback plates, with secondary attention to that motif, may indeed prove to be the most accurate ones. The Clark plate, while bearing some similarities to examples from Siena and Deruta, is probably most closely related to pieces now given to Cafaggiolo,[10] although more evidence is needed to secure an attribution to that center.[11]

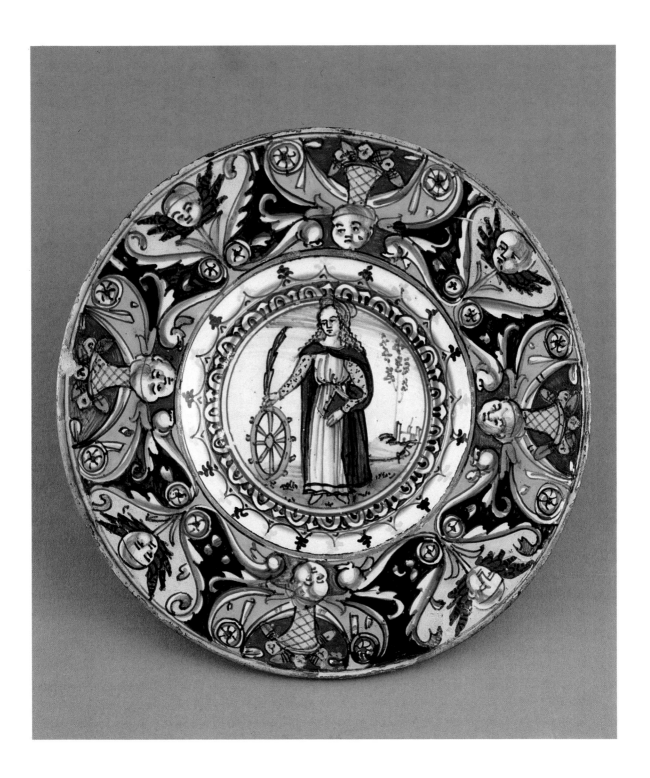

23. Albarello with a portrait of an unknown man
Naples, c.1475

H 30.7 cm; D 13.1 cm
Inv. 26.405
Provenance: Gavet; Clark
Bibliography: Gavet, cat. 439:
Corcoran/*Bulletin*, fig. 2, cat. 3;
Corcoran/Clark, 75, fig. 56.

1 Donatone connects a number of the images on albarelli with those of contemporary portraits on coins, medals, sculptures, and drawings as support for this hypothesis.
2 Donatone, fig. 6.
3 Ibid., 9. The term *spezieria* is derived from the Italian word for spices (*spezie*).
4 Ibid., 15.
5 H. Herder and D.P. Waley (eds.), *A Short History of Italy* (Cambridge, 1966), 61–62.
6 Donatone, 6.
7 Ibid.
8 Ibid., 9, n. 2. See also, A. Russo, *L'Arte degli speziali in Napoli* (Naples, 1966).
9 Ibid. Forthcoming publications by Donatone will provide further evidence of these establishments.
10 Ibid., fig. 13. The characteristic dotted background is found also in the earlier tiles of the Caracciolo chapel (Donatone, figs. 50–53). Rackham (*Ital. Mai.*, 13) says that these dots "arranged triangle-wise" were "used previously by Spanish potters of Paterna but ultimately [were] of Persian derivation."

The Clark Collection contains two fine early albarelli decorated with portraits of men on one face and an elegantly sinuous Gothic-floral pattern on the other (see also cat. 24). A number of related pharmacy jars in collections around the world have until recently been considered products of Tuscany or Faenza of the second half of the 15th century.

Albarelli normally have as part of their decoration a label indicating their contents (e.g. cat. 31). In the case of this particular group, however, they often carry portraits of men or women, sometimes inscribed with their names. In contrast to the large lustred dishes of Deruta which show ideal male and female images (e.g. cat. 102), these jars bear highly individualized representations.

Guido Donatone has recently suggested that they are not in fact Tuscan, but Neapolitan wares, and that many of the portraits can be identified with members of the Aragonese royal dynasty or other noble families of Naples.[1] Although the latter hypothesis remains to be proven, it now seems very likely that Donatone's attribution of this group to Naples is correct.

A great deal has been written of the well-known Renaissance ceramic centers of central Italy, while those of Sicily and southern Italy have received far less attention. Evidence in favor of an active local maiolica industry in Naples includes the early tiles of the Caracciolo Chapel (c.1430) in the church of S. Giovanni a Carbonara,[2] the presence of local coats of arms on some of the albarelli in question, and archival documents referring to the presence of *spezierie* (shops of pharmacists or spice-sellers) in Naples[3] and to the export of ceramics from that city to other centers.[4]

The establishment of the Aragonese dynasty in Naples under Alfonso the Great in 1435 marked the end of a period of great political upheaval and almost incessant warfare.[5] Under Aragon rule, various arts and industries were promoted to serve the needs of the royal and noble families, especially in the last decades of the century.[6] Documents show that artists and craftsmen flocked to the capital, increasing the population of such workers who were already ensconced there. Among them were maiolica painters who Donatone believes produced the albarelli "destined to adorn the royal *spezieria* of Castelnuovo, the royal palace and fortress of the Aragonese dynasty," or to be presented as gifts on the occasion of events such as engagements or weddings.[7]

Organized pharmaceutical activity is known to have existed in Naples from the time of Federico II (1194–1250), ranging from the preparation of medicines and confections, to the marketing of herbs and spices.[8] By 1493, documents recorded the presence in Castelnuovo of a *speziale* (the equivalent of a modern druggist or chemist), who prepared syrups and aromatic mixtures for his majesty Ferrante I d'Aragone, and it is thought that a royal pharmacy must have existed in the castle in the time of his father Alfonso I, as well.[9]

The present albarello bears a close resemblance to one in the Victoria and Albert Museum with a portrait thought to represent Eleanor of Aragon, particularly in the rendering of the facial features and contours, and in the dotted background of the surrounding panel.[10] Donatone assigns it to the Naples workshop around 1473. Other details such as the linear treatment of the unknown man's hair, the feather motif near the rim, and the curving Gothic-floral pattern of the reverse find parallels among other members of the group.

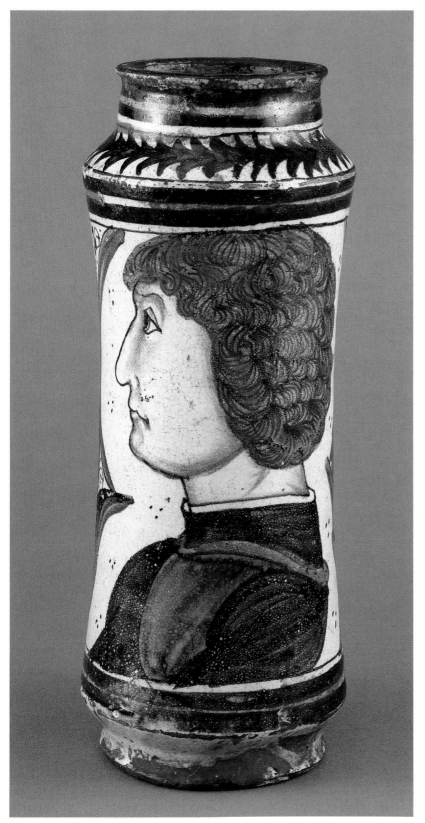

24. Albarello with a portrait of a youth (Mitriano)
Naples, c.1480

Inscribed on band to right of portrait:
"MITRIANO"
H 28.6 cm; D 13.0 cm
Inv. 26.399
Provenance: Gavet; Clark
Bibliography: Gavet, cat. 440;
Corcoran/*Bulletin*, cat. 7.

1 Donatone, figs. 45–46.
2 Ibid., fig. 5 (a pair of albarelli, one with a male portrait inscribed "LOFINO," and the other a female portrait marked "LISA BELLA").
3 Ibid., fig. 4 (an albarello with a portrait Donatone identifies as Beatrice of Aragon). See also an albarello in the Sackler Collection (inv. 79.5.9; cat. 1 in D. Shinn, *Sixteenth-Century Italian Maiolica* (exh. cat; National Gallery of Art, Washington, D.C., 1982), 11.

This albarello, like cat. 23, was probably made in one of the Naples workshops in the last quarter of the 15th century. Both of the drug jars bear similar decorative programs, profile portraits of men with Gothic-floral patterns, and use a color scheme conditioned in part by the available ceramic pigments of the time – blue, green, purple, and ochre. However, they are certainly by two different hands and the present example is probably later; its glaze is somewhat rougher and has an overall blue-grey tone that is not found in the other piece.

Several albarelli formerly in the Schiff Collection are closely related, notably a pair with portraits of young men that are also inscribed with the names of the subjects;[1] the Clark piece has the name "Mitriano" written in Roman capitals on a band to the right of the portrait. A distinctive manner of drawing both the outlines and contours of the eyes, noses, and mouths can be seen on all three jars, and the ochre background setting off the youth's profile on the present piece shows up on other Schiff jars as well.[2] The floral decoration of the reverse includes a ladder-like inset on the long swirling petals that also appears, for example, on a Neapolitan albarello in the Musée des Arts Décoratifs in Lyon.[3]

Instead of the more typical doublet worn by other male figures depicted on similar albarelli (cf. cat. 23), "Mitriano" wears a loosely-draped cape with the fold-lines casually indicated in blue. In contrast to the other Clark albarello, the youth's portrait is completely executed in blue pigment, and other colors are confined to the background and the reverse decoration.

Further study remains to be done on these intriguing albarelli, some of which are considered to be of dubious authenticity by scholars. A fuller examination of the documentary and archaeological evidence and the application of scientific tests could provide much-needed confirmation for the 15th-century Neapolitan maiolica industry.

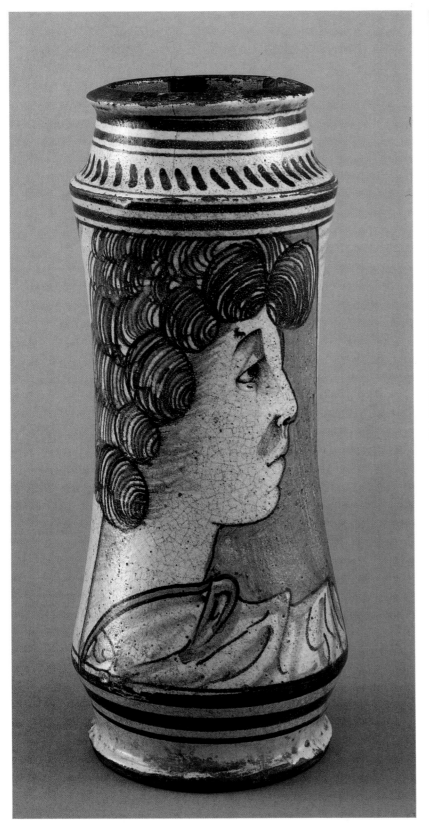

71

25. Albarello with grotesques and ornamental bands
Siena, c.1510–15

H 27.9 cm; D 14.7 cm
Inv. 26.334
Provenance: Hainauer; Clark
Bibliography: Hainauer, 112, cat. 312
(M32); Corcoran/*Bulletin*, cat. 70

1 Giacomotti, 22 and 105.
2 Including Maestro Benedetto, son of
 one "Giorgio da Faenza," and Giovan-
 ni Andrea da Faenza, both of whom
 were recorded in Sienese documents
 around 1503; see Giacomotti, 105, and
 R. Langton Douglas, "A Note on
 Maestro Benedetto and His Work at
 Siena," *BM* LXXI (1939), 89–90.
3 See Rackham, cat. 386 (one of these is
 dated 1509), Giacomotti, cats. 371–399,
 Rasmussen, cats. 79–95; see also O.
 von Falke, *Majolika (Handbücher der
 Königlichen Museen zu Berlin. Kunst-
 gewerbemuseum)* (Berlin, 1907, 2nd
 ed.), fig. 55, for tiles from the same
 group in the Berlin Schlossmuseum.

The Manfredi family was one of the main forces behind the ceramic industry of
Faenza until their downfall in 1501, after which many craftsmen left for other
maiolica-manufacturing towns in central Italy and along the Adriatic coast.[1] Siena
was a beneficiary of this political circumstance, and shortly afterwards, several
Faentine masters were documented as working in Sienese shops.[2]

This albarello and its mate (cat. 91) belong to a group of apothecary jars that
have been attributed to Siena because of their affinities with the famous Petrucci
Palace tiles of c.1509.[3] Both the tiles and the albarelli based their decoration on the
grotesques that became popular in the late 15th century (see also cat. 42). This
appealing brand of ornament captivated the imagination of painters and print-
makers alike, and quickly spread to practitioners of the decorative arts as well.
Pinturicchio (c.1454–1513) was one of the greatest proponents of the style and his
influence was strongly felt in his native Siena, where in the first decade of the 16th
century he completed a major fresco cycle for the Piccolomini Library in the cath-
edral (c.1502–08). Pinturicchio surrounded his scenes of the life of Aeneas Silvius
Piccolomini with a panoply of grotesques and archaeologically-inspired architec-
tural ornament, although his interest in such decoration had begun almost two
decades earlier during his work at the Vatican for Pope Innocent VIII.[4] Maiolica
artists in Siena – some of whom executed tiles for the paving in the Piccolomini
Library itself – could hardly fail to have been affected by this monumental work.[5]

The variations within the group of albarelli suggest that there was more than
one distinct set of pots, and certainly more than one painter.[6] In addition to the
Clark pair, examples of the genre exist in the V&A, the Wallace Collection, the
Louvre, the museum at Faenza, and elsewhere.[7] The decorative repertory of the
jars is a rich one, including bands of knots, leaf-and-berry patterns, San Bernardino
rays, and grotesques with animals, masks, chimeras, bucrania, urns, trophies, putti,
cornucopias, and ornate foliage, many of which resemble those on the tiles from
the Petrucci Palace. And as in the Petrucci tiles, a wide range of colors – yellow,
blue, orange, green, and dark red – enliven the highly ornamental surfaces of these
albarelli even further. In addition, most of the group have labels, usually in Gothic
lettering, describing their contents, although the Clark pair are unmarked.

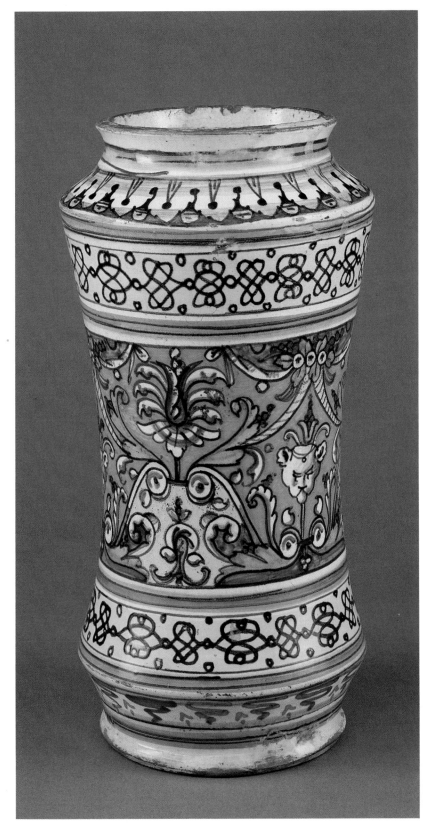

4 See J. Schulz, "Pinturicchio and the Revival of Antiquity," *Journal of the Warburg and Courtauld Institutes* 25 (1962), 35–55.

5 The taste for such ornament in Sienese maiolica may even have predated Pinturicchio's library; see two related albarelli in the V&A and the Cluny collection dated 1500 and 1501 respectively (Rackham, cat. 364, and Giacomotti, cat. 402).

6 Norman, 160.

7 See examples in the V&A (Rackham, cats. 366–367), the Cora Collection (Cora/Faenza, cat. 681), the Wallace Collection (Norman, cats. C77–78), the Louvre (Giacomotti, cat. 406–407), the Art Institute of Chicago (inv. 37.828 and 829), and an Italian private collection (ill. in Conti, fig. 148); others were formerly in the Pringsheim Collection (Pringsheim, figs. 89–93; cats. 92–93 are the most similar to the Clark pair and are of the same size; others in the group are in the 20 to 23.5 cm height range), the Beit Collection (Christie's, 24 October 1946, lots 26 and 27), and the Imbert Collection (now in the Musée Lyonnais des Arts Décoratifs; see Norman, 160–161). Cf. two others, slightly later and dated 1515, in the Metropolitan Museum of Art and formerly in the Imbert Collection (*Corpus I*, figs. 59 and 58); and related albarelli in the Bargello (Conti/*Bargello*, fig. 150) and the V&A (Rackham, cat. 371).

26. Plate with St. Lucy and grotesques

Tuscany, possibly Siena, second quarter of the 16th century

H 5.8 cm; D 38.3 cm; shape R8
Inv. 26.417
Provenance: Gavet (?); Clark
Bibliography: Corcoran/*Bulletin*, cat.
40

1 See cat. 25 for a discussion of the
 Petrucci Palace tiles.
2 Giacomotti, cat. 408 and Bruce Cole,
 *Italian Maiolica from Midwestern
 Collections* (exh. cat., Indiana Univers-
 ity Art Museum, Bloomington, 1977),
 cat. 32. The border of the Sèvres plate
 is also dominated by an intense yellow
 pigment.
3 Hall, 195.

This unusual plate is difficult to attribute to a specific maiolica workshop or center precisely because of its uniqueness, although it almost certainly belongs within the province of Tuscany. In general type, it can be allied with some of the earlier 16th-century Sienese products decorated with grotesques, such as the pair of albarelli (cats. 25 and 91), and thus with the Petrucci Palace tiles of c.1509.[1]

Other large-scale Sienese plates of c.1500–10 with related borders are in the museum at Sèvres and Indianapolis, although their central tondos bear little resemblance to the present example.[2] On the Clark plate, St. Lucy is depicted standing in a generalized landscape with her usual attributes of a dish containing two eyes and a short sword that probably represents the dagger with which she was eventually slain by her torturers. According to one version of the legend, the Early Christian martyr plucked out her eyes and sent them to her lover because of his obsession with their beauty. It was also said that the eyes and the lamp, another of her symbols, were both connected with the saint because of her name, Lucia, which signifies "light."[3]

The handling of the central figure is quite painterly in manner, unlike the precisely-drawn grotesques and folded ribbons of the border. It seems likely that the Clark plate was made some time in the second quarter of the century, looking back at Sienese and Faentine stylistic predecessors of the first decade.

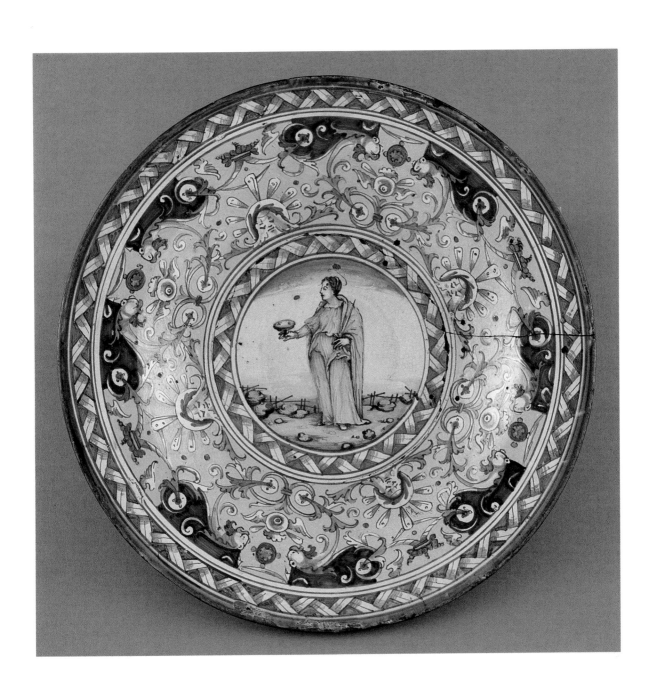

27. Votive plaque
Deruta, 1505

Inscribed on recto around rim:
"AVENDO IO IOBE DOE AMALATE
INCHAS A MERECOMANDAE
AQVISTA GLORIOSA VER MARIA
EFº SAO" (I, Job, having two sick
women in my house, entreat the glori-
ous Virgin Mary and her Holy Son)
at lower center: 1505; on verso:
"I DERVTA / G" (in Deruta)
H 1.8 cm; D 34.7 cm
Inv. 26.402
Provenance: Castellani; Gavet (?);
Clark
Bibliography: Castellani, cat. 207;
Fortnum, 231 and appendix p. 77,
mark no. 247; Corcoran/Erdberg,
72–73, fig. 8; Corcoran/*Bulletin*, cat. 50

1 Castellani, cat. 207.
2 Fortnum, 231.
3 Ibid., 229; a group of documents from
the Perugia archives pertaining to
Deruta were published in 1872 and
1874 by Professor Adamo Rossi, Count
Conestabile, and Charles Casati (see
Fortnum, 229–231). A fire in 1650 un-
fortunately destroyed Deruta's own
town archives (Join-Dieterle, 71).
4 Giacomotti (p. 130) commented on the
lack of signed Deruta pieces from the
early 16th century and noted that the
earliest known example was one in the
V&A (Rackham, cat. 430) dated 1515
(?) and carrying the inscription "fatto
in Diruta;" see also the panel with St.
Sebastian in the V&A attributed to
Deruta and dated 14 July 1501
(Rackham, cat. 437).
5 See 4 above; a piece in the Louvre dated
1544 uses the spelling "Deruta" (Giaco-
motti, cat. 917).
6 Fortnum, 226.
7 A round plaque attributed to Siena or
Deruta (dated 1521) is in the Wallace
Collection (Norman, cat. C79). An in-
teresting Deruta plaque dated 1576,
shows a man sitting up in bed giving
thanks to the Virgin and Child for cur-
ing him; an inscription reads "io pietro
esendo amalado ma bozie [sic] aquesta
madonna subito fu liberato."
(Sotheby's London, *Paintings and
Works of Art from the Collections of
the Late Lord Clark of Saltwood*,
1984, cat. 164).

This unique votive plaque is among the most important extant pieces for the docu-
mentation of the ceramic industry in early 16th-century Deruta. Once listed unac-
countably as "Castel Durante" in the Castellani catalogue,[1] its significance was
recognized by Fortnum who noted that it was "the earliest dated piece known to
us" from Deruta.[2]

Archival records document the manufacture of ceramics in the Umbrian center
as early as 1387.[3] A paucity of signed or inscribed pieces from the 15th and early
16th centuries, however, leaves a great lacuna in our knowledge of Deruta wares.[4]
The Clark plaque plays an important role in this regard. In figural style and color-
ation, it is unquestionably consistent with other early 16th-century Deruta pro-
ducts, and its inscription serves to confirm the connection to that fabric. The paint-
er carefully wrote out the message around the devotional scene and at the bottom
inserted the date, 1505. On the reverse are the words "I[N] DERVTA," and the let-
ter "G", probably the artist's own initial. Judging from surviving pieces, it was evi-
dently not the custom in Deruta to sign ceramics at this time, and why the painter
chose to do so remains a mystery. It may be that because this was a unique piece
commissioned by the patron for a specific occasion, the artist treated it as a true
document, adding the date, place, and signature of the maker.

The subject – a scene of a man and his family seeking assistance from the Virgin
for two sick women – is depicted clearly and simply, using bright pure colors and
eschewing all excess decoration except for the rosettes on the side of the bed. Even
without the inscription its intent would have been obvious, but the encircling
message makes this entreaty all the more specific and personal. It also reveals the
name of the individual – Iobe (Job) – seeking divine intervention.

On the reverse, the place of manufacture is given as "Deruta," although we
know of other inscriptions where it is spelled "Diruta."[5] Both were apparently
acceptable in this time of non-standardized spelling and even into the late 19th
century, when Fortnum used the form "Diruta" in his chapter on that center.[6]

Early Italian plaques of this sort are extremely rare and there appear to be no
contemporary parallels to the narrative depiction of a specific event, or to the
round format, pierced for hanging.[7] Other votive plaques or panels (sometimes
executed in relief) show subjects such as the Virgin and Child, the crucified Christ,
or saints and are obviously intended as more general devotional images.[8] Later in
the 16th and 17th centuries there was a great upsurge in the production of votive
plaques, especially those depicting the Virgin or the Virgin and Child.[9]

8 E.g. Giacomotti, cats. 156–157 (two
Faenza plaques with the Virgin and
Child, late 15th century); Giacomotti,
cat. 361 (panel with crucified Christ,
Florentine, Della Robbia atelier, first
half of the 16th century); Rackham,
cat. 437 (panel with St. Sebastian,
attrib. to Deruta, dated 1501).
9 See M. Cecchetti, *Targhe devozionali
dell'Emilia Romagna* (Faenza, 1984).

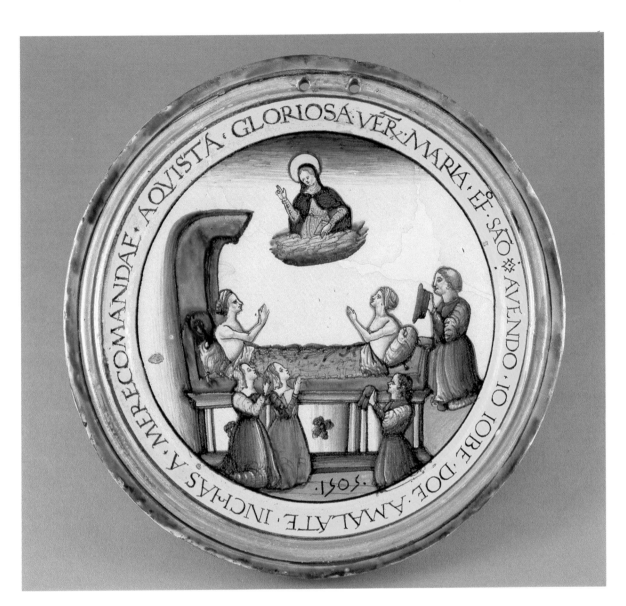

Reverse

28. Ewer basin with a coat of arms
Deruta, c.1500–10

Inscribed on recto, around boss:
"SOGIE TOVESERO PERFIHIVIVO
EPOLAMORTE" (I will be subject to
you as long as I live and even after
death); on verso: "L" (?)
Coat of arms: Azure, a fess or between
in chief three stars or and in base a
crescent argent (unidentified)
H 4.7 cm; D 34.0 cm; shape R4
Inv. 26.332
Provenance: Hainauer; Clark
Bibliography: Hainauer, 33, cat. 310
(M30); Corcoran/Erdberg, 72;
Corcoran/*Bulletin*, cat. 49.

1 Norbert Elias, *The History of Manners*
(New York, 1978), 69.
2 Ibid.
3 Erasmus of Rotterdam, *De civilitate
morum puerilium* (1530), cited in Elias,
op. cit., 90.
4 Ibid.
5 I am grateful to Valentino Pace and
Augusto Campana for assistance with
this translation.
6 Augusta Campana, verbal communi-
cation, 6/29/85; at least one of the ab-
breviation marks is also misplaced.
7 Cf. Norman, cat. C26; compare also
ewer basins in the Wallace Collection
(Norman, cat. C24; Deruta, c.1500,
inscr. "CB"), the Louvre (Giacomotti,
cats. 454–455; both Deruta, early 16th
c.), and the V&A (Rackham, cat. 391;
Deruta, c.1500).
8 Giacomotti, 130.

Renaissance table manners, eating customs, and general standards of etiquette were
quite different from those of today. It was only in the 16th century, for example,
that the fork came into use as an eating utensil, first in Italy, and later in France,
England, and Germany.[1] It was slow to be accepted, except as an instrument for
serving food from a common dish, and as late as the 17th century was still used
only by the upper classes, and made of luxury materials such as gold and silver.[2]

Normally, food was eaten with the hands, which resulted in the inevitable pro-
blem of how to maintain some semblance of cleanliness at the table. In his 1530
treatise on manners, Erasmus of Rotterdam was clear on this matter: "To lick
greasy fingers or to wipe them on your coat is impolite."[3] He and other writers of
etiquette books also noted the importance of washing one's hands before a meal:
"Usually the guest holds out his hands, and a page pours water over them. The
water is sometimes slightly scented with chamomile or rosemary."[4] A ewer basin,
such as this one in the Clark Collection, may have been intended for just such a
use.

Its inscription [5] and the presence of the *stemma* and dogs (traditional symbol of
faithfulness) indicate that this piece was probably made on the occasion of a be-
trothal or wedding. The manner in which the pledge is written also reveals some-
thing about the literacy level of the writer. Augusto Campana has suggested that
the spelling and grammar are those of a person who, while familiar with the al-
phabet, was probably functionally illiterate. Perhaps the painter of the basin, hav-
ing been given the sentence he was to write, reproduced it as best as he could, using
shortened forms for some words to fit the available space.[6]

Although we do not know the identity of this early 16th-century Deruta artisan,
he (like the maker of the votive plaque, cat. 27), marked the reverse with an initial,
"L" (?). Numerous comparative pieces can be noted including one in the Wallace
Collection with very similar leaf patterns and an "L" inscribed in a different style
on the reverse.[7] All display the clear, saturated colors and foliate motifs of the so-
called "Faentine transitional style"[8] which links Deruta with the more well-
established center of Faenza at this time. The distinctive leaf pattern filling the
spaces between the roundels on the present ewer basin continues to survive in the
decorative vocabulary and is found with great frequency on the borders of the later
piatti da pompa such as cats. 32 and 101.

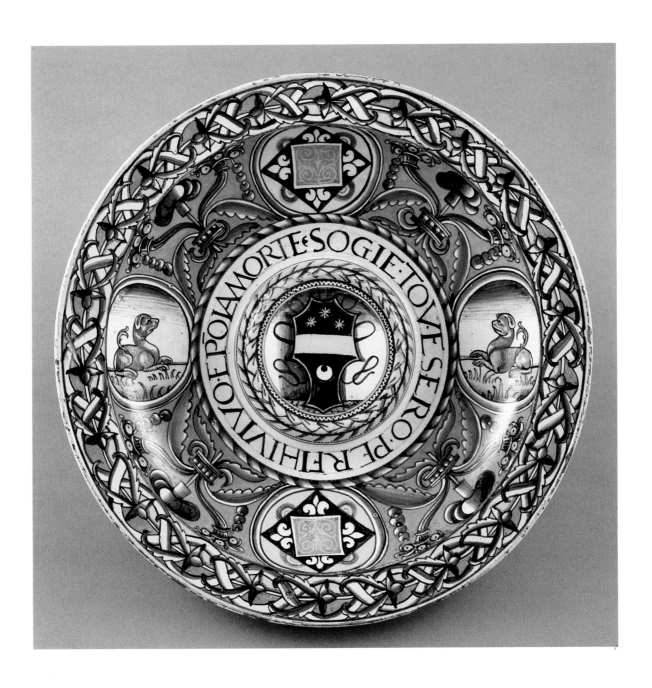

29. Tall drug jar with foliate and animal motifs and a coat of arms
Deruta, c.1500–10

Inscribed on band around center:
"A ROSATA" (rosewater)
Coat of arms: Azure, three spikes of
barley between two stars or, impaling
gules, a winged dragon, tail nowed,
vert
H 39.7 cm; D 25.2 cm
Inv. 26.383
Provenance: Hainauer; Clark
Bibliography: Hainauer, cat. 357 (M81);
Corcoran/Erdberg, 72;
Corcoran/*Bulletin*, cat. 47

1 Drey, 182–183.
2 Two in the Berlin Kunstgewerbe-
 museum (Hausmann, cats. 147–148);
 two formerly on the New York art
 market (Edward Lubin Galleries, ill. in
 The Connoisseur, December 1960, fig.
 84); one in the V&A (Rackham, cat.
 397); one in the Cora Collection
 (Cora/Faenza, cat. 737); and the Clark
 jar.
3 All are between 39 and 41 cm high.
 The measurements for the Lubin pieces
 are not known, although they appear in
 photographs to be of similar size and
 proportion.
4 Also typical of Deruta is the lead-
 glazed interior of this jar.

One of a set of tall jars made in Deruta in the early part of the 16th century, this one was meant to contain *aqua rosata*, a distillation of roses used primarily for perfume.[1] Known to have been popular in Greek and Roman times for both cosmetic and medicinal purposes, rosewater is still in use today.

Seven examples of this set, all of the same shape, are now known;[2] all are similar in size,[3] decoration, and type of inscription, and bear a coat of arms, the right half of which belongs to the Vandi family of Verona. The charge of the left side has yet to be identified, but must be that of a family with which the Vandi were allied through marriage. The heraldic-looking crowned eagle above the label does not appear on others of the set and seems to be purely ornamental in function.

Set off by expanses of brilliant white glaze, the bold and colorful decorative schemes are composed of wreath and candelabrum forms with leaves, fruit, dolphins, cornucopias, birds, and ribbons, in orange, blue, copper-green, purple, and yellow. On the reverse, trailing ribbons form geometric spirals with cursory flourishes, dots, triangles, and diamond-shapes sketched into the interstices. Some of the acanthus-like leaves, like the one below the label on the front of the present piece, are unambiguously Derutese and are found on other examples from that center in the Clark Collection (see cats. 28, 32 and 101).[4]

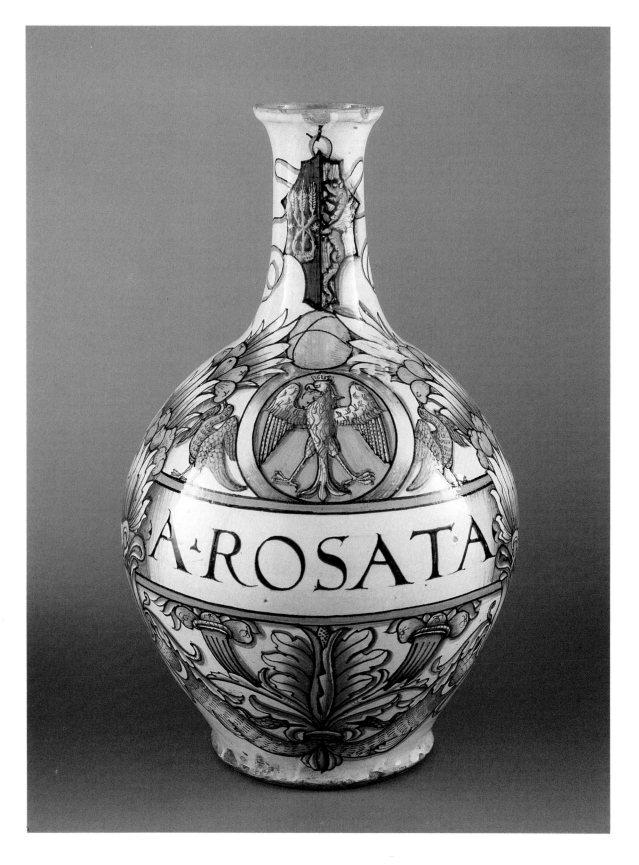

30. Spouted drug jar with typhon and trophy

Deruta, c.1507

Inscribed on band around center:
"SYR° DE REQ[?]VILITIO"
H 23.2 cm; D 17.8 cm
Inv. 26.319
Provenance: Hainauer; Clark
Bibliography: Hainauer, 109, cat. 297
(M17).

This spouted drug pot belongs to a group of related pharmacy vessels, some of which are inscribed with the date 1507 (e.g. cat. 94).[1] In addition to these two spouted jars, several albarelli in the Clark Collection can also be linked to the set.[2] Attributions to various centers have been suggested over the years, most favoring Siena or Deruta. If they do indeed belong to Deruta, as most current opinion would have it, these dated pieces would help to secure at least one stylistic current in the early 16th-century wares of that center.

Their imagery consists of fabulous creatures – typhons (snake-legged figures), sphinxes, and monsters, playful naked children, and genre scenes,[3] as well as other subjects, all encircled by wreaths of fruit and leaves with trailing ribbons; each main field is divided horizontally by a label describing the contents. The whimsical decoration of the present pot is painted with the almost pointillist technique of dots of one color applied atop another. This unusual method of enlivening the surface can be seen in other members of the group as well (e.g. cat. 97). Below the drug label here is an oval medallion with a pseudo-heraldic motif in the form of an ancient trophy of arms and armor.

As seems to be the rule with pharmacy jars, the ornamental scheme of the exterior bears no relationship to the compound contained within. This vessel, with its "rope-tied" spout and sturdy flat strap-handle, originally held a liquid confection or syrup, although the main ingredient has not yet been identified. Like some present-day pharmacies, Renaissance apothecaries were sources for sweets, as well as medicinal and cosmetic preparations.

Scratched into the clay beneath the foot of the jar are some as yet undeciphered marks that seem to occur exclusively on jars made for pharmacies in the late 15th and early 16th centuries.[4] It is interesting to note that somewhat similar engraved symbols have been found on ancient Greek vases, interpreted by some as indications of price. The true significance of the maiolica marks remains unclear, although Klesse has referred to them as "weight-marks,"[5] and Hausmann has proposed that they indicate the container's capacity in terms of either weight or volume.[6] Others have called them "shelf-marks," presumably meaning that they were used in some way by pharmacists of the time to organize their stock.

1 Among the group as assembled by Rackham (p. 139) and Rasmussen (pp. 134–136) are the following spouted jars: 1) V&A (Rackham, cat. 404); 2) Sèvres (Giacomotti, cat. 417); 3) Adda Collection (Adda, cat. 321, fig. 135 B); 4) Chompret Collection (Chompret I, pl. X); 5) two in the Pringsheim Collection (Pringsheim, cats. 103–104); 6) Boy Collection (catalogue of the Boy Collection, Paris, 1905, cat. 94, fig. 20); and 7) Hamburg (Rasmussen, cat. 100). The Sèvres and Pringsheim pieces are dated 1507. Related albarelli are: 1) Hermitage (Kube, cat. 33); 2) five in the Pringsheim Collection (Pringsheim, cats. 106–109 and 111); 3) V&A (Rackham, cat. 405); and 4) two in the Louvre (Giacomotti, cats. 414–415).

2 Cats. 94 (a spouted jar), and 95, 96, 97 and 31 (all albarelli).

3 A woman spinning appears on another Clark piece (cat. 95) and a youth grinding drugs is found on an albarello (Rackham, cat. 405).

4 Others in the Clark Collection with these marks are: albarelli cats. 95, 96, 84, 97 and 31; and spouted jars cats. 94 and 105.

5 Klesse, cat. 272.

6 Hausmann, 102. He also notes that such marks are "rare and are found exclusively on Tuscan apothecary jars," although if the Clark pieces and other related vessels are correctly attributed to Deruta, that would expand the boundaries of the practice to include Umbria.

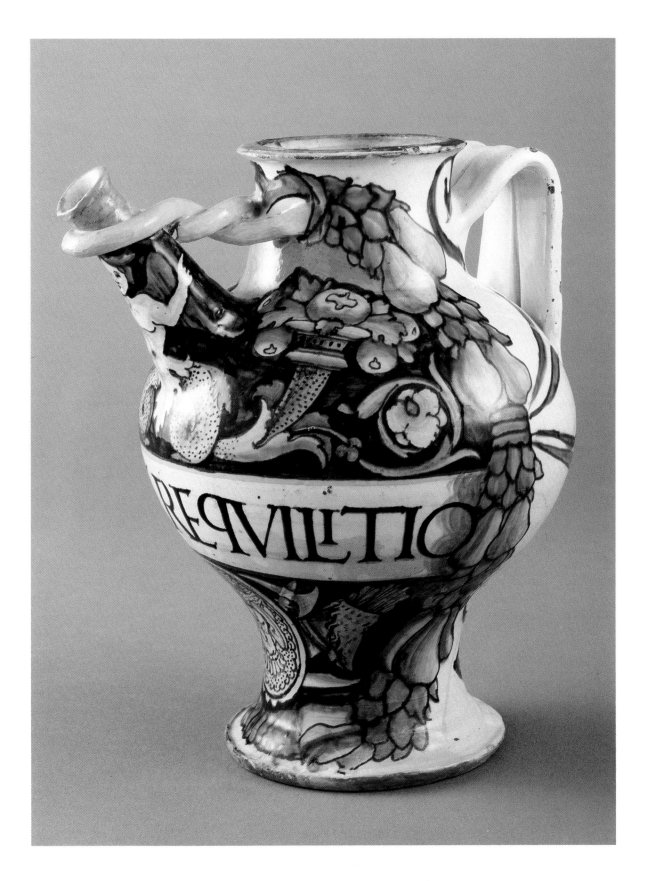

31. Albarello with nymph and satyr
Deruta, 1507

Inscribed on band around center: "ZVC°A BVGL°SA°" (candied confection of bugloss); on back: "1507"
H 23.1 cm; D 13.1 cm
Inv. 26.419
Provenance: Castellani; Gavet (?); Clark
Bibliography: Castellani, cat. 43

1 For reference to other jars in the group, see cat. 30, [1] and [3].
2 The closest comparisons to the present albarello are the Pringsheim albarello (Pringsheim, cat. 108) and a spouted jar in Hamburg (Rasmussen, cat. 100).
3 Drey, 31.
4 Drug jars with their original parchment in place can be found in the Museo Civico in S. Gimignano (ill. in Conti, fig. 121). A Hispano-Moresque albarello with parchment lid is included in a painting by Domenico del Ghirlandaio (ill. in Conti, fig. 72).
5 Drey, 190.
6 Jeanne D'Andrea, *Ancient Herbs* (Malibu, 1982), 38.

This drug jar is one of a large group of pharmacy vessels now thought to have been made in Deruta (see cat. 94 for another example).[1] Both Clark pieces are inscribed in a similar hand on the reverse with the date, 1507, which appears on others of the set as well. The decorative formula of the present albarello is consistent with the rest, and shows a nymph being chased by a satyr, and a lion attacking a horse, the two scenes divided by the horizontal drug label. A wreath of pears, leaves, and flowers encloses the main field.[2]

These may seem frivolous subjects for the pharmaceutical jars, but as Rudolf Drey has pointed out, hundreds of containers were needed for the conservation of the multitudinous compounds stocked by a conscientious apothecary and "a splendid array of drug jars was the ambition of any pharmacist" who had the necessary means.[3] In other areas and at other times, it was the custom to have sets of more uniformly ornamented vessels, but in early 16th-century Deruta, variety was clearly a desired trait. Perhaps the appeal of various designs such as a satyr pursuing a nymph actually helped to promote sales of particular substances.

Albarelli were normally used for dry or sticky substances, covered with a piece of parchment, and tied with a string below the lip.[4] The confection stored in this jar was *zucchero* (or *zuccaro*) *buglossato*. The latter term was applied to certain plants of the borage family.[5] Drugs made from them were thought to help reduce a fever, quiet a lunatic, and, added to wine, increase its exhilarating effect.[6]

Reverse

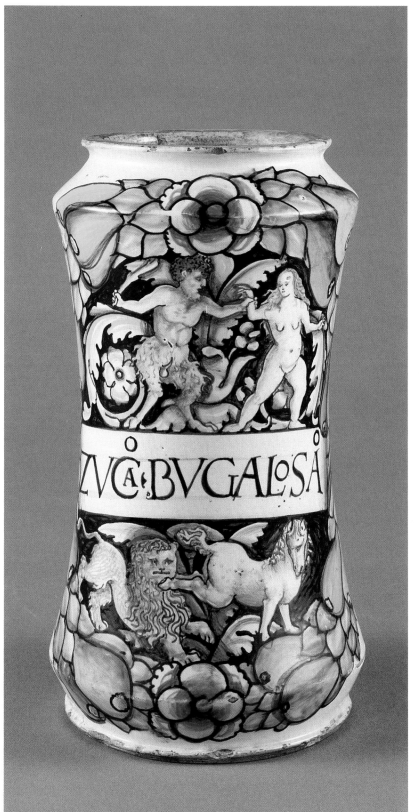

32. Dish with the Incarnation
Deruta, c.1520–25

H 9.1 cm; D 41.0 cm; shape R2
Inv. 26.336
Provenance: Hainauer; Clark
Bibliography: Hainauer, 36, 112, cat.
314 (M34); Corcoran/*Bulletin*, cat. 55.

1 Other common borders are composed entirely of scales (e.g. cat. 102), flowers and leaves, or ray patterns.
2 Similar plates were also produced in polychrome, without lustre (e.g. a smaller Clark plate, cat. 103), although in smaller quantities.
3 Note the lustred relief figure of St. Sebastian at the V&A (Rackham, cat. 437) which is dated 1501.
4 *Deruta*, 11.
5 The lectern on top of the cabinet at lower left is similar to one on a plate in the Louvre (Giacomotti, cat. 599).
6 A young woman with an accompanying motto appears on another Clark plate (cat. 102). Other popular subjects on Deruta *piatti da pompa* were saints (especially St. Francis, the most famous native of nearby Assisi), animals, heraldic motifs (cat. 101), and scenes illustrating fables, myths, or popular sayings (cat. 33).
7 Interestingly, Pinturicchio's wife was the daughter of a Deruta potter (see *Deruta*, 36). Caiger-Smith has recently gone so far as to state: "Most of the *bella donna* figures were almost certainly based on cartoons drawn from paintings by Pinturicchio." (Caiger-Smith/*Lustre*, 134).

The ceramics for which Deruta was best-known were the large *piatti da pompa*, or display plates, which began to be produced sometime in the first quarter of the 16th century. So popular were these plates that they virtually dominated Deruta's production until they finally fell out of favor after mid-century. The workshops of Deruta continued to follow this tradition even after the fashion for Urbino-influenced *istoriato* ceramics had captured the attention of painters and patrons everywhere in the 1520s.

This very beautiful example of the most common shape made by Deruta potters is typical of the elaborate products of that center. Its broad border, with a compartmentalized design of scales, leafy flowers, and radial bands of round fruits or buds, is a hallmark of the style.[1] Perhaps the most distinctive element of such plates, however, is the brassy yellow lustre that was fixed in a third firing atop the blue-painted designs.[2] It is not known how the lustre technique was brought to Deruta around 1500,[3] and the secret recipes for it were carefully guarded by potters. It is clear, however, that unless it was somehow developed independently, the knowledge must have come from Spain, where it was known from at least the 13th century and before that in Islamic lands.[4] Spanish lustre wares were much-admired in 15th-century Italy, and many were imported by Italian families, as we know from the coats of arms that frequently appear on them.

What is most unusual about this plate is its subject. The painter chose to depict the moment of the Incarnation of Christ, as Mary responds with a gesture of humility and modesty to the event marked by the appearance of the Holy Spirit in the form of a bird. In the background, an interior space is indicated by a column supporting an arcade, and a small cabinet, or lectern, whose open doors reveal a goblet and book.[5] The theme may be unique on lustred Deruta plates, which most often bear ideal portraits of women and helmeted men with mottoes or names inscribed on curling banderoles.[6] Like the Virgin here, the women depicted on these dishes show a keen resemblance to the pure, timeless faces favored by Pinturicchio, Perugino, and Raphael, whose works were undoubtedly familiar to the Deruta artisans of the time.[7]

Also somewhat unusual is the white tin-glazed reverse of the Clark plate, as Deruta craftsmen often conserved the *bianco* by covering the backs of large dishes with a yellowish lead glaze. Two holes pierce the footring, a standard practice which is testimony to the fact that these pieces were probably intended only for wall display, not utilitarian service. That being the case, it is curious that no Renaissance paintings have yet been found showing Deruta plates being used in this manner.

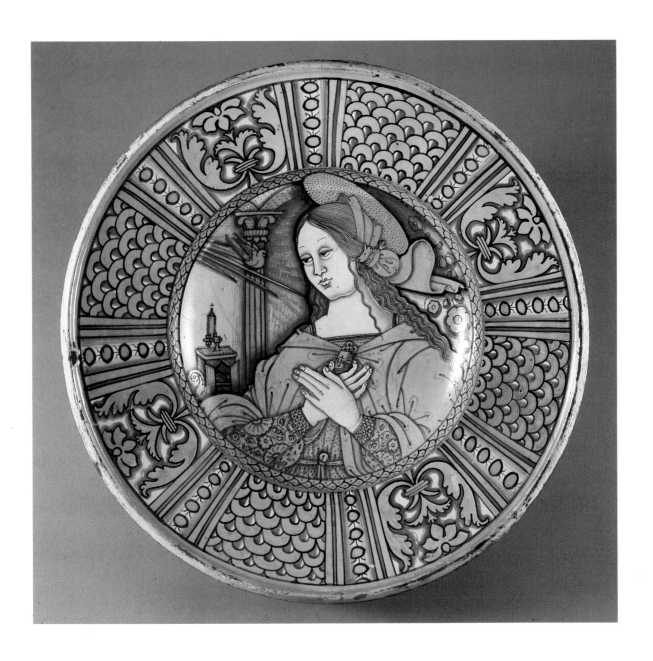

33. Dish with allegorical scene
Deruta, c.1520–25

Inscribed on recto on banderole:
"GVARD/ATE/GENTE/AHQVEE/
LMo[N]Do EVENV/TO CHELASI/No
SEVoLE/MAGNIARE E/LLVPo" (See,
people, to what the world has come
that the ass, if he wants to, can eat the
wolf)
H 9.8 cm; D 41.5 cm; shape R2
Inv. 26.380
Provenance: Hainauer; Clark
Bibliography: Hainauer, 36, 118, cat.
354 (M78); Corcoran/*Bulletin,* cat. 53

1 E.S. De Mauri, *Le maioliche di Deruta*
(Milano, 1924), 43–46.
2 This suggestion was made by Professor
Angelo Mazzocco, Mount Holyoke
College (verbal communication, May
1985).
3 *Deruta,* 28.
4 Ibid., 30. A large lustred plate with a
female portrait and a blank banderole,
now in the Los Angeles County
Museum of Art, may be a studio
sample (inv. 50.9.22). Pieces such as
this one may have been kept in a work-
shop as examples of plates that could
be ordered by clients, along with a list
of possible inscriptions that could be
written on them.
5 This proverb appears in various forms:
an example in the Cluny Collection
(Giacomotti, cat. 508) bears no inscrip-
tion at all, while one formerly in the
Pringsheim Collection (Pringsheim, fig.
129) reads ". . . si perderanno el
sapone" ("loses the soap").
6 Hall, 34.
7 Cf. Giacomotti, cats. 640–648.

Another large *piatto da pompa* of the same period as cat. 32 illustrates a saying that appears on a long twisted ribbon above the scene of an ass attacking a wolf. Popular adages or proverbs of this type show up frequently on the large Deruta plates of this style, sometimes with illustrative scenes like this one, or with por-traits of men or women. De Mauri pointed out that some of these "moralizing sen-tences" originated in the religious foundations of St. Francis of Assisi which had a profound influence on the provinces of Umbria and the Marche. Countless Deruta plates depicting the saint himself are testimony to his venerations in the area,[1] and were probably extremely popular as souvenirs for pilgrims to his nearby hilltown home.

The inscription on the Clark plate uses various abbreviations and vernacular forms of the language, perhaps indicating that both the maker and the client for whom it was intended were to be found among the middle classes.[2] Documents at-test to the fact that some Deruta ceramics were commonly sold at fairs and relig-ious festivals to people of ordinary means.[3] The larger, more elaborate display pieces, on the other hand, were probably acquired by a somewhat wealthier clientele, although it was still less expensive to purchase a plate of standard design – such as one of those with female portraits that were turned out more or less mechanically from existing workshop cartoons[4] – than a specially-commissioned work.

Less common than the portrait plates, or those representing St. Francis, are the ones that illustrate local proverbs or sayings. A number of examples are known which portray a satirical scene of a man and a donkey with the inscription: "He who washes the head of an ass wastes his effort."[5] The subject of the Clark plate, however, does not appear on any other known examples. Although its meaning is not entirely clear to us today, it must have been instantly recognizable to the people of its time. The wolf symbolized many things in the Renaissance, including guile and cleverness, as well as evil or heresy. The donkey, by contrast, has throughout history been a beast of burden with a reputation for stupidity and lazi-ness. It was also seen as a symbol of the lower classes.[6] The inscription here might thus be interpreted as a comment on contemporary societal changes, perhaps in-dicating that the world has arrived at a state in which the common people are striking back at the upper classes. The possibility should also not be excluded that it may refer allegorically to the unstable political situation in the period just prior to the disastrous Sack of Rome in 1527.

Stylistically, the Clark plate is a classic example of the conservative and almost archaizing Deruta wares around 1525. Its compartmentalized border, inscribed banderole, floral background ornaments, and patterned tile floor are all standard elements of the *piatti da pompa* for which this Umbrian center became best known. Every painter, of course, interpreted these basic motifs in his own manner; the acanthus leaves of the present piece bend inward, in contrast to the usual outward-springing ones, and enclose the central flower in a fashion that relates more closely to other Islamic-influenced Deruta wares with all-over arabesque patterns.

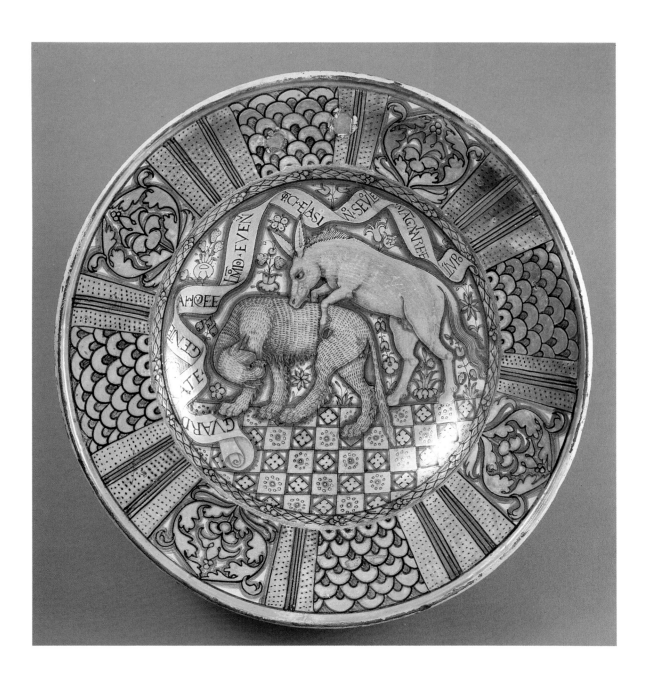

34. Molded dish with Judith and the head of Holofernes
Deruta, c.1525–30

H 6.4 cm; D 26.2 cm
Inv. 26.329
Provenance: Hainauer, Clark
Bibliography: Hainauer, 36, 111, cat.
307 (M27); Corcoran/*Bulletin*, cat. 57

1 In the V&A, three plates (Rackham, cats. 770–772, c.1525–1530) and a ewer basin (Rackham, cat. 489, c.1525); in the Lehman Collection, Metropolitan Museum of Art, a ewer basin, inv. 1975.1.1032 (George Szabo, *The Robert Lehman Collection: A Guide*, New York, 1975, 42, no. 162, c.1520); in the Hermitage, a ewer basin (Kube, cat. 42, c.1540); and in the Petit Palais, a ewer basin (Join-Dieterle, cat. 29, c.1540).

2 Cf. a Gubbio plate from the Galeazzi Collection, Terni, c.1540 (ill. in *Deruta*, fig. 58), and mold-made examples from Gubbio and Faenza of the second quarter of the 16th century in the Clark Collection (e.g. cats. 11, 12, 38, 73 and 107).

3 A coppa in Arezzo dated 1521 (*Corpus I*, no. 108, fig. 109).

4 A basin in the Louvre (Giacomotti, cat. 663).

5 Vannoccio Biringuccio, *De la pirotechnia* (1540; ed. Adriano Carugo, Milan, 1977), ch. 14, 145–146; Piccolpasso II, 42–46.

6 Such is the case with several dishes of the same size and subject – the *Adoration of the Shepherds* – in the collections of the V&A (Rackham, cat. 773, c.1530–35), the Museo Civico at Arezzo (*Corpus I*, no. 108, fig. 109, dated 1521), and Braunschweig (Lessmann, cat. 90, dated 1534), as well as one that was in the Berlin Schlossmuseum (now destroyed; *Corpus II*, no. 134, fig. 128, dated 1534). For others possibly belonging to the same group, see Lessmann, 138–139.

One of the very rare examples of lustred Deruta relief-ware is this footed dish showing Judith with the head of Holofernes, surrounded by a border of intertwined dragons, dolphins, putti, and candelabra. A few related pieces can be found in American and European museums,[1] all of them limited in palette, like the Clark piece, to the characteristic Deruta scheme of blue and white with golden lustre.

The great majority of Renaissance maiolica was fashioned on a potter's wheel, a relatively labor-intensive process. The alternative technique of using molds was also popular at various centers – Gubbio, Faenza, and others[2] – and was probably employed at Deruta from around 1520. Deruta plates have been documented with dates ranging from 1521[3] to at least 1546.[4] The use of plaster molds for the production of ceramic vessels was described at some length in the *Pirotechnia* of Vannoccio Biringuccio (1540) and by Piccolpasso,[5] who based many of his comments on that earlier treatise. One great advantage of molds, of course, is that they could be reused, and the possibility thus exists today of locating more than one work taken from the same form.[6]

Many of the molded pieces were no doubt intended to imitate the more costly *repoussé* plates in silver and gold that were painstakingly hammered by hand into the desired shape, often with complex designs. The application of a metallic lustre to the ceramic versions lends credence to this notion. A historical precedent for this practice exists in the ancient Greek and Roman vessels that were made in obvious emulation of more luxurious and expensive metal ones.

The story of Judith, taken from the *Apocrypha*, tells of the righteous widow who saved her town of Bethulia from Holofernes (Nebuchadnezzar's commander-in-chief) by gaining his trust and then beheading him after a great feast. Whether true or imaginary, the legend was a popular one – clearly intended for edification – in the Middle Ages and the Renaissance. It represents the notion of God's deliverance of his faithful and the punishment of their oppressors, as well as the idea of the triumph of the weak in a struggle against overwhelming odds.

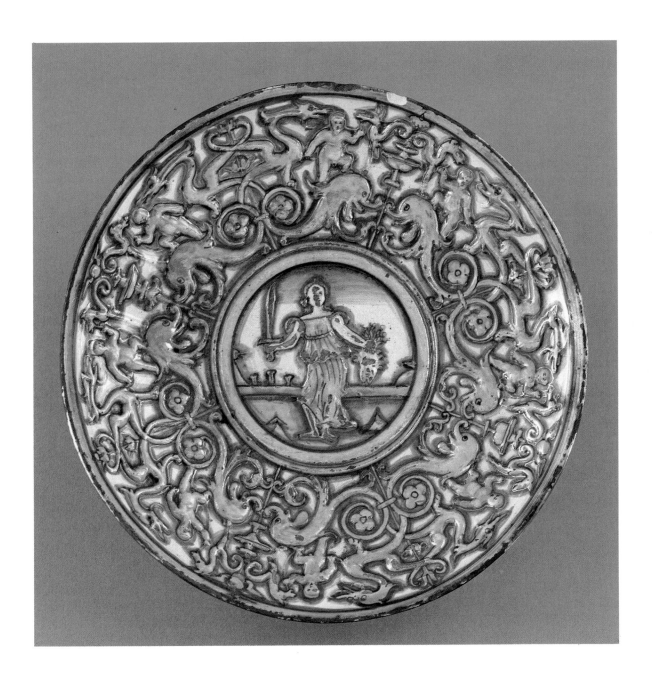

35. Dish with Salome presenting the head of St. John the Baptist to Herod and his court

Deruta, c.1540–45, Giacomo Mancini ("El Frate")

H 5.3 cm; D 25.3 cm; shape R14
Inv. 26.328
Provenance: Castellani; Hainauer; Clark
Bibliography: Castellani, cat. 113; Hainauer, 36, 111, cat. 306 (M26); Corcoran/Erdberg, 73, fig. 12; Corcoran/*Bulletin*, fig. 5, cat. 54; *Detroit*, 53 (ill.), cat. 103; Corcoran/Clark, 76, cat. 59

1 Giacomotti, 296.
2 "Filippo . . . is the son of Giacomo, called "il frate" [the brother], son in his turn of Mancino"; see G. Liverani, "Nota sui Mancini di Deruta a proposito di alcuni frammenti al Museo di Faenza," *Faenza* XVII (1929), 14–18.
3 Ibid., 15.
4 *Deruta*, 64, n. 14, and Join-Dieterle, 106.
5 In addition to the attributed Clark piece; Join-Dieterle, 106.
6 Ibid.
7 Two Heritage plates (Kube, cats. 49 and 50) are copied from engravings by Marcantonio Raimondi after Raphael; the Petit Palais basin (Join-Dieterle, cat. 28) is taken from a Caraglio print after Raphael. Mancini's plates with scenes from *Orlando Furioso* are derived from the woodcuts of a 1543 Venetian edition of Ariosto's work (see Giacomotti, 299–300).
8 Cf. Giacomotti, cats. 916–917 (1542 and 1544); note also the particular way in which the lustre is applied along the fold-lines on El Frate's works.
9 Cf. a nearly identical floor in the plate with Alexander and Roxanne in the Petit Palais (Join-Dieterle, cat. 28); the patterned floor does not exist in the print from which the design was copied (see 7 above), and was obviously the maiolica painter's own invention.
10 The Alexander and Roxanne piece is the only other one that shows an interior space.
11 Surpassed only by the Hermitage plate with two sibyls, after Raphael (Kube, cat. 50).
12 The Hainauer catalogue description reads: "Herodias with the Head of John the Baptist," although there is no reason to identify the female figure as Herodias instead of her daughter Salome.

Despite the entrenched conservatism of the Deruta ceramic workshops, the diffusion of the *istoriato* style finally came to affect even the formulaic products of this Umbrian center; the fashion for *piatti da pompa* with standard imagery (see cat. 33), eventually died out around the middle of the 16th century. Giacomotti has suggested that the new interest of Deruta painters in wares with complex iconographical themes came about as a result of their geographical proximity to Urbino, the center of the phenomenon; in addition, the artisans of Deruta had at times been called upon to apply their metallic lustres to *istoriato* pieces made by Urbino masters.[1]

The most prominent of Deruta's *istoriato* painters was a man who sometimes signed his works "El Frate." His true identity was discovered by Giuseppe Liverani who found documents of 1578 in the Museo Civico of Deruta referring to the son of this painter: "Filippo è figlio di Giacomo detto il "frate" figlio a sua volta del Mancino."[2] Other documents show that members of the family continued in the ceramic business into the 17th century.[3]

The working career of El Frate is thought to have extended from around 1540 to the 1560s, his earliest dated piece being a 1541 plate with a scene from Ovid's *Metamorphoses*.[4] Join-Dieterle has counted ten signed pieces by the artist, all dated between 1541 and 1545, as well as twelve others that can be attributed to him from the same short period.[5] In addition, she noted that two tile pavements may have been executed under his direction two decades later: one in the church of S. Pietro in Perugia (1562–63) and the other in the Baglioni Chapel at Santa Maria Maggiore in Spello (1566).[6]

Giacomo Mancini was obviously strongly influenced by trends in Urbino *istoriato* wares, as one can see from the subjects he chose – several are taken from Ariosto's *Orlando Furioso*, Ovid's *Metamorphoses*, and the life of Scipio – and his use of prints as models, including at least three after Raphael.[7] He also painted polychrome plates similar to those of Faenza and Urbino, as well as ones limited to blue and white with gold lustre like the Clark dish. In contrast to traditional practices in Deruta, he often inscribed, dated, or signed his products in the manner of Urbino craftsmen like Xanto. For all this outside influence, however, "El Frate" retained a style that was classically Derutese. His stylized, almost naive mode of depicting figures, drapery,[8] and landscape follow the pattern of earlier Deruta artists (cf. cat. 32). Also typical of his compositions is an awkwardness of spatial conception and perspective, typified by the tipped-up tile floor of the present piece.[9]

Some aspects of the Clark plate, however, set it apart from many of the others: the depiction of an interior scene rather than one outdoors,[10] the relative simplicity of the composition,[11] and the choice of the biblical story of Salome (Mark 6:17–28). The particular episode shown on the Clark plate – Salome presenting the head of the Baptist to Herod Antipas[12] – is rather rare in the 16th century, both in maiolica and in painting, although other aspects of the story sometimes appear, such as the dance of Salome or the simple image of the severed head of the Baptist.

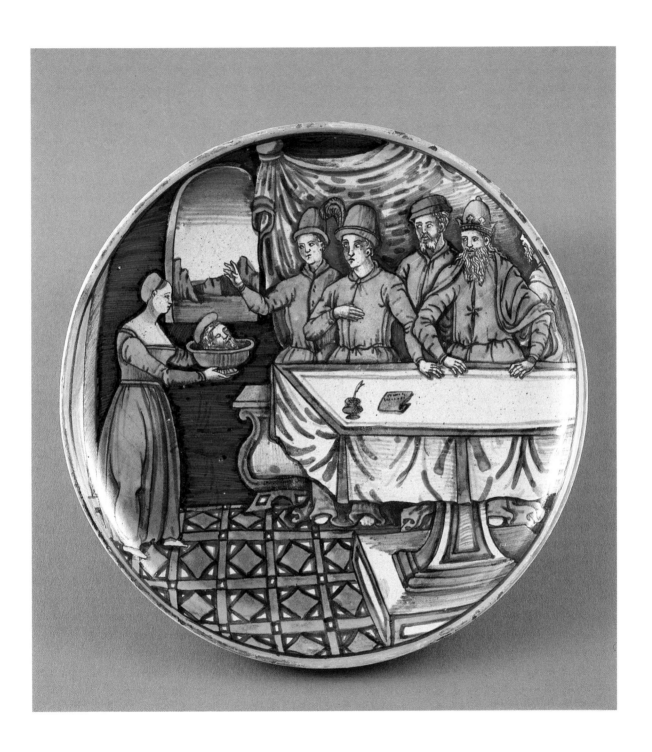

36. Plate with the arms of the Saracinelli
Gubbio, c.1525–30

Inscribed on verso: emblem with the letter "S"
Coat of arms: Party per fess: in chief, azure, a crescent argent, in base, argent, a moor's head sable; over the division a fess vert
H 4.0 cm; D 24.3 cm; shape R10
Inv. 26.343
Provenance: Hainauer; Clark
Bibliography: Hainauer, 113, cat. 321 (M41); Corcoran/*Bulletin*, cat. 66; Corcoran/Clark, 75, fig. 58.

1 Fortnum, 157.
2 Giacomotti, 208.
3 Ibid., 209 (Bibl. nat., *Ms. ital.* 361, fo 393); see also Cartari-Febei, busta 166, 37v.
4 One in the National Gallery of Art, Widener Collection (ill. in D. Shinn, *Sixteenth-Century Italian Maiolica*, exh. cat., Washington, D.C., 1982, cat. 33); two in the Louvre (Giacomotti, cats. 673 and 674; another is on deposit at the Palais des Arts de Lyon).
5 See Giacomotti, cat. 671, and Rackham, cat. 692.
6 In the wax-resist method, liquid wax was painted on the tin-glazed surface before the blue pigment was applied; it would melt during the firing, leaving a blank white design that could later be painted in with lustre. The *a sgraffio* technique may have been used here for the narrower lines and flourishes of the pattern; these would have been scratched through the blue pigment after it was applied, to reveal the white tin-glaze below, and later highlighted in lustre (see Norman, 144, for reference to these techniques).
7 Piccolpasso II, 86–87.
8 Giacomotti, 207.
9 Piccolpasso II, xii, n. 6.
10 Piccolpasso II, 86; Piccolpasso wrote "this I have seen at Gubbio in the house of Maestro Cencio of that place . . ."
11 Giacomotti refers to this mark as that of Salimbene Andreoli (p. 209). A different mark, also with an "S", can be found on other Gubbio pieces, usually accompanied by the initials of Maestro Giorgio and a date (see Fortnum, appendix nos. 94 and 95).

The small medieval hilltown of Gubbio, located halfway between Urbino and Deruta, gained great prominence in the early 16th century for its maiolica craftsmanship. Its artisans were renowned for their expertise in applying gold and ruby metallic lustres, especially to the wares of other centers such as Castel Durante and Urbino (see cat. 43). Documents prove, however, that ceramics were also manufactured in this center from the 14th century on,[1] and the present plate was probably both made and lustred at Gubbio. Its decoration has been linked stylistically with contemporary products of Faenza, perhaps as a result of the influx of Faentine artisans to Gubbio ateliers in the first quarter of the century.[2]

Prominently displayed in the deep central well of this dish is a coat of arms that has recently been identified as belonging to the Saracinelli family of Orvieto,[3] and five pieces of what was evidently a matching service survive today.[4] The *stemma* is repeated in the center of each, although the borders vary – as is also the case with a similar set made in Gubbio around the same time for the Vitelli family.[5] The Clark dish and the Saracinelli plate in the Louvre have identical borders, probably drawn using a common stencil. The blue pigment on the flat edge was probably applied while the piece revolved on a wheel, as is suggested by the continuous circular strokes, and the palmette design seems to have been made by employing both wax-resist and *a sgraffio* methods; the resulting blank areas would have been painted in with lustre afterwards.[6] Piccolpasso described this technique in his treatise:

"They leave the places where it [the lustre] is to be put on without laying any sort of colour on them; that is to say, taking an example, an Arabesque of this sort or else a Grotesque will be executed on a plate, and the leaves that would be done in green are left blank, only the outlines are drawn. The wares are then fired to a finished state like other wares, and after firing these blanks are filled with maiolica . . ."[7]

It is interesting to note that for Piccolpasso, the term "maiolica" was applied exclusively to the lustre medium. While its popularity lasted, however, its chief proponent was Giorgio Andreoli (1456–1533), who settled in Gubbio in 1498 with his two brothers, Salimbene and Giovanni.[8] So great was his talent as a ceramic artist that he was formally given the title *maestro* and was granted special privileges and tax exemptions by the Duke of Urbino in 1498 and again by Pope Leo X twenty years later, "in consideration of the honour which redounds to the city, and to his overlords, and to the community, from the popularity of these wares in whatever land they are taken, and in consideration of their great profitableness and revenue."[9]

The Saracinelli plates, notable for their fine execution and brilliant palette, are certainly products of a superior workshop, and their reverses bear the lustred marks usually associated with the Andreoli. Both of Maestro Giorgio's brothers were involved in the manufacture of ceramics at Gubbio as well as his sons Ubaldo and Vincenzo; Maestro Cencio, as Vincenzo was known, was in fact the person who demonstrated the technique of lustre, or "golden maiolica," to Piccolpasso.[10] The symbol with the letter "S" on the reverse of these plates has been interpreted by some scholars as the mark of Salimbene Andreoli, although there is no concrete proof for that conclusion.[11]

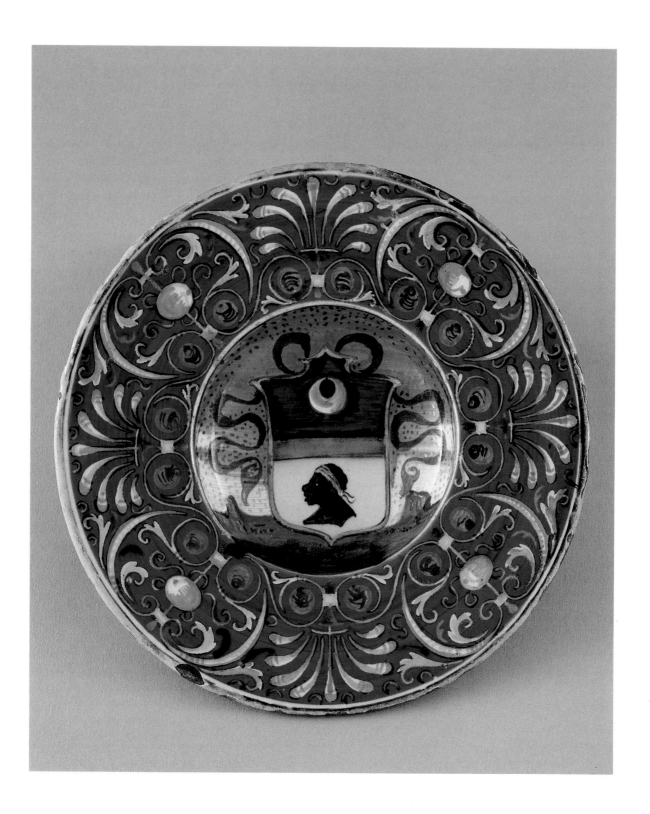

37. Plate with three satyrs
Gubbio, c.1525

H 2.2 cm; D 19.1 cm; shape L9
Inv. 26.330
Provenance: Hainauer; Clark
Bibliography: Hainauer, 36, 111, cat.
308 (M28); Corcoran/Erdberg, 73, fig.
11; Corcoran/*Bulletin*, cat. 63

1 Rackham, cat. 437.
2 Join-Dieterle, cat. 54. For a discussion
 of Maestro Giorgio as a painter of
 istoriato wares, see pp. 166–168 of that
 catalogue.
3 One in the British Museum, inv. 51,
 12–1.11 (*Corpus I*, fig. 161); and two in
 the V&A (Rackham, cats. 678–679);
 the subjects are, respectively, two
 satyrs and a woman, marine deities,
 and a scene from an unidentified con-
 temporary romance.
4 Fortnum, appendix, no. 94. Fortnum
 notes that this symbol appears also on
 the faces of two pieces, not in the con-
 text of a "Giorgio" monogram, and
 that it is seen on some Perugian coins
 as well.
5 *Corpus I*, figs. 259, 260 and 262.

The knowledge of the lustre technique was known at both Deruta and Gubbio from the beginning of the 16th century, probably first at Deruta. A relief plaque of St. Sebastian in London is inscribed with the precise date – 14 July 1501 – and is the earliest known lustred piece attributed to that center.[1] By the end of the first quarter of the century, however, Gubbio had become the lustre capital of Italy, probably because of Giorgio Andreoli's technological advances. Lustre was often applied there to plates with symmetrically patterned schemes like cat. 36 and to re-lief wares like cat. 38, but it was most often used to augment the decoration of polychrome plates that had been made and painted elsewhere. This was a routine practice with wares from Urbino and other centers, as the many examples of lustred *istoriati* with Xanto's signature attest. There is also a significant group of *istoriato* pieces that appear to have been both made and lustred at Gubbio, like the present deep-welled dish.

It has been thought that Maestro Giorgio may himself have been a talented painter of narrative and figural wares, as well as an expert and enterprising busi-nessman in charge of an active atelier, although there is no proof of this hypoth-esis. A fine plate in the Dutuit Collection showing the *Judgement of Paris*[2] bears on its reverse amidst lustre foliage, the mark of Maestro Giorgio "i ugubio" (in Gub-bio) with the date, 2 October 1520, all in blue pigment. The use of blue pigment instead of lustre for this inscription shows that it must have been done at the same time as the decoration on the front of the plate, and therefore prior to the main fir-ing (and *not* at the time of the third firing which was required for the lustre layer). This fact almost surely confirms the place of the plate's manufacture as Gubbio. Whether the inscription can be interpreted as the master's actual signature, or simply as the mark of his shop, remains to be seen. It seems clear, in any case, that *istoriato* wares were made as well as lustred by Gubbio masters and they were cer-tainly familiar with the style through contact with narratives pieces from Urbino and elsewhere.

The Clark plate can be compared stylistically with three other pieces of similar size and shape which must be by the same painter and are marked on the reverse in lustre "M° G° [Maestro Giorgio] 1525."[3] The British Museum dish with a woman and two satyrs is most like the present one, and has on its verso one of the am-biguous symbols with the letter "S".[4] The rhythmic spiral decoration on the back of the Clark piece is related to patterns on three pieces from the Berlin Schloss-museum which have Maestro Giorgio's traditional inscription along with the date 1519.[5]

Maiolica artists were keenly interested in themes and characters derived from classical sources, as is exemplified by this painter's choice of goat-legged satyrs as the main characters here. These spirited mythical creatures were favorite subjects for wall-paintings, vases, and sculptures in antiquity and regained their popularity in the Renaissance due to the renewed interest of Italian humanists in pagan class-ical themes. Satyrs and bacchic revels were often depicted by printmakers of the late 15th and 16th centuries like Zoan Andrea, Nicoletto da Modena, and Albrecht Dürer, although no print has yet been identified as the source for the present design.

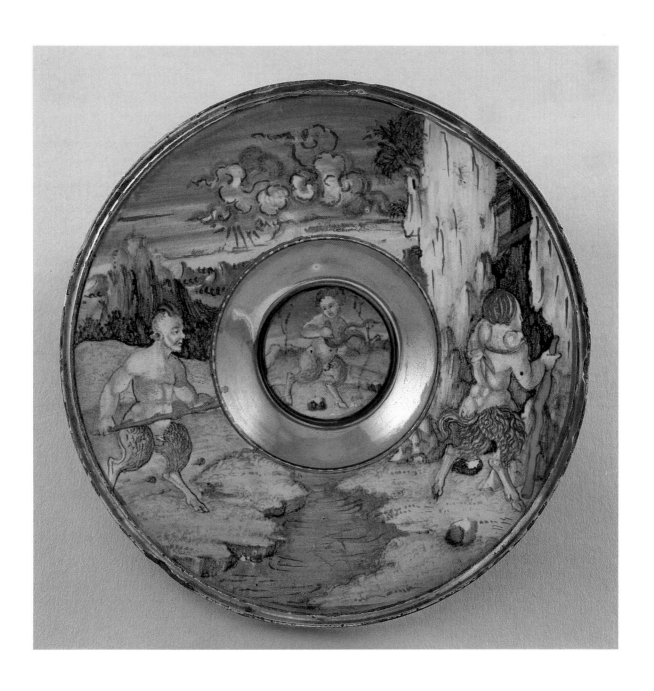

38. Molded dish with seraph
Gubbio, c.1530–50

H 6.1 cm; D 24.8 cm
Inv. 26.313
Provenance: Hainauer; Clark
Bibliography: Hainauer, 36, 108, cat.
291 (MII); Corcoran/*Bulletin*, cat. 64

1 Piccolpasso I, folio 47r.
2 The limitations of the mold technique itself naturally conditioned the types of images that could be used.
3 Giacomotti notes several pieces (cats. 708–712) marked with an N, which she associates possibly with Maestro Cencio, a son of Maestro Giorgio; cat. 713 has a P in the center which she attributes to Maestro Prestino, who ran a workshop in the 1530s. The very few dated pieces of this type of ware include a dish in the British Museum (*Corpus I*, fig. 232; dated 1530) and one in Pavia (*Corpus II*, fig. 25; dated 1531).
4 Ill. in *Deruta*, fig. 47.

Large quantities of molded lustre wares were turned out by Gubbio workshops in the second quarter of the 16th century, although most of them tend to be less interesting and of lower quality than the finer *istoriato* or patterned-border types of the same period (e.g. cats. 36 and 37). Gubbio's molded relief-wares, like those of Deruta (e.g. cat. 34), were probably intended to imitate contemporary metal vessels, their modeled surfaces exploiting the reflective qualities of the red and gold lustres to the fullest extent. "*Rosso da maiolica*"[1] or ruby lustre derived from copper, was known at both Deruta and Gubbio, but it was Maestro Giorgio who developed the more intense version of the red metallic tone for which his workshop became famous.

In general, the subjects of these works are quite limited, usually being simple religious or allegorical images such as saints (e.g. cat. 107), the lamb or monogram of Christ, images of clasped hands or a pierced heart, or winged seraphs, as in this example.[2] Their borders also follow standard patterns of high-relief oak leaves, pinecones, gadroons, and other similar rounded shapes. They were rarely dated, though they are often marked on the reverse with cursorily applied lustre spirals, sometimes with a maker's initial.[3] As with all mold-made pieces, they could be produced quickly and economically in large volume, and may have been intended for a less wealthy or less particular clientele than those who desired more original classical or mythological subjects.

Many works of this genre have survived and can be found today in the collections of the Hermitage, the Louvre, the museum at Sèvres, the Cluny Collection, and the Victoria and Albert, to name a few. The closest comparison to the Clark dish is a slightly smaller example in the museum at Faenza, which uses the same palette of blue on white with added red and gold lustres; instead of an oak-leaf border, however, it has a band of crosshatched pinecones around the central high-relief seraph.[4]

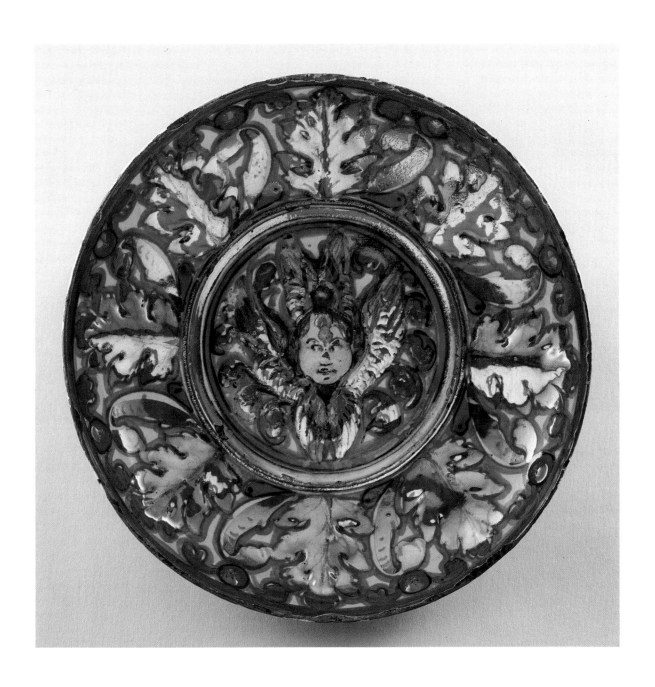

39. Plate with a portrait of a woman (Camilla)
Gubbio, 1541

Inscribed on recto, on banderole: "1541 / CAMIL/LA B" ("Beautiful Camilla")
H 5.8 cm; D 35.3 cm; shape L24
Inv. 26.312
Provenance: Castellani; Hainauer; Clark
Bibliography: Castellani, cat. 87 (ill.); Hainauer, 36, 108, cat. 290 (M10); Corcoran/*Bulletin*, cat. 67

1 Giacomotti, 243.
2 Join-Dieterle, 160.
3 Cleopatra appears on a plate in the Wallace Collection (Norman, cat. c21), and Mary Magdalen on a plate in a Florentine private collection (ill. in Conti, fig. 242). See Hausmann, 239–240, for a list of such figures and a discussion of their use on Castel Durante *coppe*.
4 Giacomotti, 243.
5 See cat. 36⁵ for a description of the wax-resist and incision techniques which were used to obtain such effects on Gubbio plates; a border very similar to the one here can be found on a plate in the Louvre (Giacomotti, cat. 678).
6 Guidotti/*Bologna*, cat. 90.
7 See the plate in Sèvres dated 1535, for example (Giacomotti, cat. 802).

Although this plate was probably both made and lustred at Gubbio, it is based on a type that originated in the town of Castel Durante, less than forty kilometers away. Usually taking the form of shallow footed dishes, the Durantine wares after which the Clark plate was styled were known as *coppe amatorie* (love cups), or *bella donna* dishes, normally showing bust-length portraits of women accompanied by their names and the adjective "bella" (beautiful). Perhaps intended as betrothal or wedding gifts, these dishes were made in substantial quantities in Castel Durante, although they were also turned out by Faentine and Urbino workshops as well.[1] The Deruta *piatti da pompa*, while dissimilar in style, are related in type and function.

The maiolica painters of Castel Durante began to produce *bella donna* plates around 1525, and the popularity of the style apparently lasted for at least fifteen years although very few of the works are actually dated. Von Falke attributed many of them to Nicolò da Urbino (formerly known as Pellipario), a suggestion that has been cast in doubt by recent research showing that Nicolò was not a Castel Durante native and may never have worked there.[2]

In addition to the beautiful women who adorned these plates, historical, literary, and religious figures such as Cleopatra and Mary Magdalen were also chosen as subjects.[3] Giacomotti has divided the idealized female portraits into four distinct categories: those with elaborate patterned damask turbans; those with coiffures including a braid across the top of the head and a small round cap at the back (like the present example); those without headwear, but with beribboned chignon hairstyles; and the latest group, in which the top of the head is cropped by the edge of the dish and the inscription is written directly on the plate, instead of on a twisting banderole as in the first three groups.[4]

The present plate varies significantly from the standard Castel Durante type in its elaborate border, which is stylistically similar but technically inferior to another Clark piece from Gubbio (cat. 36). The complex pattern of the rim was probably in this case executed by cutting or scraping through the blue glaze to reveal the light ground below, and the reserved areas lustred afterwards.[5] Durantine artists were known to have occasionally used ornamental borders in combination with female portraits, as can be seen from the example of a blue and white plate in Bologna with *grottesche* surrounding the central tondo.[6]

Set against the golden-lustred background in the well of the Clark plate is a bust portrait of a woman in front of a curving ribbon that is inscribed: "1541 Camilla B[ella]." The figure is clearly derived from the Castel Durante type, but varies enough to suggest that she was drawn by a Gubbio artist imitating the models emanating from that nearby center. The stylized and somewhat abstract drawing of the figure is not inconsistent with Durantine products which themselves varied widely in quality.[7] All the usual conventions are followed, including the braided hairstyle with a single cascading tendril and the neat brocade cap that sits on the back of the woman's head. Since *coppe amatorie* were quite frequently sent to Gubbio for applications of its famous lustre, it would not be unusual for a painter there to combine familiar motifs with those of the imported wares to produce an interesting hybrid.

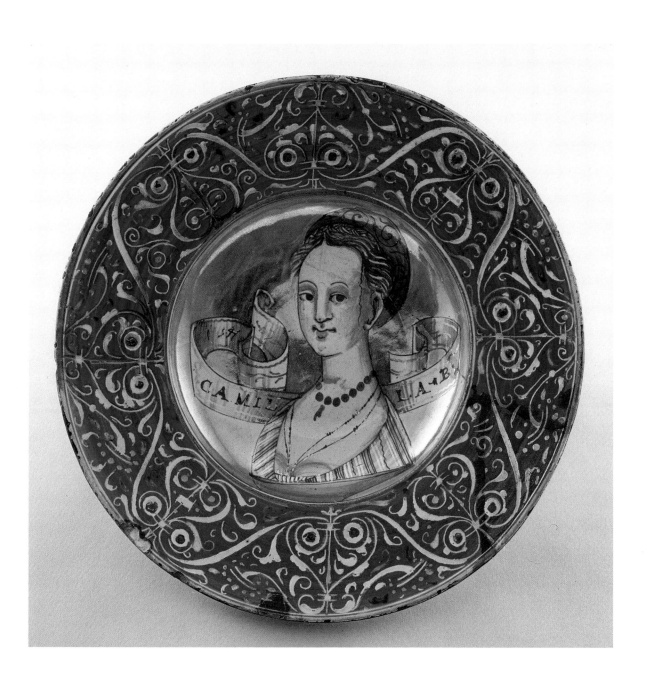

40. Vase with the arms of Guidobaldo I Montefeltro and Judith with the head of Holofernes

Castel Durànte or Urbino, probably before 1508

Coat of arms: Quarterly: 1 & 4, or, an eagle displayed sable crowned or; 2 & 3, bendy of six azure and or, in the fourth bend in the second quarter and the second bend in the third quarter an eagle displayed sable; overall on a pale gules the papal tiara and crossed keys. The painter has represented sable (black) by dark blue.

H 23.5 cm; D 26.4 cm
Inv. 26.327
Provenance: Hainauer; Clark
Bibliography: Hainauer, 36 (ill.), 111, cat. 305 (M25); Corcoran/*Bulletin*, cat. 72; *Detroit*, 60 (ill.), cat. 119

1 For the V&A piece, see Rackham (cats. 207 and 206, the companion); Pesaro (Della Chiara, cat. 170). Another Deruta plate in Sèvres (Giacomotti, cat. 526) has the same arms with slight variations and probably belongs to the same period. A flask with the same arms, dated 1552, which was sold at Sotheby's (24 June 1964, lot 39) is no longer thought to be authentic. I am grateful to Timothy Wilson for this information.
2 Rackham, 66.
3 Ibid; see also F.V. Lombardi, "Note storico-araldiche sugli stemmi di Federico da Montefeltro nella valle del Marecchia," *Studi Montefeltrani*, 5, (1977/78), 109.
4 A.M. Hind, *Early Italian Engravings*, vol. II (London, 1938), pl. 132, 133b. These prints, however, show the headless body of Holofernes in the background behind Judith.
5 It is not actually clear from the inscriptions whether Giovanni Maria (or "Zoan Maria," as he was called) was both a potter and a painter or simply a potter who headed a workshop but did not himself paint; see B. Rackham, "European Ceramic Art, Review of W.B. Honey's European Ceramic Art," *BM* XCV (1953), 394.
6 See Rackham, cats. 535–537.

A readily identifiable coat of arms appears on this large jar made in the Duchy of Urbino – that of Duke Guidobaldo I who ruled Urbino from 1482 to 1508. His *stemma* appears on other pieces of maiolica, including another jar of the same size and shape at the Victoria and Albert Museum, and a large Deruta plate with a female portrait and the inscription "Viva Viva E Ducha D'Urbino" in the museum at Pesaro.[1] In the Clark vase the coat of arms has been augmented with a central band displaying the crossed keys and tiara of the Pope – the insignia of a gonfalonier of the Holy Roman Church, an office granted to Guidobaldo in 1502.[2] Although the same honor was granted to Guidobaldo's father Federico in 1474, the style of this vase precludes the possibility that the arms refer to the earlier duke,[3] and the date of its manufacture can probably be fixed at some time before Guidobaldo's death in 1508.

The other side of the vase shows Judith with the severed head of Holofernes. In this depiction, the painter has shown the heroine in modern dress, standing alone in the landscape outside the city walls of Bethulia with the head of Holofernes in one hand and his sword in the other. She looks demurely away to one side and seems a perfect representative of the weak conquering the strong. The subject of Judith was relatively uncommon in Renaissance painting and printmaking; when it does appear, it is normally done with a sense of propriety and restraint. Although a definite source has yet to be found for the figure of Judith on this jar, it does bear some resemblance to two anonymous Florentine prints, both in round format, from around 1465–80.[4]

The attribution of the vase to the Duchy of Urbino is suggested both by its coat of arms and its style. The putti and trophies of the two minor faces recall works signed by Giovanni Maria, who was working in Castel Durànte at the time the Clark jar was made.[5] It might therefore be suggested that the present piece was painted in that center as well, although by a somewhat less accomplished hand. The figures of the putti and some of the decorative details such as the garlands of colored spheres and trophies are related to a number of pieces at the Victoria and Albert Museum which are attributed to Castel Durànte as well.[6]

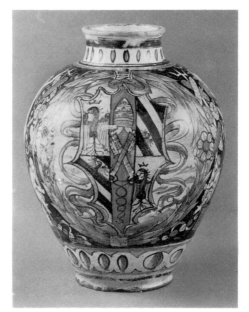

Reverse

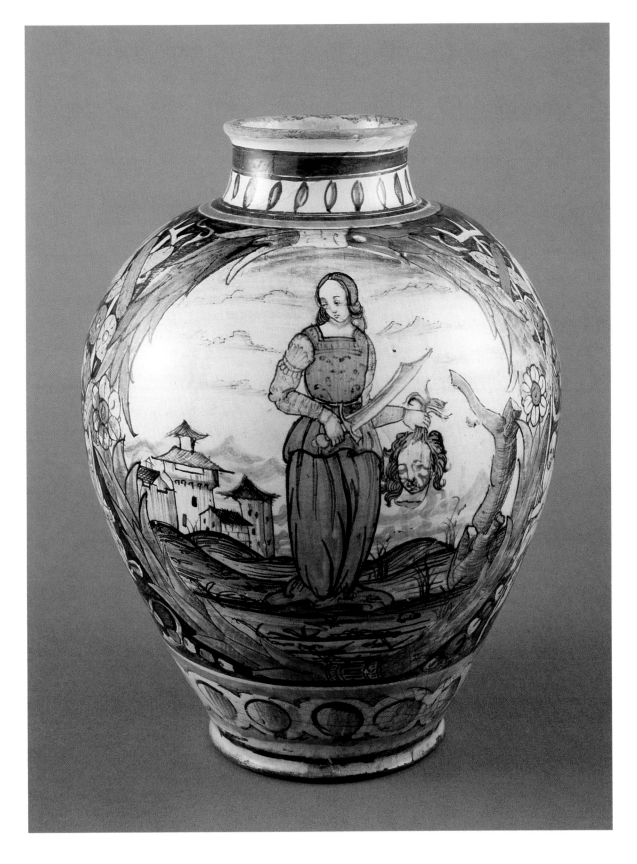

41. Dish with Orpheus charming the beasts

Castel Durante, the "in Castel Durante" Painter, c.1520–25

H 5.5 cm; D 26.6 cm; shape R14
Inv. 26.342
Provenance: Castellani; Hainauer;
Clark
Bibliography: Castellani, cat. 188;
Hainauer, 37, 113, cat. 320 (M40);
Corcoran/*Bulletin*, cat. 73

1 Mallet/*PLII*, 340–345.
2 His *Martyrdom of St. Felicity* of
c.1520–25 (B.XIV, 117) is the source for
another plate by the same painter in
Arezzo (*Corpus I*, tav. XXI; inscribed
"in Castel Durante 1526").
3 *Seated Man holding a Flute* (B.XIV,
467); for two Venetian pieces of
c.1550–60 using the same image, see
Lessmann cats. 587 and 590; see also a
plate (c.1524–26) by the "in Castel
Durante" Painter which uses a close
variant of the Orpheus figure in the col-
lection at Polesden Lacey (see Mallet/
PLII, fig. 1).
4 Cf. the Raimondi print *Orpheus and
Eurydice* (B.XIV, 295) for similar
details.
5 Hainauer, 113.
6 Ovid/Innes, 246.
7 The popularity of the Orpheus legend
was fairly continuous from antiquity
through the Renaissance. In Greek and
Roman art he appears often in vase-
painting, sculpture, and wall-painting.
In the early Christian era, Orpheus was
used as the basis for catacomb paint-
ings of the messiah prophesied by
Isaiah and for the concept of Christ as
the lyre-playing shepherd of his flock.

Once called "Pseudopellipario" because of his stylistic kinship to Nicolò da Urbino ("Pellipario"), this artist has now been accorded independent recognition and renamed the "in Castel Durante" Painter after the inscriptions on the reverses of some of his pieces.[1] A less accomplished draughtsman than Nicolò, he is some-what awkward in anatomical and spatial rendering, though this artless naivete is certainly part of his appeal.

All of the dated works of the "in Castel Durante" Painter fall within the short span of 1524–26, although it is thought that he may have been at work as early as 1520. The chronology of the undated plates has yet to be sorted out, but changes in his use of color may be significant, reflecting the general shift in Castel Durante and Urbino wares in the mid-1520s from a cooler, blue-dominated palette to a warmer one. In the present dish, he has used a harmonious though restrained range of green, blue, orange, and yellow; in other works, he employs an expanded palette with more intense and vivid hues.

An examination of the subjects chosen by the artist reveals that he also derived his inspiration from prints upon occasion, particularly those of Marcantonio Raimondi.[2] In this case, Orpheus is taken from a Marcantonio print which appa-rently had a wide currency and was used by Venetian maiolica-painters a quarter of a century later.[3] It appears that the "in Castel Durante" Painter may even have borrowed some of his stylistic hallmarks from these prints, including the delicate fringes at the edges of the trees, shrubs, and grassy areas, the prominent strewn rocks and pebbles, and the manner in which he delineates anatomical detail.[4]

Although the Clark plate was once described by Wilhelm Bode as showing "Apollo with bow and mandolin in a landscape,"[5] the lack of any specifically Apollonian attributes probably points instead to Orpheus as the true subject. It is well known that the two mythological figures were always closely connected, Apollo being the deity associated with music, archery, prophecy, and medicine. Orpheus, on the other hand, was a Thracian singer and poet; as a musician, his patron god was Apollo. Both were commonly depicted in antiquity as beautiful youths associated with the higher attainments of civilization, and were highly praised for their musical talents. Orpheus was especially well-known for his ability

Right:
Marcantonio Raimondi, *Seated Man Holding a Flute* (after Baccio Bandinelli)

to captivate beasts and even trees and rocks: "By such songs as these the Thracian poet was drawing woods and rocks to follow him, charming the creatures of the wild . . . "[6] This passage, drawn from Ovid's *Metamorphoses*, was very familiar to Renaissance writers and artists and probably served as part of the inspiration for the Clark dish.[7]

The bow held in the figure's right hand is certainly a musical one, not Apollo's hunting weapon. In antiquity, the lyre – played by plucking the strings with the fingers – was the instrument most commonly associated with Orpheus and Apollo. In Renaissance depictions, however, it was frequently transformed, as it is here, into a *lira da braccio* or a *viola da braccio*, hand-held instruments played with a bow which were in general use from the 15th to 18th centuries.

42. Dish with grotesques and a coat of arms
Metauro area, probably Castel Durante, circle of Giovanni Maria, c.1520–30

Coat of Arms: Or, an eagle displayed crowned sable (unidentified)
H 4.7 cm; D 24.8 cm; shape R14
Inv. 26.305
Provenance: Hainauer; Clark
Bibliography: Hainauer, 34 (ill.), 107, cat. 283 (M3); Corcoran/*Bulletin*, cat. 58

The touchstone for the attribution of this plate and others like it is a fine dish in the Lehman Collection at the Metropolitan Museum of Art.[1] It is painted in the ornate *a candelieri* (candelabrum) style, and incorporates the coat of arms of Pope Julius II, as well as satyrs, putti, cornucopias, ribbons, trophies, and other decorative devices. On the reverse is inscribed "1508 adi 12 de seteb facta fu i Castel durat Zouamaria vro" ("made in Castel Durante on the 12th day of September 1508 by Giovanni Maria, potter").

It is not certain whether Giovanni Maria was exclusively a potter, as he signed himself (*vasaro*), or also a painter; the separation of these occupations was quite common in the Renaissance, as it was in antiquity. Little is actually known about this artisan,[2] although it seems certain that he came to Castel Durante from Faenza where he began his career. For a time, most *a candelieri* plates were automatically attributed to him, but it soon became evident that there were several hands at work and probably even more than one workshop.[3] Giovanni Maria was among the first to adopt the distinctive style, arranging motifs symmetrically around a strong central axis. He and his associates inserted grotesques, trophies, and heraldic motifs into the *a candelieri* compositions, as in the Clark plate, filling virtually all the available space and linking the elements of the design with fine ribbons.

Piccolpasso illustrated the *grottesche* and *a candelieri* patterns that he asserted were popular in the state of Urbino (including Castel Durante), although he went on to add that "grotesques have almost fallen out of use, and I do not know why; it is a delicate style of painting."[4] By 1557, when Piccolpasso wrote this, it may indeed have been true, but earlier in the century such ornamental schemes were very much in fashion. The ancient wall-paintings and stucco decorations of the Roman ruins were avidly studied by many major painters, and soon incorporated into the work of printmakers like Nicoletto da Modena and Giovanni Antonio da Brescia. As these prints became available, they inspired other craftsmen, including maiolica painters.

Plates like the present one may have been based on such engraved ornamental panels,[5] with motifs arranged to suit the desires of a particular painter or patron. In this case, a coat of arms held up by winged creatures is the central focus of the composition.[6] Although certain elements of the *stemma* – a black crowned eagle on a gold ground – can be associated with both the Gonzaga and the Montefeltro, neither family used these precise arms. The eagle was, in fact, a recurrent heraldic device among Italian families, and this shield remains to be identified.

An attribution to Castel Durante cannot be proven for the Clark plate, yet it seems clear that the design is based upon the style taken up by Giovanni Maria in the first decades of the 16th century,[7] and it was probably produced by a workshop influenced by that artist around 1520–30.

1 Ill. in *Corpus I*, figs. 43 and 243.
2 Two basic articles on the painter are: B. Rackham, "Der Majolikamaler Giovanni Maria von Casteldurante," *Pantheon*, 1928, 435–445 (part I), and 1929, 88–92 (part II).
3 Norman, 58.
4 Piccolpasso II, 113; on folios 67r and 71r, he illustrates the *"groteche"* and *"a candelieri"* styles.
5 E.g. cat. 98 in *Ital. Engrs.*, Giovanni Antonio da Brescia, *Ornamental Panel Inscribed "Victoria Augustus,"* c.1516.
6 The unidentified coat of arms has suffered some damage and been repainted. It is likely, however, that it originally looked much as it does today, although the position of the bird's head and the existence of the crown cannot be proven.
7 Cf. Rackham, cats. 523–526 and 535–537 for related works. Parallels have not been found for the alternating blue spirals and crossed squares of the reverse except for similar marks on plates lustred in the Gubbio workshop of Maestro Giorgio (dated 1520 and 1522; see *Corpus I*, figs. 270, 276, and 281).

43. Plate with the arms of the Marganti family of Foligno
Made at Castel Durante (or Gubbio), lustred at Gubbio, 1540

Inscribed on recto, on cartouche: "1540"; on verso: an unidentified emblem
Coat of arms: Per pale argent and azure, two storks confronting counterchanged
H 5.5 cm; D 23.2 cm; shape LII
Inv. 26.344
Provenance: Geremia Delsette; Alexander Barker; Hainauer; Clark
Bibliography: L. Frati, *Di un'insigne raccolta di maioliche dipinte delle fabbriche di Pesaro e della provincia metaurense* . . . (catalogue of the Geremia Delsette collection; Bologna, 1844), 25, 34, cat. 166; Hainauer, 37, 113, cat. 322 (M42); Corcoran/*Bulletin*, cat. 75

1 Piccolpasso I, folio 66r.
2 Piccolpasso II, 111.
3 See G. Liverani, *La maiolica italiana* (Milan, 1957), pl. xi, for a Faentine *alla porcellana* plate at the Museo Internazionale delle Ceramiche (Faenza).
4 Lessmann, cat. 16.

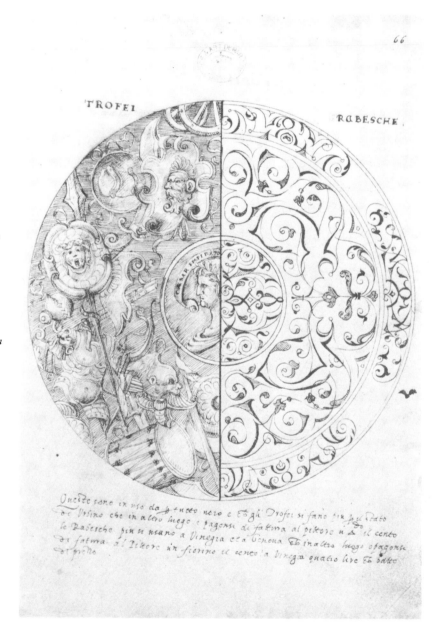

Among the sample designs given by Piccolpasso in his treatise on the potter's art are two variations of "trophy" patterns (*trofei*) that were commonly found on maiolica of the time, similar to those on this small plate (see also cat. 44). As a native of Castel Durante, Piccolpasso no doubt was particularly aware of this motif, which had its greatest popularity there.[1] Piccolpasso himself commented that "These are in use everywhere, though it is true that 'trophies' are made more often in the state of Urbino than elsewhere."[2]

Early examples of trophies can be found in late 15th-century Faentine ceramics[3] and mixed with *grottesche* in the work of 16th-century Castel Durante potters like Giovanni Maria and his associates.[4] By about 1525, they appeared as the primary border decoration on smaller plates, with coats of arms, portraits of Roman em-

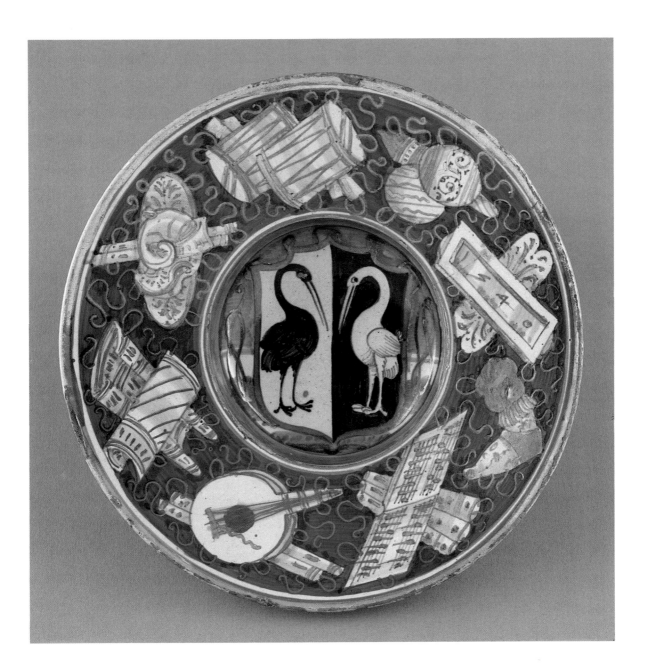

Opposite:
Drawing of trophy and arabesque
patterns from Piccolpasso's "I tre
libri dell'arte del vasaio" (By cour-
tesy of the Board of Trustees of the
Victoria and Albert Museum)

5 For examples, see Mark Zucker, ed., *The Illustrated Bartsch, Early Italian Masters*, vol. 25 (New York, 1980), Andrea Mantegna (13/236 and 14/236), Giovanni Antonio da Brescia (23/330), and the Master of 1515 (7/412, 20–22/418–419, and 24/420).

6 Piccolpasso II, folio 66r.

7 Giacomotti, 229.

8 A plate of similar design with the same date and a finishing layer of ruby lustre is found in the Louvre (Giacomotti, cat. 772); see also cats. 773–774 and Rackham, cat. 717.

9 Parke-Bernet Galleries, *The Magnificent Collection of Italian Maiolica formed by the late Mortimer L. Schiff* (sale cat., New York, 1946), 62, lot. 85.

10 V. Palizzolo Gravine, *Il Blasone in Sicilia* (Bologna, 1972), 344–345, pl. LXIX.

11 Cartari-Febei, busta 172, no. 3109.

12 Angelo Messini and Feliciano Baldaccini, *Statuta Communis Fulginei* (Perugia, 1969, 2 vols.), vol. I, 221.

13 Federigo Melis, *Aspetti della vita economica medievale* (Studi nell'Archivio Catini di Prato, Siena, 1962), vol. I, pls. XXI–XLII.

perors, and putti in their central tondos. Like the imperial portrait busts, *trofei* had their origins in the art of antiquity. An upsurge of interest in this ancient motif is evident in the late 15th/early 16th-century engravings by Andrea Mantegna, whose famous *Triumph of Caesar* series shows men carrying trophies in triumphal procession; other artists, such as Giovanni Antonio da Brescia and the Master of 1515 executed prints concentrating specifically on ancient trophies, architectural ornament, and *grottesche*.[5]

To judge from the many surviving examples, small maiolica dishes decorated with *trofei* were quite popular from the 1520s through at least 1570s. Piccolpasso quotes the price for such plates by the hundred – "the painter is paid for their fashion a scudo a hundred."[6] Around 1525–30 many trophy-decorated plates were produced at Castel Durante and sent on to the town of Gubbio to be lustred, although it is thought that Gubbio potters may also have adopted the motif and manufactured their own similar plates,[7] which may be the case with the Clark dish.[8]

The *stemma* on the present plate is found on another piece of maiolica that was once in the Schiff Collection, where it was said to belong to the Sclafani family of Palermo.[9] A closer examination of the heraldry, however, reveals that the Sclafani arms are reversed in color (i.e., on the left, a silver stork on a black ground, and on the right a black stork on a silver ground). In addition, it seems that the family became extinct with the death of the last male heir in 1354.[10] It now appears that the crest on the present plate belongs to the Marganti family of Foligno.[11] The geographical proximity of Foligno makes it a more probable location for a patron, rather than far-away Palermo which had its own active factories in this period. Although little is known of the Marganti today, mention of them is made in the town statutes as early as 1350.[12]

A final clue about the source of this dish remains undeciphered – the as-yet unidentified design on the reverse. Marks of this sort have long been referred to as emblems of monastic foundations, and that is clearly the case with some of them. Others, however, remain unidentified. Federigo Melis, in his book on aspects of medieval economic life, published a number of related symbols as trademarks of *operatori economici* – individuals who act as buyers or sellers of goods or services in the marketplace.[13] Further research in this area may thus reveal that the marks – which are not uncommon on Italian maiolica – may refer either to the workshop itself or to a "middleman" between the factory and the buyer or patron.

Detail of reverse

44. Dish with trophies and a putto pouring water
Castel Durante, c.1550

Trophies, like grotesques, found great favor with artists and craftsmen amid the revivalist atmosphere of the Renaissance, although they no longer retained the same meaning that they had had in antiquity. Originally, trophies consisted of actual enemy armor that was mounted on stakes on the battlefield to symbolize victory. They were also placed in sanctuaries of deities as dedications after successful military encounters. Around the late 6th century BC, trophies began to be adapted in art and were commonly incorporated into sculptures and architecture of the Hellenistic and Roman periods.[1]

The combination of a trophy border with a central putto or cherub motif was introduced into Castel Durante around 1515 by the maiolica painter Giovanni Maria.[2] These popular works were produced in great numbers in Castel Durante and other countries and later, after mid-century, in Venice as well.[3]

Although undated, this piece is inscribed with the letter "S" in one of the trophies at lower right, probably representing the name of the owner or patron, rather than the maker.[4]

H 5.0 cm; D 22.3 cm; shape R14
Inv. 26.311
Provenance: Hainauer; Clark
Bibliography: Hainauer, 108, cat. 289 (M9).
Corcoran/*Bulletin*, cat. 74

1 OCD, 1097.
2 Hausmann, 253.
3 See examples of Venetian pieces in Rackham (cats. 975–976; the former is dated 1557); compare the Clark plate to those in Hausmann, cats. 184–187.
4 Fortnum (p. 278) makes a similar suggestion about a trophy plate in the V&A (Rackham, cat. 715) with the letters "A.M."

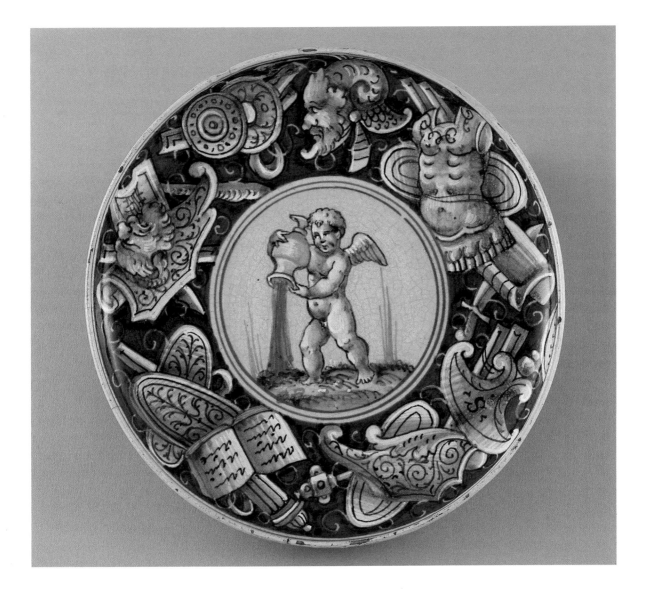

45. Plate with an allegorical scene of Calliope and a youth (from the Ladder Service)

Urbino, Nicolò da Urbino, c.1525–28

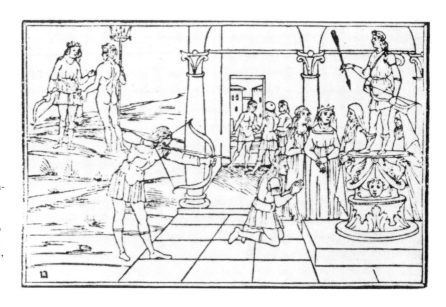

Inscribed on recto, on book: "omnia vin/cit am/or et ce/damus / omnia . . . [illegible]"; on triangular tablet: "0/519/462/370"; on verso: a cross-shaped mark[1]
Coat of arms: Azure, a ladder in bend or, out of it a standard in pale argent
H 4.3 cm; D 26.2 cm; shape R6
Inv. 26.348
Provenance: Castellani; Hainauer; Clark
Bibliography: Castellani, cat. 272; Fortnum, appendix, 54, no. 173; Hainauer, 37–38 (ill.), 114, cat. 326 (M46); B. Rackham, "Some Unpublished Maiolica by Pellipario," *BM* 52 (1928), 236, pl. IVc; Corcoran/Erdberg, 73, fig. 14; Corcoran/*Bulletin*, fig. 1 (cover ill.), cat. 71; *Detroit*, 44 (ill.), cat. 120A; Corcoran/Clark, 76, fig. 60

1 Cf. a similar cross-shaped mark on the back of one of the Correr Service plates (inv. Cl. IVº, no. 11).
2 Berardi, 17, n. 9; for more information on Nicolò, see Jörg Rasmussen, "Zum Werk des Majolikamalers Nicolò da Urbino," *Keramos* 58 (1972), 51–64, and Mallet/*Gonzaga*, 39–43 and 175–178.
3 For the Correr Service (also called the "Ridolfi Service"), see Henry Wallis, *XVII Plates by Nicolo Fontana da Urbino at the Correr Museum, Venice, A study in Early XVI^th Cent^y Maiolica*, London, 1905.
4 Although the Este-Gonzaga Service has traditionally been dated to c.1519, the year Isabella was widowed, Mallet has suggested on stylistic grounds that it was probably executed around 1525 (see Mallet/*Gonzaga*, 40).
5 There are five pieces in the Royal Scottish Museum, Edinburgh, and one each in the British Museum, the Cluny Collection, the Metropolitan Museum of Art, the Getty Museum, and the Clark Collection, all of which are illustrated in Rackham's 1928 article (see bibliography above). A piece was once in the Damiron collection (current whereabouts unknown; ill. in *Apollo* XXVI, 255). The Clark plate is the only one of its shape in the group.

Perhaps the finest and most intriguing of the Clark maiolica is this footed dish, painted in brilliant colors in a style easily recognizable as that of Nicolò da Urbino. Recent archival research has disproven the long-held notion that this artist was Nicola Pellipario, the father of Guido Durantino, the Urbino maiolica master,[2] although he worked in Guido's shop late in the 1520s. One of Italy's pre-eminent maiolica artists, if not its best, he was probably active from late in the second decade to around 1540, and was one of the major forces in early *istoriato* painting.

It is regrettable that we know so little about an artist who was so richly talented and so highly sought-after by patrons as important as Isabella d'Este, for whom he executed a service that is among his finest work. Other important sets attributed to Nicolò include the early Correr Service (c.1517–20),[3] with its unusual delicate palette, and subjects taken from mythology (with an emphasis on Orpheus and Apollo) and contemporary romance. Following that in his chronology are the dated plate in the Hermitage of 1521, the spectacular Este-Gonzaga Service of around 1525,[4] and the 1528 Bargello plate. Among his later works were two groups painted in the 1530s for Isabella's son, Duke Federico, and for the Duke and his wife Margherita Paleologo. These examples from the last decade of Nicolò's activity are somewhat less accomplished and less original than the earlier pieces, and show certain stylistic affinities with the work of his contemporary, Xanto.

The so-called Ladder Service, to which the Clark plate belongs, is comprised of eleven pieces with a variety of mythological, religious, and allegorical subjects.[5] Although no distinct program has yet been determined for the choice of themes in any of Nicolò's services, it is particularly tempting to try to discern one in the sets with known patrons. In the case of the Ladder Service, the patron (or perhaps the recipient) appears to have been Luigi Calini, a member of the distinguished Brescian family whose coat of arms is prominently displayed on all the plates.[6]

In 1954, Erwin Panofsky postulated that "the subject of the plate, probably given to a young man on the occasion of his confirmation or of his departure for a university, is a kind of educational program,"[7] representing a muse encouraging the youth to study all the liberal arts. Claudia Rousseau has recently suggested, however, that various elements of the composition – such as the bearded man in oriental garb with a celestial globe, and the numbered triangular tablet below – point

Opposite:
The Shooting of Achilles, from
Ovid's *Metamorphoses* (1497)

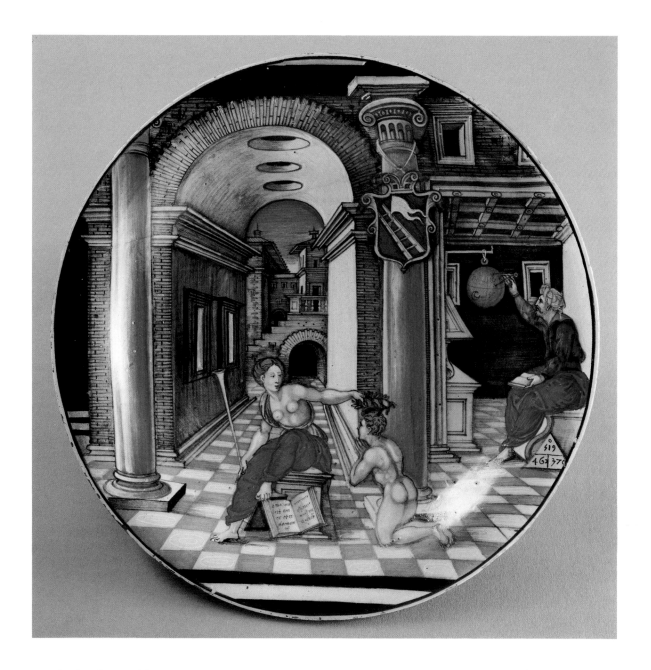

6 I owe the identification of these arms to
 Timothy Wilson, who very kindly pro-
 vided me with a copy of the article by
 H. von Schrattenhofen, "La nobile
 famiglia bresciana Calini di Calino,"
 Rivista del Collegio Araldico, (June
 1927), 243–257. See also, C. Ravanelli
 Guidotti, "L'araldica della nobile fam-
 iglia Calini su alcuni piatti compen-
 diari," *Faenza* LXXI (1985).
7 Letter, 29 March 1954 (Corcoran files).

8 I am indebted to Claudia Rousseau, Washington University, for the many useful suggestions regarding the astrological aspects of the iconography of this dish which have made possible the hypothetical interpretation offered here.

9 Virgil, *Eclogues* X, 69.

10 *Theogony*, 75 ff. (transl. R.M. Frazer, *The Poems of Hesiod*, Norman, Oklahoma, 1983); reference to this poem of Hesiod was provided by Claudia Rousseau in a letter of 5 January 1985.

11 Nicolò appears to have drawn upon two different woodcuts from the 1497 Ovid for this figure: one from the scene of Paris slaying Achilles (Book XV, Ch. 1) and the other from the scene of Peleus and Thetis (see Wallis, op. cit., fig. 6). This was a favorite of Nicolò's and he used it several times (see J. Petruzzellis-Scherer, "Fonti iconografiche librarie per alcune maioliche del Castello Sforzesco," *Rassegna di studi e di notizie*, X, Anno IX, 1982, figs. 1, 3, and 4.

12 Records are contradictory as to the number of children in Luigi Calini's family; see von Schrattenhofen's article (⁶ above) and V.I. Comparato, "Calini, Muzio," in *DBI*, vol. 16, 725.

13 Ibid., 725–727.

14 See C.H. Clough, "Canossa, Ludovico," in *DBI*, vol. 18, 189.

15 See Rackham, cat. 574; the plate and a corresponding view of the Palazzo Ducale are illustrated in G. Papagni, *La maiolica del Rinascimento in Casteldurante, Urbino, e Pesaro* (Fano, n.d., c.1980), figs. 54–55. On the subject of architecture in Nicolò's work, see Rackham, "Nicola Pellipario and Bramante," *BM* 86 (1945), 144–148.

to an astrological interpretation.[8] The female figure at center is almost certainly Calliope, the muse of epic poetry, accompanied by her standard attributes of trumpet, laurel crown, and books; at her feet, the open volume can easily be identified as Virgil's *Eclogues* from its text, which reads: "Omnia vincit amor"[9] Hesiod referred to Calliope as the most important of the Muses because she "grants her ready attention to honorable kings" and, with her sister Muses, guides these nobles in wisdom and justice.[10] Thus, the kneeling prince being crowned by the muse,[11] together with the astrologer – who represents the importance of being aware of the potential gifts indicated by one's astrological chart – may indicate that the iconographical program refers to the horoscope of a particular young man or boy.

In terms of both style and color, the Clark dish fits into Nicolò's chronology near, or just after, the Este-Gonzaga Service, but before the St. Cecilia plate in the Bargello. If it, and the entire Ladder Service, can be dated to c.1525–28, one could examine the Calini family history of those years for an event appropriate for commemoration on a maiolica service. Muzio Calini, the first son of the 10 or 11 children of Luigi Calini, was born around 1525, and his father was particularly concerned with the planning of a classical, humanistic education for the boy.[12] Muzio subsequently went into the Church and attained high levels of distinction, participating in the Council of Trent and eventually becoming an archbishop.[13] While it was quite unusual for a first son to follow an ecclesiastical career, it might have been encouraged if his horoscope indicated strong possibilities for an especially successful future in the Church. Unfortunately, Muzio Calini's exact date of birth has yet to be found, and it is thus not possible to determine whether the carefully delineated celestial globe shows a horoscope that could, in fact, be his own. If confirmed, this hypothesis might lead to interesting interpretations of the other subjects which appear on the remainder of the Calini plates.

The identity of the patron of the service may never be known, although Luigi Calini is a strong possibility; another candidate might be Ludovico Canossa, the highly esteemed churchman. He was a close friend of Luigi and might have been inspired to order such a gift on the occasion of the birth of his friend's first son. Interestingly, Canossa was also a member of the circle of Isabella d'Este (whose own service by Nicolò he probably saw), and was known to have been present in Urbino in 1525 and again in 1528,[14] where he could have taken the opportunity to commission maiolica from Nicolò for his Brescian friend Calini.

The architecture which features prominently in this and many of Nicolò's other plates, appears to have been inspired by contemporary buildings or architectural prints of which he had first-hand knowledge; a maiolica plate in the V&A, for example, shows an exact replica of the view through the barrel-vaulted entrance hall and into the courtyard of the ducal palace at Urbino.[15]

46. Plate with Apollo and Marsyas
Urbino, Painter of the Milan Marsyas, c.1525–30

Among the more recently-identified maiolica artists is the man John Mallet has named the "Painter of the Milan Marsyas," after an inscribed piece in the Castello Sforzesco.[1] Unfortunately, although this Urbino artist marked a number of pieces with descriptions of their themes, he never signed or dated any plates that we know of. It is obvious, however, from his style and choice of subject matter that he worked closely with Nicolò da Urbino, perhaps in the same shop.[2] A close scrutiny of the large body of work once attributed to Nicolò, or "near Nicolò," turns up a substantial number of pieces that can now be placed among the Milan painter's œuvre instead. As John Mallet has recently commented, the Milan Marsyas Painter was "a busy chap, almost as busy as Xanto, and considerably busier than Nicolò."[3] Some of his most noticeable stylistic traits include a distinctive manner of highlighting noses, chins and beards, elbows, knees, and anklebones; in frontal views of noses he uses a vertical stripe of white highlighting and a horizontal black dash below, and the eyes are made with a horizontal black line and a small dark dot for the pupil. Feet are drawn delicately in profile, or frontally with splayed toes. The painter had a special fondness for fluttering graceful drapery in rich colors, with ruffled edges and smoothly rhythmic foldlines.

In his landscapes, the Milan Marsyas Painter often included orange and black rock outcroppings that seem to spring out of the earth; normally, although this is not evident on the Clark plate, these cliffs are marked with strange vertical forms resembling attenuated teardrop shapes. Trees with thick foliage and dark trunks highlighted in white often occupy the foreground, while rows of round trees or bushes mark the rise and fall of the distant landscapes. Like Nicolò, the Milan painter had a special interest in architecture, and he frequently incorporated interesting round buildings and towers into the backgrounds of his compositions. Architecture features even more significantly in the foregrounds of some works, like the other Clark plate by the painter (cat. 47) and one in the Castello Sforzesco.[4] In several instances, the painter links the planes of his compositions with pebble-strewn zigzagging paths that lead back into the distance.

Because of the lack of signatures and dates on the works of Nicolò, the Milan Marsyas Painter, and other as yet unnamed followers of Nicolò's style, it is difficult to sort out their respective bodies of work and to form a clear chronology. It is probable that a number of painters – the Milan artist among them – worked anonymously in the workshops of Guido Durantino and others in the 1520s, 30s, and 40s, inscribing plates with the notation "made in the botega of Maestro Guido Durantino in Urbino," but not including their own names.[5] In addition, there is evidence that the Milan Marsyas Painter may have been associated not only with Nicolò, but also with Urbino's other preeminent maiolica artist, Francesco Xanto Avelli.

Inscribed on verso near center: "af 55" (scratched into glaze; Fountaine inventory number)
H 4.0 cm; D 26.0 cm; shape R10
Inv. 26.363
Provenance: Fountaine; Hainauer; Clark
Bibliography: Fountaine, cat. 176; Hainauer, 38, 116, cat. 341 (M61); Corcoran/*Bulletin*, cat. 83).

1 Castello Sforzesco, inv. 133. See Mallet/*Gonzaga*, 176 and an article, "I seguaci di Xanto, il pittore del Marsia di Milano," from the forthcoming transactions of the 1980 Convegno Internazionale di Studi sull'Opera di Francesco Xanto Avelli da Rovigo.
2 Certain figures in the Milan painter's plates appear to be derived either from known works by Nicolò, or from the same graphic sources that he used; cf. figures in the Milan artist's Apollo and Daphne plate (Castello Sforzesco, inv. 139) with those on Nicolò's Este-Gonzaga dish of the same subject (ill. in Mallet/*Gonzaga*, fig. 131), the figure of Marsyas on the Milan name-piece (see [1] above) with another Este-Gonzaga version of the theme (ill. in Mallet/*Gonzaga*, fig. 133), or the plates by both artists showing Latona and the frogs (Castello Sforzesco, inv. 132 and Mallet/*Gonzaga*, fig. 132). Several figures in these works are taken from the 1497 illustrated Ovid.
3 Letter to author, 29 January 1985. An initial list of some works that can be attributed to the Milan Marsyas Painter are: at least six pieces in the Castello Sforzesco (inv. nos. 129, 132, 133, 135, 139, and 143); one in the Correr Museum (inv. CL IVº, no. 54, Rape of Europa, with a Contarini coat of arms); three in the Louvre (Giacomotti, cats. 833–835); one in a private collection (ill. in V. Serra, "Maioliche di Nicolò Pellipario," *Antichità Viva* II, 1963, fig. 5); one in the Museo Civico, Pesaro (Della Chiara, cat. 100); and two in the Walters Art Gallery (Erdberg/Ross, cats. 47 and 50). For other attributions and notes on the painter, see Join-Dieterle (p. 200) and Rasmussen (pp. 169 ff.).
4 Castello Sforzesco plate with Mucius Scaevola (inv. 143).
5 Sèvres (Giacomotti, cat. 840), Louvre, (Giacomotti, cat. 841), and Hermitage (Kube, cat. 69).

6 Hall, 27.

The Clark dish depicts two moments in the story of Apollo and Marsyas using the convention of continuous narrative, moving from left to right. Taken from Ovid's *Metamorphoses* (Book IV), this was a favorite theme in art and especially in maiolica in Renaissance Italy, where the myth was imbued with new allegorical meaning. Marsyas, a satyr and follower of Bacchus, was a skillful flute player whose pride in his own talent angered Apollo, the patron god of music. Apollo challenged him to a contest in which the satyr would play his flute and Apollo his lyre; the victor was to be allowed to choose a penalty for the loser. The judges were to be the Muses, Apollo's own companions on Parnassus, who naturally declared him the superior player. As Marsyas's punishment, the god tied him to a tree and flayed him alive.

In the present plate, as in many Renaissance depictions, Marsyas appears without his goat-like features, playing pan-pipes, while Apollo holds a *lira da braccio* instead of a classical lyre. The two classes of instruments were considered by Renaissance humanists as representing opposing ideals: the cool sound of strings was seen as morally and spiritually uplifting, while the earthier tones of the pipes invoked Bacchic passions. The flaying of the unfortunate satyr was also interpreted allegorically as a scene of spiritual purification, or stripping away of the outer sensual self.[6]

47. Plate with Marcus Curtius
Urbino, Painter of the Milan Marsyas, c.1525–30

Inscribed on verso near rim: "20"
(scratched into glaze; Fountaine inventory number)
H 3.7 cm; D 47.4 cm; shape L21
Inv. 26.358
Provenance: Fountaine, Hainauer;
Clark
Bibliography: Fountaine, cat. 207;
Hainauer, 38, 115, cat. 336 (M56);
Corcoran/Erdberg, 73, fig. 13;
Corcoran/*Bulletin,* cat. 76

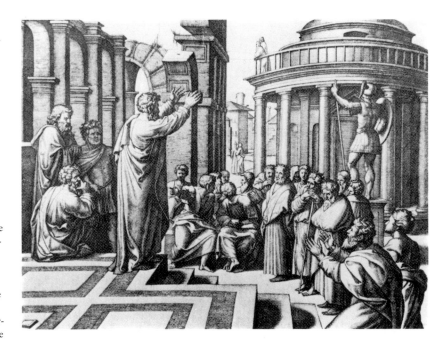

1 See bibliography above; Erdberg also
 suggests, erroneously I believe, that the
 present plate and one in the Cluny col-
 lection showing Paris and Achilles
 (Giacomotti, cat. 836) are by the same
 hand.
2 Cf. the head of the bearded man at the
 extreme right with that of Marsyas on
 the name-piece in Milan (Castello Sfor-
 zesco, inv. 133), or the treatment of the
 profile of St. Paul with that of the
 figure of Apollo at the right of Clark
 cat. 46.
3 E.g. the Louvre plate (Giacomotti, cat.
 831), and British Museum plate (ill. in
 Rackham, "Some Unpublished
 Maiolica by Pellipario," *BM* 52 (1928),
 pl. IIIA). For other illustrations of
 maiolica with strong architectural com-
 ponents, see C. Bernardi, *Immagini
 architettoniche nella maiolica italiana
 del Cinquecento,* (exh. cat., Milan,
 1980).
4 B.XIV, 44. Raphael's cartoon is in the
 V&A.

In the 1884 catalogue of the Fountaine collection, this plate was referred to as a
work of Nicola Pellipario; later, in 1955, Joan Prentice von Erdberg argued for its
attribution to Francesco Xanto, "prior to 1530, a time when Xanto was greatly
under the influence of Nicola Pellipario and before he had begun to sign his
work."[1] With the recent identification of the so-called Painter of the Milan Mar-
syas, it now appears that the truth lies somewhere in between. This large flat dish
manifests many characteristics of that newly-named artist's style: the delicate
boyish faces of the youths with their highlighted chins and small features, the old
men with their full white beards,[2] the general palette, and the treatment of land-
scape, architecture, and distant background. In place of the Milan painter's
idiosyncratic sweeping rock cliffs at left and right are two large buildings based on
classical and Renaissance models, much like those of Nicolò. It seems, in fact, that
the artist of the Clark dish was strongly affected by works by Nicolò like the
Louvre's Pasiphae plate, with its commanding monumental round temple, or the
Apollo and Pan dish from the Ladder Service in the British Museum, in which
architecture also plays an important role.[3] As in many other Milan Marsyas pieces,
smaller buildings appear in the background, perched on hillsides amid rows of
round shrubs.

The choice of subject and the complexity of the many-figured composition are
unusual in the œuvre of the artist. Perhaps his largest work, it shows the heroic
Marcus Curtius leaping into the chasm, surrounded by fellow Romans. The sense
of familiarity one experiences upon looking at this plate stems from the fact that it
is based on Raphael's *St. Paul Preaching at Athens,* which the artist no doubt knew
from Marcantonio Raimondi's print (c.1517–20) after drawings by Raphael for the
tapestry cartoon.[4]

Other maiolica painters drew upon the same popular graphic source, as is well
demonstrated by another Clark plate (cat. 48), whose maker took a more direct ap-
proach, copying the scene almost line for line. The Milan painter chose instead to
excerpt two groups of figures from Raphael's design, inserting his own elements

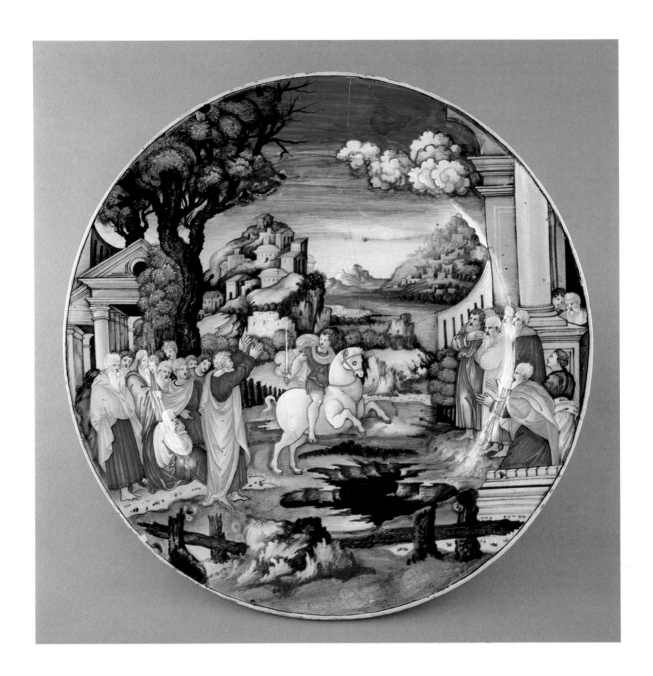

Opposite:
Marcantonio Raimondi, *St. Paul Preaching at Athens* (after Raphael)

5 This would be consistent with Join-Dieterle's comment (p. 200) that both the Milan Marsyas Painter and Xanto may have worked on the service with a coat of arms of three crescents – as yet unidentified; see also Erdberg/Ross (cat. 50) for a plate of that service in the Walters Art Gallery that must be by the Milan painter.

6 Livy, *History of Rome (Ab Urbe Condita)*, Book 7, Ch. 6.

7 Among the numerous maiolica plates with this subject are the famous Cafaggiolo plate (c.1510–15) in Braunschweig with an unusual *di sotto in su* view of the equestrian figure (Lessman, cat. 83), and one by an artist near Nicolò in the Hermitage (Kube, cat. 55); an Urbino plate, once in the Adda Collection, shows the devotion of Marcus Curtius and here too the artist has excerpted the left portion of the Raphael design (Adda, cat. 441, pl. 199A).

here and there, in much the same fashion as Xanto. This fact, along with certain other compositional elements like the spiral clouds at the upper right, or the fundamental notion of a larger, more extensively populated scene, suggest that the Milan Marsyas Painter may have been looking at Xanto's work when he made this plate.[5]

The subject of Marcus Curtius – taken from Livy's *History of Rome*[6] – had regained popularity in the Renaissance as an allegory of civic virtue. It was one of several legends devised by the Romans to explain the presence of the Lacus Curtius, a pond in the middle of the ancient Forum. A chasm had opened in the ground there which the oracle said could only be filled by throwing into it something of the greatest value. The brave young soldier Marcus Curtius interpreted this as meaning a sacrifice of one of the city's finest youths, and in devotion, leapt fully armed on horseback into the open pit. To Renaissance humanists – who were zealously studying Livy and the other classical authors, and forming pantheons of famous men and women to honor their virtues and achievements – the story of Marcus Curtius was a highly appealing one.[7]

48. Plate with Saint Paul preaching at Athens
Urbino, Workshop of Guido Durantino, probably by
Orazio Fontana, c.1535

The association of Italian maiolica with the name of Raphael has been a long one, with much confusion about the exact relationship of the great Urbino master with 16th-century painted ceramics. As early as 1650, John Evelyn wrote of a visit to Jean Lincler's cabinet of curiosities in Paris, where among the other works of art, he saw "many Vasas (sic) designed by Raphael."[1] So strong was the link in the mind of collectors that maiolica was known by the name "Raphael-ware" well into the 19th century in England,[2] although there is no proof that the artist ever had any direct connection with designs for ceramics.

In actuality, his name was correctly associated with decorated tin-glazed earthenware through the proliferation of grotesque ornament, which he helped to popularize (see cats. 59 and 60). More importantly, his major works, translated into engravings by Marcantonio Raimondi, Agostino Veneziano, and others, made possible the diffusion of his designs throughout Italy and beyond. They quickly became the basis for countless compositions on *istoriato* wares, particularly in the Duchy of Urbino.

The present plate shows one of Raphael's most famous compositions for the tapestries that were commissioned for the Sistine Chapel. As did the artist of the Clark Marcus Curtius plate (cat. 47), many maiolica painters adapted this image to their own purpose, sometimes in fragments. Here, however, the artist took his inspiration quite directly from the print by Marcantonio Raimondi (c.1517–20) after Raphael;[3] a few very minor changes have been made to accommodate the round shape of the plate and the technical restrictions inherent in maiolica painting (note, for instance, that the steeple in the architecture at rear has been moved from the narrow intercolumination of the round temple to the open space in the center background).

The use of prints by maiolica artisans can at times complicate the matter of attribution. Direct copying of a composition has a tendency to obscure the individual style of a painter, while at the same time causing him to adopt certain characteristics as his own. The author of the St. Paul plate, however, did leave us a clue about his identity, inscribing a tablet at lower left with Greek letters ΦΔ. A dish in the museum at Frankfurt with the theme of David and Goliath bears a similar inscription on a stone in the right foreground.[4] Both the Clark and Frankfurt plates were once together in the Fountaine collection and may have been meant as companion pieces, as they are also identical in size. In the catalogue of the Fountaine sale in 1884 it was suggested, probably correctly, that the monogram stands for "Fontana Durantino." The Frankfurt plate and one in the Louvre from the Cardinal Duprat Service[5] were both derived from the same print by Marcantonio Raimondi after Raphael,[6] and appear to be by a single hand. The Louvre piece is marked on the reverse with the subject and the notation, "Nella bottega di Mᵒ Guido Durantino in Urbino," which would seem to secure all three pieces as products of that shop.

Guido himself was from the town of Castel Durante, as his name shows, and he set up a large and successful workshop in Urbino in the early 1520s. His three sons, Camillo, Orazio, and Nicolo, all of whom later adopted the name "Fontana," were also involved in the business. The identity of individual artists in Guido's workshop remains somewhat obscure because none of the painters in the atelier ever signed his work, except for Nicolò da Urbino on the 1528 Bargello plate. The mark ΦΔ was attributed to Orazio Fontana in 1932 by Robinson,[7] and it appears that

Inscribed on recto at lower left: "ΦΔ"; on verso near rim: "af 3" (scratched into glaze; Fountaine inventory number)
H 7.2 cm; D 34.7 cm; shape R14
Inv. 26.366
Provenance: Fountaine; Hainauer; Clark
Bibliography: Fountaine, cat. 43; Hainauer, 38, 116, cat. 344 (M64); Fortnum, appendix, 58, no. 185; William Chaffers, *Marks and Monograms on Pottery and Porcelain* (London, 1932, 14th ed.), 59; Corcoran/Erdberg, 74; Corcoran/*Bulletin*, fig. 7, cat. 98; Corcoran/Clark, 77

1 *The Diary of John Evelyn*, ed. E. S. de Beer, (Oxford, 1955), vol. III, 11, quoted in Norman, 20, and n. 15.
2 Norman, 20.
3 B.XIV, 44. See also Shoemaker (cat. 47), who notes that the print itself differs from Raphael's cartoon, showing the engraver's intervention in the composition.
4 Frankfurt, inv. 3336. I am grateful to Timothy Wilson for bringing this plate to my attention. Why the painter chose Greek letters is not clear, because their use was uncommon; perhaps he thought the inscription should be in keeping with a scene set in Athens, or was attempting to indicate his own (or the workshop owner's) degree of erudition. A slight crack at the point of the inscription on the Clark plate has resulted in a break in the second letter, but it was certainly a delta originally.
5 Giacomotti, cat. 841.
6 B.XIV, 10.
7 Chaffers, 59 (see bibliography above).

Plate: *David and Goliath* (Museum
für Kunsthandwerk, Frankfurt)

8 Giacomotti, 323.

this interpretation is the most logical one. Orazio (b. 1510), the most talented of
the brothers, worked with his father until 1565, when he opened his own shop and
began to sign his works "in bottega di Orazio Fontana in Urbino."[8] It would not
seem unusual for him, as a youthful artist working under his father, to have previ-
ously signed works "Fontana Durantino," in homage to the paternal name and
town of origin.

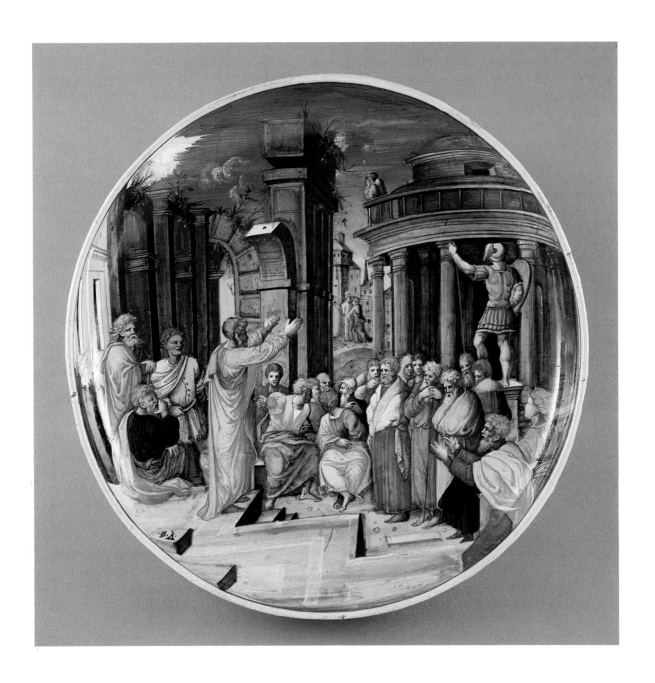

49. Plate with the Massacre of the Innocents

Urbino, Francesco Xanto Avelli da Rovigo, c.1527–30

Inscribed on verso: "P Cristo morse
l'innocenti i infantia [flourish]" ("For
Christ the infants died in their
infancy")
H 5.3 cm; D 48.9 cm; shape L21
Inv. 26.350
Provenance: Spitzer; Hainauer; Clark
Bibliography: Spitzer, cat. 124; Hain-
auer, 37 (ill.), 38, cat. 328 (M48);
Corcoran/Erdberg, 73;
Corcoran/*Bulletin,* cat. 78

1 See Introduction, [51].
2 J.V.G. Mallet, "La biografia di Fran-
cesco Xanto Avelli alla luce dei suoi
sonetti," *Faenza* LXX (1984), 401.
3 For Xanto's chronology and his identi-
fication with F.R., see Mallet/*PLIII* and
"A maiolica plate signed 'F.R.',"* Art
Bulletin of Victoria* (1976), 4–19. For
an earlier, opposing view that Xanto
and F.R. were not the same artist, see
Rackham and Ballardini, "Il Pittore di
Maiolica 'F.R.'," *Bolletino d'Arte* XI
(1933), 393–407, and Rackham, "Xanto
and 'F.R.': An Insoluble Problem?,"
Faenza XLIII (1957), 99–113. It should
also be noted that the y/φ flourish was
sometimes combined with Xanto's ac-
tual name on plates.
4 Cf. the figural style of a plate in Arezzo
with Hercules and Deianira (*Corpus I,*
pl. XXVII, dated 1528 and marked with
the flourish); two plates in the Walters
Art Gallery (Erdberg/Ross, cats. 48–49,
both marked with the flourish); and a
plaque with Sts. Sebastian and Roch in
the V&A (Rackham, cat. 628, dated
1528).

This impressive *istoriato* plate is one of the earliest of the six works by Francesco
Xanto Avelli in the Clark Collection. Xanto was easily one of the most celebrated
of Urbino's maiolica craftsmen, and the large number of extant signed pieces
(whether by his own hand or by assistants) confirms that he ran an extensive work-
shop operation there. The biography of the artist and the chronology of his works
has long been a matter of investigation among maiolica scholars; despite the abun-
dance of documentary pieces that remain today, we know surprisingly little about
him as an individual. In the *Fondo Urbinate* of the Vatican Library, however, there
remains a group of sonnets written by Xanto in praise of Francesco Maria della
Rovere, Duke of Urbino. These poems contain many references to actual historical
events, often in a veiled or oblique manner, that allow us to deduce at least a few
facts about the artist's life.[1]

Indeed, John Mallet's recent reconsideration of these sonnets has resulted in a
completely new assessment of his chronology, and pushed his birthdate back by
about thirteen years, to around 1486/87.[2] Xanto was probably the same artist who
signed plates with the initials "F.R." and "F.L.R." in the period around 1522–27,
and with the flourish resembling a "y" or "φ" – as on the present plate – in the last
years of that decade (c.1527–30).[3] It was only in 1530 that he began to sign his
actual name on works, the same year in which he started to write the phrase "in
Urbino" on them.

The present plate shows the deep vibrant blue tones characteristic of the period
1527–30, before the change to the warmer orange-yellow tones that became domi-
nant in most *istoriato* painting at Urbino toward the end of that decade. In com-
parison to others of this time, the Clark dish is extraordinarily large and much
more complex in composition; could it be that Xanto saw and was inspired by
Nicolò's great masterpiece, the St. Cecilia plate in the Bargello, which was
executed in Urbino in 1528? The present work shows stylistic affinities to other
pieces from this phase of Xanto's work, some of which are dated and some marked
with the painter's characteristic y/φ flourish.[4]

The subject of the present piece, the Massacre of the Innocents (Matthew
2:16–18), is inscribed on the reverse ("For Christ the innocents died in their in-

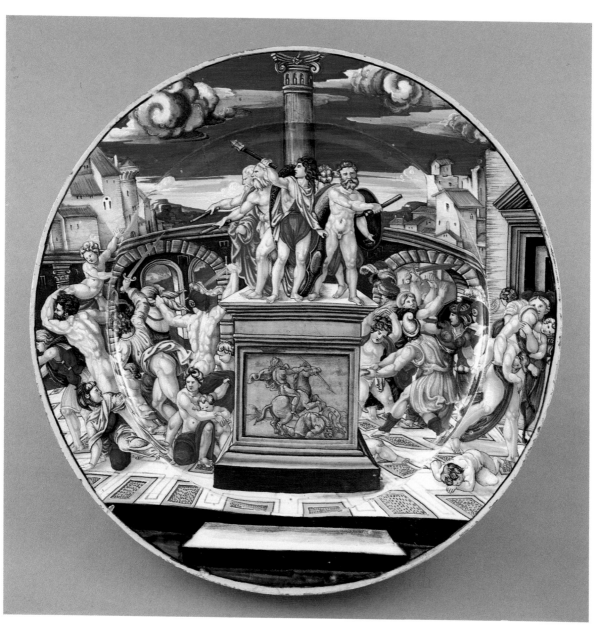

Opposite:
Marco Dente, *Massacre of the Innocents* (after Baccio Bandinelli)

Left:
Detail of reverse

5 B.XIV, 18.
6 B.XIV, 21.
7 B.XIV, 242; this print is said to have
 been based on a drawing by Raphael
 after a relief in the Church of S. Vitale,
 Ravenna.
8 B.XIV, 209.
9 Shoemaker, 96.
10 Cf. a plate in Braunschweig, perhaps
 by Nicolò da Urbino of c.1528–30
 (Lessmann, cat. 138); one by Orazio
 Fontana in the Louvre (Giacomotti,
 cat. 993); and a third of 1566 in the
 Bargello (Conti/*Bargello*, cat. 43).

fancy"). Like so many other plates by this artist, it is based on not one but several prints, the primary source being Raimondi's *Massacre of the Innocents*, after Raphael, which includes a similar squared pavement, as well as the arched bridge and distant architecture.[5] Marco Dente's version of the same theme is used for the central group of men with batons and for several other figures;[6] the youth to the right of the pedestal is derived from another Raimondi print after an ancient relief;[7] and the male figure with a Phrygian cap at the right center is taken from Marcantonio's *Rape of Helen*, also after Raphael.[8]

The *Massacre of the Innocents* was said by Vasari to have been among the first works that Marcantonio Raimondi engraved after a design by Raphael, and shows Raphael's developing interest in drawing the nude, influenced by Michelangelo's *Battle of Cascina* cartoon that he saw in Florence a few years earlier.[9] Xanto's choice of this print and the others mentioned above for his composition may reflect his own burgeoning preoccupation with the nude figure in this period – especially if one accepts as his work the earlier pieces marked "F.R./F.L.R.," most of which, by contrast, show a high proportion of clothed or draped figures. This particular print appears to have been quite popular in Urbino maiolica studios and several other examples of its use can be found in Braunschweig, the Louvre, and the Bargello.[10]

Opposite, top:
Marcantonio Raimondi, *Massacre of the Innocents* (after Raphael),

Opposite, left:
Marcantonio Raimondi, *Bas-Relief with Three Cupids* (detail; after Raphael)

Opposite, right:
Marcantonio Raimondi, *The Rape of Helen* (detail; after Raphael)

50. Plate with an allegorical scene with a woman and a putto
Urbino, Francesco Xanto Avelli da Rovigo, c.1527–30

Inscribed on verso: "mech, moch. /
leggi [flourish]"
H 3.2 cm; D 19.8 cm; shape R10
Inv. 26.331
Provenance: Castellani; Hainauer;
Clark
Bibliography: Castellani, cat. 283;
Hainauer, 38, 111, cat. 309 (M29);
Corcoran/Erdberg, 73;
Corcoran/*Bulletin*, cat. 77

1 Possibly related is a plate in the Cas-
tello Sforzesco by Xanto and dated
1530 representing the New Year, which
shows a cupid pulling a cart with two
standing nude muses (ill. in Petruz-
zellis-Scherer, figs. 5 and 6).
2 Mallet/*PLIII*, 173, figs. 4 and 12; cf.
other works of this phase in the
Walters Art Gallery (Erdberg/Ross,
cats. 48, 49, and 51; the latter has very
similar background details).
3 B.XIV, 217. In his *Polesden-Lacey III* ar-
ticle (p. 174), Mallet wrote of the cupid
figure: "The figure, probably based on
an engraving, occurs on two other
pieces with the y/φ flourish, both bear-
ing the lustred date 1528 . . . [one at
Arezzo, *Corpus I*, pl. XXVII, fig. 339R;
and one at the Petit Palais, *Corpus I*,
figs. 207 and 343R] . . . The same figure
of Cupid is, however, found in various
guises on plates signed by Xanto be-
tween 1531 and 1535."
4 B.XV, 17; see other Xanto works which
include this figure in the Castello Sfor-
zesco (inv. M226; Petruzzellis-Scherer,
fig. 11; Allegory of Rome, Naples,
Florence, and Genoa, signed with both
the painter's name and his y/φ symbol,
but no date; c.1530–31); Walters Art
Gallery (Erdberg/Ross, cat. 49; the
style of this plate is somewhat different
from that of the Clark piece).
5 The outlines of printed or drawn im-
ages on paper were pricked with a pin,
then "pounced," using a cloth bag
filled with charcoal dust; the black
powder would be forced through the
small holes, tracing the outline of the
image onto whatever surface the artist
desired; the technique of tracing out-
lines with a stylus was probably also
used.
6 Shoemaker, 9.
7 J.V.G. Mallet, "A maiolica plate signed
'F.R.'," *Art Bulletin of Victoria* (1976), 11.
8 An examination of the various forms of
Xanto's inscriptions is currently being
undertaken by Julia Triolo.

The strange and as yet undeciphered inscription on the reverse of this plate
("mech, moch / leggi") provides no clue about the meaning of the equally puzzling
subject on the front. A seated half-nude woman (Venus?) sits on a flat wheeled cart
near an undefined building, while a cupid hails her from the left side of the compo-
sition. Between them is a gnarled tree, reminiscent of Nicolò da Urbino, and a
landscape with buildings and an arched bridge.[1] The "y/φ" mark after the inscrip-
tion, and the general style of the piece place it among the œuvre of Xanto just
before he started signing his name to his works around 1530. The collection at
Polesden Lacey includes a comparable plate with an allegory of the 1527 Sack of
Rome, inscribed "Tybri avaritia co las/civia aggiunti/ nota y/φ" ("the avarice of
the Tiber joined with lasciviousness, take note").[2] In the center of that dish is a
putto identical to that on the Clark plate, and very similar architectural details
with an arched bridge in the background.

Both the putto and the seated woman reappear in numerous other works by
Xanto, and both are derived from prints: the cupid is excerpted from Marcantonio
Raimondi's "Dance of the Cupids" after Raphael (c.1517–20),[3] and the female
figure is based on the woman at lower right in "Envy driven from the Temple of
the Muses" by the Master of the Die.[4] Xanto's use of such models was clearly al-
ready well-established, and continued throughout his career. Later, when he had
his own workshop, it made it possible for him to employ assistants who, using car-
toons or pricked images, could reproduce similar images on plates to which Xanto
could sign his own name.[5] Vasari and others mentioned the important market of
artists who sought graphic works for use in their paintings, and this concept was
likewise applicable to maiolica craftsmen who owned or borrowed such prints as
well.[6] Unfortunately, this practice sometimes resulted in an occasional decline in
quality, particularly after 1530, when maiolica from Xanto's studio was in high
demand and production soared.[7]

A plate similar to the present one is in the collection of the Glasgow City Art
Gallery and it also bears a perplexing subject: two putti carry small flag-like pin-
wheels while an old man holds a staff topped by a crescent. On the reverse, a no-
tation reads "tich, tach. / nota y/φ". The mystery of these two curious pieces re-
mains to be solved, although perhaps examining them together may produce new
thoughts about their iconography and inscriptions. Like many of Xanto's works,
they carry brief postscripts or messages to the viewer, like "nota" (take note), or
"leggi" (read); others are marked "fabula" or "historia" (signifying "fable" or
"story").

These relatively early inscriptions, short and telegraphic in form, are one of
several types commonly used by Xanto. Others consist of longer phrases, some-
times derived from literature (see cat. 54) and often carefully noting the exact
source (see cat. 51), while some of the most extensive are actually poems (see cat.
53), either composed by the painter himself or borrowed from another author.[8] As
we know from the laudatory sonnets Xanto created in honor of Duke Francesco
Maria, the artist had fairly serious pretentions about his poetic endeavors.
Although other maiolica painters were known to have signed or initialed their
works even earlier (e.g. cats. 9, 27, and 41), it was this Urbino master who conven-
tionalized the practice.

Far left:
Marcantonio Raimondi, *Dance of the Cupids* (detail; after Raphael)

Left:
Master of the Die, *Envy Driven from the Temple of the Muses* (detail; after B. Peruzzi)

51. Plate with Amphiaraus and Eriphyle (from the Hercules Service)

Urbino, Francesco Xanto Avelli da Rovigo, 1532

Inscribed on verso: "1532 / Quell' auara moglie/ di Amphiarao / Nel VIIII L de Ouidio Meth: / fra : Xanto A Roui/giese, i Urbino / pi :" ("That greedy wife of Amphiaraus/ In the ninth book of Ovid's Metamorphoses / Francesco Xanto Avelli from Rovigo in Urbino painted it")
Coat of arms: Or, Hercules rending the Nemean lion proper
H 3.5 cm; D 25.9 cm; shape L9
Inv. 26.354
Provenance: Hainauer; Clark
Bibliography: Hainauer, 115, cat. 332 (M52); Corcoran/Erdberg, 73–74; Corcoran/*Bulletin*, cat. 79

1 The service includes: two plates in the British Museum (inv. 1855, 12–1, 45 and 1913, 12–20, 120, the latter ill. in *Corpus II*, fig. 38); two in the V&A (Rackham, cats. 630–631); one at the Museo Internazionale delle Ceramiche, Faenza (ill. in *Faenza* LIV, 1968, pl. LXVIIb); one at Armstrong College (University of Durham, Newcastle-on-Tyne); one formerly in the Pringsheim Collection (ill. in *Corpus II*, fig. 37).
2 E.g. Mallet/*PLIII*, pl. II. The Painter of the Milan Marsyas also had a hand in this group as well; see B. Rackham, "Xanto and 'F.R.'," *Faenza* XLIII (1957), 106, n. 24, for a list of the pieces in the Three Crescents Service.
3 B.XIV, 104.
4 *Isaac Blessing Jacob* (after Raphael), B.XIV, 6.
5 Other Xanto plates with the subject of Amphiaraus are in the Musées d'Art et d'Histoire, Brussels (*Corpus II*, fig. 22), the Hermitage (*Corpus II*, fig. 23), and the museum at Sèvres (*Corpus II*, fig. 88).
6 OCD, 53.
7 Verbal communication with author, 7/7/85.
8 Cartari-Febei, busta 175, folio 434r, no. 8.
9 Vittorio Spreti, vol. VI, 459. Spreti's description of the *stemma* reads: "D'azzurro all'Ercole appoggiato sulla schiena d'un leone in atto di squarciargli la gola; il tutto al naturale; movente dal terreno di verde, accompagnato dal sole d'oro orizzontale destro e sormontato da un breve d'argento carico del motto: De forti dulcedo."

At least eight plates remain from a service executed by Francesco Xanto Avelli in 1531–32 for a family whose coat of arms shows Hercules rending the lion's jaw.[1] The Hercules group appears to be the earliest of the painter's signed and dated services, although he was almost certainly responsible also for part of another group (c.1530) with a *stemma* of three crescents which he signed with his y/φ flourish.[2] Among the factors linking the two sets is the standing woman at the right of the Clark plate which is also used to represent Psyche on the Three-Crescent piece at Polesden Lacey. In both cases, Xanto has transformed a male figure taken from Marcantonio Raimondi's print of the Martyrdom of St. Lawrence (after Baccio Bandinelli) into female characters for the purposes of these two compositions.[3] This graceful draped figure, seen from behind, was one of his favorites, and is found on many of the artist's works; here, she represents Eriphyle, the wife of Amphiaraus. Another Raimondi print [4] provided the inspiration for the crouching Amphiaraus, although Xanto altered the original youthful figure by reversing it and adding a full white beard.

The story, mentioned only briefly in Ovid's *Metamorphoses* (Book IX), refers to the prophet Amphiaraus, who foresaw the disastrous outcome of Polyneices' campaign of the "Seven against Thebes," and that none of the seven would return alive except his brother-in-law Adrastus. He eventually was forced to join the enterprise, however, because he had sworn an oath to let his wife Eriphyle decide all disputes between himself and her brother (Adrastus) who was in favor of the attack. Eriphyle, having been bribed by Polyneices with a dazzling golden necklace, persuaded her husband to participate.

This scene, portrayed many times by Xanto,[5] has usually been interpreted as the moment after the attack at the Homoloian Gate of Thebes when Amphiaraus was driven off, and as he fled was swallowed up in a chasm created by a thunderbolt from Zeus.[6] Timothy Wilson has suggested, quite plausibly, that although this was the portion of the legend recounted in the 1497 Venetian version of Ovid's *Metamorphoses* (upon which Xanto often relied), the scene shown here is Amphiaraus hiding to avoid participation in the fateful campaign. In fact, this theory would be more consistent with the presence of Eriphyle and the golden necklace, and Polyneices (?) with two other warriors at left.[7] Also supporting that hypothesis is the fact that Xanto is known to have depended not only upon Ovid for his subjects, but also upon the works of other authors and mythographers such as Hyginus for more complete details.

The coat of arms of the service has long remained unidentified, although it is a distinctive and unusual one; a proposal that it belonged to the Ercolessi family has not been substantiated. It seems, however, that the *stemma* may be related to a Ferrarese family whose name, Squarzioni, suggests the Italian word *"squarciare,"* meaning "to rend open a jaw or mouth." A pen and ink drawing of their coat of arms – Hercules rending the lion's jaw – is recorded in a manuscript in the Archivio di Stato in Rome,[8] but without color notations. Spreti's more recent description of the Squarzioni arms is generally consistent with the arms drawn by Xanto, although it includes a sun and motto above the figure of Hercules.[9] Two possibilities may be offered for the differences in the arms: that the family's heraldry underwent minor changes or additions, as was sometimes the case, or that because of the limitations inherent in the technique of maiolica painting, it was not possible to insert the finer details of sun and motto. Further research will be needed to confirm this attribution, but it is tempting to suggest that the service was indeed produced for the Squarzioni family, whose main branch was in Ferrara, near Xanto's own home town of Rovigo.

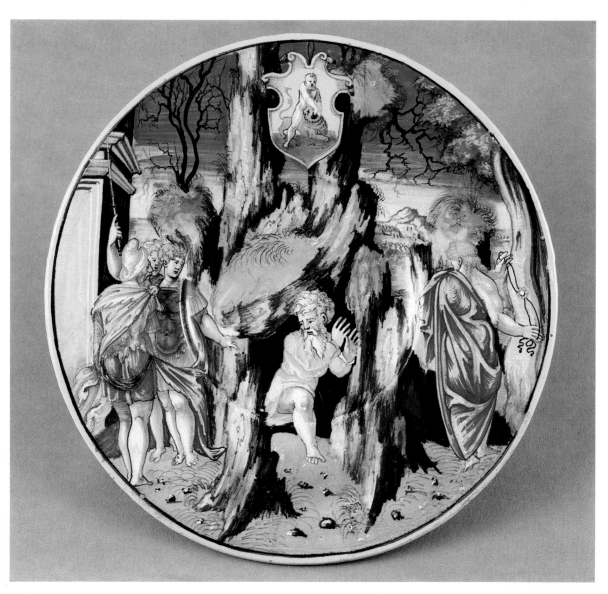

Far left:
Marcantonio Raimondi, *Isaac Blessing Jacob* (detail; after Raphael)

Left:
Marcantonio Raimondi, *Martyrdom of St. Lawrence* (detail; after Baccio Bandinelli)

52. Plate with the Sinking of the Fleet of Seleucus (from the Pucci Service)

Urbino, Francesco Xanto Avelli da Rovigo, 1532

Inscribed on recto, on banner: "SELE/VCO" ("Seleucus"); on verso: "1532 / La Classe di Seleuco i / mar'sommersa / Nel XXVII Libro d Iustino Histo: / fra: Xanto A / da Rouigo, i / Urbino" ("The fleet of Seleucus, submerged in the sea, in the 27th book of Justin's History, Francesco Xanto Avelli of Rovigo, in Urbino"); on verso near rim: "af 84" (scratched into glaze; Fountaine inventory number)
Coat of arms: Argent, a moor's head proper wearing a headband argent charged with three hammers sable; behind the shield is an *ombrellino*
H 2.6 cm; D 25.7 cm; shape L9
Inv. 26.361
Provenance: Bernal; Fountaine; Hainauer; Clark
Bibliography: H.G. Bohn, *A guide to the knowledge of pottery, porcelain and other objects of vertu . . . an illustrated catalogue of the Bernal Collection . . .* (London, 1862), cat. 1738; Fountaine, cat. 40; Hainauer, 116, cat. 339 (M59); Corcoran/Erdberg, 74; Corcoran/ *Bulletin*, cat. 8; Corcoran/ Clark, 77, fig. 61

1 The most recent list of the Pucci Service can be found in Timothy Wilson's forthcoming article, "Heraldic Pottery of the Renaissance: Associations and Problems of Some Historic Pieces," *Ringling Museum of Art Journal*; see also the forthcoming catalogue of the Lehman Collection of the Metropolitan Museum of Art by Jörg Rasmussen, which will treat the group, and a dissertation in progress on the Pucci Service by Julia Triolo (Pennsylvania State University).
2 Mallet/*PLIII*, 176–177.
3 See Wilson's forthcoming publication (¹ above).
4 Litta, vol. XIV.
5 It is not clear exactly how they were displayed on *credenze*, which are large sideboards or chests with flat tops; it is probable that there must have been a temporary shelf or rack atop the *credenza*, which would in turn support the plates. Silver and gold plates are sometimes shown displayed in this way in paintings, as in Giulio Romano's *Wedding of Psyche* in the Palazzo del Tè.

Certainly the largest and perhaps the most studied of Xanto's services is the one to which the present plate belongs.[1] There are at least thirty-seven pieces, including plates of various sizes and a salt-cellar in the British Museum; all bear dates of 1532, except two that are marked 1533. The Hercules Service of 1531–1532 (see cat. 51) and the Pucci Service must therefore have been either chronologically contiguous or possibly even overlapping. Mallet has noted that the quality of the Pucci plates is often not outstanding, and that they frequently have a "hurried" look about them, perhaps the result of large orders being commissioned from Xanto's workshop under tight deadlines.[2]

The substantial number of surviving pieces from the set makes possible an examination of the choice of subjects, as well as the style, level of quality, and breadth of graphic sources employed by the painter. Several plates bear scenes which have yet to be identified, although most, like the Clark dish, have inscriptions referring to their sources on the reverse. Among the known themes are fourteen from Ovid's *Metamorphoses* (Xanto's mainstay), six from Virgil's *Aeneid*, two each from Valerius Maximus and Ariosto's *Orlando Furioso*, and one each from Petrarch, Pliny the Younger, and Justin.[3] Thus far, no particular program has been discerned in the present service, except for the obvious concentration on classical authors, especially Ovid and Virgil, as might be expected.

Little documentation is available on the intriguing question of how a painter like Xanto had access to these literary sources and to the prints and drawings that were adapted for use on maiolica. It is clear that Xanto was quite well-educated, perhaps even erudite, but no evidence remains of either a library or patternbooks owned by him. Patrons would presumably have been one possible source for literary or visual resources, but such materials were certainly available to Xanto long before he began receiving major commissions in his own workshop.

The patron of this service was a member of the Pucci family, whose coat of arms includes a moor's head with a white headband. The three small shapes on the band were described by Litta as hammers, representing the art of woodworking once practiced by the family's ancestors; later, these tools were transformed into the letter "T," symbolizing the motto "Tempori, Tempora, Tempera."[4] Here, the arms are augmented by the addition of the Papal Gonfalon (the small umbrella-like baldachin over the shield), and have always been said to belong to Piero Maria Pucci (b. 1467) who supposedly became Gonfalonier to Pope Leo X in 1520. This information has been passed down in the literature for many years, although there appears to be no documentary evidence for Piero Maria's elevation in 1520 to that papal office. The issue of who was the true patron of Xanto's service must therefore remain uncertain until further research can be undertaken in the Pucci family archives.

In any case, it is certain that some Pucci family member commissioned the large group, which was probably displayed on *credenze*, rather than employed in the service of food.[5] While some pieces – such as pharmaceutical wares – were certainly intended for utilitarian functions, others were most likely meant as part of the household decoration of an aristocratic family. The display of such *istoriato* wares in one's palazzo would also, of course, serve to point up the host's level of erudition by the choice of subjects on the maiolica. The selection of the themes on the Pucci service, for example, is a direct reflection of the *cinquecento* preoccupation with the revival of antique literature, as well as the strong interest in "moderns" such as Ariosto and Petrarch.

The subject of the Clark plate – the sinking of the fleet of Seleucus – is recorded in Marcus Junianus Justinus' *History of the World* (Book XXVII), as Xanto noted

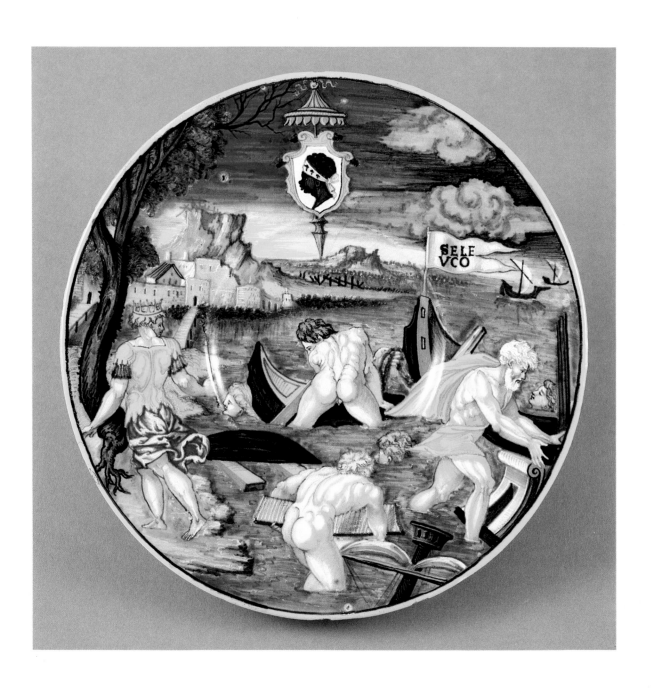

6 *OCD*, 571.

7 John S. Watson, *Justin, Cornelius Nepos, and Eutropius* (London, 1853), 205–207.

8 At least one other plate by Xanto with a Seleucus subject exists (Fitzwilliam Museum, inv. c87.1961; 1533); a marine battle scene, possibly related is in the Musée des Arts Décoratifs, Lyon; a plate of 1533 by Xanto showing the escape of Seleucus was sold at Sotheby's (6/25/1931, lot 8) but may be the Fitzwilliam plate.

9 B.VIII, 14; see Norman, 179, for a discussion of Xanto's many other uses of this print.

10 B.XIV, 104, after Baccio Bandinelli.

11 B.XIV, 226.

12 Petruzzellis-Scherer, fig. 31.

carefully on the back. Justin was, in actuality, not properly an author, but an abridger who made an "epitome" (or edited version) of Pompeius Trogus' *Historiae Phillipicae*, probably in the third century AD, that was widely read in the Middle Ages and the Renaissance.[6] The particular event shown here involves Seleucus II, who upon succeeding his father as King of Syria, put to death his stepmother – the sister of Ptolemy (King of Egypt) – and her small son. Horrified by this deed, a number of cities under Seleucus' domain revolted and took the side of Ptolemy. The fleet raised by Seleucus in defense was completely destroyed by a huge storm that suddenly arose, "as if the gods themselves had taken vengeance on him for the murder," leaving him with little more than his life and a few companions.[7] In a curious reversal, the rebelling cities, feeling that recompense had been made, put themselves under his rule once again. The story is a complex political one, and one wonders if Xanto chose to depict it (as he did more than once)[8] as an allegory of some contemporary event in Italy.

The fleet's destruction is portrayed in an allegorical fashion, with large figures (meant to represent gods?), fragmented ships, and drowning figures. As usual, Xanto has taken his characters from prints: the crowned figure at the left (Seleucus) from a print of 1528 by the Master I.B. (Georg Pencz);[9] the red-haired nude above perhaps based upon a kneeling man to the right of the saint in Marcantonio Raimondi's *Martyrdom of St. Lawrence*;[10] the bearded man rushing out of the composition at right from Marco Dente da Ravenna's *Naked Man pursuing a Naiad*;[11] and the nude foreground figure from Marcantonio Raimondi's licentious series of prints after drawings by Giulio Romano showing various sexual poses.[12]

Opposite:
Detail of reverse

This page, top:
Marco Dente, *Naked Man
pursuing a Naiad*

Below left:
Master IB (Georg Pencz), *Sol*
Below right:
Marcantonio Raimondi, print
from the series *I Modi* (after
Giulio Romano)

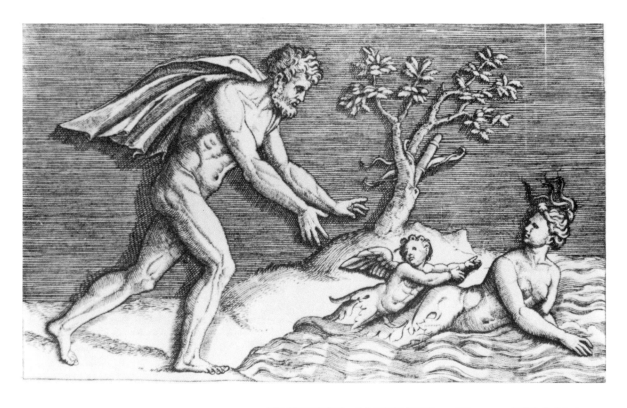

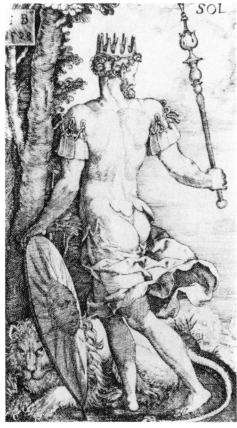

53. Plate with the Battle of Roncevaux
Urbino, Francesco Xanto Avelli da Rovigo, 1533

Inscribed on recto, on shield: "M D X/XX/II/I" ("1533"); on banner: "M Y / X / H Q"; on verso: "M D XXXIII / Arme, Co[?]tasti, guerre & gra battaglie / Dio no si truoua i terra altro che Marte / Co[?]i[?]gi, saccomani, ombre, e bagaglie / Nel []so libro del Vescouo Turpino / o credi o no & [flourish]/ f X A / Ruuigiese i / Urbino" ("1533 / Arms, [?], war, and great battles / No god can be found on earth except Mars / [?], sacks, shadows, and baggage (loot?) / from the [?] book of Bishop Turpin, either believe it or not, etc. / Francesco Xanto Avelli from Rovigo, in Urbino")
H 4.0 cm; D 43.4 cm; shape L21
Inv. 26.356
Provenance: Hainauer; Clark
Bibliography: Hainauer, 115, cat. 334 (M54); Corcoran/Erdberg, 74; Corcoran/*Bulletin*, cat. 81.

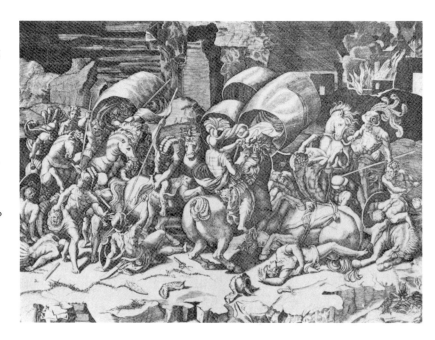

1 Marcantonio Raimondi (after Raphael), *Rape of Helen* (B.XIV, 209); Gian Giacomo Caraglio (after Rosso Fiorentino), *Hercules Killing Cerberus* (B.XV, 44), *Hercules Killing the Hydra* (B.XV, 46), *Hercules Fighting Cacus* (B.XV, 49); Marcantonio Raimondi or Marco Dente (after Giulio Romano), *Battle with Cutlass* (B.XIV, 211). The kneeling figure in the right foreground appears also in cat. 52 and its source is unknown; it bears some resemblence to a figure in the *Martyrdom of St. Lawrence* (after Baccio Bandinelli), but may also be derived from one of the lost prints of Giulio Romano's "I Modi" series (see cat. 52).
2 None of the Xanto plates in the Clark Collection were lustred, although the painter often sent his *istoriato* wares to Gubbio for the addition of the metallic pigment, as we know from the inscriptions and dates written on their reverses in Maestro Giorgio's workshop (e.g., *Corpus I*, figs. 207 and 343R; *Corpus II*, figs. 107 and 353R).
3 Rackham, cat. 632; it has a three-line poem on the reverse describing the subject which Xanto adapted from Petrarch's *Trionfo di Fama*, transforming the original reference to Semiramis into one to Roxanne.

One of the largest pieces in the Clark Collection and the most imposing of the group by Xanto, this monumental plate is dated 1533, the year after the Hercules and Pucci examples (cats. 51 and 52). The present composition is much more crowded and elaborate than either of those, however, and the broad shallow expanse was used to its fullest advantage by the painter, who concentrated the action of the frenzied battle scene in a frieze-like band across the center of the plate.

As in his other works, Xanto drew heavily on engravings for his characters, in this case taking at least fifteen main figures from five and possibly six prints: Marcantonio Raimondi's *Rape of Helen* (after Raphael), three prints by Gian Giacomo Caraglio showing Hercules battling Cerberus, the Hydra, and Cacus, and the *Battle with a Cutlass*, engraved by Raimondi or Marco Dente after Giulio Romano.[1] Comparing the latter print, with its broad band of rearing horses and furiously fighting warriors, as well as its spare foreground and dramatic background of burning buildings, it seems likely that Xanto may have derived his composition, as well as a few of his figures, from Giulio's original design.

In a sense, the present plate represents Xanto at the height of his career, taking on a major compositional challenge (while relying on familiar graphic sources), and executing the many muscular figures with his characteristic volumetric modelling and a full, rich palette of yellow, orange, green, blue, turquoise, purple, brown, black and white.[2] The background architecture is an interesting mixture of classical motifs (in the manner of Nicolò), with additional elements of both fortress and fantasy. A comparable work from the same year is the large and sumptuous Alexander and Roxanne dish with the arms of Frederico II and Margherita Paleologo; based mainly on Caraglio's print after Raphael of the same subject, the V&A plate includes two of the same figures from the *Battle with Cutlass*.[3]

Xanto's inscriptions of this period occasionally took the form of three or four-line poems, sometimes of his own invention, and sometimes adapted from other

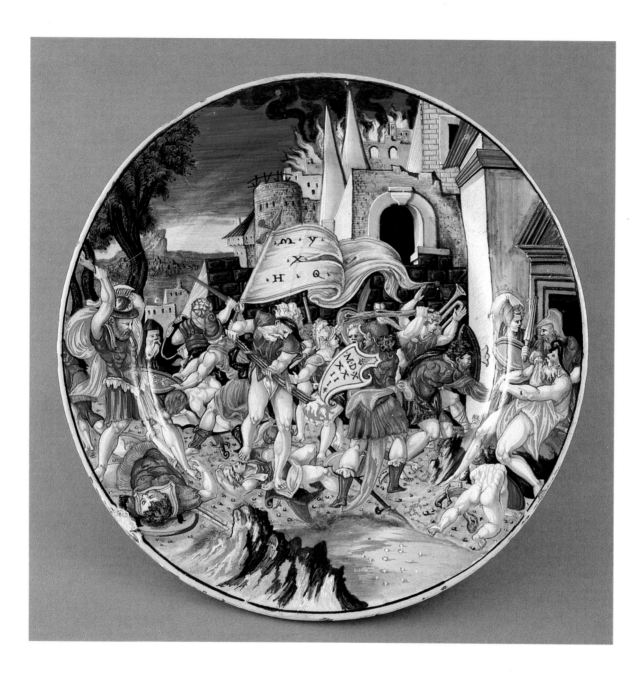

Opposite:
Marcantonio Raimondi, *Battle with a Cutlass* (after Giulio Romano)

G.G. Caraglio, *Hercules Battling the Hydra* (after Rosso Fiorentino)

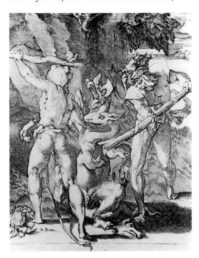

G.G. Caraglio, *Hercules and Cacus* (after Rosso Fiorentino)

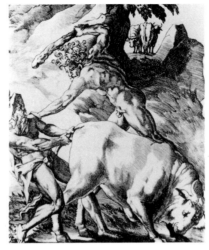

G.G. Caraglio, *Hercules Battling Cerberus* (after Rosso Fiorentino)

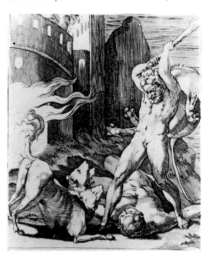

4 Three- and four-line poetic inscriptions by Xanto, dating from 1531 to 1535, are recorded in Ballardini's *Corpus II* (figs. 222, 246, 247, 258, 275, 307, and 349).

5 The curious letters on the banner in the center of the battle scene have also not been decoded.

6 I am grateful to Professors Donald and Sarah Maddox for their assistance with the interpretation of the subject matter on this plate.

7 W.S. Merwin, "The Song of Roland," in *Medieval Epics* (New York, 1963), 93.

8 The most recent treatment of this work is Ronald N. Walpole's *Le Turpin français, dit le Turpin I* (Toronto, 1985); see also by the same author, *An Anonymous Old French Translation of the Pseudo-Turpin "Chronicle"* (Cambridge, MA, 1979).

9 U.T. Holmes, Jr., *A History of Old French Literature from the Origins to 1300* (New York, 1962), 78.

10 A Franco-Italian version of the original epic (the *Chanson de Roland*) exists in the library of San Marco, Venice (Merwin, op. cit., 93), but no Italian version of the Pseudo-Turpin is mentioned by Walpole, who lists vernacular translations in Provençal, Catalan, Galician, Welsh and Old Norse (Walpole, *An Anonymous Old French Translation . . .*, 5).

authors.[4] The poem on the Clark plate is difficult to decipher, in part because of breaks and restorations, but it clearly refers to things of a warlike nature.[5] Xanto is clear about his source, noting that the story is taken from the book of Bishop Turpin, although he hastens to add the disclaimer "believe it or not." Considering the combination of the battle scene with its source notation, the scene must represent the great Battle of Roncevaux.[6] This appears to be Xanto's only use of this literary source, a re-telling of the *Chanson de Roland*. Known as the *Historia Karoli Magni et Rotholandi* of the Pseudo-Turpin, it was part of a 12th-century *Guide to the Pilgrims of Santiago de Compostella*,[7] written in Latin prose and translated into French around 1210–20.[8] So enormous was the popularity of this version of the tale that the Roland windows of the basilica at St. Denis and Chartres cathedral were based upon it instead of on the original French epic.[9]

The composer of this fictional "eye-witness" account of the campaigns of Charlemagne and Roland against the Saracens in Spain was apparently an unknown cleric who identified himself with Turpin, the archbishop of Reims and faithful companion of Roland, who in the original tale died at the Battle of Roncevaux. In the later version, he survived the battle and lived on to tell the story. In the Middle Ages, the work of the Pseudo-Turpin was seen as an accurate account of the story, and it was only in the Renaissance that its fictional nature became evident.

It is not certain how Xanto came to know the Pseudo-Turpin, or which of the several translations he may have used.[10] As this was his only reference to the tale – and no other known maiolica painter seems to have based a work on it – it may have been specifically requested by a patron who himself owned such a manuscript. Xanto's comment, "believe it or not," however, is evidence that he was well aware of the spuriousness of this supposedly historical account.

54. Plate with Pyramus and Thisbe
Urbino, Francesco Xanto Avelli da Rovigo, 1536

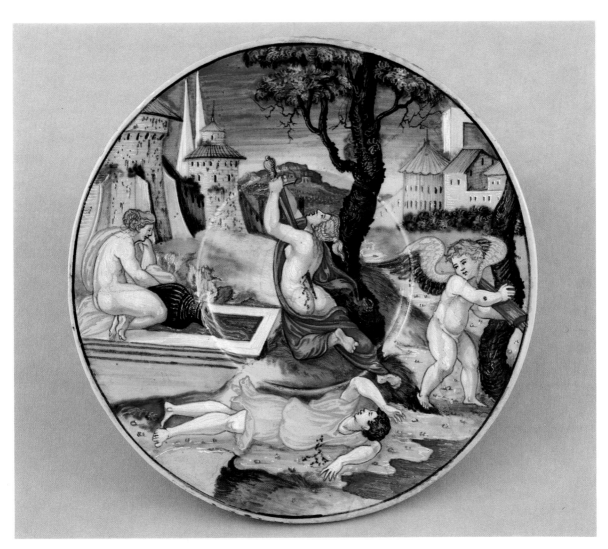

Inscribed on verso: "1536 / Vedi piramo ,e, Tisbe/ isieme a l'ombra / F X / Roui:" ("1536 / Behold Pyramus and Thisbe, together in the shade of the tree / Francesco Xanto from Rovigo")
H 2.5 cm; D 26.1 cm; shape L9
Inv. 26.360
Provenance: Hainauer; Clark
Bibliography: Hainauer 38, 115, cat. 338 (M58); Corcoran/Erdberg, 74; Corcoran/*Bulletin,* cat. 82

Far left:
Master PP. *Maenad*
Left:
G.G. Caraglio, *Contest between Pierides and the Muses* (detail; after Rosso Fiorentino)

1 See J.V.G. Mallet, "La biografia di Francesco Xanto Avelli alla luce dei suoi sonetti," *Faenza* LXX (1984), 398–402.

2 The latest dated work of the artist (1542) is referred to by Kube as being in the Hermitage collection, although it is not included in the 1976 catalogue (Kube, 47).

3 Mallet, "La biografia . . .", pls. CXI–CXII.

4 Mallet/*PLIII*, 182.

5 Guidotti/*Bologna*, cat. 96.

6 The graphic sources for the figures are as follows: the crouching nude is taken from G.G. Caraglio's *Contest between Pierides and the Muses* (after Rosso; B.XV, 53); the figure of Thisbe is based on a print of a maenad by the Master PP (B.XIII, 1); and the figure of Pyramus is a variation of the dead soldier in the foreground of Raimondi's *Battle with Cutlass* (after Giulio Romano, B.XIV, 211). The putto at right appears in many of Xanto's works and is similar, but not identical to one in the *Marriage of Alexander and Roxanne* (Caraglio, after Raphael; B.XV, 62), also used very often by the artist. An example of Xanto's sometimes bizarre reuse of these figures is a plate in the National Gallery of Art, Washington, showing the theme of Hero and Leander; in this composition, the maenad used to represent Thisbe is turned sideways to become Hero leaping out of her tower window.

7 A list of several pieces with this subject is given in Hausmann, 197; see also Giacomotti, cat. 857, for a Pyramus and Thisbe plate by Xanto at Sèvres; and the Bologna piece (5 above).

8 Identified by Giacomotti, 268.

9 Ovid/Innes, 97.

10 Ibid., 21.

By the time Xanto painted this plate with Pyramus and Thisbe in 1536, he was already close to fifty years old, if Mallet's newly-proposed chronology is correct.[1] He continued to sign and date his works up to 1542, sometimes abbreviating his signature, as he does here, to a simple "F.X." or later "X."[2] In 1541, about three years before his death (c.1544), he signed at least one plate: "In Urbino nella bottega di Francesco de Silvano,"[3] indicating that he was in fact working in that shop towards the end of his life. As Mallet has pointed out, it is actually not known "how far Xanto was his own master at any stage of his career" and that "he never signed himself *maestro*."[4]

The present plate is a very fine example of his work of the mid-thirties, well-drawn and coloristically harmonious. The existence of another Pyramus and Thisbe dish of 1535 in the Museo Civico of Bologna provides an opportunity to compare two versions of the same theme executed by the painter only a year apart.[5] Both use identical graphic sources for the four figures,[6] although Xanto has made a few judicious changes in the composition, reversing the prone figure of Pyramus in the foreground and altering the position of one arm, moving the central tree slightly to the right to provide a less obstructed view of the dying Thisbe, and replacing the masonry wall at right with more unobtrusive distant architecture. The later composition is a better-balanced and more well-considered rendition of the subject.

The tragic love story was taken up several times by Xanto, from as early as 1531, when he painted a plate now in the Victoria and Albert Museum, until 1539, the date of the last known version in Berlin.[7] The inscription on the Clark plate, like those of Bologna, Sèvres, and Berlin, is a citation from Petrarch's *Triumph of Love, II* although Xanto does not identify it as such.[8] The tale is taken once again from Ovid's *Metamorphoses* (Book IV), and tells of Pyramus and Thisbe, two young lovers in Babylon who talked through a crack in the wall between their houses but were forbidden by their parents ever to marry. They agreed to meet in secret one night near the tomb of Ninus, outside the city walls. Thisbe arrived first at the tomb, where there was a white mulberry tree and a cool spring (represented allegorically by Xanto in the form of a crouching nude pouring water from a large jar). Frightened away by a fierce lion, Thisbe dropped her veil and the lion ripped it apart "with bloodstained jaws."[9] Pyramus, finding the stained veil, feared the worst for his lover, and killed himself in despair; discovering his lifeless body upon her return to the tomb, Thisbe joined him in death, stabbing herself with the same sword. Their blood flowed to the roots of the nearby mulberry tree, which ever after bore only red fruit.

Of all the tales in the *Metamorphoses*, that of Pyramus and Thisbe proved one of the most popular, a fact that is reflected in the repeated use of the theme by Xanto. Boccaccio, who was especially attracted to Ovid among the classical authors because of his storytelling ability, retold the legend of the tragic lovers in his *Amorosa Visione*. The episode's appeal also extended to England, where Chaucer based a story upon it in his *Legend of Good Women*, and, at the end of the 16th century, Shakespeare included a burlesque of the tale in *A Midsummer Night's Dream*.[10]

55. Plate with the Plague of Phrygia (after Raphael)
Urbino, c.1535–40

The unknown painter of this plate made an unusual and interesting choice in selecting Raphael's *Plague of Phrygia* as his subject, a composition known today through two surviving drawings and Marcantonio Raimondi's superb engraving of c.1515–16.[1] Apart from the inscription on the base of the central herm, however, the anonymous artist left no indication of his identity or workshop affiliation, the date of the piece, or the source from which the theme was taken. Perhaps one of the finest and most technically impressive of the engravings that resulted from the Raphael-Marcantonio Raimondi collaboration, the image may in fact have been readily recognizable to most viewers, as some thirty years had already elapsed between the completion of the print and the execution of the Clark plate.

Raphael's composition, also known as "The Morbetto," or "little plague" because of its small size, is thought to have been designed specifically for Marcantonio to engrave, and is identical (though in reverse) to the Uffizi drawing which must have served as the final model for the print.[2] The subject is drawn from the third canto of Virgil's *Aeneid*, as is the inscription at the center: "The people either lost their precious lives, or could hardly move, so ill they were."[3] This part of the story tells about the great plague that descended upon the Trojans in Crete, and the subsequent dream of Aeneas in which he was instructed to lead them to Hesperia, the so-called Western Land: "The inhabitants used to be Oenotrians; but it is said that their descendants have now called the country Italy after one of their leaders. This Italy is our true home."[4]

Chosen by Dante as his guide through the Underworld to the Gates of Paradise, Virgil was without doubt the most revered of all ancient writers in Renaissance Italy and the *Aeneid*, the third and longest of his poems, was probably the most widely read secular book in Europe.[5] This legendary epic celebrates the origin and growth of the Roman empire, and traces the Roman line of descent back through the hero Aeneas to the inhabitants of Homer's Troy. The episode recounted in Canto III and reproduced on the present plate is one of the critical points in the journey of the Trojans from the eastern Mediterranean to Italian soil, which may have been one reason Raphael chose to depict it. Considering the high esteem in which Virgil's *Aeneid* was held, it is curious that relatively few pieces of maiolica show themes from it, nor, indeed, does it appear often in the major arts of the period.[6]

Raphael's design emphasizes the nocturnal setting of the scene, taking fullest advantage of the opportunity to exploit unusual effects of light and space. Raimondi's engraved version is a tour-de-force of the technique, using rich textures and a varied tonal range to translate Raphael's drawing effectively into the print medium.[7] Night scenes appear rarely on maiolica, and perhaps it was this challenge that so appealed to the painter of the Clark plate, despite the difficulty of converting the compositional format from rectangular to round, and transforming the subtle monochromatic nuances into colorful ceramic pigments. Yet the result is not as successful as it might be due to the limitations of both the artist and the maiolica technique itself. In the adjustment of the composition from one shape to another, the scene becomes compressed because of the reduced width, and somewhat distorted because of the three-dimensional nature of a dish. The painter also

Inscribed on recto, on pedestal:
"LINQUEBANT / DULCES ANI/MAS AVTAE/ GRA TRAHE/BANT / CORP"
H 2.5 cm; D 26.7 cm; shape L9
Inv. 26.369
Provenance: Spitzer; Hainauer; Clark
Bibliography: Spitzer, cat. 126; Hainauer, 38, 117, cat. 347 (M67); Corcoran/*Bulletin*, cat. 86.

1 B.XIV, 417; Shoemaker, 118; see drawings in the Uffizi (inv. 525E; "The Morbetto") and Windsor Castle, Royal Library (inv. O117; "Landscape with classical ruins").

2 Shoemaker, 118.

3 Virgil, *The Aeneid* (Baltimore, 1962; transl. W.F. Jackson Knight), 79.

4 Ibid., 80.

5 Ibid., 23. The translator of this edition also pointed out that "For nearly five hundred years, from soon after printing was invented, at least one new printed edition was published annually."

6 Around the same time as "The Morbetto," Raphael made another design for an engraving by Marcantonio, the "Quos Ego," with ten scenes from Book I of the *Aeneid*, arranged in the style of a first-century AD Roman relief (Shoemaker, 120–122); this print seems to have had more appeal for maiolica painters, and eight examples of its use on plates and bowls have been noted by Norman (including the one in the Wallace Collection, cat. C36, 88–90). Subjects from the *Aeneid* became more popular with painters in the Baroque era.

7 Shoemaker, 118.

Marcantonio Raimondi, *The Plague of Phrygia* (after Raphael)

apparently did not have a complete grasp of perspective drawing, and the background (particularly the fallen column on the right) suffers from a lack of spatial coherence. The scene of Aeneas' vision at the upper left now appears to hover in the darkness rather than recede into depth as it does in the original design.

The anonymous author of this plate, whose ambitions may have proved greater than his talents, was probably at work in an Urbino studio around the time of Xanto. He declined to sign his work, and his personal style is somewhat masked by the fact that the present composition is a direct copy rather than a free invention. It is therefore difficult to offer any specific attributions, and no comparative works have as yet been found.

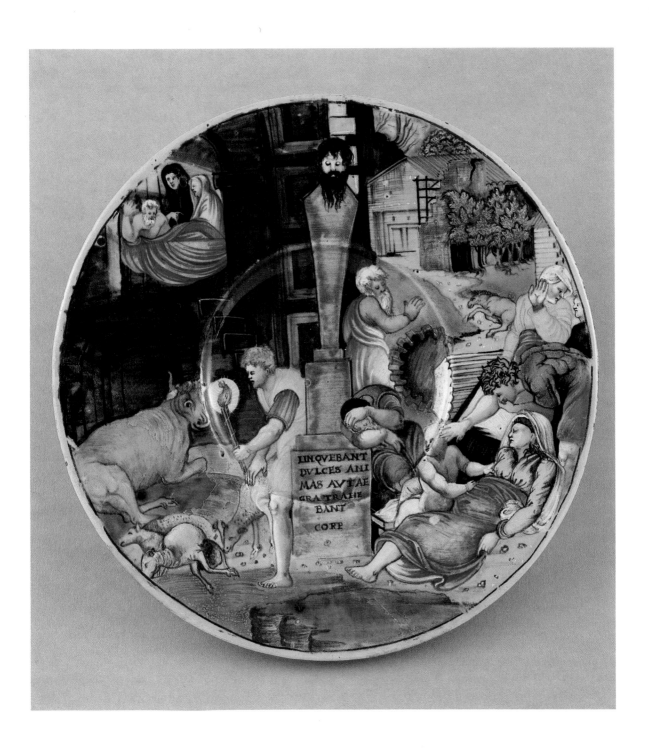

56. Plate with Apollo and Marsyas
Urbino, Painter of the so-called Della Rovere Service, 1541

Inscribed on verso: "1541 / Dapolo : e marsia / Vrbino" ("of Apollo and Marsyas, Urbino"); on verso near rim: "af 51" (scratched into glaze; Fountaine inventory number)
H 3.3 cm; D 27.5 cm; shape L8
Inv. 26.364
Provenance: Hainauer; Clark
Bibliography: Hainauer, 116, cat. 342 (M62); Corcoran/*Bulletin*, cat. 87

1 In addition to the Clark piece, examples are found in the V&A (Rackham, cats. 869–874); the British Museum (*Hercules carrying the pillars*; see Rackham, 290); the Museo Civico, Bologna (Guidotti/*Bologna*, cats. 107–109); Musée d'Art et d'Histoire, Chambery (ill. in Guidotti/*Bologna*, figs. 107c–d); Braunschweig (Lessmann, cat. 311); other pieces listed by Guidotti are in the collection of the Art Museum of Princeton University, the Hermitage, and an unnamed private collection; Lessmann notes two others on the London market and in the Musée des Beaux Arts, Lyon.
2 Rackham, 290.
3 Ibid.
4 For architecture on maiolica, see C. Bernardi, *Immagini architettoniche nella maiolica italiana del Cinquecento*, (exh. cat.; Milan, 1980).
5 See Guidotti/*Bologna*, cat. 108 and Rackham, cat. 873.

At least eighteen pieces of maiolica have been noted by various scholars as belonging to the same hand as this Clark plate, a number of them having inscriptions and dates ranging from 1541 to 1545 in a style of handwriting that is both distinctive and consistent.[1] Originally, this artist was called the "Painter of the Della Rovere Dishes" by Fortnum because of the two plates in the V&A and the British Museum with a *stemma* he erroneously identified as belonging to "Cardinal Giuliano della Rovere, Archbishop of Ravenna."[2]

Although there is a certain diversity among them in subject and manner, specific stylistic traits pervade the group, notably the extremely crowded and intricately interwoven compositions with unusual landscape conformations (such as the craggy foreground here), rich vegetation, and an emphasis on architecture in both the foreground and background. Rackham pointed out some particular mannerisms in the drawing of human figures, especially their "high narrow heads with close-set eyes and long noses;"[3] in addition, his characters often have wild flame-like hair, elongated limbs with small, narrow feet, and pronounced calf muscles set off by a curving line. What the artist lacks in anatomical understanding or perspectival accuracy, he makes up for in dramatic intensity. The story of Apollo and Marsyas – an obvious favorite of maiolica painters – possesses a heightened theatricality not seen in the other version in the Clark Collection (cf. cat. 46).

The artist's figural style and his frequent and prominent use of architecture in his scenes[4] suggest that he was looking carefully at the work of other contemporary Urbino painters of the time – especially Nicolò and his colleague the Painter of the Milan Marsyas, as well as Xanto – and may even have been trained by or worked alongside them. The round temple here, with its scale-patterned dome, and the related pavilion in the artist's *Fetonte* plate in Bologna are clearly reminiscent of buildings on Nicolò's plates, as are the classically-derived structures that form the backdrop for the action on the *Camillus* plate in the V&A.[5]

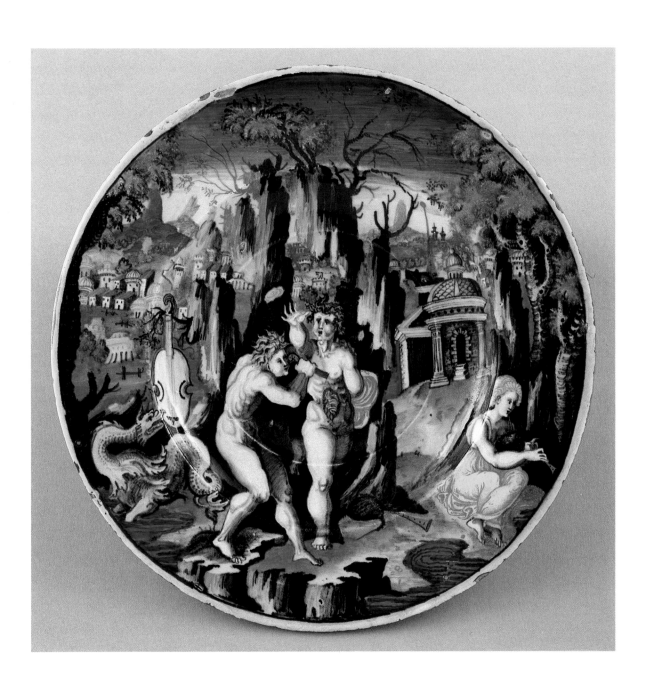

57. Plate with Marsyas and his Companions

Urbino, Francesco Durantino, 1545

Inscribed on verso: "marsia vilano/ d
ouidio alibro VII / 1545" ("Marsyas,
the boastful one, from the 7th book of
Ovid, 1545")
H 4.2 cm; D 30.1 cm; shape L8
Inv. 26.349
Provenance: Hainauer; Clark
Bibliography: Hainauer, 114, cat. 327
(M47); Corcoran/*Bulletin*, cat. 88.

1 The word *vilano* (or *villano*) today
means either a peasant, or more pejor-
atively, a rude or ill-educated person. It
once had the sense of an upstart, or
boastful boor, which is probably the
way in which it was intended here. The
painter has erroneously noted in his in-
scription that the scene is from Ovid,
Book VII; the story actually appears in
Book VI of the *Metamorphoses*.
2 E.g. the British Museum plate with
Coriolanus and his Family (signed and
dated 1544; the wine cooler in the
Adda Collection (signed and dated
1533; Adda, cat. 448); note also an in-
teresting fragment in the museum at
Stockholm, dated 1546, which has a
long inscription with Nicolò-style
monograms, probably also the work of
Francesco Durantino (Lutteman, 95).
3 From a signed piece in the museum at
Schwerin (inv. KG 513), noted by
Mallet in "C.D.E. Fortnum and Italian
Maiolica of the Renaissance," *Apollo*
CVIII (Dec. 1978), 402 and n. 47; see
also Mallet/*Erddig*, 42.
4 Mallet/*Erddig*, 42. An important forth-
coming article by Timothy Wilson on
Francesco Durantino in Monte Bagnolo
(to be published in the *Faenza*) will
treat the painter's chronology and, in
particular, the Monte Bagnolo phase.
5 A close parallel to the Clark plate is
one in the Museo Civico of Pesaro with
the *Rape of the Sabines* (Della Chiara,
cat. 209; ill. in color in Conti, fig. 296),
which has several similar figures; note
especially the bearded man at the right
of the Marsyas plate with a nearly
identically corresponding figure on the
border of the Pesaro piece.
6 Lessmann, 175.
7 Ibid., cat. 152.

Another example of the Marsyas legend in the Clark Collection (see also cats. 46
and 56) attests to the popularity of this subject on Italian maiolica as well as the
diversity of its depiction. The scene here is vastly different from those of the other
Clark plates, and far more peaceful. In this version, the satyr is shown happily
playing a long flute in a bucolic scene among his woodland companions, before the
confrontation with Apollo. The painter's inscription on the reverse describes the
subject with the words "marsia vilano" which can be loosely interpreted as "Mar-
syas, the boastful one,"[1] in anticipation of the fateful contest with the god Apollo
and its outcome.

The figures of Marsyas and his friends are noticeably different from those drawn
by Xanto and his contemporaries: here the emphasis is not on sturdy, solid figures
with strong outlines and heavily muscled bodies, but rather on more graceful,
elongated types, delicately drawn with their musculature indicated by an almost
sfumato-like modelling. The compositions of this artist tend to be quite busy, filled
with lively figures and vigorous landscape elements like the painterly rock cliff at
the right of the present example; he characteristically includes the two types of
trees seen here, one with frothy indeterminate foliage and the other with clearly
drawn, elongated leaves.

This artist – who can be identified through a number of signed and dated works[2]
– was Francesco Durantino, who was presumably a native of Castel Durante,
although no documentary evidence has as yet been discovered regarding his origins
or early training. We know from inscriptions that he was working in Urbino in the
atelier of Guido da Merlino by 1544[3] and that by 1549 he apparently had estab-
lished his own workshop in Monte Bagnolo, a small town near Perugia.[4] Dated
works by him have been documented from 1543 to 1553 so far, and the present
plate, which is inscribed 1545, was probably executed while he was still in Urbino.[5]
The activity of Guido da Merlino's own studio can be charted, at least in part,
from dated works ranging from 1542 to 1551,[6] and one can draw parallels between
the work of at least one other unnamed painter in that studio (c. 1540–45, now in
Braunschweig)[7] with the Clark Marsyas plate in terms of both anatomical deline-
ation and figure types.

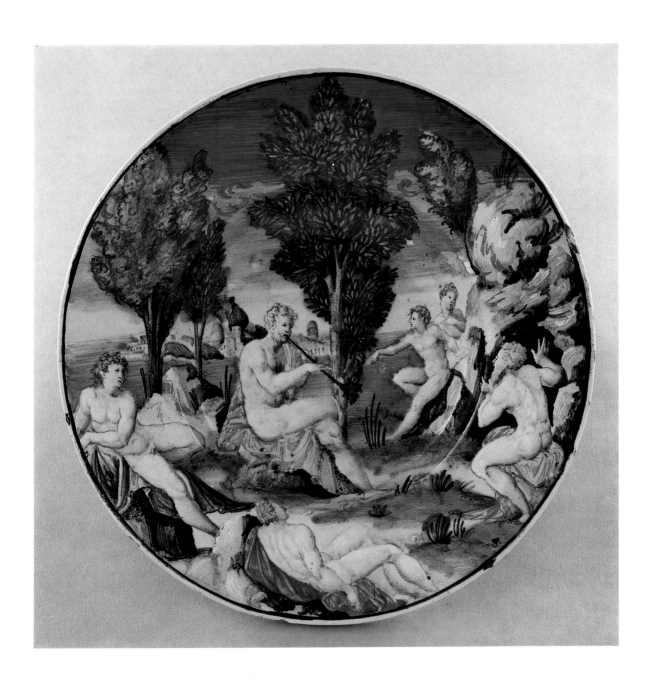

58. Plate with a heraldic design after Hans Sebald Lautensack
Urbino, c.1552–63

Inscribed on recto on cartouche:
"SPARTAM QVAM NAC/TVS ES/
HANC ORNA/ Johann Newdörffer
Rechenmeister"; on band below shield
at lower center: "HSL 1552"
Coats of arms: Azure two chevronels
between three stars or (for Neudörffer);
azure, two halberts or, headed argent,
crossed in saltire (for Nathan); argent,
the 'merchant's mark' of Neudörffer
azure
H 4.0 cm; D 24.1 cm; shape LII
Inv. 26.370
Provenance: Hainauer; Clark
Bibliography: Hainauer, 39, 117, cat.
348 (M68); Corcoran/Erdberg, 74;
Corcoran/*Bulletin*, cat. 97.

1 See Caiger-Smith/*TGP*, 103, and A.
Alverà Bortolotto, "Una nuova coppa
istoriata di Maestro Domenico al
Museo Correr di Venezia.," *Faenza*
LXV (1979), 38–40; see also letters of
1546–47 documenting this relationship,
published by Max Sauerlandt in *Faenza*
XVII (1929), 71–85.
2 In the same way, Italian families, such
as the Medici, had earlier sent copies of
their own arms to Spain to be applied
to Hispano-Moresque lustred wares.

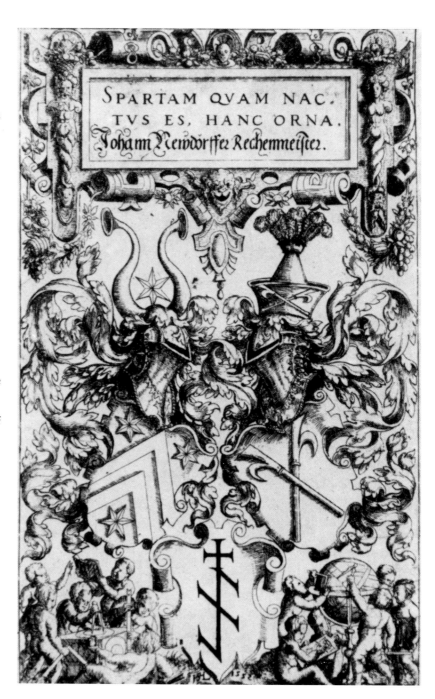

The active trade relationship that existed in the 16th century between Italy and the
North has been well documented by the existence of maiolica wares produced in
the workshops of Venice and Urbino for families in south German cities like
Augsburg and Nuremberg.[1] Throughout the *cinquecento*, the practice of ordering
Italian maiolica was very much in fashion with the Germans and other northerners.
They often sent copies of their coats of arms as the basis for ceramic designs[2] and,
later, narrative prints to be transformed into *istoriato* wares. Graphic works from
the North had, of course, been in circulation in Italy from at least the early 16th

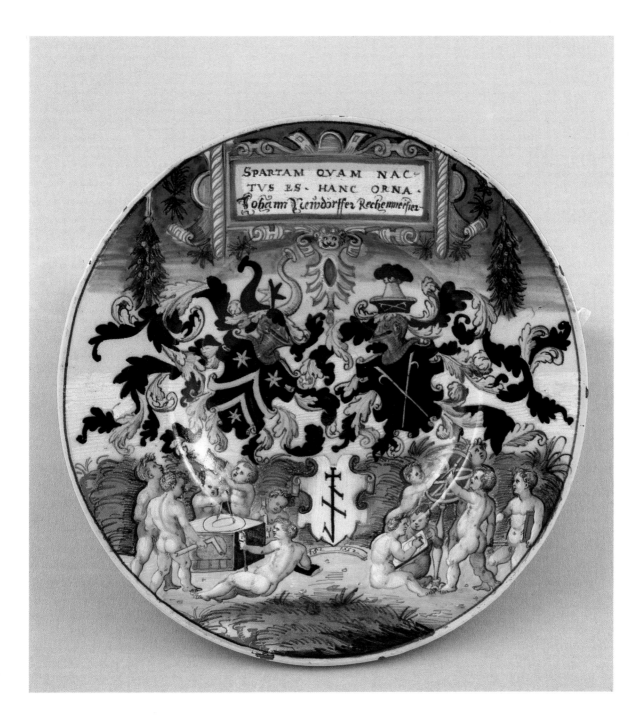

Opposite:
Hans Sebald Lautensack, Heraldic
print with the Arms of the Nathan
and Neudörffer Families

3 The five surviving pieces of the service are: a pitcher and plate in the Berlin Schlossmuseum, the latter ill. in Robert Schmidt, "Italienische Majoliken, ihre deutschen Vorbilder und deutschen Besteller," in *Festschrift für Wilhelm Waetzoldt* (Berlin, 1941), pl. 12; a plate in Hamburg (Rasmussen, cat. 129); and a plate in Kassel, Staatliche Kunstsammlung, Hessisches Landesmuseum (ref. no. B XII.11). I am grateful to Timothy Wilson for bringing the Kassel plate to my attention.

4 J.C. Smith, *Nuremberg, A Renaissance City, 1500–1618* (exh. cat., Austin, Texas, 1983), 253.

5 Ibid., cat. 163.

6 Katarina's arms are those of the Nathan family, the name Sidelmann belonging to her late first husband, a famous Nuremberg goldsmith.

7 An error in the writing on the Hamburg plate, noted by Rasmussen, gives the title as "Renmeister," although it is correctly written ("Rechenmeister") on both the Clark and Berlin plates.

8 A. Nauck, ed., *Tragicorum Graecorum Fragmenta*, (Leipzig, 1856, 1st edition), no. 722 (no. 723 in 2nd ed.). I am grateful to Professor Philippa Goold for her invaluable help with the translation and interpretation of this motto.

9 Ludolphus Kusterus, ed., *The Suda* (or *Suidas*) (Cambridge, 1525).

10 Norman, cat. C113.

11 Ulrich Thieme and Felix Becker, *Allgemeines Lexikon der Bildenden Kunstler* (Leipzig, 1940), vol. XX, 404.

12 Rasmussen has aptly compared the putti here with others on Urbino wares of around the same time (1550–60s); see 3 above.

century, as is exemplified by a number of ceramics bearing subjects derived from the beautiful engravings of Martin Schongauer, Albrecht Dürer and others.

The present plate belongs to a service made for Johann Neudörffer (1497–1563),[3] a distinguished Nuremberger who gained great renown as a calligrapher and teacher of arithmetic, geometry, and related disciplines. He was the author of the first German art historical book – a collection of biographies of the city's artists – in 1547, three years before Vasari's own *Lives of the Artists* was published in Italy. Neudörffer also designed the script for several of Albrecht Dürer's prints, among which was probably his monumental *Triumphal Arch of Maximilian*.[4]

The design of the Clark plate is based on a print of 1552 by Hans Sebald Lautensack, a follower of Altdorfer who was best known for his fine landscape compositions, including an extraordinary three-part etching showing a panorama of Nuremberg.[5] The composition on the plate is copied exactly from Lautensack's print, with the usual adjustments to allow for the transposition from rectangular to round format, and displays the arms of Neudörffer and his wife, Katarina Nathan Sidelmann,[6] along with a third shield bearing the "hausmarke" (trademark) of the Neudörffer family. At the lower left and right, representing Johann Neudörffer's special interests, are groups of playful nude putti engaged in mathematical and astronomical activities, armed with measuring and drawing tools, an armillary sphere, and reference books.

Above, an ornate cartouche carries a Latin motto, below which is Neudörffer's name and title, *Rechenmeister* (teacher of mathematics), written in the script for which he became famous.[7] The motto is a Latin translation of a line from Euripides' lost play *Telephus*.[8] Apparently, it was preserved because it became proverbial, and was quoted frequently by Greek and Roman writers including Cicero. In the play, Agamemnon speaks the line to Menelaus, "You got Sparta, adorn that." A 10th-century dictionary known as the *Suda* quotes the words, and interprets them as follows: "It seems to me that I shall bear my fate calmly and myself adorn my Sparta, since I believe that this is the challenge that has been made to my life, if I do not desert Philosophy even when she fails."[9] Johann Neudörffer must have found personal meaning in the proverb, and chose it as his motto, perhaps to represent his mission to enrich and adorn his own city, Nuremberg, through his art.

Plates with double crests were sometimes ordered on the occasion of a marriage or betrothal, like the Urbino plate of c.1593 in the Wallace Collection which bears the arms of the Christell and Mayr families.[10] The Neudörffer-Nathan service, by contrast, was made at least ten years after their marriage (c.1542),[11] sometime between 1552 (the date of Lautensack's print) and 1563 when Johann died. The possibility also exists that the group was commissioned in his honor, rather than by Neudörffer himself.

Although Bode attributed the Clark plate to Venice, probably because of the well-known trade connections between that city and Nuremberg, the style of the group belongs more properly to Urbino.[12] The prominent use of black on the pieces – necessitated by heraldic requirements – gives them a very striking appearance that is somewhat unusual, although the darker pigments seem to have gained in popularity in Urbino and Pesaro around the middle of the century, and were particularly applied to rocky landscape elements that appear on the wares of these centers.

59. Plate with a scene from the life of Scipio
Urbino, Fontana Workshop, c.1565–75

One of the most significant innovations in Italian maiolica after the mid-16th century was the development of the new style using grotesques like those painted by Raphael and his pupils in the Vatican loggias. The delicate ornamental motifs were distributed liberally over a white ground, virtually covering the entire surface with strange and fantastic creatures and designs, sometimes on both front and back. Central tondos (or compartments in other varied shapes) were reserved for narrative scenes, as on the present plate, and smaller cameo-like vignettes were inserted among the grotesques as well.

The workshop responsible for the popularity of the new trend – also known as the *a raffaellesche* style – was that of the Fontana family, including Orazio, Nicolo and Camillo, the sons of Guido Durantino. Orazio (1510–71) was the most talented of the three, and worked in his father's Urbino shop, helping to produce the *istoriato* wares for which it was renowned. Later, in 1565, he opened his own studio, and works began to appear signed "in bottega di Orazio Fontana in Urbino."[1] While continuing to manufacture traditional *istoriato* wares, they created the distinctive new genre with grotesques, combining that whimsical form of decoration with narrative scenes, sometimes of their own design and sometimes derived from drawings or prints of other artists.

The present monumental plate is clearly a product of an artist in the Fontana atelier and is related in both style and manner of execution to the large luxurious service made by them (c.1565–71) for Guidobaldo II, Duke of Urbino.[2] Along with its fine *grottesche*, the Clark piece includes two narrative scenes after designs by Battista Franco (c.1510–61), an Italian mannerist painter and *disegnatore*[3] who executed many of the designs for Guidobaldo's maiolica. Vasari recounted that although the duke was disappointed with a fresco he had commissioned from Franco, he was exceedingly pleased with the artist's drawings for ceramics: "So [Guidobaldo] made Battista do a large number of drawings which, when executed in that, the finest earthenware in all Italy, turned out marvellously well."[4]

On the front of the present plate is a Roman ceremonial scene of a man being "crowned" with a helmet by another soldier who stands atop a pedestal; the subject is known from a print by Franco after a bas-relief on the Arch of Constantine illustrating an episode from the History of Scipio.[5] Another print by the same artist is the basis for the very curious, possibly sacrificial, subject on the reverse, painted in monochrome blue, which shows a seated man holding a pig by its hind leg with one hand and a pitcher with the other;[6] the maiolica painter has, however, deleted from the scene a statue of a goddess that appears in the original. Interestingly, the artist repeated this unusual theme, which may also be taken from an ancient source, on the front of the plate in one of the border vignettes.

Prominently featured on the reverse above the tondo is a coat of arms with a cardinal's hat and tassels, undoubtedly belonging to the patron or recipient of this grand plate. The *stemma* combines the arms of the Della Rovere and Montefeltro families[7] and may be that of Giulio della Rovere (1533–78) who was named cardinal in 1548.[8] The Clark plate is stylistically consistent with Guidobaldo's service, and was probably contemporary with it.

Coat of arms: the arms of Della Rovere (Dukes of Urbino) surmounted by a red Cardinal's hat
H 5.6 cm; D 44.8 cm; shape L22
Inv. 26.335
Provenance: Hainauer; Clark
Bibliography: Hainauer, 39, 112, cat. 313 (M33); Corcoran/*Bulletin*, cat. 99

1 Giacomotti, 322–323. Giacomotti notes also that Nicolo Fontana died that same year (1565), while Orazio lived on until 1571 and Camillo until 1589; Flaminio, the son of Nicolo, carried on in the family business until late in the century.

2 Many pieces from this service remain in the collection of the Bargello (see Giovanni Conti's 1971 catalogue of the Bargello maiolica).

3 For an extensive treatment of Battista Franco's involvement with maiolica, see Timothy Clifford and J.V.G. Mallet, "Battista Franco as a Designer for Maiolica," *BM* CXVIII (June 1976), 387–410, and Johanna Lessmann, "Battista Franco disegnatore di maioliche," *Faenza* LXII (1976), 27–29, and bibliographic references in those articles.

4 Quoted in Clifford and Mallet, op. cit., 388.

5 B.XVI, 53. The maiolica painter has added extra figures to fill out the composition at the left.

6 B.XVI, 88.

7 For the arms, see Litta, vol. IX, and F. Cioci, "I Della Rovere di Senigallia e alcune testimonianza ceramiche," *Faenza* LXVIII (1982), 251–259.

8 Giulio's dates are given in the *New Catholic Encyclopedia* (New York, 1967), vol. 4, 738; information about his elevation to the cardinalate is cited in L. von Pastor, *The History of the Popes* (2nd edition, London, 1923), vol. 12, 367–8; Cardinal Giulio della Rovere's arms are illustrated in G. Smith, *The Casino of Pius V* (Princeton, 1977), 70, fig. C (taken from A. Chacon, *Vitae et res gestae Pontificium Romanorum et S.R.E. Cardinalium*, III, Rome, 1677, 730, LXVI).

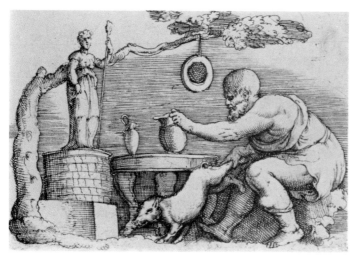

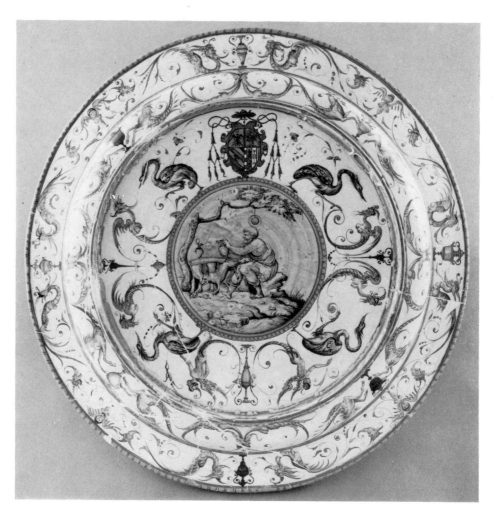

Reverse

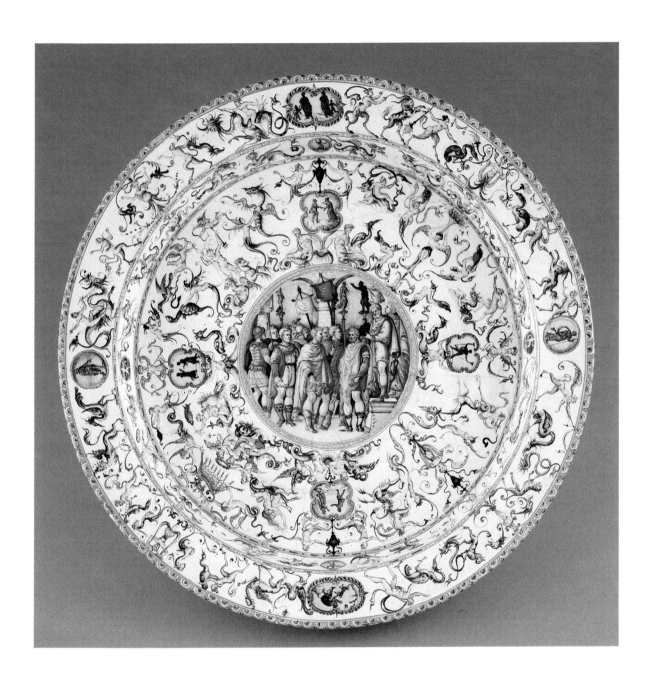

Opposite, top left:
Battista Franco, *Sacrificial
Scene (?)*

Opposite, top right:
Battista Franco, Print after a relief
on the Arch of Constantine

60. Ewer basin with Europa and the Bull and Cadmus and the Dragon
Urbino, Fontana Workshop, c.1565–75

Inscribed on verso near rim: "af 13" (scratched into glaze; Fountaine inventory number)
H 5.1 cm; D 45.6 cm
Inv. 26.317
Provenance: Fountaine; Hainauer; Clark
Bibliography: Fountaine, cat. 200; Hainauer, 39, 109, cat. 295 (M15); Corcoran/*Bulletin*, cat. 101; Corcoran/Clark, 77–78, fig. 62

1 Conti/*Bargello*, cat. 5.
2 See cat. 59³, for references to Battista Franco as a designer of maiolica.

Very similar in overall style and also belonging clearly to the Fontana workshop around the time of the Guidobaldo II Service (see cat. 59) is this elaborate ewer basin with its prominent raised boss that once held a tall pitcher. Because of its function, the center of the piece is emphasized by decorative bands imitating ancient architectural motifs (such as the egg-and-dart and bead-and-reel patterns). The grotesques – which in later works fall prey to the degeneration of the style – are still extremely fine and carefully painted, suggesting a date around 1565–75.

Although it is difficult to identify individual artists in this genre, the grotesques of the Clark basin closely resemble those of some other works, including at least one large plate from the Guidobaldo group in the Bargello.[1] The central scenes of the two pieces, on the other hand, could not be more different. This diversity of hands reminds one that it is not improbable that more than one artist could have worked on a single piece, as Mallet has suggested, and as was often the case in antiquity. In pieces of this genre, it probably would have been more useful and efficient to divide the labor between artists who specialized in grotesques, or even in cameo-vignettes or borders, leaving the narrative scenes to painters with special talents in that area. The two tondos on the present example are, in fact, sufficiently diverse that they may have been done by different artists.

The two historiated roundels show scenes drawn from a familiar source, Ovid's *Metamorphoses*, and are linked by familial relationship and physical proximity: Europa and the Bull is the last story in Book II, while the legend of her brother Cadmus is the first episode of the next chapter. Here Europa, the daughter of King Agenor of Tyre, is shown in the traditional fashion, being borne across the waves by Jupiter, who fell in love with her and transformed himself into a bull in order to carry her off; two distraught friends of the maiden gesture dramatically from the shore as she is taken away by the god. Cadmus was sent by their father in a vain attempt to find Europa, and in the course of his travels, Apollo's oracle directed him to establish the city of Thebes on a certain site where there was a spring guarded by a vicious dragon. Attempting to fetch water for a libation, Cadmus' companions were killed by the fierce monster, which was in turn slain by the young man. He is shown here – in this unusually colored blue and green tondo – holding his sword in one hand and a symbolic libation bowl in the other. Although no drawings or prints have yet been found for these two images, they may have been derived from the works of other artists, as was not uncommon with Fontana products. The Cadmus figure in particular is reminiscent of types prevalent in drawings of Battista Franco.[2]

Detail of reverse

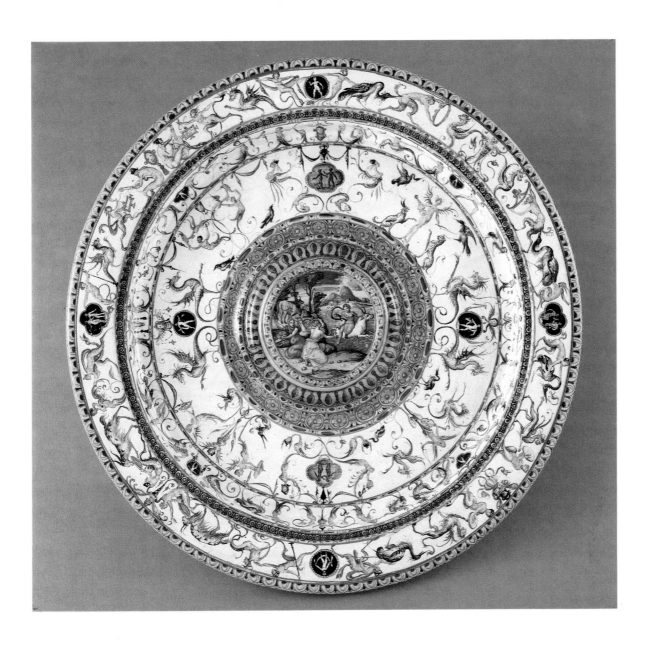

61. Footed dish with Galatea
Urbino, Fontana Workshop, c.1560–80

H 11.7 cm; D 25.1 cm
Inv. 26.375
Provenance: Hainauer; Clark
Bibliography: Corcoran/*Bulletin*, cat. 103

1 Piccolpasso I, folios 10–12.
2 See the section entitled "Notes on Types of Ware and Terminology," in Piccolpasso I, xxxiii–xxxvii.
3 Norman, 18–19.
4 The high foot on the Clark piece was lost and reconstructed during an earlier restoration, although it is probably close in appearance to the original.
5 See Jacob Burckhardt, *The Civilization of the Renaissance in Italy* (New York, 1958), II, ch. VIII, for details on Renaissance festivals and *trionfi*.
6 Giacomotti, cats. 1077–1080.
7 Lessmann, cat. 230.
8 Conti/*Bargello*, cat. 4.

Although Piccolpasso devoted part of his treatise to a description of various pottery shapes, how to fashion them, and their proper measurements, he seldom discussed their actual function.[1] As Lightbown and Caiger-Smith commented in their annotated edition of the treatise, "the subject of the vessels used at meals, either simple or ceremonial, in medieval and Renaissance Italy is one that still awaits investigation."[2] In addition, different names were applied to certain shapes in the various regions of Italy, and terminology was, in any case, evidently very loosely applied.[3] A shallow bowl with a tall foot, like the present one,[4] may have been intended only for display, but also would have been appropriate as a serving dish for the sweetmeats (preparations of preserved or candied nuts and fruits) that were so popular in the Renaissance.

Black birds in flight are strewn randomly over the otherwise plain blue ground of the exterior of the dish and the interior is occupied by a favorite subject of Raphael and many other Renaissance artists: Galatea borne across the sea by dolphins in the company of winged putti. The tale of Galatea, as told by Ovid (Book XIII) contains a detailed account of Polyphemus' unrequited love for the nymph, and her passion, in turn, for the young Acis, who was eventually killed by the jealous Cyclops. Maiolica painters, however – like Raphael in his great Farnesina fresco of 1513 – generally chose to depict Galatea in a triumphant marine procession, with decorative billowing drapery, cavorting sea creatures, and putti. Their preference for this aspect of the story was in keeping with the contemporary fascination with "triumphs," (*trionfi*) which had been taken up earlier in literature by both Dante and Petrarch. Triumphal processions in honor of pagan gods – based on the Roman military tradition of parades for victorious generals – became extremely popular in Renaissance Italy, eventually surpassing the religious festivals from which they were derived in both frequency and popularity.[5]

In addition to their use of Raphaelesque grotesques on a white ground, the Fontana workshop was responsible for the stylistic innovation of marine deities and creatures immersed in a background of sinuous blue waves.[6] They were often applied to the backs of large oval platters, as well as other shapes like the elaborate pilgrim flask in Braunschweig,[7] and trilobed wine cooler in the Bargello.[8] The Clark plate, with its somewhat coarse drawing style, is less refined than those examples, and was probably executed by one of the lesser artisans in the Fontana shop around the third quarter of the century.

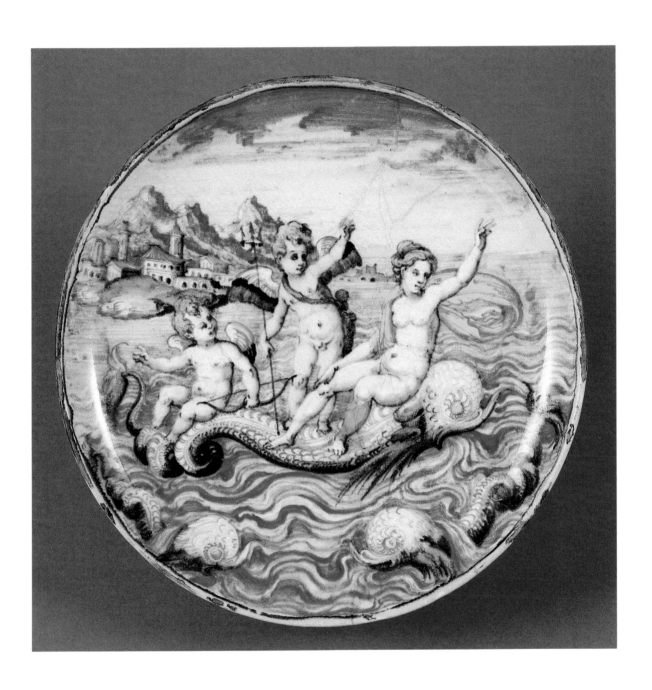

62. Pilgrim flask with Myrrha and Adonis
Urbino, Fontana Workshop, c.1570–80

H 43.4 cm; W 27.9 cm; D 16.8 cm
Inv. 26.357
Provenance: Hainauer; Clark
Bibliography: Hainauer, 39, 115, cat.
335 (M55); Corcoran/*Bulletin*, cat. 100

1 Certain characteristics, such as the modelling of the figures and drapery, give the feeling that this work and its associated pieces hover somewhere between the Fontana and Patanazzi workshops, or were in any case influenced by styles prevalent in both studios.
2 See Guidotti/*Bologna* (cat. 125) and Jiřina Vydrová, *Italienische Majolika in Tschechoslowakischen Sammlungen* (Prague, 1960), color plate VI. Possibly also by the same artist are two plates in Bologna (Guidotti/*Bologna*, cats. 115 and 116) with allegories of the months April and July; other related pilgrim flasks by the Fontana with marine scenes are in collections in Stockholm (Lutteman, cats. 20–22), Braunschweig (Lessmann, cat. 230), and Kansas (Bruce Cole, *Italian Majolica in Midwestern Collections*, exh. cat., Bloomington, Indiana, 1977, cat. 37).
3 See Guidotti/*Bologna*, 133, fig. 101b; the story appears in Book X of the *Metamorphoses*.
4 The woodcut illustration contains four separate episodes of the story: Cinyras chasing his daughter with a sword when he realizes her identity after the incestuous union; the birth of Adonis from the tree; Venus and Adonis reclining together with hunting weapons on the ground nearby; and, in the background, Adonis slain by the boar with Venus hovering overhead.
5 Ovid/Innes, 239–245.
6 Piccolpasso I, folio 5. The top that is currently on the Clark flask does not belong to it, although the original was undoubtedly very similar.

This pilgrim flask was once attributed by Wilhelm Bode to a Venetian workshop, perhaps because of the casual and sketchy handling that resembles the work of Maestro Domenico and his associates (see cat. 70). A comparison of the Clark bottle with other surviving examples, however, suggests that it was made in Urbino around 1570–80 in the Fontana workshop.[1] By the same hand are two flasks, one in Bologna with the Sacrifice of Isaac, and another in Prague with the story of Cain and Abel.[2]

The pastoral scenes on the main faces of the flask have not previously been identified, and in fact contain few clues about the stories they represent. Both sets of figures, however, appear to be derived from a woodcut in the 1509 edition of Ovid's *Metamorphoses*,[3] illustrating the tragic tale of Myrrha, who from an incestuous union with her father conceived a child. In despair, she begged to be transformed into a tree, from which her son Adonis was later born. The scene of the young woman with the bearded man may refer to the love of Myrrha for her father Cinyras, while the subject on the opposite side probably represents the subsequent death of the beautiful youth Adonis – beloved of Venus – who was slain by a boar while hunting.[4] Ovid describes Venus' changed appearance during this passionate love affair in a manner consistent with the artist's depiction: "Though she had always before been accustomed to idle in the shade, devoting all her attention to enhancing her beauty, now she roamed the ridges and woods and tree-clad rocks, her garments caught up as high as her knees, just as Diana wears hers, shouting encouragement to the dogs, and pursuing such animals as it is safe to hunt . . ."[5]

The shape of this flask (see also cats. 109 and 110), with its applied grotesque masks and volutes, is derived from the dried hollow gourds commonly used by travellers to carry water. The holes in the base and loops at the sides are vestiges of the custom of suspending containers of this sort on cords. Maiolica pilgrim flasks were normally made with screw-on tops surmounted by ornamental finials. The complex and clever technique of making these threaded caps was described and illustrated by Piccolpasso in the first book of his treatise, where he compares them to those used on silver flasks.[6]

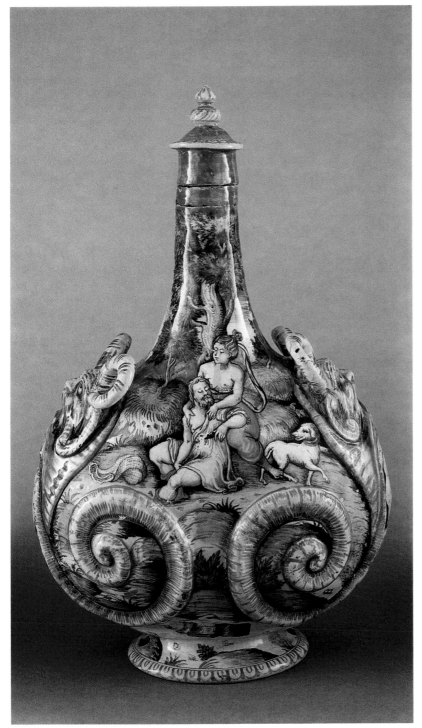

Right, bottom:
Legend of Myrrha (detail), from
Ovid's *Metamorphoses* (1509)

63. Quadrilateral flask with St. John the Baptist and grotesques
Urbino, Patanazzi Workshop, c.1580–90

H 24.3 cm; W 13.4 cm; D 11.1 cm
Inv. 26.377
Provenance: Hainauer; Clark
Bibliography: Hainauer, 38–39, 117,
cat. 351 (M75); Corcoran/*Bulletin*, cat.
109

1 Norman, 16.
2 Lessmann, 234.
3 Cf. standing figures on another Pata-
nazzi piece (c.1580) in the Bargello
(Conti/*Bargello*, cat. 28).
4 A pair of late 16th-century quadran-
gular bottles of a simpler shape with
grotesque decoration are in the Museo
Civico, Bologna (Guidotti/*Bologna*,
cats. 175–176). Another four-sided flask
of about the same size, made in the
18th century in Piedmont (possibly
Turin?) can be found in the Cora
Collection (Cora/*Faenza*, cat. 360,
color plate II); it is inscribed "Oll
irini," indicating that it once held a
liniment made from iris rhizome and
olive or sesame oil (Drey, 208).
5 E.g. Lessmann, cats. 254, 261, 267, and
Join-Dieterle, cat. 87.
6 Metropolitan Museum of Art, inv.
32.100.363a–c.

The style of maiolica-painting using grotesques in this manner – also called *a raf-
faellesche* – was especially popular in the Duchy of Urbino, where it was enthusi-
astically taken up by the workshops of the Fontana and later the Patanazzi before
spreading to other ceramic-producing centers like Pisa and Rome.[1] The activity
of the Patanazzi as maiolica artisans has been documented from 1580 to 1631,
although, as Lessmann has pointed out, they apparently did not all work in the
same studio. A signature of Francesco Patanazzi in 1608 indicates that he was the
proprietor of his own atelier, while Alfonso signed a piece in 1607 with the nota-
tion "in the workshop of Giovanni Battista Boccione."[2] The consistency of their
wares has, however, led maiolica scholars to refer traditionally to these works as
products of the "Patanazzi Workshop."

This rare four-sided flask in the Clark Collection is covered with grotesques
typical of the style, but with the somewhat incongruous insertion on two sides of
figures representing St. John the Baptist, looking more like a satyr than a saint.[3]
The other faces have three-dimensional masks and serpentine loop handles that are
probably more decorative than functional. The purpose of the bottle is unclear,
and there is no evidence that it ever had a ceramic stopper or top like the pilgrim
flasks that were also popular at the time (see cat. 62).[4] It is interesting to note that
unusual shapes – often quite elaborate ones – came into fashion simultaneously
with the "Raphaelesque" style, probably because this type of decoration was easily
adaptable to molded forms and curving surfaces. Salt cellars, tall ewers, shell-
shaped bowls, and other unorthodox forms, frequently with three-dimensional ap-
plied masks, leaves, or sinuous handles, obviously appealed to the taste of the
time.[5] One of the most elaborate of all is a large writing chest in the Metropolitan
Museum of Art with drawers, compartments, removable sections, and even a
statuette group of Apollo and the Muses (after Raphael), dated 1584 and inscribed
with the name Patanazzi.[6]

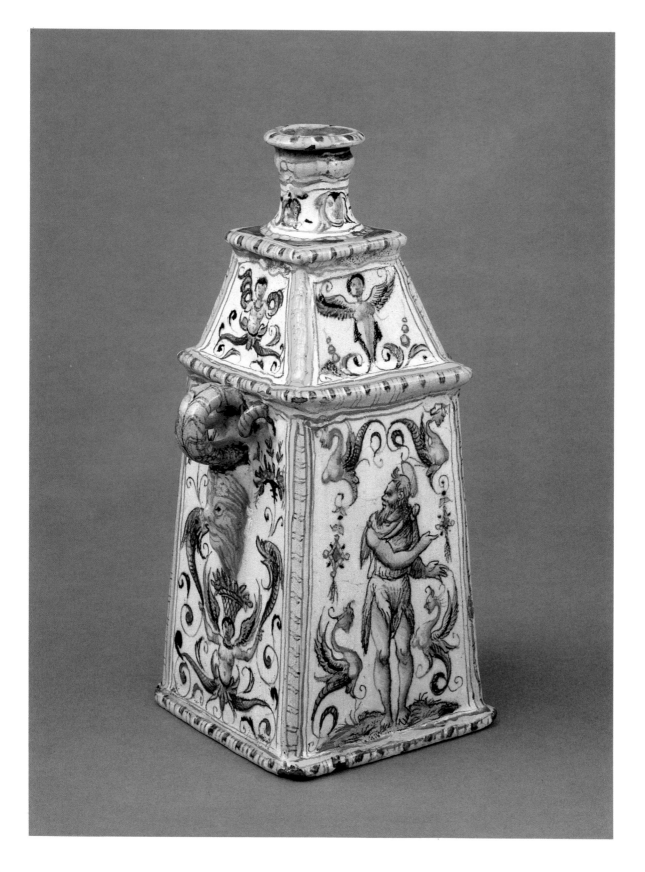

64. Plate with a scene from the Trojan War
Urbino, Patanazzi Workshop, c.1575–1600

Coat of arms: Tierced per fess: 1, gyronny or and azure; 2, gules, a cubit arm argent erect vested azure holding two palm branches crossed in saltire argent; 3, paly of six or and argent (unidentified)
H 5.2 cm; D 47.9 cm; shape L22
Inv. 26.395
Provenance: Hainauer; Clark
Bibliography: Hainauer, 119, cat. 367 (M93); Corcoran/*Bulletin*, cat. 110

1 Ovid/Innes, 284.
2 Norman, cat. C147.
3 For handling similar to that of the Clark plate, compare a trilobe basin in the Louvre (Giacomotti, cat. 1081) that was part of a service for Alfonso II d'Este at the time of his marriage to Margherita Gonzaga in 1579.

The scene shown here probably represents an episode from the Trojan War, treated in Books XII and XIII of Ovid's *Metamorphoses*, in which Agamemnon, King of Mycenae and leader of the Greek expedition, hangs up the armor of the dead hero Achilles in preparation for the debate over who should be allowed to have it. As Ovid recounts the tale, "Only Ajax, son of Telamon, and the son of Laertes, Ulysses, had sufficient confidence in themselves to claim such a glory . . . Agamemnon, in order to shift from his own shoulders the burden of a decision which was bound to cause ill-feeling, commanded the chieftains of Greece to take their seats in the centre of the camp, and handed over the judgement of the case to the general assembly."[1] A two-part border of grotesques surrounds the central narrative, along with an unidentified coat of arms; the reverse is undecorated except for concentric yellow circles and there are no inscriptions identifying either the painter or the subject.

The same theme appears on a stylistically similar plate in the Wallace Collection, though the composition is quite different, being derived from a Bernard Salomon woodcut in the 1557 Lyon edition of the *Metamorphoses*.[2] Like the Wallace piece, the Clark dish was almost certainly made in the Patanazzi workshop in the last decades of the 16th century. The *a raffaellesche* style of grotesques on a white ground – either combined with *istoriato* scenes (as in this case) or with smaller compartments occupied by a single putto or allegorical figure (see cat. 113) – continued strongly throughout the 16th century and well into the first half of the next one. As it went on, however, it lost some of its freshness and originality, and the quality tended to deteriorate; the handling in the later stages becomes drier and heavier, with a more limited palette and a sharper contrast between the lights and darks, as well as a more cursory style of modelling. The figures on the present plate display the dark, deep-set eyes, elongated fingers, and smooth, almost boneless limbs characteristic of the Patanazzi style.[3] The earlier Urbino preoccupation with detailed musculature and anatomical exactitude has given way to the more generalized treatment that tends to prevail in maiolica painting into the next century.

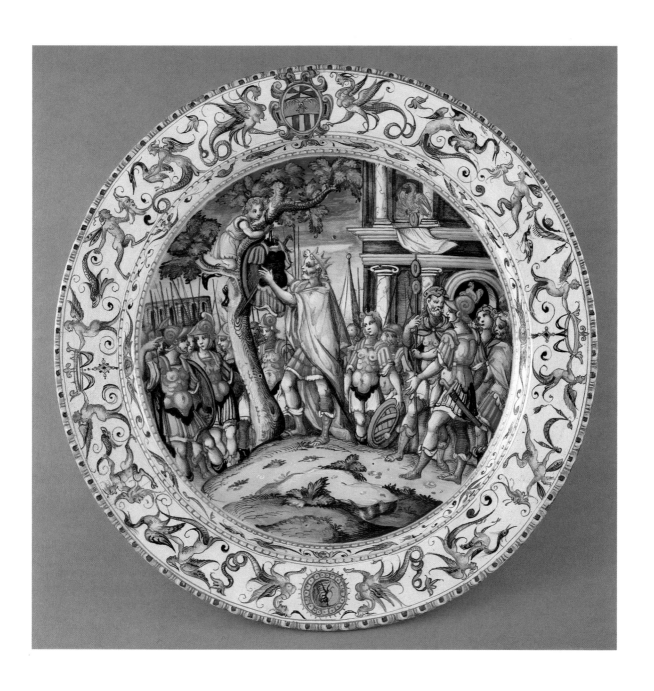

65. Molded dish with Joseph's Robe being presented to his Father
Urbino, 1575–1600

Inscribed on verso: "La Veste al / Patre di Gioseph / Appresentata / p frelli" ("The robe being presented to the father of Joseph by the brothers")
H 5.3[1] cm; D 27.9 cm
Inv. 26.351
Provenance: Hainauer; Clark
Bibliography: Hainauer, 114, cat. 329 (M49); Corcoran/*Bulletin*, cat. 94

1 The original foot has been sawed off, probably after being partially broken.
2 Claude Paradin, *Quadrins Historiques de la Bible & Quadrins Historiques d'Exode*, illustrated by Bernard Salomon, printed by Jean de Tournes at Lyon; the illustration used here is from Genesis, Chapter XXXVII. Salomon's woodcuts for Ovid's *Metamorphoses* were also popular with maiolica painters. See the recent article by Carmen Ravanelli Guidotti, "Figure della *Bibbia* e del *Metamorphoseo* di Ovidio per le istorie di alcuni capi al Museo di Faenza," *Faenza* LXVIII (1982), 167–177.
3 Join-Dieterle (p. 264) gives references to two documentary pieces: one in the British Museum of 1582 from "Leon" (Lyon), and another in the Louvre, dated 1589, from "Nvres" (Nevers).
4 This book was issued in many editions from 1553 on, in several languages including Italian, English, French, Spanish, German, Flemish, and Latin (see Norman, 286); see also Mallet/*PLII*, 345.
5 Mallet/*PLII*, 345.
6 See bibliography above.
7 Compounding the attribution question in France is the problem of determining the difference between wares made in Lyon and those of Nevers; see Robert Boulay, "Le problème Lyon-Nevers," *Cahiers de la céramique*, nr. 33 (1964), 16–28.
8 Metropolitan Museum of Art, inv. 1974.286, with the arms of the d'Este of Ferrara; the Waddesdon piece was noted by Mallet (*PLII*, 345, n. 24) and belongs to a large set of drug jars from the pharmacy of Roccavaldina, near Messina.

This scene from Genesis of Joseph's bloody robe being shown to his father by his treacherous brothers was taken almost line for line from a woodcut illustration by Bernard Salomon (c.1506/10–c.1561) for the *Quadrins Historiques de la Bible & Quadrins Historiques d'Exode*, first printed by Jean de Tournes in Lyon in 1553.[2] The painter has made a few minor changes to the composition, deleting two small background figures, adding a building at the rear, articulating the surfaces of the wall and barrel vault with a brick pattern, and adding volume and shape to the drapery behind the enthroned Jacob. The conceit of the billowing drapery, often tied with a large knot, was one which appears frequently in maiolica in the later 16th century, particularly in the Duchy of Urbino, where this *crespina* was probably made.

Documents show that Italian potters were working in the French cities of Lyon and Nevers by the second half of the 16th century[3] and brought with them the technology needed to manufacture maiolica, or *faience*, as it became known in that country. The use of the Salomon woodcuts has been interpreted by some as proof of the French origin of ceramics like the Clark dish. However, it would be rash to base attributions of this sort solely on such evidence, because of the numerous foreign-language editions of that Bible, and its availability in Italy and other countries.[4] A number of pieces made between 1560 and 1580 by the Fontana and Patanazzi adapted the same woodcuts and are proof that Italian potters of Urbino were well aware of these graphic sources and were actively using them.[5]

That the Clark dish was thought by Breckenridge and von Erdberg to have been made either in Lyon or Urbino,[6] is an example of the French-Italian dilemma. It remains extremely difficult to discern whether a later 16th-century piece of historiated maiolica was made in Italy by an Italian craftsman, in France by an Italian immigrant artisan, or by a Frenchman working under the influence of his Italian colleagues and teachers.[7] The language chosen for the reverse inscriptions can sometimes be of assistance, although it cannot be proven on the basis of an Italian notation that the present dish, for example, was not made in France by an Italian.

The same subject, drawn again from the Salomon woodcut, is known on at

Opposite:
Bernard Salomon, *Joseph's Robe
being Presented to his Father,* from
Quadrins Historiques de la Bible . . .
(1553)

least two other Italian pieces: a plate, probably from Urbino, in the Metropolitan
Museum of Art, and an albarello attributed to the Patanazzi in the Rothschild
Collection at Waddesdon Manor.[8] The Clark *crespina* appears to be related to
wares of the Patanazzi school, though no direct parallels have yet been found to
link it securely to them. The unusual attenuation of the figures – not a standard
Patanazzi trait – is clearly derived from the mannered anatomical style of
Salomon's own print. Although no attribution can be made with absolute cer-
tainty, there is at present no real evidence pointing to a French origin for it, and it
seems most likely that the present piece was made in Urbino in the last quarter of
the century.

66. Plate with Hercules and Omphale
Pesaro, Sforza di Marcantonio, 1551

Inscribed on verso: "se ridussi Afilar e/rchol si forte 1551" ("He was reduced to spinning, Hercules so strong 1551")
H 3.5 cm; D 24.4 cm; shape L2
Inv. 26.362
Provenance: Hainauer; Clark
Bibliography: Hainauer, 38, 116, cat. 340 (M60); Corcoran/*Bulletin*, cat. 85

1 Giovanni Battista Passeri, *Istoria delle pitture in majolica fatte in Pesaro e in luoghi circonvincini* (Venice, 1758); see Fortnum, 140.

2 Paride Berardi, *L'Antica maiolica di Pesaro dal XIV al XVII secolo* (Florence, 1974).

3 Grazia Biscontini Ugolini, "Sforza di Marcantonio, figulo pesarese cinquecentesco," *Faenza* LXV (1979), 7.

4 Ibid., 8.

5 Join-Dieterle, 254; Guidotti/*Bologna*, cat. 129.

6 Guidotti has noted a piece at Brescia, dated 1560 with the initials S.F., which may be the earliest piece with both a date and a monogram (Guidotti/*Bologna*, 176).

7 John Mallet is currently compiling information on the early phase of the artist's career, as well as a list of works that can be attributed to Sforza, to be included in a forthcoming article. Lists of works attributed to the artist are given in Lessmann (p. 345), Guidotti/*Bologna* (p. 176), Join-Dieterle (pp. 254–255), Berardi (pp. 188–189), and the article by Biscontini in ³ above; see also a plate by Sforza recently acquired by the British Museum with the subject of Astiage, ill. in T. Wilson's review of Ravanelli Guidotti's Bologna catalogue in the *Burlington Magazine* CXXVII (1985), fig. 89.

8 Cf. Wallace, cat. C145.

9 Berardi, 188.

Giovanni Battista Passeri's early book (1758) on the pottery of his native Pesaro contributed much valuable information about maiolica, although he tended to exaggerate greatly the importance of that center's role in the history of Italian Renaissance ceramics.[1] Pesaro was subsequently overshadowed by the emphasis on Urbino, Castel Durante, Faenza, and other towns in modern research, and it was not until Paride Berardi's recent book that a new and well-deserved assessment of Pesaro ceramics was undertaken.[2]

Among the painters who have emerged as major forces in the *istoriato* movement of that city is an artisan named Sforza di Marcantonio, who was listed in documents first as a lowly shop worker ("jug maker") in 1562, but later became a master in his own right.[3] Born in Castel Durante, he came to Pesaro quite early and, according to Biscontini, was probably trained in the shop of the vase-painter Lanfranco.[4] Sforza was first identified by Leonhardt, who noted his signature ("SFORZA D.P. 1567") on a plaque in the British Museum depicting the Annunciation; another rectangular plaque of the same date in the museum at Bologna is also signed in capital letters, "SFORZA."[5] Dated pieces by his hand exist from at least 1560 to 1576, often marked in addition with a large S; a recognizable peculiarity of his inscriptions is that the number 5 in his dates resembles a capital S.[6]

It has recently been suggested that earlier works by Sforza, from the 1540s and 1550s, may be identified in a number of pieces previously thought to have emanated from Urbino workshops.[7] The present plate and cats. 67 and 116 belong among this group; all are signed in a clear and readable script, and dated 1551 with the young Sforza's characteristic S-shaped fives and dotted ones.[8] Many of the stylistic mannerisms described by Berardi are present in these two plates: long, thin noses, outward and downward-sloping eyebrows that give a quizzical look, elongated fingers (note especially the long pointing index fingers that regularly appear in his works), heavily muscled, rounded shoulders, the three-plane composition including a lake in the distance, and so on.[9]

The theme Sforza has chosen here is that of Omphale and Hercules, which is told in the works of Apollodorus and Ovid as a story symbolic of female domination over men, possibly originating in an early mother goddess legend. As a punishment and purification ritual for having killed Iphitus in a fit of madness, Hercules was sold into temporary slavery to the Lydian queen, Omphale. She set him to various tasks, including work normally done by women, and consequently he is often shown dressed in women's clothes and jewelry. Sforza has allowed him to retain his lion skin, although he looks all the more ridiculous in it as he delicately spins wool under Omphale's watchful gaze; the inscription on the reverse – "he was reduced to spinning, Hercules so strong" – has a satirical ring to it that is consistent with the painter's somewhat humorous depiction.

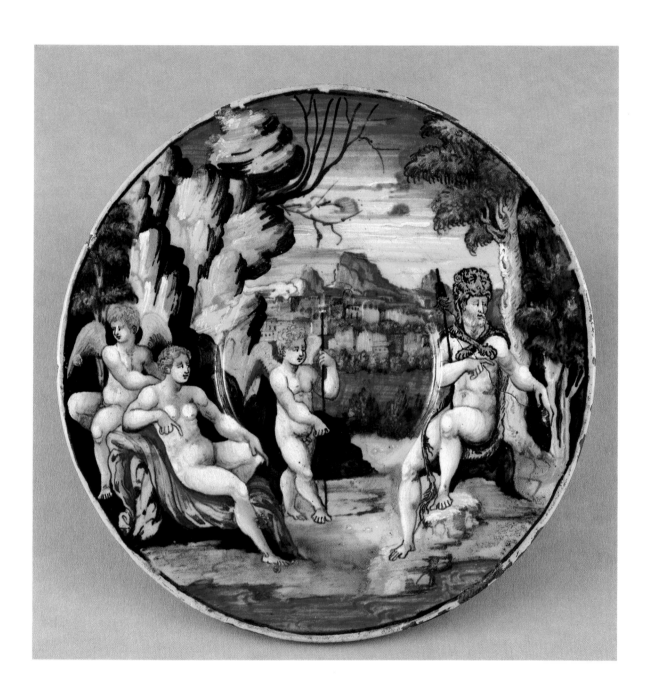

67. Plate with Philyra and Saturn
Pesaro, Sforza di Marcantonio, 1551

Inscribed on verso: "Saturno Amando
si / Changio in Chauallo/ 1551" ("the
loving Saturn changed himself into a
horse 1551")
H 3.0 cm; D 23.3 cm; shape L2
Inv. 26.352
Provenance: Hainauer; Clark
Bibliography: Hainauer, 38, 114, cat.
330 (M50); Corcoran/*Bulletin*, cat. 96

1 See cat. 66 ⁶.
2 Hyginus, *Fabularum Liber* (Basel, 1535;
Garland edition, New York, 1976),
CXXXIII.
3 Petruzzellis-Scherer, fig. 13.
4 E.g. Kube, cat. 76.
5 Timothy Wilson has suggested that the
relationship of the young Sforza with
the master Xanto may have been more
direct than was previously thought
(conversation with author, 7 July
1985); see Wilson's review of Ravanelli
Guidotti's Bologna catalogue in the
Burlington Magazine CXXVII (1985),
907–908, figs. 88–89.

The high foreheads, rounded shoulders, long noses, and tell-tale prominent index fingers on this plate are hallmarks of the style now thought to belong to the young Sforza di Marcantonio before he began to sign his works in 1560.[1] Like the Hercules and Omphale plate (cat. 62, and also cat. 116), this one bears the date 1551, and is inscribed in the artist's precise and readily recognizable script, "the loving (or 'lovemaking') Saturn changed himself into a horse." The notation refers to the tale, briefly recounted by Hyginus, of Saturn (or Kronos) who fell in love with the Oceanid Philyra and, caught by Rhea, transformed himself and his lover into horses to avoid detection.[2] Sforza – in contrast to Xanto – frequently provided only a short, oblique reference to his subject, in this case avoiding all mention of the other main protagonist, Philyra, or the source from which he derived the theme.

The composition is somewhat awkward, a tendency not uncommon in Sforza's works, and it is not completely clear who is represented by each of the figures. At left, below the hovering cupid, are the reclining nude Philyra with Saturn in the form of a horse; the standing figure must be Saturn in his normal appearance, and the woman at right is either Rhea, discovering the illicit affair, or, more likely, Philyra at an earlier stage of the story, in a continuous narrative (cf. cat. 46). Sforza's deviations from Hyginus' version of the story suggest that he may have relied on yet another literary source, or on his own evidently active imagination. Perhaps too, he may have been influenced by another maiolica-painter's interpretation of the scene.

The figure of Philyra is taken from a print in Marcantonio Raimondi's provocative series after designs by Giulio Romano showing various sexual poses.[3] This particular figure happens to have been a favorite of Xanto's as well, and he used it often in his own compositions, especially in allegorical depictions of the 1527 Sack of Rome,[4] where she represents "lascivious Rome." Painters of *istoriato* wares in Pesaro must have been enormously influenced by trends in Urbino, the center of that stylistic genre, and the possibility is currently being investigated that there may have been a more direct contact early in his career between Sforza di Marcantonio and the master Xanto.[5]

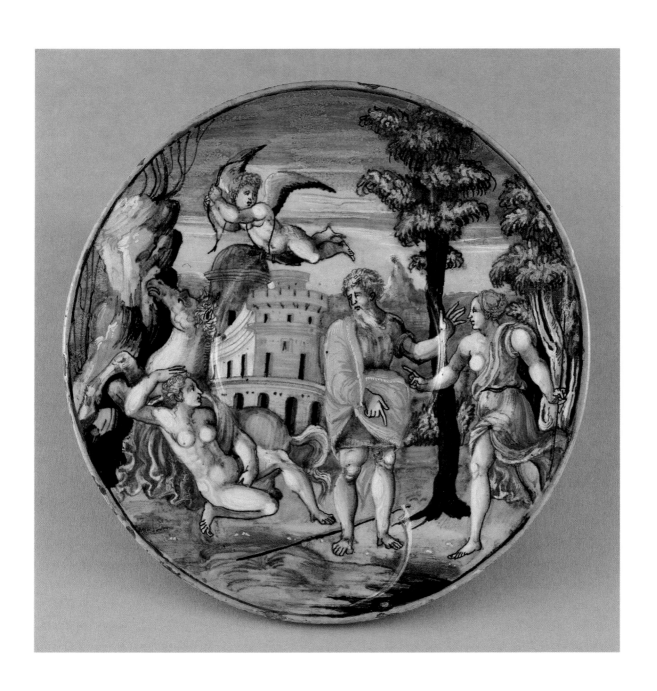

Left:
Marcantonio Raimondi, print
from the series *I Modi* (after
Giulio Romano)

68. Dish with the Legend of Atilius Regulus
Pesaro, Zenobia Painter, c.1552

Inscribed on verso: "Atillio Romano da / Cartaginesse fu messo / jn una Botte piena di / chioui nela qualle fini / LA uitta" ("Atilio the Roman was put by the Carthaginians into a barrel full of nails, in which he ended his life")
H 6.0 cm; D 27.3 cm; shape R14
Inv. 26.355
Provenance: Hainauer; Clark
Bibliography: Hainauer, 115, cat. 333 (M53); Corcoran/*Bulletin*, cat. 90

1 Lessmann, 335–344; see also Grazia Biscontini Ugolini, "Alcune maioliche del Castello Sforzesco riconosciute opere di fabbriche pesaresi," *Rassegna di studi e di notizie* XI (1981), 154–158 (note the Castello Sforzesco plate with *Scipio and the Surrender of the Carthaginians*, fig. 4) and Berardi, 186–187. The artist's handwriting here is consistent with that of other inscribed works, although rather crowded, due to the constricted area in which he was working (cf. Lessmann, cat. 468).

2 V&A (ill. in Biscontini, op. cit., fig. 5; dated 1552); Braunschweig (Lessmann, cat. 467; n.d.); Lessmann notes that the story of Zenobia is taken from the *Historia augusta* 24, 3.

3 OCD, 911; the story is contained in Horace, *Carmina* 3.5. Although not at all a common subject, it can be found also in a ceiling painting designed by Giulio Romano at the Palazzo del Tè (ill. in F. Hartt, *Giulio Romano*, New Haven, 1958, II, fig. 286).

4 Cf. the present plate with cats. 66–67.

The Zenobia Painter is yet another Pesaro artisan of the mid-16th century whose œuvre is just now beginning to be assembled and understood. Lessmann has gathered together at least twenty-five works belonging to him and his workshop, nineteen of which are in the collection at Braunschweig.[1] The artist, from whom we have only a single dated piece and no signatures at all, has been named after the subject which appears on a pair of nearly identical large pieces in the V&A and at Braunschweig illustrating the story of Zenobia.[2] On both, the beautiful and intelligent but ruthless Palmyrene queen is shown being paraded in chains at Aurelian's triumph after her defeat.

An iconographical analysis of the Zenobia Painter's often very imaginative works reveals that he was fascinated with scenes of figures in Roman armor. He tended to choose subjects specifically involving ancient history or legend, such as the story of Marcus Atilius Regulus, which is treated on the Clark plate. This Roman consul of the 3rd century BC was responsible for the defeat of the Carthaginians and the capture of Tunis, although his fortunes were later reversed, and Atilius himself became a prisoner in Carthage. After being sent on parole to Rome to negotiate an exchange of captives, or perhaps peace-terms (the evidence is not clear), he returned voluntarily to Africa where he was sent back to prison and died. The legend of his torture and death in a nail-studded barrel appears to have been an apocryphal one – invented to compensate for the torture of some Punic prisoners by his vengeful widow in Rome[3] – although it became a national epic, holding Atilius up as a paragon of the Roman military hero.

The present work epitomizes the Zenobia Painter's style in many ways, with its horizontally arranged groups of soldiers clad in leather cuirasses, visored helmets, and flowing capes, whose drapery virtually takes on a life of its own. He often inserts into his compositions dramatic distant landscapes punctuated by arcaded structures and rugged vertical mountains, or ancient buildings and ruins embellished with robust sculptural herms. The gathered and tied curtains on the tent at the rear and the frothy foliage overhead give a vigorous feeling to the painterly composition, overshadowing the artist's inadequacies as draughtsman. Figures in the Zenobia Painter's works are often ill-proportioned, with heads too small or too large for their bodies, and overly muscular arms and legs ill-balanced by tiny feet; looking at his hands, with their prominent index fingers, one cannot help wondering if he might have been influenced by Sforza in this regard.[4] An emphasis on the yellow-orange spectrum of the palette is noticeable in the work of both Pesaro artists as well, along with their tendency towards a freer and more impressionistic manner.

Detail of reverse

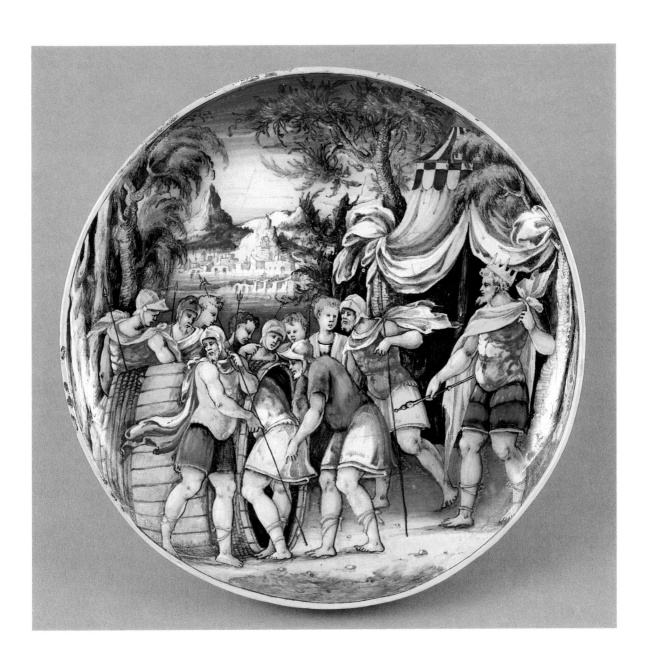

69. Drug jar with heads of women
Venice, Workshop of Domenico da Venezia, c.1550–70

H 23.8 cm; D 22.8 cm
Inv. 26.359
Provenance: Hainauer; Clark
Bibliography: Corcoran/*Bulletin*, cat.
112; *Detroit*, 60 (ill.), cat. 124

Venice was well known as a pottery-manufacturing center from as early as the 15th century, although a lack of raw materials necessitated the importation of clay from other places. Piccolpasso, who refers often to the city and its wares in his discussions of maiolica technology, says that Venetians used clay from a variety of locations, including Ravenna, Rimini, and Pesaro, on the coast, and Ferrara and Padua, farther inland; these clays varied in quality and he pronounced that of Pesaro the very best.[1] Kube has noted that the ceramic industry in Venice was carefully protected by bills passed in the Senate there, including a decree of 1545 which prohibited the importation of all foreign maiolica except the Hispano-Moresque wares, thus securing the market for local products.[2]

Among the most numerous and familiar varieties of Venetian Renaissance pottery that exist today are the large rounded drug jars like the present example (and cat. 120), and similarly decorated albarelli, large pitchers, and other shapes, which were popular in the second half of the 16th century.[3] They usually have a dark blue ground richly covered with fruits and flowers, white incised flourishes, and large medallions on both sides, often framed by scrollwork, containing images of men or women, figures of saints, helmeted soldiers, or exotic Turks with turbans. Occasionally the decorative program also includes a pharmaceutical label revealing the intended contents of the jar. In the section of his treatise where he illustrates popular decorative motifs, Piccolpasso shows similar floral and fruit patterns with the comment, "these designs are truly Venetian, very pretty things."[4] Saturated blue and yellow pigments predominate in these works and haloes of golden yellow with radiating orange streaks are often used to set off the medallion portraits. The very painterly execution of the subjects in the roundels gives them a freshness and immediacy that is highly appealing, although the generalized male and female heads – reminiscent of those of the Deruta *piatti da pompa* – are probably not intended as true portraits.[5]

The most famous of all Venetian workshops, that of the artist called Maestro Domenico, was instrumental in turning out ceramics in this style, and even more numerous *istoriato* wares (see cat. 70); the museum at Braunschweig alone counts more than 230 examples among its holdings.[6] Signed pieces by this master include a vase in Messina marked "domenego da venecia 1562," a plate in Frankfurt dated 1568, and two from that same year in Braunschweig;[7] on the latter two plates, he even took care to describe the quarter in which his studio was located, perhaps hoping for additional customers: "al pontesele . . . per andar a san polo."[8] Recent archival research has suggested that Maestro Domenico was born around 1520–25 and died sometime between 1569 and 1574,[9] although the workshop may have gone on somewhat longer and his influence was certainly felt at least until the end of the century.

1 Piccolpasso II, 13.
2 Kube, 29; see also Fortnum, 297–298.
3 E.g. Conti, figs. 353–357.
4 Piccolpasso II, 115.
5 Ennio Concino, in "Un contributo alla definizione della cronologia ed all'ambiente di Maestro Domenico da Venezia," *Faenza* LXI (1975), 138–139, has hypothesized – based on a letter of the 16th-century author Andrea Calmo – that the female faces may represent specific individuals, particularly women belonging to "an intermediate category between the courtesan of rank and the vulgar prostitute."
6 Lessmann, 409–507.
7 A. Alverà Bortolotto, "Due pittori maiolicari nella Venezia del Cinquecento," *Arte Veneta* 34 (1980), 155; see also Lessmann, cats. 737–738.
8 Ibid. The inscription may be translated as "at the little (or temporary/wooden) bridge, on the way to the church (or the quarter) of S. Polo"; I am indebted to C. Douglas Lewis for his suggestions regarding this translation.
9 Concina, op. cit., 137–138.

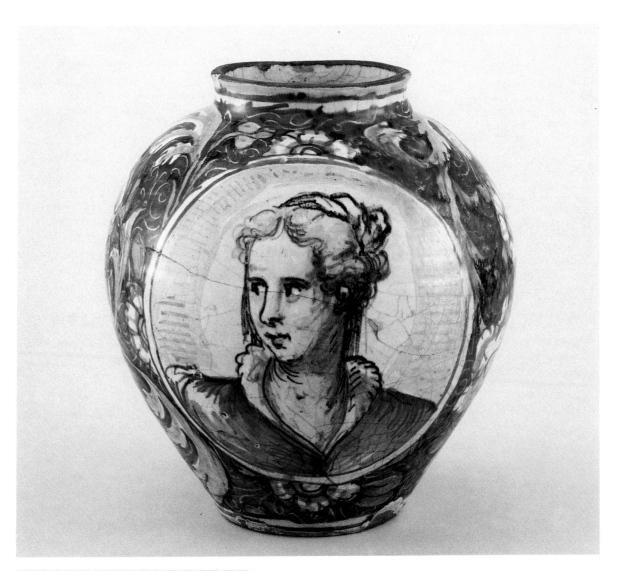

Reverse

70. Plate with Diana and her Nymphs
Venice, Maestro Domenico (or workshop), c.1565–70

Inscribed on verso near center: "af 67" (scratched into glaze; Fountaine inventory number)
H 4.8 cm; D 30.3 cm; shape L8
Inv. 26.373
Provenance: Fountaine; Hainauer; Clark
Bibliography: Hainauer, 39, 117, cat. 350 (M71); Corcoran/*Bulletin*, cat. 106

1 Cf. the famous fruit swags and bucrania on the interior of the Roman Ara Pacis, for example.
2 British Museum, inv. 88.9–5.1 (dated 1542; ill. in Liverani, fig. 53).
3 Lessmann, cats. 737–738.
4 Sackler Collection, inv. 79.5.4.
5 Lessmann, cat. 738, 763, and 765, for example.
6 Ibid., cats. 721–723.
7 Ibid., 175.
8 Piccolpasso II, 64.

This extremely rare, perhaps unique Venetian plate is unlike any other known example, although it is linked stylistically to many plates from the workshop of Maestro Domenico, and may even be by hand of the master himself. While the central narrative section is not in itself particularly unusual – it shows a bathing Diana accompanied by her nymphs – the square enframing window through which it is seen is unparalleled. The "window" is surrounded by antique-style fruit swags with a bucranium,[1] lion heads, and goat-legged figures perched atop animal heads in front of large scrolls; behind all the applied decoration is a pale brick-patterned wall. The palette of the Clark plate is limited, but brilliant, with the pale cream-colored wall setting off the brightly colored surface ornaments, and emphasizing the jewel-like greens, blues, and oranges of the central scene as well. The painter carefully drew the window frame in correct perspective – no easy task when one considers the three-dimensional shape of a plate – darkening the inside of the left and top moldings to provide a sense of natural directional lighting.

Enframing schemes of a different sort were used occasionally by maiolica painters in Venice, especially in Maestro Domenico's studio, and at least one Pesaro plate is known in which the artist, Lanfranco, pierced the rear wall of an interior scene with a window, revealing a distant landscape.[2] More formal uses of this compositional device are seen in works by Domenico and his colleagues: two plates in Braunschweig, both signed and dated 1568 by the master, have a narrative subject in the central well of the plate with a border of compartmentalized vignettes enclosed and linked by scrolls;[3] a large round-bodied pitcher in the Sackler Collection from the same Venetian shop, shows the Baptism of Christ inside a medallion festooned with greyish scrolls.[4]

The figures of the sumptuously garbed nymphs find ample comparisons among Domenico's works, particularly in one of the 1568 plates in Braunschweig, and several other pieces given by Lessmann to workshop assistants.[5] The light, full dresses frequently worn by these female figures have a fluffy overfold at the waist and a high sash under the breasts, the thin, clinging fabric revealing their navels beneath it. The heads of the women, not surprisingly, bear a strong resemblance to those on the large pharmacy jars, like cat. 69, although on a much different scale. Landscape elements of quickly-drawn, almost calligraphic grasses, arrangements of small crossed sticks, striated trees, and soft, smooth hills are consistent with the products of Domenico's atelier, as is the laurel-branch wreath held by two of the nymphs here.[6] The free sketchy handling of the Clark plate is characteristic as well of most Venetian *istoriato* products of the time.

The *istoriato* style itself apparently was brought to Venice by visiting or emigrating potters from ceramic centers farther to the south; Guido da Merlino, an Urbino painter, inscribed two works of 1542 with the comment that they were made in "san polo," referring to the Venetian quarter of that name.[7] Piccolpasso also remarked upon the presence in Venice of potters from Castel Durante, and there is additional evidence that a workshop was established there by the celebrated Maestro Giacomo from Pesaro.[8]

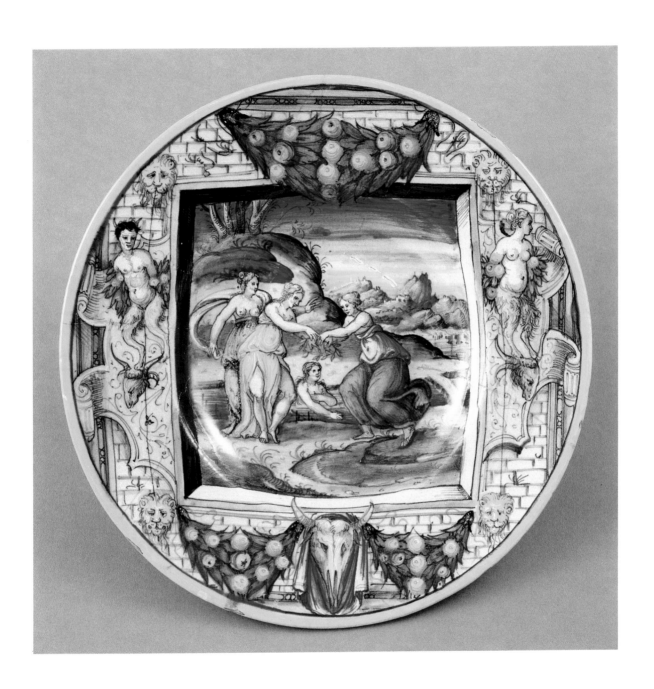

Faenza

71. Plate with candelabrum and geometric motifs
Late 15th–early 16th century
H 3.2 cm; D 23.0 cm; shape R10
Inv. 26.407
Provenance: Gavet; Clark
Bibliography: Gavet, cat. 443; Corcoran/*Bulletin*, cat. 16
Cf. cats. 6 and 7.

71

72. Plate with floral and geometric motifs
Late 15th–early 16th century
H 4.7 cm; D 20.8 cm; shape R10
Inv. 26.418
Provenance: Gavet; Clark
Bibliography: Gavet, cat. 445; Corcoran/*Bulletin*, cat. 18
A Faentine plate with a similar central motif – which Rackham calls a "stylised pink" – is in the collection of the V&A (Rackham, cat. 229).

72

73. Molded dish with equestrian figure
c.1535–40
H 6.2 cm; D 28.9 cm
Inv. 26.388
Provenance: Hainauer; Clark
Bibliography: Hainauer, 34, 119, cat. 362 (M86); Corcoran/*Bulletin*, cat. 36
It has been suggested that the armor-clad equestrian figure is St. George of Cappadocia, although he could equally well represent Marcus Curtius or another character from ancient history. At least two similar pieces have been noted in the museum at Berlin (Hausmann, cat. 131) and the Adda Collection (Adda, cat. 124).

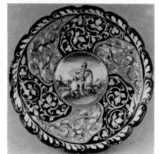

73

74. Two-handled vase with putti
Possibly Faenza, c.1550–75
H 36.0 cm; D 23.4 cm
Inv. 26.384
Provenance: Hainauer (?); Clark
Bibliography: Corcoran/*Bulletin*, cat. 42
Although some doubts have been expressed about the authenticity of this piece, it shows affinities with five vases in the museum at Braunschweig which are attributed to the Faentine workshop of Virgiliotto Calamelli (Lessmann, cats. 39–43). The distinctive style of the figures and their *sfumato* modelling, as well as the molded handles and lion-head bosses are consistent with the latter works, suggesting that they may have come from the same atelier. A pair of related vases at Braunschweig, given to the Fontana workshop (Lessmann, cat. 187), indicate that the shape was also in use in Urbino in the middle of the 16th century.

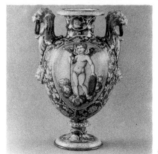

74

75. Albarello with Turk's head, mascaroon, rinceaux, and trophies
c.1550–75
H 28.4 cm; D 14.5 cm
Inscribed on front on band: "[?]iua: simpli"
Inv. 26.378
Provenance: Hainauer; Clark
Bibliography: Hainauer, 37, 117, cat. 352 (M76); Corcoran/*Bulletin*, cat. 38
Cf. Guidotti/*Bologna*, cat. 71, and Drey, pl. 22B, for other albarelli decorated with a head of a turk, a motif popular also in Venice.

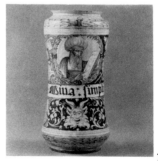

75

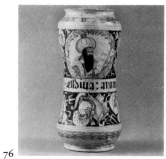

76

76. Albarello with Turk's head and trophies

c.1550–75
H 29.1 cm; D 14.3 cm
Inscribed on front on band: "[?]iua: aromati"
Inv. 26.379
Provenance: Hainauer; Clark
Bibliography: Hainauer, 37, 118, cat. 353 (M77); Corcoran/*Bulletin*, cat. 39
Pendant to cat. 75.

Orsini-Colonna Wares

77. Dragon-spouted drug jar with two men

c.1520–40
H 25.2 cm; D 16.8 cm
Inscribed on band on lower body: "dIA CARIdION"
Inv. 26.320
Provenance: Hainauer; Clark
Bibliography: Hainauer, 110, cat. 298 (M18); Corcoran/Erdberg, 72; Corcoran/*Bulletin*, cat. 21
The drug name on the label – *Dia caridion* – may actually refer to *Diacridium* or *Diagridium*, a soothing viscous medicinal compound made by combining scammony (a gum resin from a plant) and fruit juice (see Drey, 199). It should be noted that the upper part of this jar has been reconstructed incorrectly (cf. cat. 17).

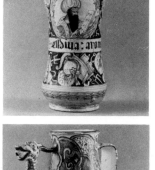

77

78. Tall drug jar with a woman holding a bowl of berries (?)

c.1520–40
H 40.4 cm; D 22.6 cm
Inscribed on band on lower body: "a plantaginis" (a medicinal solution made from plantain)
Inv. 26.323
Provenance: Hainauer; Clark
Bibliography: Hainauer, 37, 110, cat. 301 (M21); Corcoran/Erdberg, 72; Corcoran/*Bulletin*, cat. 24
An Orsini-Colonna vase in the Cora Collection (now at the museum in Faenza; Cora/Faenza, cat. 775), shows a woman with similar costume and gesture.

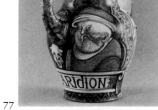

78

79. Tall drug jar with two babies riding a griffin

c.1520–40
H 41.1 cm; 22.9 cm
Inscribed on band on lower body: "a calamet^m" (solution of *Calaminthus officinalis*)
Inv. 26.326
Provenance: Hainauer; Clark
Bibliography: Hainauer, 37, 110, cat. 304 (M24); Corcoran/Erdberg, 72; Corcoran/*Bulletin*, cat. 27

80. Tall drug jar with Mary Magdalen in the Desert

c.1520–40
H 42.6 cm; D 24.3 cm
Inscribed on band on lower body: "a de capitt [or capill?] / ueuer"
Inv. 26.340
Provenance: Hainauer; Clark
Bibliography: Hainauer, 37, 112, cat. 318 (M38); Corcoran/Erdberg, 72; Corcoran/*Bulletin*, cat. 28
The inscription on this label may refer to *Capillus veneris*, or maidenhair ferns, whose dried fronds were used in pharmaceutical compounds.

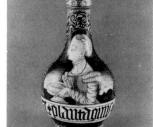

79

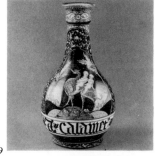

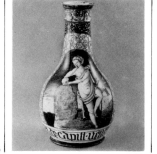

80

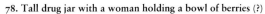

81. Tall two-handled drug jar with bust of a woman

c.1520–40

H (without handles) 36.1 cm; H (with handles) 36.6 cm; D 20.6 cm; max W 23.5 cm

Inscribed on band on lower body: "a [?]euz comuneuz [?]"

Inv. 26.322.

Provenance: Hainauer; Clark

Bibliography: Hainauer, 37, 110, cat. 300 (M20); Corcoran/Erdberg, 72; Corcoran/*Bulletin*, cat. 23

Cf. cat. 14.

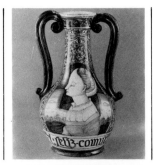

81

82. Tall drug jar with St. George Slaying the Dragon

c.1520–40

H 42.0 cm; D 22.8 cm

Inscribed in roundel on neck: "IHS" (monogram of Christ); on band on lower body: "a menta" (mint solution)

Inv. 26.341

Provenance: Hainauer; Clark

Bibliography: Hainauer, 37, 113, cat. 319 (M39); Corcoran/Erdberg, 72; Corcoran/*Bulletin*, cat. 29

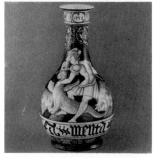

82

83. Albarello with bust of a woman

c.1520–40

H 24.6 cm; D 14.6 cm

Inscribed on band on lower body: "v basilico"

Inv. 26.392

Provenance: Hainauer; Clark

Bibliography: Hainauer, 37, 119, cat. 365 (M90); Corcoran/Erdberg, 72; Corcoran/*Bulletin*, cat. 31

Unguentum basilicum is described by Drey (p. 188) as "an ointment made from wax, pitch, olive oil, myrrh, frankincense and other resins . . . used to promote healing of wounds." Its name is taken from the Greek word for "king," and means royal ointment.

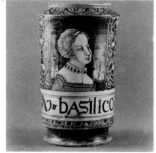

83

84. Albarello with bust of a woman

c.1520–40

H 21.2 cm; D 12.8 cm

Inscribed on band on lower body: "VN p SCABIe" ("unguent for scabies," a skin ailment); beneath foot: undeciphered scratched marks

Inv. 26.393

Provenance: Hainauer; Clark

*Bibliography:*Hainauer, 37, 119, cat. 366 (M91); Corcoran/Erdberg, 72; Corcoran/*Bulletin*, cat. 32

As is illustrated by the different figural style and type of lettering on this albarello, several hands must have been involved in the production of the so-called Orsini-Colonna pharmacy wares (see cats. 14–17).

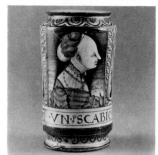

84

Tuscany

85. Tile with St. Martin and the Beggar

Tuscany, possibly Cafaggiolo or Siena, c.1500–20

H 18.4 cm; W 18.1 cm

Inv. 26.310

Provenance: Hainauer; Clark

Bibliography: Hainauer, 35, 108, cat. 288 (M8); Corcoran/Erdberg, 72; Corcoran/*Bulletin*, cat. 10; *Detroit*, cat. 97

The story of St. Martin sharing his cloak with a beggar is featured on this piece, the only tile in the Clark Collection. Although its exact attribution remains uncertain, its style, decorative vocabulary, and palette suggest that it belongs to a Tuscan workshop.

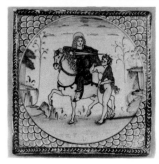

85

86

86. Dish with a reclining unicorn

Tuscany, possibly Montelupo, c.1510
H 4.5 cm; D 33.2 cm; shape R8
Inv. 26.410
Provenance: Gavet; Clark
Bibliography: Gavet, cat. 458; Corcoran/Erdberg, 72; Corcoran/*Bulletin*, cat. 11; *Detroit*, cat. 96
The distinctive border patterns of this dish appear on a number of ceramics attributed to the Tuscan centers of Montelupo, Florence, Cafaggiolo, Faenza, and even Narbonne (cf. Cora/Faenza, cats. 515–519; Klesse, cat. 276; Cora/*Firenze*, pls. 262a and c, 263, 267a–c; Giacomotti, cat. 447; Join-Dieterle, cat. 93).

87

87. Plate with the arms of the Bramanti and children playing bagpipes

Tuscany, c.1520–30
H 3.3 cm; D 18.8 cm; shape R9
Inscribed on verso in center: a faint monogram, possibly "AD"
Coat of arms: Per fess, in chief or, a demi-goat salient sable, in base azure, three stars or
Inv. 26.306
Provenance: Hainauer; Clark
Bibliography: Hainauer, 34, 107, cat. 284 (M4); Corcoran/*Bulletin*, cat. 20
The coat of arms on this unique and charming plate belongs to the Bramanti family of Florence (Cartari-Febei, busta 174, folio 280r, #9). The decorative elements and palette – notable for the inclusion of red pigment – may point to Cafaggiolo as its source.

Central Italy

88

88. Dish with Gothic-floral design

Central Italy, possibly Faenza, late 15th–early 16th century
H 5.5 cm; D 24.7 cm; shape R3
Inv. 26.422
Provenance: Gavet (?); Clark
Bibliography: Corcoran/*Bulletin*, cat. 8
Cf. cat. 19 and V&A, Rackham, cat. 146.

89. Albarello with a man wielding a club

Central Italy, late 15th century
H 22.6 cm; D 15.3 cm
Inscribed on band on lower body: "GIERA PICRA SOLVTIVA" (*Hiera picra*, a thick, sweet purgative liquid compound made from spices such as saffron and cinnamon, aloes, and other ingredients; see Drey, 206)
Inv. 26.412
Provenance: Gavet (?); Clark
Some scholars have questioned the authenticity of this unusual jar because of the lack of comparative pieces. Assuming its authenticity, it remains difficult to assign it to a particular ceramic center: Faenza, Deruta, Pesaro, and Naples have all been suggested as possible sources (cf. Giacomotti, cats. 471 and 475, both Deruta, early 16th century). The subject is not known, although it is likely that the figure is excerpted from a print such as Mantegna's *Flagellation of Christ* (c.1475–80; see *Ital. Engrs.*, cat. 78); a similar figure, derived directly from this print, is found on a tile from the monastery of San Paolo, Parma, now in the Museo Archeologico Nazionale of Parma (see Berardi, fig. 123c).

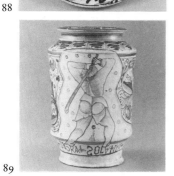

89

90. Albarello with busts of a man and woman

In the style of Central Italy, late 15th century (?)
H 21.5 cm; D 13.3 cm
Inv. 26.411
Provenance: Gavet (?); Clark
Bibliography: Corcoran/*Bulletin*, cat. 9
Although it bears a resemblance to certain pieces of the last quarter of the 15th century (e.g. Rackham cat. 110, Faenza, c.1475; Hausmann, cat. 84, Florence ?, c.1480), this drug jar may be a later reproduction. It has also undergone extensive damage and restoration.

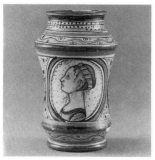

90

Siena

91. Albarello with grotesques and ornamental patterns

c.1510–15
H 28.2 cm; D 14.0 cm
Inv. 26.333
Provenance: Hainauer; Clark
Bibliography: Hainauer, 111, cat. 311 (M31); Corcoran/*Bulletin*, cat. 69
Pendant to cat. 25.

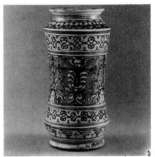

91

92. Plate with a coat of arms and ornamental patterns

c.1510–20
Coat of arms: Azure, a fess between three crescents argent, impaling gules, a moor's head sable (unidentified)
H 4.0 cm; D 24.9 cm; shape R10
Inv. 26.403
Provenance: Gavet (?); Clark
Bibliography: Corcoran/*Bulletin*, cat. 14
The knot pattern of the border of this plate is identical to one that appears on a pair of Sienese albarelli in the Clark Collection (cats. 25 and 91). While the coat of arms has not been identified, the left half appears to belong to the large and distinguished Tolomei family, which was based primarily in Siena (Spreti, VI, 618–624).

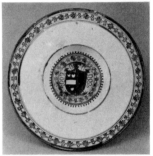

92

Deruta

93. Plate with the arms of the Orsini

c.1500–10
Coat of arms: Bendy of six gules and argent; on a chief argent, supported by a divise or charged with a wavy line (i.e. an eel), a rose gules
H 2.1 cm; D 24.1 cm; shape L2
Inv. 26.423
Provenance: Gavet (?); Clark
Bibliography: Corcoran/*Bulletin*, cat. 48
The distinctive coat of arms of the Orsini family is found frequently on maiolica and appears on two pieces in the Clark Collection (see also cat. 101). Note on the reverse a petalback pattern with a star in the center. A related ewer basin is in the V&A (cf. Rackham, cat. 396).

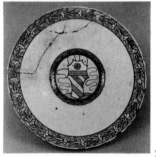

93

94. Spouted drug jar with sphinxes

1507
Inscribed on recto on band: "SYRᵒ IVIVBINO" ("syrup of jujube"); on verso: "1507"; beneath foot: undeciphered scratched marks
H 22.4 cm; D 17.8 cm
Inv. 26.318
Provenance: Hainauer; Clark
Bibliography: Hainauer, 109, cat. 296 (M16)
Cf. cat. 30 and Pringsheim, cat. 109.

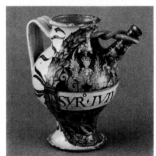

94

95. Albarello with woman spinning and putti on sea monsters

c.1500–10
H 12.3 cm; D 22.3 cm
Inscribed on recto on band: "FILONIO" (*Philonium*); beneath foot: undeciphered scratched marks
Inv. 26.338
Provenance: Hainauer; Clark
Bibliography: Hainauer, 112, cat. 316 (M36)
Drey notes that *Philonium* was a polypharmaceutical compound (i.e. made from many ingredients) of opium and other ingredients, used to relieve pain and induce sleep; its name was taken from that of a first-century BC physician, Philon of Tarsus (see Drey, p. 222); cf. Rackham, cat. 405.

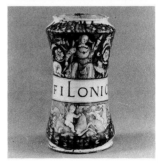

95

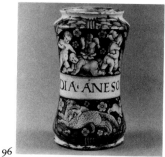

96

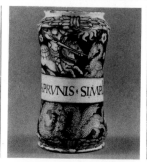

97

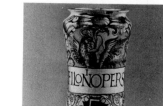

98

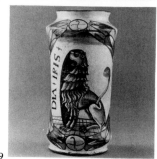

99

96. Albarello with playing children and fighting animals

c.1500–10

H 20.9 cm; D 12.2 cm

Inscribed on front on band: "DIA ANESO"; beneath foot: undeciphered scratched marks

Inv. 26.339

Provenance: Hainauer; Clark

Bibliography: Hainauer, 112, cat. 317 (M37)

"Dia" is a prefix meaning "made from"; the second word in the inscription may represent an alternative spelling of *aneto*, or dill, which was used in various pharmaceutical preparations (Drey, 185); cf. Rackham, cat. 405.

97. Albarello with St. George Slaying the Dragon and fighting dragons

c.1500–10

H 22.5 cm; D 12.2 cm

Inscribed on front on band: "DIA PRVNIS SIMPLEX"; beneath foot: undeciphered scratched marks

Inv. 26.401

Provenance: Castellani; Gavet (?); Clark

Bibliography: Castellani, cat. 40

The label indicates that this albarello once held a simple, or unmixed, compound made from plums or prunes. Above, St. George is depicted wearing armor of a type termed *alla romana* (in the Roman style), common to the period around 1500; his helmet, a sallet, or *celata*, is comparable to one worn by an angel in Signorelli's fresco *The Damned* in the S. Brixio Chapel in Orvieto Cathedral (c.1500).

98. Albarello with Ganymede and a coat of arms

c.1500–10

H 24.1 cm; D 13.1 cm

Inscribed on front on band: "FILONIO PERSICO" (*Philonium persicum*); beneath foot: undeciphered scratched marks

Coat of arms: Azure, on a mount of three hillocks vert a leopard rampant or spotted azure holding in the fore-paws a carpenter's square argent (unidentified)

Inv. 26.416

Provenance: Gavet; Clark

Bibliography: Gavet, cat. 532; Corcoran/*Bulletin*, cat. 62

Ganymede, the beautiful son of one of the legendary kings of Troy, is shown here being carried off by Jupiter in the form of an eagle; the tale is recounted in Book X of Ovid's *Metamorphoses*. *Philonium persicum* was a polypharmaceutical preparation made from the fruit and/or blossoms of the peach tree (see also cat. 95).

99. Albarello with lion

c.1500–10

H 26.4 cm; D 13.8 cm

Inscribed on band to left of lion: "DIA IRIS" ("made of iris"); beneath foot: undeciphered scratched marks

Inv. 26.408

Provenance: Gavet (?); Clark

Bibliography: Corcoran/*Bulletin*, cat. 61

Two drug jars in the Clark Collection – this one and cat. 13 – were used to store a compound made from the iris plant rhizome. An albarello related to the present one is in the Gambier-Parry collection (see Mallet, "Italian maiolica in the Gambier-Parry collection," *BM* CIX, 1967, fig. 57); see also a jar formerly in the Adda Collection (Adda, pl. 164B).

100. Albarello with bust of a woman

c.1510–20

H 23.2 cm; D 12.5 cm

Inscribed on band at left of medallion: "DIA SENA" ("made of senna" – a purgative solution made from senna leaves)

Inv. 26.398

Provenance: Gavet (?); Clark

The portrait of a woman on this albarello is very similar to one on a plate also attributed to Deruta in the Louvre (Giacomotti, cat. 456). The symbol which appears at the top and bottom of the encircling wreath and includes the letter "S" resembles one noted by Fortnum (*Marks and Monograms*, no. 94) and reproduced by Ballardini (*Corpus I*, figs. 297–301), although its precise significance is not yet known.

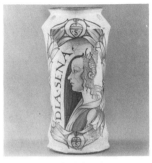

100

101. Dish with the arms of the Orsini

c.1520–30

H 7.3 cm; D 41.1 cm; shape R2

Coat of arms: Bendy of six argent and gules, on a chief argent, supported by a divise or, a rose gules; the painter has used lustre pigments to represent equally gules (red) and or (gold)

Inv. 26.381

Provenance: Castellani; Hainauer; Clark

Bibliography: Castellani, cat. 121; Hainauer, 36, 118, cat. 355 (M79); Corcoran/*Bulletin*, cat. 56

The Orsini, one of the largest families of Rome (with branches in various other cities), were among the most active patrons of maiolica, to judge from the frequency with which their arms appear on 16th-century plates, particularly those from Deruta workshops (cf. cat. 93; see also a related Deruta plate showing a sphinx holding an Orsini shield, Join-Dieterle, cat. 15).

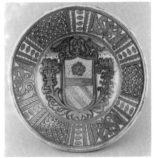

101

102. Dish with bust of a woman and motto

c.1520–30

H 8.0 cm; D 40.5 cm; shape R2

Inscribed on banderole at left center: "V / MBELMo/RIRETVTTALA V/I/TAONO/RE" ("Un bel morire, tutta la vita onore")

Inv. 26.337

Provenance: Hainauer; Clark

Bibliography: Hainauer, 36, 112, cat. 315 (M35); Corcoran/*Bulletin*, cat. 52

Other Deruta plates in this style with the same inscription can be found in the Museo Civico at Pesaro (Della Chiara, cat. 118) and the V&A (Rackham, cat. 749). Rackham translates the motto as "A fair death makes honorable a whole life." Two additional plates with similar mottoes are in the collection of the Hermitage (see Kube, 35, note 45).

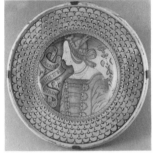

102

103. Plate with trophy and foliage

c.1520–30

H 3.6 cm; D 24.8 cm; shape R10

Inv. 26.385

Provenance: Gavet; Clark

Bibliography: Gavet, cat. 536, pl. LII^bis; Corcoran/*Bulletin*, cat. 59

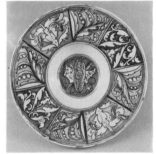

103

104. Two-handled vase with two women

c.1525–50

H of body 26.9 cm; D of body 19.8 cm; max H 28.1 cm; max W 22.1 cm

Inscribed inside medallion on one side: "G"; inside medallion on other side: "S"

Inv. 26.391

Provenance: Hainauer; Clark

Bibliography: Hainauer, 119, cat. 364 (M89); Corcoran/*Bulletin*, cat. 91

A very similar vase with two female portraits accompanied by the letters "A" and "F" is in the Dutuit Collection at the Petit Palais (Join-Dieterle, cat. 24; that author notes that there is another closely-related piece in the Museo Regionale della Ceramica Umbra in Deruta).

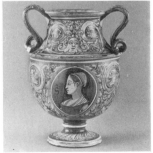

104

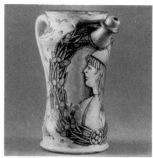

105

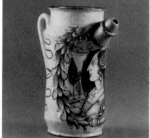

106

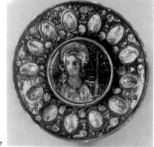

107

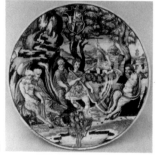

108

105. Spouted jar with bust of a youth
In the style of Deruta, early 16th century (?)
H 22.7 cm; D 12.9 cm
Inv. 26.390
Provenance: Hainauer (?); Clark
This anomalous shape is the result of the addition of a spout and handle onto a standard albarello. Although this piece and another related jar in the Clark Collection (cat. 106) have not been scientifically tested, there is some doubt about their authenticity. The possibility also remains, however, that the handle and spout were added later to an original piece. The portrait on the present work is identical to one that appears on at least two other albarelli: one in the Adda Collection (Adda, cat. 369, pl. 160A) and another in the Metropolitan Museum of Art (inv. 46.85.38).

106. Spouted jar with bust of a woman
In the style of Deruta, early 16th century (?)
H 23.2 cm; D 12.5 cm
Inv. 26.414
Provenance: Gavet (?); Clark
Similar in shape and style to cat. 105, this spouted albarello has also been called into question by scholars (cf. Adda, cat. 370, pl. 160B, the pendant to the albarello compared to cat. 105, above).

Gubbio

107. Molded dish with female martyr-saint
c.1530–40
H 5.0 cm; D 24.9 cm
Inv. 26.314
Provenance: Castellani; Hainauer; Clark
Bibliography: Castellani, cat. 96; Hainauer, 36, 109, cat. 292 (M12); Corcoran/*Bulletin*, cat. 65
Dark areas on both front and back of this molded lustred piece are evidence of its having been burnt during firing.

Urbino

108. Plate with Pan and Apollo
c.1535–40
H 4.0 cm; D 27.1 cm; shape R10
Coat of arms: Impaled: Dexter, party per pale: 1, tierced per fess, sable, or and azure; 2, azure, on a bend sinister or three raven's heads sable (for Rabenhaupt von Suche). Sinister, party per fess: in chief, azure, a griffin argent; in base, azure two pole-axes crossed in saltire argent (for Lamparter).
Inscribed on verso: "Pan et Appollo"
Inv. 26.368
Provenance: Hainauer; Clark
Bibliography: Hainauer, 38, 117, cat. 346 (M66); Corcoran/*Bulletin*, cat. 84
These arms have recently been identified by Dr. Fischer of the Hauptstaatarchiv, Stuttgart, as referring to the marriage of Genoveva, third daughter of the Chancellor of Württemberg, Gregor Lamparter, and Nikolaus Rabenhaupt von Suche, Chancellor of Lower Austria. (I am grateful to Timothy Wilson for this information). At least ten pieces are known with this coat of arms (four in Budapest, two in Vienna, and one each in the British Museum, Museum für Kunst und Gewerbe, Hamburg, and the Pringsheim Collection; see Rasmussen, 180–182 for full references). Stylistic variations suggest that there must have been at least two and possibly more painters at work on these plates; in addition, the shields on which the coats of arms appear take three distinctly different shapes. Common to many of them, however, is an interest in background architecture with an emphasis on imaginary centralized buildings. The present plate is closest to two of the Budapest pieces (cf. Ilona Pataky-Brestyanszky, *Italienische Majolikakunst*, Budapest, 1967, pls. 35–36).

109. Pilgrim flask with Jupiter and Io

Francesco Durantino, c.1545–50
H 35.8 cm; W 22.3 cm; D 13.0 cm
Inv. 26.367
Provenance: Hainauer; Clark
Bibliography: Hainauer, 116, cat. 345 (M65); Corcoran/*Bulletin*, cat. 89
The Clark flask bears a strong resemblance to one in the Petit Palais (Join-Dieterle, cat. 78; there given to the Fontana School). Both are almost certainly from the hand of Francesco Durantino (cf. cat. 57).

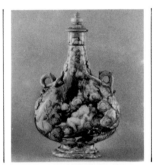

109

110. Pilgrim flask with Diana and Actaeon

Urbino or Duchy of Urbino, c.1545–55
H 35.7 cm; W 22.9 cm; D 12.9 cm
Inv. 26.365
Provenance: Hainauer; Clark
Bibliography: Hainauer, 116, cat. 343 (M63); Corcoran cat. 93
The subject of Diana and Actaeon was extremely popular among maiolica painters and appears on many 16th-century pieces (see P. Castelli, "'Atteon converso in cervo', un episodio delle *Metamorfosi* di Ovidio nelle ceramiche cinquecentesche," *Faenza* LXV 1979 313–331). Here, and in a number of the other examples, the composition is based on a print by the Master I.B. with a Bird (B.XII, 2). The Clark flask may be by the same Urbino artist responsible for two plates in the museum in Pesaro dated 1545 and 1549 (Della Chiara, cats. 36–37).

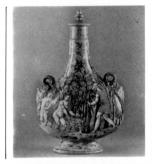

110

111. Molded dish with the Judgement of Paris

Urbino, or Duchy of Urbino, c.1550–60
H 7.3 cm; D 30.0 cm
Inscribed on verso: "Iuditio d/ Paris" ("The Judgement of Paris")
Inv. 26.372
Provenance: Hainauer (?); Clark
Bibliography: Corcoran/*Bulletin*, cat. 105
The composition is loosely based upon the print by Marcantonio Raimondi of the same subject (B.XIV,245).

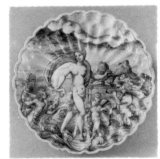

111

112. Molded dish with Galatea

"Um 1570" Group, c.1570
H 6.6 cm; D 31.0 cm
Inscribed on verso: "Galatea bella" ("beautiful Galatea")
Inv. 26.376
Provenance: Hainauer (?); Clark
Bibliography: Corcoran/*Bulletin*, cat. 108
The present dish belongs to an extensive group of ceramics that were turned out in Urbino around 1570 under the influence of the Fontana workshop. A substantial number of these works are now in the museum in Braunschweig (see Lessmann, 276 ff.; other related pieces are in the Correr Museum, inv. Cl.IV, nos. 83 and 84; at Erddig, Mallet/*Erddig*, fig. 7c; Bologna, Guidotti/*Bologna*, cat. 82; and the Wallace Collection, Norman, cat. C142). The figural types that appear on the Clark dish are repeated in many of these pieces (cf. Lessmann, cats. 399, 408–409), as is the marine setting and formulaic architecture in the distant background (cf. cats. 407–408). The inscription, with its characteristic enframing flourishes, is also stylistically consistent with notations on other dishes (cf. Lessmann, cats. 353 and 399).

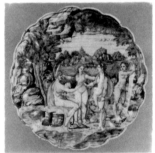

112

113. Plate with putto and grotesques

Patanazzi Workshop, last quarter of the 16th century
H 3.0 cm; D 22.4 cm; shape L4
Inv. 26.397
Provenance: Hainauer; Clark
Bibliography: Hainauer, 120, cat. 369 (M95); Corcoran/*Bulletin*, cat. 102
Cf. a very similar piece in the Museo Civico, Pesaro (Della Chiara, cat. 306).

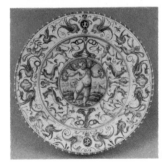

113

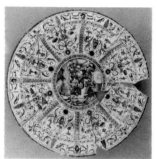

114

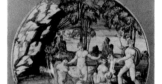

115

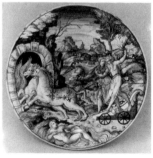

116

117

114. Molded dish with Gideon choosing his Warriors
c.1580–1600
H 4.0 cm; approx D 48.0 cm (fragmentary)
Inscribed on verso: "Gideo selegit co[n]tra / madian IVD IIIII" ("Gideon selecting his forces against Midian, Book of Judges, 5")
Inv. 26.396
Provenance: Hainauer; Clark
Bibliography: Hainauer, 120, cat. 368 (M94); Corcoran/*Bulletin*, cat. 111
The story of Gideon and the Midianites is contained in the Book of Judges, Chapter 6 (not 5 as noted in the inscription on the Clark plate); it recounts the episode in which Gideon is instructed to choose his warriors by the manner in which they drank from a stream. The present dish is a typical example of the latest phase of the Urbino style which used elaborate grotesques on a white ground combined with narrative scenes (cf. cats. 59 and 60).

Pesaro

115. Plate with the Death of Narcissus
Probably Pesaro, near the Lanfranco workshop, c.1545–50
H 2.8 cm; D 24.4 cm; shape L9
Inscribed on verso: "narciso / mutato / in fiore" ("Narcissus changed into a flower")
Inv. 26.353
Provenance: Castellani; Hainauer; Clark
Bibliography: Castellani, cat. 278; Hainauer, 114, cat. 331 (M51); Corcoran/*Bulletin*, cat. 91
The plate shows the tragic death of Narcissus as told in the third book of Ovid's *Metamorphoses*. It is comparable stylistically to a number of works from the workshop of Maestro Girolamo di Lanfranco and his son Giacomo delle Gabicce (see Grazia Biscontini Ugolini, "Di alcuni piatti pesaresi della bottega dei Lanfranco delle Gabicce," *Faenza* LXIV, 1978, 27–32; cf. especially pl. XIa, from the Wallace Collection; cf. also cat. 14 in G. Liverani, *Le maioliche della Galleria Estense di Modena*, Faenza, 1979).

116. Dish with the Fall of Icarus
Sforza di Marcantonio, 1551
H 5.1 cm; D 23.5 cm; shape R14
Inscribed on verso: "iccharo peruolar tro/ppo sublime nel mar / folle garzon chadde e / morio 1551" ("Icarus, by flying too high, fell into the sea, crazy young man, and died 1551")
Inv. 26.346
Provenance: Hainauer; Clark
Bibliography: Hainauer, 113, cat. 324 (M44); Corcoran/*Bulletin*, cat. 95
The theme of Icarus was a popular one in the Renaissance, and Hall has noted that some moralizing authors used it to illustrate the danger of rash action and the virtue of moderation (Hall, 159). Two other plates by Sforza di Marcantonio dated 1551 are in the Clark Collection (cats. 66 and 67).

117. Plate with the Rape of Persephone
c.1550–70
H 3.6 cm; D 23.6 cm; shape L8
Inscribed on verso: "il rapimento d proser/pina" ("the rape of Proserpina")
Inv. 26.345
Provenance: Hainauer; Clark
Bibliography: Hainauer, 113, cat. 323 (M43); Corcoran/*Bulletin*, cat. 92
Several similar versions of this subject are found in other works from Pesaro, including examples by the Zenobia Painter and Sforza di Marcantonio or his school (e.g. Lessmann, cats. 479, 486, and 495). The present plate probably belongs near Sforza's workshop and can be compared to a plate by him in the collection at Braunschweig (Lessmann, cat. 486) which Lessmann suggests is based on a woodcut in Ludovico Dolce's 1553 version of Ovid's *Metamorphoses*.

Venice

118. Plate with the Triumph of Bacchus
Workshop of Domenico da Venezia, c.1560–70
H 4.9 cm; D 30.5 cm; shape R10
Inscribed on verso: "trionfo dibacho" ("the triumph of Bacchus")
Inv. 26.374
Provenance: Hainauer (?); Clark
Bibliography: Corcoran/*Bulletin*, cat. 107

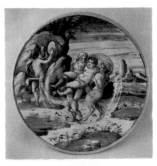

118

The theme of the drunken Bacchus being borne in procession by his companions was popular among maiolica painters. A print of that subject by Agostino Veneziano (B.XIV,215) provided the inspiration for the present plate and a number of others in Venice and in other centers (e.g. Lessmann, cat. 695, also from the workshop of Domenico da Venezia, which bears the same scene on the recto and a nearly identical inscription on the verso; cf. also cat. 739, dated 1569 from the same shop, and an earlier version of the theme by an artist near Nicolò da Urbino, Giacomotti, cat. 869, c.1535).

119. Molded dish with the Parting of Lot and Abraham
Workshop of Domenico da Venezia, c.1565–70
H 6.0 cm; D 30.0 cm
Inscribed on verso: "del gienesi Capi XIII" ("from Genesis, Chapter 13")
Inv. 26.347
Provenance: Hainauer; Clark
Bibliography: Hainauer, 39, 113, cat. 325 (M45); Corcoran/*Bulletin*, cat. 104

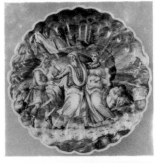

119

The scene of the parting of Lot and Abraham was featured in several illustrated Bibles, providing inspiration for maiolica painters in Urbino and Venice. Giacomotti describes a similar scene on a pilgrim flask in the Louvre (Giacomotti, cat. 1146, Urbino/Lyon/Nevers?, 1550–1600) as being based on Bernard Salomon's vignette in D. Maraffi's *Figure del Vecchio Testamento* (1554, fol. B 7 verso). The composition on the Clark flask is identical to part of a woodcut in *Figure de la biblia illustrate da stanze tuscane da Gabriele Symeoni* (Lyon, Guillaume de Roville, 1564, 23; cf. a piece in Braunschweig based on the same print, Lessmann, cat. 278). For stylistically related pieces from the workshop of Domenico da Venezia inscribed in the same hand, compare Lessmann, cats. 760 and 767.

120. Drug jar with heads of a warrior and a man
Workshop of Domenico da Venezia, last quarter of the 16th century
H 25.7 cm; D 28.2 cm
Inv. 26.394
Provenance: Hainauer (?); Clark
Bibliography: Corcoran/*Bulletin*, cat. 113; *Detroit*, cat. 125

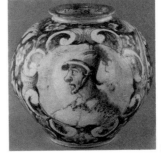

120

Cf. cat. 69. Note in the present jar the runny and somewhat bubbly glaze which was not uncommon in Venetian pieces of this period.

(those with R numbers are derived from Rackham's *Italian Maiolica*; those with L numbers from Lessmann's *Italienische Majolika*)

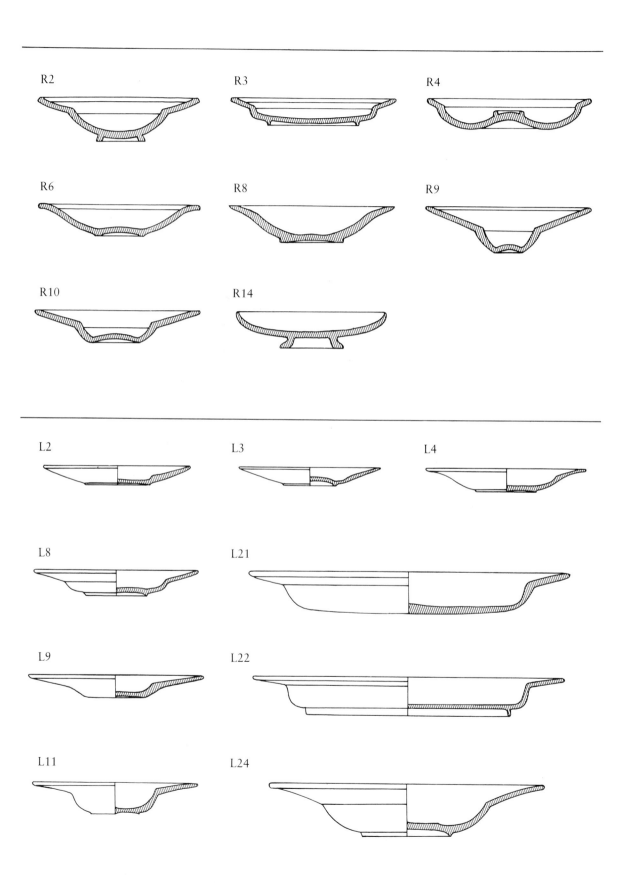

R2 R3 R4

R6 R8 R9

R10 R14

L2 L3 L4

L8 L21

L9 L22

L11 L24

Bibliography, with abbreviations of frequently cited sources

Adda	Bernard Rackham, *Islamic Pottery and Italian Maiolica. Illustrated Catalogue of a Private Collection* (Adda Collection) (London, 1959)
B.	Adam von Bartsch, *Le Peintre Graveur* (21 vols. in 12, Leipzig, 1808–54)
Berardi	Paride Berardi, *L'Antica maiolica di Pesaro dal XIV and XVII secolo* (Florence 1974)
BM	*Burlington Magazine*
Caiger-Smith/*Lustre*	Alan Caiger-Smith, *Lustre Pottery. Technique, tradition, and innovation in Islam and the Western World* (London, 1985)
Caiger-Smith/*TGP*	Alan Caiger-Smith, *Tin-Glaze Pottery* (London, 1973)
Cartari-Febei	Anton Stefano Cartari, "Prodromo gentilizio overo trattato delle armi ed insegni delle famiglie, preliminare alla Europa gentilizia…" (Archivio di Stato di Roma, 1679)
Castellani	Hotel Drouot, *Catalogue des Faiences italiennes … M. Alessandro Castellani* (Paris, 1878)
Charleston	Robert Charleston, ed., *World Ceramics* (London, 1981)
Chompret	J. Chompret, *Répertoire de la Majolique italienne* (Paris, 1949)
Conti	Giovanni Conti, *L'Arte della maiolica in Italia* (2nd ed., Busto Arsizio, 1980)
Conti/*Bargello*	Giovanni Conti, *Museo Nazionale di Firenze. Palazzo del Bargello. Catalogo delle maioliche* (Florence, 1971)
Cora/Faenza	Gian Carlo Bojani, Carmen Ravanelli Guidotti, and Angiolo Fanfani, *Museo Internazionale delle Ceramiche in Faenza. La Donazione Galeazzo Cora. Ceramiche dal medioevo al XIX secolo, Vol. I* (Milan, 1985)
Cora/Fanfani	Galeazzo Cora and Angiolo Fanfani, *La maiolica di Cafaggiolo* (Florence, 1982)
Cora/*Firenze*	Galeazzo Cora, *Storia della maiolica di Firenze e del contado* (2 vols.; Florence, 1973)
Corcoran/*Bulletin*	James D. Breckenridge, "Italian Maiolica in the W.A. Clark Collection," *The Corcoran Gallery of Art Bulletin* vol. 7, no. 3 (April 1955), n.p.
Corcoran/Clark	*The William A. Clark Collection, An exhibition marking the 50th Anniversary of the Installation of the Clark Collection at The Corcoran Gallery of Art, Washington, D.C., 26 April–16 July 1978* (section on maiolica by Carl Christian Dauterman)
Corcoran/Erdberg	Joan Prentice von Erdberg, "Italian Maiolica at the Corcoran Gallery of Art," *BM* 97 (1955), 71–74
Corpus I	Gaetano Ballardini, *Corpus della maiolica italiana, I. Le Maioliche datate fino al 1530* (Rome, 1933)
Corpus II	Gaetano Ballardini, *Corpus della maiolica italiana, II. Le Maioliche datate dal 1531 al 1535* (Rome, 1935)
DBI	*Dizionario Biografico Italiano*
Della Chiara	Maria Mancini della Chiara, *Maioliche del Museo Civico di Pesaro. Catalogo.* (Bologna, 1979)
Deruta	*Maioliche umbre decorate a lustro* (exh. cat., Spoleto, 26 June–18 July 1982; Florence, 1982)
Detroit	Paul L. Grigaut et al. *Decorative Arts of the Italian Renaissance 1400–1600* (exh. cat., Detroit Institute of Arts, 1958)
Donatone	Guido Donatone, *Maioliche napoletane della spezieria aragonese di Castelnuovo* (Naples, 1970)
Drey	Rudolf E.A. Drey, *Apothecary Jars* (London 1978)
Erdberg/Ross	Joan Prentice von Erdberg and Marvin Ross, *Catalogue of the Italian Majolica in the Walters Art Gallery* (Baltimore, 1952)
Fortnum	C. Drury E. Fortum, *Maiolica. A Historical Treatise on the Glazed and Enamelled Earthenwares of Italy…* (Oxford, 1897; reprinted 1979, New York)
Fountaine	Christie, Manson and Woods. *Catalogue of the Celebrated Fountaine Collection of Majolica… from Narford Hall, Norfolk* (London, 1884)
Freeman	Margaret B. Freeman, *Herbs for the Medieval Household* (Metropolitan Museum of Art, New York, 1943)
Gavet	Émile Molinier, *Collection Émile Gavet. Catalogue Raisonné* (Paris, 1889).